Romantic Roots in Modern Art

Romantic Roots
in

Modern Art

Romanticism and Expressionism:
A Study in Comparative Aesthetics

August K. Wiedmann

GRESHAM BOOKS

© 1979 August K. Wiedmann
All rights reserved. No part of this publication may be reproduced in
any form without the permission of the publisher
Published by Gresham Books, Unwin Brothers Ltd.,
The Gresham Press, Old Woking, Surrey, England.
Typeset by Reproprint, Leatherhead, Surrey
Printed by Unwin Brothers Ltd., Old Woking, Surrey.
First Published 1979
ISBN 0 905418 51 4

To Gideon and Daniella

Acknowledgements

My gratitude to Northwestern University for its generous assistance when writing the original version of this study. I would like to thank the various galleries and museums for allowing works from their collections to be reproduced.

I am grateful to the following people for highly recommending the present study to the publishers: Professor Peter Selz, University of California, Mr. Ian Jeffrey, Senior Lecturer of Art History, Goldsmiths' College, London, Dr. Stefan Kalmar, Berkeley, California, and Mrs. Rita Golomb-Robinson, Tel-Aviv. Mrs. Rohan, my mother-in-law, took upon herself the daunting task of re-typing large parts of the manuscript.

My special thanks to the librarians of the Goethe Institute, London, for their saintly patience and unstinting help. If there is a scholar's home away from home it is surely this pleasant, civilized library.

Contents

List of Plates and Illustrations

Introduction

The principal aim of this study is twofold: to reveal the spiritual affinity between Romanticism and Expressionism, and to show, where possible, how the Romantic movement laid the aesthetic and intellectual foundation from which sooner or later modern art was bound to evolve. The theme is not new. Only recently, and after the present study was completed, Robert Rosenblum published his perceptive *Modern Painting and the Northern Romantic Tradition*, which approaches the subject from a more limited art-historical perspective. Before him a number of critics and scholars – notably German – were engaged in similar speculations. The result of their labour has been occasionally enlightening, frequently eccentric. In most cases, the treatment proved much too general and unsupported in the main by any sustained argument. Therefore the following study aims to go deeper, and remains faithful to T. S. Eliot's motto that the greatest debts are not always the easiest to recognize.

To relate two large and complex cultural movements such as Romanticism and Expressionism understandably poses immense problems. Both are notoriously difficult to define; both, in the last analysis, defy compartmentalization. This has become painfully clear in the case of Romanticism, for no other historical movement has assumed such a fearful variety

of meanings. Historians as a rule have singled out one or more defining characteristics to the exclusion of others, equally prominent and important. The common error here occured in the failure to recognize that Romanticism was not a systematic philosophy, nor, in terms of art, a unified style. Instead it was, first and foremost, an attitude to life and the universe, a *Lebensphilosophie* exhibiting a number of common, though by no means consistent, assumptions which found diverse expression in philosophy, criticism, poetry and painting. The same applies with even greater force to Expressionism. While the artists usually grouped under this elastic concept comprised a body of highly individual poets, critics and painters, nonetheless they shared a *Weltanschauung*. As will be shown, this derived to a large extent from the spirit of the Romantic movement.

Of course this spirit did not pass down unbroken and unmodified, nor, evidently, was it the exclusive driving force behind Expressionism and modern art. Other factors, truly modern, played their part in the development of the latter. This clearly must be born in mind in a study concentrating on continuities rather than on differences. While, ideally, a writer ought to deal with both, the nature of the ideas to be considered militates against any such undertaking.

The material has been organized along the following lines. A characteristic Romantic theme is presented and explored in terms of its diverse and frequently unacknowledged implications, while the succeeding chapter treats the recurrence of similar and related themes among Expressionist poets and painters. The same comparative method is maintained throughout with the exception of the last chapter (Part Five). If this procedure creates something of a see-saw pattern and with it an inevitable criss-crossing and overlapping of ideas, it is no more than what a scrupulously conducted comparison demands. To proceed in any other way is to court confusion or, worse still, to produce portentous generalities. In any case, the complex nature of both Romanticism and Expressionism precludes a simple comparative approach. Each must be broken down into its

constituent components before the affinities between them can be perceived. And since Romanticism is historically prior to Expressionism and prepared the ground for things to come, any thematic treatment must begin with it. In this respect the study throws light not only on Expressionism but on the Romantic movement as well. Evidently those familiar with the latter need not linger over chapters devoted to Romantic sources.

Stylistically, an attempt has been made to add colour and persuasion to the views presented. Only those who care little about poetry and art tend to reduce it to a series of propositions, corollaries and abstract definitions. Necessary as these are, they should simply serve as a skeleton to a more evocative argument, an argument which must appeal to the reader's emotion and imagination as well as to his reasoning. As Wilhelm Dilthey pointed out long ago, any aesthetic, cultural or historical movement can only be reconstructed by an active process of 'sympathetic understanding'.

With the exception of poetry, all quotations have been translated into English. Illustrations were kept at a minimum since this is not an art-historical inquiry but an essay in comparative aesthetics and in the history of ideas.

Part One

C. D. Friedrich: *The Monk by the Sea*

Chapter One
The Romantic Weltanschauung

I. The Quest for Unity

When examined too closely the fearful variety and embarrassing complexity of Romantic thought seems to foil any attempt to find one dominant idea shared alike and to the same extent by each and every Romantic. Yet a more panoramic view will easily disclose such an idea which historians, blinded by detail or faithful to differences, have consistently neglected, if not altogether ignored. The underlying theme of Romanticism, a *Leitmotiv* accompanying its cult of feeling, its praise of individualism and the imagination, invariably centred on the idea of oneness or wholeness. What characterized the Romantic movement, above everything else, was its universal striving for unity and integration with the living order of creation.

The Romantics consistently postulated identification with the universe as their great ideal. They lived and thought under the spell of the cosmos. A pantheistic, cosmic feeling pervaded and motivated the whole Romantic generation. It found expression in Friedrich Schlegel's demand for 'infinite unity' and 'infinite fullness', in Novalis' desire to achieve an 'inner total fusion' with the world in Hoelderlin's passionate yearning to merge with nature: 'To be one with all, this is the life of the Godhead, this is the heaven of man.'[1] A striving for oneness expressed itself in Krause's 'symphonic music of the

All', in Schelling's system of identity, in Baader's, Steffens' and Creuzer's various equations between the self and the world.

A pantheistic feeling permeated the world of Schleiermacher who felt his being irresistibly drawn to a divine cosmos: 'When shall I embrace it in action and in contemplation and achieve an inner union with the All?'[2] The same feeling for total fusion welled forth in Goethe's 'How yearns the solitary soul to melt into the boundless whole,'[3] in the bold para-scientific speculations of Oken, Schubert and Carus whose philosophies of nature aimed to discover the world's undivided wholeness. 'A great life-force everywhere', wrote Novalis, 'Blossoms forth and comes to bear / All must link in harmony / Each through the other flourish and fruitful be.'[4]

All must link in harmony! With the Romantics the unique emphasis invariably lay on the words 'all' and 'everything'. Everything quivered with a unitary life. 'Every leaf and blade of grass', wrote Philipp Otto Runge, 'swarms with one life, the earth is alive ... everything rings in one chord.'[5] Man's soul responded to the soul of things. A profound bond of solidarity abolished the distinction between subject and object, between the self and things. All was one world, one *magical* universe in which man felt no longer separated from all that lived. And this 'all' and 'everything' to the Romantics was spiritual throughout. Independently of Hegel, they proclaimed a 'world spirit' ruling over the universe and all its manifestations, or spirit that impelled 'all thinking things, all objects of all thought.'[6] 'Unity', demanded Schelling, 'must be spiritual in kind and derivation.'[7] No duality must remain. Mind and matter, although seemingly distinct and separate, must be shown to derive from and return to that original spiritual unity which was the source of all. Novalis meant just that when he wrote: 'All that is visible rests on an invisible foundation, all that is audible on an inaudible foundation, and all that is tangible on an impalpable foundation.'[8] What sustained the world was the unifying force of an invisible universal spirit.

The Romantics' craving for unity carried over into the social sphere and into their reading of history. Their attitude was marked by a deep communal sense and a strong tendency towards collectivism. While affirming the variety and differences between peoples and nations, they foresaw a world community which would join all societies into one single whole, a community based on and ruled by the common ideals of love and the brotherhood of man. Thus Krause developed his idea of a cosmic *Menschheitsbund*, a collective human organism permeated by a single life. Novalis, more mystically, dreamt of a future 'golden age', of a 'world-marriage' uniting all beings and races. 'Men, plants, beasts, stones and stars ... meet as one family. They act and converse as one species.'[9] To Novalis, as to other Romantics, history strove toward the 'fulfilment of time', towards mankind's unification and reconciliation with the divine. We shall hear more about their eschatological expectations and chiliastic hopes in later chapters.

The ideas of unity and the whole played a decisive role in the Romantics' understanding and appreciation of art. To Philipp Otto Runge the concept of the whole was basic to artistic creation. 'Does a work of art not originate the moment I perceive a connection with the whole?' This 'perception of the relationship of the whole universe' to works of art, he insisted, 'drives us on and urges us to communicate.'[10] A.W. Schlegel was no less emphatic. The artist's awareness of 'totality', his vision of the universe in its entirety, determined 'the degree of his artistic genius.'[11] Proceeding from an awareness of totality the work of art exhibited an imprint of totality. Hence A.W. Schlegel's definition: 'Each work of art is a miniature imprint ... of the great whole.'[12] Schelling likewise demanded that the object of art was the universe in its unity and totality. The artist's function was to comprehend and represent 'the idea of the whole'. None succeeded better in conveying this idea than Caspar David Friedrich whose famous *Monk by the Sea*, for instance, provides one of the most striking and compelling images of man's feeling for the infinite or whole.

Friedrich Schlegel appealed to the notion of unity in his famous definition of Romantic poetry as a 'universal-progressive poetry'. It was *universal*, not in the restrictive sense of seeking to conform to norms and universality of appeal, but in the wider sense of striving to embody within itself all the actual and possible forms of existence. Romantic poetry was *progressive*, in that it aimed at expressing the expansion, the growth and process of life understood as a ceaseless becoming.[13] In Romantic poetry, wrote his brother, 'all contraries: nature and art ... spirituality and sensuality, terrestrial and celestial, life and death are ... blended together in the most intimate combination.'[14]

Intoxicated with unity the Romantics desired the synthesis of the arts. Their dream was of a 'total work of art', a joining together of peotry, painting and music into one *Gesamtkunstwerk* that stirred into activity man's various senses at once, engendering in the beholder a state of synaesthetic reverberation which lifted the soul from the commonplace to a feeling of oneness with the world. The arts, A.W. Schlegel insisted, should be drawn together. Each one should naturally lead to another until they are all fused into one harmony. Then 'statues perhaps may quicken into pictures, pictures become poems, poems music.'[15] The Romantics, above all, strove to harmonize the impression of sight and sound. In Coleridge's words: 'The poet must ... understand and command what Bacon calls the *vestigia communia* of the senses, the latency of all in each, and more especially ... the excitement of vision by sound and the exponents of sound.'[16] In keeping with such aims Runge embarked on his series of pictures entitled *Seasons of the Day* which he described as an 'abstract, pictorial, fantastic-musical poem.'[17] His plan was that such compositions should be kept in a kind of sanctuary where they could be viewed to the accompaniment of music and poetry to evoke in the beholder a 'total' experience.

In the Romantics' endeavour to activate various senses simultaneously we have, of course, the origin not only of Wagner's music-drama, but also of modern psychedelic art, one of the latest aesthetic developments sounding the shallow

waters of a *sensorium commune* in search of man's complete involvement.

The Romantics in general were emphatic about the unifying and spiritualizing force of the arts. 'Through the artist', declared Friedrich Schlegel, 'mankind becomes one individual' and the world *one* world.[18] In the aesthetic experience, in creating and beholding art, man communed with the world soul, partook of universal being. The Romantics, as we shall see in greater detail later, accorded to art the highest metaphysical significance. Art was supposed to be the unique and irreplaceable connecting link between the human and the divine. It disclosed a noumenal realm. To the initiate, it revealed the very mysteries of cosmic life. Through art man communicated with a reality transcending that of the senses and of reason, a spiritual reality far removed from the, prosaic concerns and the commonness of the everyday world.

Everywhere then in Romanticism we meet this universal urge towards wholeness. Everything strove for unification and fusion: soul and things, self and society, man and God, spirit and matter, the immanent and the transcendent. Nothing remained in isolation. All was seen by the Romantics as part and parcel of one undivided universal life. To be sure, this holistic vision of the world was not exclusively Romantic, since it can be traced throughout the history of mankind. Yet never before was it proclaimed with such force and fire.

II. Love and Longing

What fanned the flames of this fire was the Romantics' mystical conception of love. Love in Romanticism was not regarded as a purely subjective emotion, but as a cosmic force. It was the 'world-creating, world-weaving power of all-unifying love' that sustained the whole of creation.[19] Love, according to Novalis, was the end of world history, 'das Unum des Universums', the key to the mystery of life.[20] Love not merely bound person to person, it bound person to things and things to themselves. A vast emotional bond of

love was the interlocking force of all. 'Love', wrote Franz von Baader, 'is the common factor that links all the creatures in the universe and holds them together'. Without it 'no wholeness, no world is conceivable.'[21]

This cult of love in Romanticism must not be confused with a state of langour and the vapours. It was quite compatible with a worship of force, with a dionysian celebration of life which harboured within itself tremendous potentials of energy – often subversive energies. The spirit of love the Romantics adored was often Christian only in name. In essence it was a restless creative deity which was, above all, beholden to *'becoming'*, beholden, therefore, to strife, conflict, discord. A cosmic passion, a 'God of intoxication' in Novalis' words, its countenance frequently bore the features of Pan whose kingdom was *night* or *eros*, both of which the Romantics honoured as divine potencies of life.

Together with love the Romantics stressed longing as an emotion fundamental to life. Love engendered longing, the longing to hold and embrace the world. It was at the root of art which A.W. Schlegel defined as 'an expression of longing.'[22] To his brother Friedrich, yearning paradoxically was a state which promised quiet and repose. 'Only in longing do we find peace.'[23] This, of course, was an indirect admission that the universe was too vast an object to encompass and possess. Yet the yearning to do so was a devouring sickness which drove the Romantics to look for the world both within and without, in the labyrinth of the self as well as in the farthest corners of the earth. The Romantics' demand for a *Weltanschauung* – a neologism significantly coined by them – was not merely a metaphysical challenge, it was also a geographical call which mobilized a whole generation into frantically exploring the sights of visible creation to discover its invisible meaning. This feverish mobility expressed itself even more in the Romantic hero: in Tieck's *Franz Sternbald* and *William Lovell*, in Novalis' *Heinrich von Ofterdingen*. Restlessly roaming the earth in search of their 'islands of happiness' which would connect them with the universe again, these Romantic pilgrims

anticipated that migration of artists which later in the century and in our own time spread over Europe to Arles and Brittany and further, to Tahiti and Africa, to any place that offered redemption from fragmentary experience, from the ills of a rootless civilization. Friedrich Schlegel's 'only in longing do we find peace' should be translated into: only in constant mobility does man find rest; only in perpetual motion, in transcending every situation in the mental and material universe, does the self fully realize itself. Romanticism was the flight towards invisible, unobtainable splendours. It was the glorification, in the last analysis, of becoming without being, of the journey without a goal, of love and longing without an object, and not least – of art without a subject.

III. The Rejection of Mechanism and Materialism

Striving for unity and fusion, the Romantics, not surprisingly, were ill-disposed to the scientific cosmologies of the eighteenth century. In the name of unity they unanimously rejected the determinist philosophies of Newton and the French materialists in favour of an idealism which, going to the other extreme, embraced mind and soul as the only abiding reality.

The Romantics' reaction to Newtonian science was often one of horror and revulsion. Thus Wordsworth spoke of man so scientifically minded and anti-human that he would 'peep and botanize on his mother's grave', as well he might, for in a world ruled over by matter and mechanical causation 'soul is dead and feeling has no place'. The Romantic response to Holbach's *System of Nature*, the treatise which most openly flaunted an atheistic materialism, was even more hostile. 'It appeared to us so dark', wrote Goethe, 'that we found it difficult to endure its presence.'[24] In its 'atheistical half-night' the beauty of the earth and the heavens vanished, and what remained was an 'eternal matter in an eternal motion'. To Novalis both mechanism and materialism presented a world

of death and desolation, a world from which all gods had disappeared. 'Lonely and lifeless nature lay prone, fettered with an iron chain, strict measure and the arid number prevailed.'[25]

To the Romantic the materialist and the mechanist explanation of the universe was a monstrous distortion of reality, an aberration begotten by barren and abstract minds insensitive and blind to the wonders of the world. The scientific explanations it proffered left vast areas of reality unaccounted for. Based on a one-sided quantitative analysis which perceived physical phenomena in terms only of their *primary* qualities, it ignored or denied altogether a universe rich in *secondary* and *tertiary* qualities, a world, that is, filled with colours, sounds, scents and an infinite variety of modes of feeling. By denying or dismissing such qualities, materialists and mechanists denied the existence of soul and spirit, the essence of beauty. What they offered was not life by a 'universe of death'.

On the surface, the Romantics' attack on mechanism and materialism was not a condemnation of the scientific spirit as such. Some indeed professed to have no quarrel with Newtonian science itself, but only with its mistaken and boundless metaphysical presumptions. To other Romantics the very existence of this science, however, posed a threat to the well-being of art and life. Science, in their view, stripped the world of its pristine beauty and splendour. Reducing phenomena to their physical causes and components, it destroyed the poetry of things, that magic presence which was their first property. Science, in Keats's oft-quoted words, 'will clip an angel's wing, conquer all mysteries by rule and line.'[26] In the end there will remain a world without magic, a silent, mechanized planet, a mute cosmos containing no ciphers, transmitting no meaning. Things will have become petrified, remote, their spirit a victim to the multiple properties science discovered in them.

To the Romantics such fears were real enough to raise the question of artistic survival itself. With science seemingly triumphant, everywhere explaining the why and wherefore

of things, what future was there for poets and painters? In the words of Thomas Campbell: 'When science from creation's face / Enchantment's veil withdraws / What lovely visions yield their place / To cold material laws?'[27] Few Romantics, to be sure, pressed the matter as far as that. Nearly all of them, however, commented critically on the seeming irreconcilability of art and science, between the poet's and painter's vision of reality which apprehended the world as whole and living, and the scientist's dissecting perception which carved the given into lifeless, unconnected parts. Hence Wordsworth's well-worn lines of the 'meddling intellect' which first must kill in order to dissect.[28]

It was a recurrent issue in Romanticism. Science invariably stood accused of presenting an 'inanimate, cold world' in which 'objects as objects are essentially fixed and dead'. The scientist was the *Scheidekünstler* under whose hands nature perished, while the poet and painter revealed her as a living creature. Some Romantics strove to heal the breach by demanding a form of science not only based on 'analytic industry', but on an imaginative intuitive understanding as well, an understanding peculiar to poetry and art. Thus Novalis decreed that 'the sciences must all be made poetic.'[29] The spirit of poetry must pervade the scientist's efforts since it alone enabled him to weave the isolated threads into a living whole. The claim of the whole, the desire for unity, made Novalis and Friedrich Schlegel conceive a kind of *Totalwissenschaft*, a synthesis of science, art, poetry, and philosophy. This 'universal science', encompassing all departments of knowledge, drawing on feelings, fantasy, logic and mathematics was supposed to disclose the final mystery of life.

While critical of Newtonian science, the Romantics at the same time proved greatly susceptible to scientific developments falling wholly outside the scope and methods of the mechanists' approach to things. Such developments centred around the recently discovered phenomena of electricity, galvanism and magnetism. When the idea that electricity was the animating force in matter, the bridge from

the inorganic to the organic, made its appearance, its effect
on the Romantic mind was pronounced, 'electrifying', to use
the phrase that came into its own in the wake of these
experiments and discoveries. They reinforced the Romantics'
belief that the universe was alive, that contrary to the
materialists' assumption, matter as an independent primary
substance did not exist. What did exist was active force, a
form of primal energy which the Romantics had no trouble
identifying with the divine, with God who was seen to
manifest himself in 'nature's vase ever-acting energy! / In
will, in deed, impulse of all to all.'[30]

 This 'energizing' of the universe wrought deep and
profound changes in the Romantics' conception of things. It
engendered a new cosmology which, briefly stated,
substituted for the concepts of mechanism and atomism the
concepts of universal dynamism and organicism. The
Romantic movement, as critics have stressed again and again,
was the great dividing line between the 'atomistic' and the
'organic', the historically epochal transition from a
predominantly Parmenidean point of view which postulated
the unchanging nature of things to an essentially
Heracleitean understanding of the world which stressed its
dynamic features. The Romantic period, in Jacques Barzun's
ponderous description, was the 'great revolution which drew
the intellect of Europe ... from the expectation and desire of
fixity into desire and expectation of change.'[31] Romanticism
made everything fluid. It was the triumph of motion over
stasis, of process over permanence, of force and flux over
solid form and substance. Setting everything in motion, the
Romantics, as was noted in the previous section, could indeed
nowhere find stability and peace. Philosophically, the
Romantics' apothesis of process and change found its
corresponding expression in the lofty systems of German
Idealism, the origins of which, according to Friedrich
Schlegel, had to be sought, not in the developments of
metaphysics, but in the realm of non-Newtonian physics, that
is, in the newly discovered phenomena of electro-magnetism
and galvanism. Certainly Schelling's early philosophies of

nature could not have been conceived without these scientific discoveries. They provided the bridge in his sytems from the world of matter to the world of mind.

This new dynamic view of life profoundly transformed the Romantics' understanding of poetry and art. Every art, insisted Schelling, must always return afresh to the world's 'primordial energy.'[32] According to Philipp Otto Runge, the painter's function was to create 'symbols of our conceptions of the great forces of the world.'[33] Of the poem and painting the Romantics persistently demanded that it exhibit or hint at the primal flux of things, the dynamic process underlying nature. Romantic art generally cannot be understood without taking into account this passionate involvement with change, process, force, a concern which dramatically affected its substance and form. In this respect, it presaged the admittedly more exclusive preoccupation of contemporary art. It marked the beginning of the modern poets' and painters' obsessive devotion to the dynamics of things, generating an art no longer substance-minded but process-minded.

IV. The Retreat from Reason

The Romantics' vision of nature predictably changed their view of human nature. Man, as a part of creation, or more than that – as the microcosm faithfully mirroring the macrocosm – was seen to participate in the 'vast ever-acting energy' sustaining all. Man, as Blake tells us with unrestrained rhapsodic delight, was a divinely ordained centre of energy, a repository of force that penetrated his whole being. This force to the Romantics was not only active in the creative workings of the imagination; it was equally present in the soul's passion and feelings, in the stirrings of sensation, in the ferment of dreams, visions, intuitions. The conception of an all-pervading energy active in human nature brought the Romantics into head-on collision with the hitherto accepted view of reason as the one and only controlling element in life.

Ostensibly, and in keeping with its universal urge for wholeness, Romanticism, of course, strove to harmonize reason and feeling, 'head' and 'heart', mind and imagination. Thought, the Romantics insisted, should become imaginative and imagination thoughtful; feeling should not exclude understanding, nor understanding feeling. The highest aim, as Coleridge wrote of Wordsworth's poetry, was to achieve a 'union of deep feeling with profound thought'. At any rate this was the publicly proclaimed ideal. In reality, the Romantics' relationship to reason was far more complex, as it was wrought with conflict, tension and ambiguity. This relationship ranged from Hoelderlin's apparent anti-intellectual 'man is a god when he dreams, a beggar when he reflects,'[34] to Friedrich Schlegel's highly intellectual conception of 'Romantic irony' as form of consciousness eternally contemplating itself. It ranged from Schlegel's and Novalis' dream to fuse a new philosophy and poetry into a 'transcendental poesy', to Heinrich von Kleist's anti-rational vitalism which reflected his despair in reason. 'Every first impulse, all that is involuntary, is beautiful, and everything is crooked and cramped as soon as it understands itself. O Reason, miserable Reason.'[35]

Nearly everywhere in Romanticism, and frequently in one and the same person, we meet the coexistence of two factors: an excessive capacity for reflection and a great intellectuality on the one hand, and on the other an extreme concern over its debilitating effect, which forced the Romantics into the pit of irrationalism. Romanticism in this respect was the tension *between* a uniquely self-conscious intellect and an equally self-conscious anti-intellectualism. It was rarely an unadulterated, pure form of irrationalism. Where it passed as such, it was the irrationalism of world-weary, sophisticated minds.

Here we shall be concerned with the anti-intellectual trends of Romanticism, its elevation of life into a power surpassing reason. To the Romantics the 'fullness of life' stood in marked contrast to the barrenness of thought that merely rendered the dry bones of existence from which the vital breath had departed. Life's fullness revealed itself to the

senses, to the passions and the feelings fused into one by the unifying force of the imagination. 'O for a life of sensation rather than of thought,'[36] wrote Keats expressing the Romantics' fierce craving to recapture the bliss and innocence of the senses, the immediacy of instinct and impulse, the childlike unity of vision which embraced the self and things.

The Romantics' insatiable desire was to be fully and ecstatically alive to the point, paradoxically, of courting sickness, if not madness, for the sake of living more intensely. This tendency to plunge unreservedly into the whirling currents of life right down to its chthonian depths, the tendency to follow spontaneously instinct, impulse, the force of passion, might be called Romantic vitalism which, borrowing Hegel's dionysian conception of truth, frequently turned existence into a 'bacchanalian revel where not a soul is sober.'[37] Irving Babbitt once rightly described the Romantics as 'the votaries of the god Whirl.'[38] With Faust they could dedicate themselves to vertigo, to a life of intoxication from which they usually awoke to a feeling of spectral despair.

Romantic vitalism was, of course, an expression of Romantic emotionalism: the general inclination to seek for fulfilment and the meaning of life in the 'holiness of the heart's affection', in the depths of man's soul and feelings. Much has been written on this thorny subject. As we shall see later when specifically dealing with the concept of art as the expression and communication of emotion, the Romantics' deification of feeling was far removed from the uncomplicated emotionalism of the mid-eighteenth century, the 'Age of Sentiment'. It also differed fundamentally from the spontaneous subjectivism of the '*Storm* and *Stress*' movement. The cult of feeling launched by the Romantics, effecting a change of sensibility from which we have never recovered, was not without its own distinct metaphysics. It was an 'intellectual' cult which ascribed to emotion a transcendental function denied to reason. 'Whereas reason', wrote A.W. Schlegel, 'can only comprise each object separately, feeling can perceive all in all at one and the same

time.'[39] Emotion, in other words, was capable of comprehending the whole, while reason, that false secondary power, multiplied distinctions dissolving the sacred totality into a lifeless plurality.

Reiterated by many Romantics, this was the theme of Novalis' *Die Lehrlinge zu Sais*. Sympathetically reviewing the credentials of philosophy and science, Novalis concluded that it was man's search for knowledge, his acquisitive intelligence, which led to his alienation and separation from nature. One of the apprentices castigated intellect in these words: 'Thought is only feeling's dream, feeling that has expired, a pallid and feeble life.'[40] Man, Novalis pleaded, must return to a state of pure feeling which on a higher plane recaptured the bliss and innocence mankind experienced in a previous 'golden age'. 'Through feeling would return the old days for which he yearns.'[41]

Implicit in Novalis' argument was a Rousseau-like rejection of intellectual and mechanical civilization in favour of more 'natural' and spontaneous forms of existence. Novalis' version, however, was more subtle in meaning. It suggested that it was not only analytical science and thought, but the power of reflection or consciousness itself which drove man from the springs of life into the arid desert of a world without purpose and meaning. The metaphysical implications of this view were made explicit by Karl Gustav Carus. 'The higher intelligence develops, the brighter the torch of science shines, the more the sphere of the miraculous and the magical contracts.'[42] To Carus, as to other German Romantic philosophers of nature, the advance of a rational and scientific culture was synonymous with a decline of the 'cultic'. Once a utilitarian reason began to perceive the pragmatic value of things, once consciousness was capable of articulating distinctly in terms of cause and effect, the realm of the magical order in which the self felt secure in the world receded to give way to a universe divorced and estranged from man.

The Romantics looked with apprehension and despair to the increasing rationalization of life at the mercy, they

believed, of a cold Cartesian reason which viewed things analytically 'in disconnection, dead and spiritless', a reason which dogmatically denied both what was below and what was beyond itself. Their immediate reaction was to stem the tide by trying to reinstate man's sense of awe and wonder, by invoking the ultimate and inexplicable mystery of things. It was in the name of mystery that Friedrich Schlegel and Novalis reproached Lessing for 'seeing too clearly', for drawing analytical distinctions inimical to the 'magical view' of the whole.[43] It was in the name of mystery that A.W. Schlegel attacked the barren rationalism of the Enlightenment. A feeling of mystery, he insisted, was essential to man's life, it was essential to art, 'the soul of all poesy.'[44] And so indeed it was judging by the poet's and painter's preference for phrases like 'miraculous', 'mysterious', 'marvellous', 'magical', 'secretive', 'extraordinary'. Romanticism in this respect was a commitment to the enigmatic, to everything strange and 'wonderful' which it made sure was removed from the disenchanting clutch of a mundane intellect.

At first rightly concerned to shield the fundamental mystery of life and things from the encroachment of science and reason, the Romantics unfortunately ended up embracing mystery for its own sake, creating it where there was none, or worse still, seeking it exclusively in the depths of the barbarous, the primitive and the primeval. 'To become an artist', wrote Friedrich Schlegel, 'means nothing less than to dedicate oneself to the deities of the underworld', to demonic and destructive denizens, who obeyed the law only of Dionysus.[45] Deprived of its apollonian dwelling to which reason showed the way, mystery was driven by Romanticism underground into the dark night of instincts, dreams and visions, into the dimly-lit forest of formless feelings. 'Who', wrote Novalis, defining the Romantic *homo mysticus*, 'does not love to wander in twilight?', in those shadowy, unreal regions which defied everything clear and distinct?[46]

It was quite in keeping with this twilight mentality that the Romantics should have become the ready disciples to any

mysticism at large, that they should have espoused the occult esoteric theosophies of Master Eckhardt, Jacob Boehme, Tauler, Hemsterhuis, Oetinger and Franz von Baader, all of which promised sanctuary and salvation to hungry souls in search of the miraculous and marvellous. Their disenchantment with rational thought revealed itself in no small measure by their readiness to embrace the occult in any form to the extent even of rescuing alchemy from its medieval slumber.

V. The Significance of the Unconscious

The Romantics' retreat from reason advanced straight through the territories of the unconscious. Although the recognition of the unconscious predated Romanticism, the Romantics were the first to explore its mysterious depths, the first to realize its unique significance in the affairs of man. By 1800 the unconscious had become a widely accepted notion stimulating various forms of research in abnormal psychology and in fields like somnambulism, hallucinatory behaviour and hypnosis (or mesmerism as it was called then, in tribute to F.A. Mesmer who claimed to neutralize conscious processes through the use of 'animal magnetism'). The realm of consciousness soon came to be seen more and more as a *surface* phenomenon, the roots of which reached far beyond into regions inaccessible to rational control. Thus Wordsworth could write: 'Oh! mystery of man, from what a depth / Proceed thy honours! As to man's creative gift, it arose from 'the mind's abyss', from those unlit caverns deep within which sun could never penetrate.[47]

The Romantics' recognition of subliminal mental powers activating, if not wholly determining, human behaviour totally and irrevocably transformed the psychology of art. Henceforth the unconscious came to be understood as the inexhaustible well nourishing all that was truly original and genuine in artistic creation. Raised to a metaphysical power by Schelling, to a myth-making faculty by Jean Paul, whose

fertile ideas directly point to Jung's theories, and envisaged generally as the umbilical cord connecting man with the universe, the unconscious was acknowledged as the irresistible generative force compelling the artist, often against his wishes, to create things the ultimate meaning of which remained a mystery even to himself. This account of artistic creation replaced the time-hallowed concept of 'divine inspiration' with the idea of unconscious gestation. The poetic muse which according to previous ages descended on the artist from 'above' now made her entrance from 'below' through those dark 'caverns' in the human soul no ray of light could ever pierce.

With the unconscious carrying the weight of artistic creation, the function of the cognitive element in art necessarily declined. The Romantics, of course, strove to unify both. Thus A.W. Schlegel, following Schelling, defined true genius as the 'most intimate union of unconscious and self-conscious activity ... of instinct and purpose, of freedom and necessity.'[48] The Romantics, however, left few doubts as to which was the more decisive factor in art. Rational deliberation was always subordinate to the demands of unconscious promptings. Reason performed a purely menial task, its function being to serve, not to assume command. In Jean Paul's words: 'The most powerful thing in the poet, which blows the good and the evil spirit into his works, is precisely the unconscious.'[49]

Similar utterances were rather common among the Romantics and their contemporaries. Some, reacting strongly against the restrictive rationalism of neo-classical theory, strove to banish reason altogether from the confines of art. 'It is the beginning of all poetry', wrote Friedrich Schlegel, 'to abolish the law and method of the rationally proceeding reason and to plunge us once more into the ravishing confusion of fantasy, the original chaos of human nature.'[50] Thought, deliberation, purpose and prudent reflection, all those hitherto respected and cherished attributes of the creative spirit were suddenly seen to be not only irrelevant, but a positive hindrance to the free exercise

of the spirit.

Friedrich Schlegel's injunction has been well heeded in the art of our time. The significance of the unconscious for the modern poet and painter requires no documentation. All-pervasive it has been – and still is – the blindly accepted operating principle in artistic creation. The Romantics' contribution here can hardly be exaggerated. With it began the artist's extensive forays into the far and unillumined reaches of the human mind, his spontaneous surrender to the unconscious in proud defiance of each and every reason. As one modern painter put it: 'To think while painting is a form of degradation.'[51] It was no lone voice. Prefigured in Romanticism, such precepts reveal to what extent modern art has plunged into the currents of the sub-rational to the detriment not only of everything rational, but to the detriment of art itself which in the process has become increasingly incoherent and devoid of meaning.

* * *

As a commanding creed, Romanticism was short-lived, its 'official reign' of brief duration. Such all-embracing pantheistic visions could not and did not remain unchallenged for long, so that within a comparatively short time a more 'tough-minded' outlook contested and finally prevailed over the Romantic spirit. Yet this spirit never wholly disappeared not even during those decades that saw the rise of a new materialism and positivistic science. While driven underground, it persisted like a groundswell throughout the nineteenth century surfacing here and there. It certainly came to the fore again with Symbolism and a somewhat genteel neo-Romanticism at the turn of the century. It was still more visibly present in Expressionism to which we shall now turn for the sake of comparison.

Chapter Two
The Romantic Weltanschauung in Expressionism

I. The Quest for Unity

In Expressionism we are again face to face with the Romantics' ecstatic striving for fusion with all creation. Once more a restless desire for union and communion with the inward existence of the world consumed artist and poet. A longing to transcend fragmentary experience and attain a vision of the whole was at the very root of the Expressionist movement. The Expressionist's desire was not merely to express reality in aesthetic terms. His overriding aim was to restore the essential unity between man and nature, to recapture an experience of the world that went far beyond the visual toward a cosmic feeling with deep religious overtones.

Expressionist art and literature were permeated by this titanic striving for wholeness. It expressed itself in numerous exultant hymns addressed to the unity of life and creation. We meet it in Wolfenstein's 'The heart apprehends the profound oneness;'[1] in Gerrit Engelke's 'Man, man, all stretch out their hands over forests, seas toward the oneness of the world;'[2] in August Stramm's 'Worlds unfold quietly out of me. Worlds, worlds;'[3] in Iwan Goll's 'All that is yours, earth, shall call itself brother.'[4] The same longing to participate in an undivided total life informed the lyrics of Stadler and Heym, the prose and poems of Rubiner, Werfel, and the

cosmic mythologies of Däubler. It is found even in so politically committed a poet as Ernst Toller who longed to listen to 'the one heartbeat of all species, all stars, all beasts, all forests, all flowers, all stones.'[5] Expressionism in Hermann Hesse's definition was no less than the 'reverberation of the cosmic, the memory of *Urheimat*', the world's primeval home where all was one and undivided.[6] With a touch of irony which fell somewhat short of any real sympathy, Robert Musil described the Expressionist as one who 'tries to discover a cosmic sense as a chemist tries to discover synthetic rubber.'[7]

The same intoxication with the unity of life and being consumed the painters of this generation. 'The world resounds', wrote Kandinsky. 'It is a cosmos of spiritually active beings.'[8] Kandinsky and other painters laid a great stress on synthesis, and like the Romantics delighted in using the words 'all' or 'everything'. 'All things', wrote Kandinsky, 'were revealed to me: not only the much sung flowers and woods – but many, many more. All opened to me their essence – their secret meaning.'[9] In Nolde's words: 'Everywhere I looked nature was alive, in the sky, in the clouds, atop every stone.'[10] A similar Romantic sentiment expressed itself in Franz Marc's conviction that 'all is one', in his desire to heighten his 'feelings for the organic rhythm of all things, to achieve pantheistic empathy with the throbbing and flowing of nature's blood-stream – in trees, in animals, in the air.'[11] Marc gave expression to these feelings in an early woodcut entitled *'Reconciliation*, a Romantically naive yet eloquent testimonial to the artist's quest for union and integration with the totality of nature. (*Ill.* page 44).

A striving for unity was fundamental to Klee's outlook on life. 'I dissolve into the whole ... the thought of the earth retreats before that of the world.'[12] It was equally fundamental to Ludwig Meidner, a curiously ignored Expressionist painter of this period, who defined his aim as the 'mirroring of ... the unity which we feel with the primeval forces of the earth.'[13] Nearly all Expressionist painters viewed reality under the aspect of totality of which

man was an integral part. It was the theme of Kasimir Edschmid's celebrated manifesto of Expressionism which paid a glowing tribute to the artists' 'cosmic envelopment', their active participation in creation. 'Their heart, a brother to all things, beats in the same rhythm as the world.'[14]

The world thus celebrated was declared to be spiritual throughout! Like the Romantics, the Expressionist poets and painters proclaimed reality to be the manifestation of an all-pervasive living spirit. 'It is spirit', affirmed Kandinksy categorically, 'that rules over matter and not the other way round.'[15] In the words of Theodor Däubler: 'Spirit reconciles and dominates the world.'[16] Other Expressionists were no less emphatic in praise of the spiritual which they saw reflected in the vitality and expressiveness of things, which communicated itself directly to the soul of the beholder without the mediation of a pale and lifeless reason.

In keeping with the Romantics, these artists' inordinate striving for unity extended once more to a vision of society embracing the whole of mankind. 'My only wish', wrote the young Werfel, 'is to relate to you, O man!'[17] This outcry defines a prominent aspect of Expressionism: its passionate commitment to the brotherhood of man, a commitment which, on balance, was more radical and unreserved than that professed by the Romantics. It frequently took the form of political activism which in the main by-passed any narrow dogmatic allegiance to party or creed. The Expressionists' aims were more ethical and spiritual than political. Their ideal was to tear down the barriers between people and nations and erect a 'new community' in which men lived as equals and brothers motivated by love for their fellow men. Kandinsky's statement was typical of such lofty ideals: 'It is high time to wipe out frontiers, to make the blood flow through the entire body of mankind. It will be one single body, a single heartbeat – the resurrection of paradise lost.'[18] This naive utopianism was part of *messianic* Expressionism which, like Romanticism, looked with glowing expectation to a golden future, 'to the end of time' reconciling the human and the Divine.

The concept of the whole, the idea of totality, *directly* affected once more the Expressionist's understanding of art. In poetry, for instance, it expressed itself in the choice of a vocabulary which invariably gravitated toward words suggestive of the cosmic, such as world, sun, sphere, ether, light, flame. Poets again and again coined neologisms conjuring up visions of the universe and its productive powers. Expressionist prose and poetry abounds with untranslateable superlatives and word-compounds of this kind: *Urbrunstglut, Urfeuer, Ätherwut, Sonnenliebe, Sternenkind* (Däubler); *Sonnen-Chöre, Lichtgründe, Wutorkan* (Becher); *Himmelsatem, Sternfalten* (Otten); *Orgelsturm, Himmelschale* (Goll); *Weltvernichtungsgeist, Weltlobgesänge, talfernes Sonnenläuten* (Unruh); *Weltfreund, Weltnacht, sternende Sphäre* (Werfel). The Expressionist was indeed a *Weltfreund*, the name Werfel gave to his famous collection of poems; a 'friend of the cosmos', he claimed the whole universe as his domain.

The idea of the whole loomed large in the painter's comprehension of artistic creation. To Klee a 'sense of totality' was inseparable from the artist's 'conception of the object', a conception which saw everything in terms of one 'cosmic community.'[19] This sense of totality informed the painter's 'metaphysical view of the world' which Klee declared to be an essential condition for the creation of 'free abstract structures.'[20] What Klee called totality Franz Marc called fullness. 'The truly creative work', he maintained, 'originates out of an experienced fullness.'[21] A.W. Schlegel, a century earlier, expressed it far more clearly. 'The fullness, the totality with which the universe is reflected in the human spirit ... determines the degree of his artistic genius and puts him in a position to form a world within the world.'[22]

This conception touches on the very core of Kandinsky's thought. An awareness of totality, he declared, was part of artistic creation. To Kandinsky, lack of totality, the absence of any total cosmic setting in art, was a sign of its spiritual decay. True art, he insisted, must proceed from and reflect the idea of the whole. 'If this inescapable connection [with the whole]

is not present it means the work is no work of art.'[23] The artist, Kandinsky urged repeatedly, must strive for union and communion with the whole of creation. He must cultivate 'inner vision', a form of *pure* perception, which enabled him to perceive 'dead matter' as something essentially alive with the 'inner voices of things not sounding in isolation, but in one concord – the music of the spheres.'[24] This 'music' Kandinsky believed formed 'the germ' of the artist's work, the *'unconscious'* generative principle operative in all genuine production.[25]

In Kandinsky's view it was precisely the painter's ability to relate directly to the totality of things which made abstract art possible. As he put it: 'One can abstain from the mediation [representation] of nature if one can put oneself into direct relationship with the whole.'[26] To Kandinsky, as we shall see more clearly later, abstract art was the direct expression of a cosmic creativeness which on the painter's canvas issued into new levels of organization, into new modes of 'spiritual being' which no longer imitated nature, but expressed the mysterious workings of a universal spirit.

Striving for unity awakened in these painters once more the old Romantic notion of the *Gesamtkunstwerk*, the blending of various artistic media into one. 'Sometimes', wrote Klee, 'I dream of a work on a vast scale which would embrace the whole field of the elements of art, subject-matter, content and style.'[27] Klee's interest in a 'monumental work of art', his interest, above all, to fuse the realm of sound and sight was directly inspired by Philipp Otto Runge in one of whose letters we read: 'The analogy between vision … and hearing gives great promise of a future union between music and painting.'[28] Klee expressed it almost identically when he wrote: 'Today a synthesis between the worlds of sound and appearance seems to be a possibility'.[29] In Kandinsky such tendencies reached their peak. Where Klee merely dreamt of such possibilities, Kandinsky put them into practice. Influenced by Wagner's music-drama, stimulated by Scriabin's experiments with sounds and colours, he strove toward a synthesis of all the arts, a fusion of all the senses. His

stage play *Yellow Sound* was such an attempt – by his own admission a rather unsuccessful one – to combine drama, music, the dance and colour. The artist, Kandinsky believed, should aim to activate the mysterious interconnections of the senses, 'the latency of all in each', in Coleridge's phrase, to heighten the total aesthetic effect on the beholder. The concentrated effect obtained by a synthesis of the arts was to raise and refine the soul and make it throb in harmony with the spirit of the world.

Behind such tendencies we meet no more than the Romantics' quest to seek for salvation in and through an expanding sensorium which plunged the whole world into a state of synaesthesia bringing about that 'tenebrous and profound unity' in Baudelaire's words where scents, sounds, forms, colours, and feelings correspond to one another and to the totality of things.

II. Love, Longing and Despair

What sustained these artists in their Romantic quest for unity was an intense love of creation, admittedly a more questioning and tormented love than that felt by the Romantics, but nonetheless all-consuming. It welled forth in Theodor Däubler's notion of a 'cosmic love' creating worlds for the sake of creating; in Reinhard Sorge's 'Poets are lovers, lovers of the world and limitlessly addicted to their love,'[30] in Franz Werfel's incantation: 'Everything *is* if you love.'[31] 'I love the song of love', we read in Marianne Werefkin's diary with its passionate affirmation of everything Romantic.[32] In a letter to Delaunay, the French painter, Franz Marc wrote: 'I strive to put myself into a state of great love.'[33] It was in a spirit of love that Kandinsky believed he saw everything quiver with an inward meaning, perceived in all things their inner 'sound' or soul. 'Dalliance, dreams', wrote Nolde, 'are like bubbling brooks, love is the great river'[34] – the great river, to the Expressionists, which brimmed over into the ocean of the world.

The love professed by these poets and painters transcended, but did not exclude love in its specific Christian sense. As with the Romantics, love was mystical and pantheistic, erotic and spiritual and frequently given to a dynamic, dionysian intoxication with life which embraced conflict, strife, tension as the preordained order of things. Together with love the Expressionists also glorified longing as a state of soul defining their emotional relationship to things. It was always the longing for union and communion with the spirit of the world, the 'yearning' as one Expressionist put it 'for a paradise which is lost but lies ahead of us.'[35] In Klee's words it was 'the yearning to free ourselves from earthy bonds', the desire to live 'in the womb of nature' that motivated the artist.[36] Franz Marc gave ringing voice to such Romantic aspirations:

> Yearning for indivisible being, liberation from the sensory illusion of our ephemeral life: this is the state of mind at the bottom of all art. Its great goal is to dissolve the whole system of our partial sensations, to disclose an unearthy being that dwells behind all things, to shatter the mirror of life in order to behold being.[37]

Yearning for being, or for the 'spiritual', was at the root of art according to Kandinsky. In a manner reminiscent of A.W. Schlegel he wrote: 'All art has been, is and will always be an expression of longing.'[38]

Unmistakably Romantic in this context was the Expressionist's frequent association of the colour blue with longing or with the object of this longing: the whole or infinite. 'Blue is the heavenly colour', wrote Kandinsky. 'We feel a call to the infinite, a desire for purity and transcendence.'[39] To Marc blue was a 'masculine spiritual principle'. Joined with a 'feminine' yellow, it helped to silence the oppressiveness of matter.[40] Together with Marc, Kandinsky chose this colour to characterize the *Blaue Reiter* association of painters. The same colour appeared again later with the group of the '*Blue Four*' (Kandinsky, Klee, Feininger, Jawlensky).

Blue generally figures prominently in many an Expressionist poem. 'I have brought love into the world', wrote the poetess Else Lasker-Schüler, 'that every heart might blossom into blue.'[41] In Trakl's poetry it recurs again and again; 'stillness lives in blue spaces'; 'An angel stepped softly out of the blue eyes of lovers.'[42] Heym celebrated the 'eternally blue'; 'All landscapes found fulfilment in blue.'[43] Klemm speaks of the 'blue hours of peace', Becher of the 'pure blue of my celestial sustenance,'[44] Rene Schickele of the 'mindfree blue days' that come with 'the tides of eternity.'[45] Even Benn, who strongly opposed the use of colour-tonalities, made an exception for blue.[46]

Poets and painters of this generation indeed suffered from the 'blues' – from what seemed to be an unquenchable, incurable longing. In one of Kandinsky's letters we read: 'I want something, but what? I yearn, but for what? I do not know'.[47] This admission is only too familiar in the writings of the Romantics with whom these artists shared their inner disquiet and a restlessness which drove them to explore once more the inner spaces of the self as well as the outward aspects of the visible world. Roving souls, shifting from town to town, from country even to country, they were always in motion, in search of something. 'Always we walk and walk in longing', wrote Iwan Goll in his poem entitled the 'Caravans of our Yearning', which nowhere found an 'oasis of shadows', an island of peace.[48] In a note to Gabrielle Münter, Kandinsky once characterized himself thus: 'always, continuously restless. This indeed is the unexpected naked truth ... Do you understand? *No moment* of repose.'[49] It was symptomatic of Expressionism. Like the Romantics, these poets and painters found peace only in longing, rest only in a feverish mobility which they believed to be the 'cosmic fate' of man. As an element of the universe, wrote Kandinsky, man 'has been so created as to exercise constant, perhaps eternal movement.'[50] This, as we shall see, was by no means the one and only time that the Expressionist justified the ways of man and the artist by sweeping and pious appeals to the cosmos and its operations.

A longing such as theirs predictably took its toll. Both the Romantics and the Expressionists discovered this to their great cost. Of Philipp Otto Runge's cosmic aspirations Goethe wrote shrewdly: 'It wants to embrace everything and in doing so becomes lost in the elemental.'[51] Hoelderlin, who learned the virtue of a wise self-limitation in the grip of a limitless craving for the All recognized the latter for what it was, a self-destructive urge, a 'mysterious yearning for the abyss.'[52] In reaching for 'total fusion' man overreached himself and suffered the fate of 'total isolation'. Expressionist pantheism, as Becher called it, was no exception. Its reverse was an unmitigated pessimism and nihilism. The poet's and painter's prodigious straining to embrace everything often left the heart painfully empty, conscious only of its exclusion, loneliness and despair. Their 'song of love' was at the same time a lament over man's insignificance and isolation. A sense of tragedy crept into their conception of the world. 'And this is the cosmic tragedy', wrote Kandinsky, 'in which the human element is only one "sound", only one of the contributing voices.'[53] Klee spoke of the 'tragedy of spirituality', a spirituality which in man was tied to a weak body. 'Man is half a prisoner, half born on wings. Each of the two halves perceives the tragedy of its halfness.'[54] While Klee's metaphor may have derived from Plato, the union, however, of which he dreamt was pantheistic, a 'mixture of *logos* and *eros*', to use his description of art.

From this feeling of tragedy the painters sought refuge in art. 'Painting', wrote Franz Marc as early as 1906, 'must free me from my fear', which he correctly interpreted as a form of 'panic terror' (*Panschrecken*), caused by the experience of utter estrangement.[55] Kandinsky spoke of his 'deep inner turmoil', with his whole being 'a prey to anxiety', a state from which drawing and later painting would lead him 'away from reality into a timeless and limitless space where I would forget the world and even myself.'[56]

Was the rise of abstract art related to such feelings of restlessness, anxiety and despair? Klee suggested as much when he wrote: 'The more horrible the world is (as today) the

more abstract art will be, whereas a happy world produces a realistic art.'[57] This of course, was written under the sway of Wilhelm Worringer's famous dissertation *Abstraction and Empathy* which argued that man's 'urge to abstraction' was the result of his inability to establish a harmonious and spontaneous relationship with nature. The creation and contemplation of abstract forms, in this view, afforded temporary consoling relief from the frightful confusion of life, from the threatening unending flux of human existence oppressed by space and ravaged by time. Such factors may well have been present in the painter's pursuit of abstraction. At the same time, it would be a grave error to reduce the rise of abstract art wholly to an explanation such as this, since Kandinsky, Klee, Marc and others also affirmed the very opposite by their repeated insistence that a feeling of oneness with the world was part of abstract creations. In any event, Worringer's thesis, although suggestive and attractive, is much too simple an explanation to account for so complicated a phenomenon as the birth of non-objective art, the entangled roots of which branched out into many layers and directions. The same, of course, applies to Expressionist poetry which was similarly subject to pronounced spells of pessimism, anxiety and cosmic despair, to what, ever since Romanticism, the Germans have come to call *Weltschmerz*.

Indeed, among the poets the realization of man's failure to achieve total fusion with the All was, if anything, more intense. Suspended between the finite and the infinite, they frequently turned into tragic bearers of a glorified longing which always remained unfulfilled. Hence Kurt Pinthus's telling phrase: 'Zug von sehnsüchtigen Verdammten' – a procession of man doomed to eternal yearning.[58] Franz Werfel conveyed this state of mind in verse:

Und immer diese Wand!
Warum bin ich nicht durch die Welt gespannt,
Allfühlend gleicherzeit in Tier und Bäumen,
In Knecht und Ofen, Mensch und Gegenstand?[59]

Gottfried Benn expressed the same feeling of exclusion and isolation with even greater poignancy:

> Vor uns das All
> unnahbar und verhängt
> und wir, das Ich
> verzweifelt, totbedrängt.[60]

Both Werfel's and Benn's despair was already prefigured in Novalis' words: 'We seek the infinite everywhere and always find only finite things.'[61] Else Lasker-Schüler in one of her poems diagnosed this craving to be at one with all as a fatal incurable affliction. 'A yearning knocks at the door of the world of which we must all die.'[62] Some Expressionists did indeed glorify death as the only remedy for man's isolation. Others, disenchanted with a receding far-off infinite, soon channelled their inordinate longings into religious and political movements: the Catholic Church, the Third International, Zionism. A few sought refuge even in the 'folk community' of National Socialism.[63]

The parallel with Romanticism here is obvious. Under the pressure of the whole, consumed by a craving for the infinite, some Romantics courted death and, as in the case of Kleist, even died by their own hand. Others again, like Novalis, the Schlegels and Brentano, sought safety in the comforting arms of 'mother' church or in the mythical concept of a newly awakened German nation, an ideal which particularly attracted the *later* Romantics.

III. Beyond Materialism and Positivism

In keeping with their Romantic leanings, the Expressionists fiercely rejected positivistic science and the materialistic civilization of their time. Their indictment of modern materialism and positivism was a passionate protest on behalf of a world not ruled by matter and mechanical causation, but sustained by an omnipresent living spirit.

Their hostile reaction was not without justification. Throughout the nineteenth century positivistic science, reinforced by a spectacularly successful technology, had greatly gathered in force and momentum. Blinded by its success and achievements, it began to assume the role of a prophet proudly predicting the impending solution to all mysteries, the answers to all puzzles and apparent enigmas about man and the universe. Its naive faith in progress proclaimed that any phenomenon, however remote and immaterial in appearance, was in principle capable of being reduced to material causes and components without recourse to some mysterious 'spirit'. Viewed in terms of such basic assumptions, the positivism and materialism dominant at the turn of the century hardly differed from the somewhat cruder forms of mechanism and materialism which victimized minds in the days of the Romantics. Gottfried Benn put it simply when he wrote: 'Today's technology, yesterday's mechanics.'[64]

In the face of an all-domineering scientific world view wholly deterministic and crassly materialist in outlook, the modern artist's reaction, like that of the Romantics a century earlier, was one of revulsion and despair. Thus Benn bemoaned the fate of European man at the mercy of modern science which dissolved the meaning and beauty of this world into dead formulae of abstractions. For unity, it substituted plurality, for completeness, fragmentation, for concrete realities, arid numbers indifferent to man's heart and the life of things. Kandinsky made virtually the same observation. Reminiscent of Goethe's and Novalis' response to an atheistic philosophy celebrating an 'eternal matter in eternal motion' he deplored the 'nightmare of materialism which turned life into an evil, senseless game', plunging the world into spiritual darkness.[65] In this darkness all finer feelings atrophied. The soul suffocated through 'lack of belief'. God was dead, heaven empty. Atheism was the ruling order of the day. Men of science controlled the world, 'positivists, recognizing only those things which can be weighed and measured.'[66]

Kandinsky's distrust of 'materialist science' was in part the

result of an epochal scientific event: Rutherford's discovery in 1904 that the atom which had been regarded as the ultimate indivisible substance was yet further divisible. 'This discovery', wrote Kandinsky, 'struck me with terrific impact, comparable to the end of the world. In the twinkling of an eye, the mighty arches of science lay shattered before me.'[67] Positivistic science could never be trusted again. Its unshakable verities of today were the proven falsehoods of tomorrow. The world it construed was a world of 'mere delusion'. Kandinsky, convinced that a new spiritual era was about to dawn, prophesied the imminent dissolution of the 'positivistic methods' in science. What was to take their place? A new syncretic science drawing on 'feelings' and the 'unconscious', a form of *Totalwissenschaft*, like that imagined by Novalis, which was grounded in a mode of vision peculiar to poetry and art. This new science to come, Kandinsky believed, would achieve the 'great synthesis' – the final unity of life.[68]

Other poets and painters joined in the condemnation of what they considered the vainglorious progressiveness of positivism, the rational arrogance of minds reared on a soulless materialism. Some questioned the spirit of science itself on grounds similar to those put forward by Keats, Carus and other Romantics. In essence, their argument proceeded once more from the assumption that a meddling utilitarian intellect proved fatal to the life of things. Once we know the scientific why, the pragmatic wherefore of an object or event, its poetic and expressive value disappears.

This was the charge Marc hurled at science. He accused it of having brutally distorted the face of things. 'Our European eyes may have disfigured and poisoned the world.'[69] To Marc man's quest to discover the material causes of appearances was undertaken at the expense of discovering their spiritual essence. 'Do we not have the experience of a millenium that things become the more mute, the more distinctly we present them with the optical mirror of their appearances?'[70] With a crude scientific mirror held up to life, not only did things conceal their very being, man's soul itself became coarse and

unseeing in the process. 'The soul, hardened like an empty nutshell', Kandinsky complained, has lost its power to penetrate to the depths of objects 'where their pulse becomes audible.'[71] The spirit of science, Marc despaired, was dangerously close to becoming a common whore whose calculated embrace soiled all it touched.

With an insight rare for a painter, Marc understood the natural sciences as a highly developed and predominantly analytical form of Western thought. It was no more, however, than *one* kind of *Weltanschauung*, merely *one* way of looking at things and the most destructive one at that, for its relationship to objects was one of possessiveness and greed. Hence his lament over the 'cosmic fall of science' which turned a pure discipline into a utilitarian enterprise motivated by gain.[72] Its unholy conceit, which left no stone unturned, strove to enter even into 'the forbidden world of spirits'. Nothing in the end was secure from the greedy grasp of a scientific mind, from a profane, inquisitive intelligence which ruthlessly destroyed the sacred life of things. The cold touch of science, in short, merely succeeded in emptying the world of its divine magic and splendour.

Marc and a great many modern artists here simply revived and continued the Romantic controversy concerning art and science, the controversy, that is, between the artist's vision of reality – a magical 'incantatory' vision which perceived the world as whole and living – and the scientist's analytical perception, under whose dissecting gaze things seemed to shrivel and die. Both ways of looking at the world were believed once more to be irreconcilable. 'Those who maintain that genuine art is irreconcilable with our scientific and technical age are quite right – but I believe they are wrong in thinking that art will die.'[73] Franz Marc's words clearly imply that in an age dominated by empirical science and a materialist technology the question of artistic survival was at stake, just as it had been at stake in the days of the Romantics.

Given this hostility toward positivistic science what were its artistic repercussions? Poets and painters strove to reawaken

man's forgotten longing for a 'spiritual' reality which went beyond what could be analysed and measured. To Kandinsky one of the functions of art was 'the undermining of the soulless materialist life of the nineteenth century.'[74] As a first step this meant, as it did to the Romantics on a similar path, that art must free itself from the clogging element of naturalism or realism – the artistic style commensurate with a scientific, materialist outlook. Purely representational art came to be identified with materialism. In conscious opposition to their time which was concerned only, in Kandinsky's words, with the 'visible and comprehensible', poets and painters now searched for the 'invisible and incomprehensible', for all that remained hidden under the surface layers of life.

In search of the 'invisible' these artists, like the Romantics a century earlier, turned their attention to post-Newtonian developments in science which they believed dealt a deathblow to positivism and materialism. The findings of *sub*atomic physics, the theory of relativity, the discoveries in bio-chemistry and related fields all seemed to be proof to the artist that the material and visible universe was but a front behind which lay a more fundamental reality the substance of which was not matter, but various forms of energy. Thus Kandinsky was full of praise for those daring men of science 'who finally cast doubt on that very *matter* which was yesterday the foundation of everything.'[75] Franz Marc was more explicit. 'Our minds', he wrote, 'already sense that the fabric of nature's law hides something that lies behind it, a greater unity'. The law of gravity, he insisted, was merely a 'foreground law' and matter 'something which man still tolerates, but does not recognize.'[76] The artist, Marc declared, was no longer drawn to flowing streams, to painting pictures of battles. What excited his 'will to form' was the study and expression of energy in paintings 'full of charged wires and tensions, of the wonderful effects of modern light, of the spirit of chemical analysis which breaks forces apart and arbitrarily joins them together.'[77]

For Marc, Kandinsky and others of their generation, the

physicist's neutral energy soon turned into a numinous spiritual power engendering a kind of 'energy mysticism' in which cosmic longing, dreams and understanding pushed the frontiers of science toward the mythical and the divine. 'Today', wrote Marc with mystic rapture, 'we look through matter, and the day is not far distant when we shall be able to cleave through her oscillating mass as if it were air.'[78] The same pseudo-scientific spiritualism made Kandinsky hold forth on the impending 'dissolution of matter', an event instrumental, he believed, in bringing closer 'the hour of pure composition,'[79] the art, that is, of pure abstract painting – the scientism of all spiritual man!

All the same, the influence generally of post-Newtonian physics on the artist's mind was profound and all-pervasive, as profound and all-pervasive as was the influence on the Romantic imagination of scientific developments in the fields of electricity, galvanism and magnetism. Then as now, revolutionary scientific discoveries falling outside the limits and methods of the mechanistic sciences helped to shape an artistic consciousness which increasingly came to comprehend reality not in terms of stable solids, but in terms of changing dynamic fields of forces. The result was an art no longer concerned with things as such, but with process and relations. It signalled the end of the separate, self-identical object in artistic representations. Form in the sense of solid substance and simple location now dissolved on the painter's canvas or in the poet's diction into directions of force, networks of tension, trajectories of energy. The aim generally, to borrow Benn's words, was to effect a 'transmission of the last bit of substance into forming processes, transformations of forces into structures.'[80] This intense preoccupation with the dynamic potential of things harks back, as we have seen, to the Romantics. Klee paid tribute to it when he wrote: 'There is a close kinship between dynamics and Romanticism.'[81] There was indeed, even though the Romantics still relied on nature's outward forms and features to express her inner force and energy. Friedrich Schlegel's words were as true of the Expressionists as they

were of the Romantics: 'The self of the world [*das Welt-Ich*] must be thought of as living and evolving. It must be understood in its life and becoming, for otherwise . . . it changes into a *thing*, into a dead, unmoving cosmos.'[82]

IV. The Retreat from Reason

In Expressionism the Romantic tension between head and heart, 'reason and energy', reached new dramatic heights. Since Romanticism this tension had become an integral part of the German cultural tradition where it frequently hardened into two extremes: on the one hand, a cold detached rationalism spinning its seemingly bloodless categories into esoteric constructs far removed from the concrete realities of life; on the other, various forms of vitalism which, impatient with the limitations and restrictions of reason, courted powers below and above reason. In terms of academic schools of thought, the conflict, roughly, was between the neo-Kantians who strictly pursued a 'philosophy of mind' and a group of prominent thinkers who subscribed to a 'philosophy of life' faithful to Nietzsche's misunderstood phrase that life must be saved from reason. Glorified by Bergson, this anti-intellectual philosophy of life received its ultra-Romantic expression in the outlook of Theodor Lessing and, above all, in the writings of Ludwig Klages, a contemporary of the Expressionists, who exerted considerable influence on the thought of his time. To Klages, drawing directly on Romantic sources, the intellect was the deadly enemy of man's soul and instincts which before the intrusion of mind lived in blissful harmony with the totality of things. The rise of reason, in Klages' view, brought about the 'ruin of the soul' by cutting off its roots in nature. Mind was the evil demon disrupting man's 'vitally magnetic connection with the images of the world' – the trees, rivers, rocks and mountains which in the distant past magically responded to human needs and desires.[83]

An attack on consciousness itself, Klages' anti-

intellectualism with its Romantic orientation was closely related to Expressionism. Hanş Arp's lament that 'reason uproots man and causes him to lead a tragic existence,'[84] was echoed by many, whose suspicion of the intellect transformed them into raving vitalists seeking salvation in the realm of the unconscious, the spontaneous, the immediate, in everything undiluted by reason, uncontaminated by reflection. Such vitalist tendencies, inversely related as a rule to acute and painful states of self-consciousness, found their provocative expression in Gustav Sack's words: 'Lieber verroht als vergeistigt' 'Better barbarized than intellectualized.'[85] Reason, demanded Max Pechstein the Expressionist painter, must be overcome. A festering sore on life, it required drastic treatment. 'Smash the brain ... The cursed brain! ... One must tear off the head', live a life of 'intoxication', wallow in the frenzy of liberated instincts.[86] 'Instinct', proclaimed Nolde 'is ten times more important than knowledge.'[87] Knowledge paralyzed, instinct 'energized'. It put the artist in direct touch with the vital force of things.

The desire to free art and life from the enervating curse of reason and with it a longing to retrogress to simpler, more vitalistic and instinctive modes of existence where the eye could behold once more the 'primal light' was one of the keynotes of Expressionist poetry and prose. It reached its climax in Gottfried Benn's craving to return to a subconscious vegetative reality. 'O to be like these again: meadow, sand ... Earth would nourish me in cool and tepid waves. No more forehead. I would *be* lived.'[88] No more forehead! This was the wretched outcry of the rootless intellectual who looked on reason as the cancerous sore preventing union and communion with man and the world. It was the old Romantic dream to merge with plants and trees, to transcend the debilitating effects of rationality by descending into a subrational vegetative unity which obliterated all thoughts of separateness and isolation. Yet Benn, the spokesman of a primitive biological vitalism which before long was to degenerate under Nazism into the absurd destructive myth of 'blood and soil', the same Benn who desired to be no more

than his 'ancestor's ancestors / A little ball of slime in a tepid moor'[89] was quite capable of worshipping the abstract intellect, of glorifying the 'constructive mind' as he called it, which imposed law and form on the chaos of life. As Sokel has shown, in Expressionism a 'headless' vitalism and a hyperactive cerebralism often met, either successively or even simultaneously, in one and the same artist.[90] Even Nolde, not much given to profound reflection, gave voice once to this polarity in his conception of the ideal man whom he described as 'both natural and civilized, god-like and animal-like, a child and a giant, naive and refined, emotional and rational.'[91] This well described the Expressionists' mentality. Few were able to resolve the duality inherent in a conception such as this, nor did they desire to. Indeed their art throve on the tension this duality generated. A 'mixture of *logos* and *eros*', of bowels and brains, of intellect and *élan vital*, Expressionist art could be all flesh and all spirit, at home alike with vulgar prostitutes and disembodied saints. Its spectrum ranged from a crude sexuality to a mystic spirituality forming a balance as uneasy and precarious as it was short-lived.

A similar though less pronounced duality of vitalist and intellectualist conceptions characterized Kandinsky's understanding of life prior to the First World War. The emphasis at first was decidedly anti-intellectual. Reacting against the barren rationalism of the late nineteenth century Kandinsky wrote that 'everything precise, analytical, clearly defined . . . today has suddenly become strange and unnecessary.'[92] Like the Romantics, Kandinsky condemned the spirit of reason as being inimical to a conception of the whole. He prided himself that in his art he had always turned to intellect least of all. His pre-war vision of reality was attuned, as he put it, to the sound of 'drama', 'collisions', 'explosions', to the ferment of life which swept away all rational constraint, all efforts at balance and repose. 'Storm and tempest, broken chains, antithesis and contradictions – these make up our harmony.'[93] Long before Kandinsky, Marianne Werefkin put it almost identically when she wrote

that art was no longer the expression of harmonious life, but 'life itself, pained, passionate, confusing and self-contradictory.'[94] Yet in Kandinsky's case, as in that of Benn and other Expressionists, this stormy vitalism was quite compatible with a detached intellectualism which envisaged a form of abstract art owing precious little to instinct and impulse and nearly everything to reason, purpose and conscious reflection. 'We are fast approaching a time of reasoned and conscious composition.'[95] Kandinsky's art certainly seemed to move in this direction. The ecstatic quality, the furious clash of forms and colours, that distinguished his painting of the 'dramatic' period, gave way to a cool geometric style after the First World War. By then, however, Expressionism as a movement was already on the wane.

All the same, in those few and fateful years prior to the war, which witnessed the birth and peak of Expressionist art, no such spirit of cool detachment cleared the Expressionists' cloud-ridden horizon. Although often painfully conscious of the dualism in their being, poets and painters passionately sided against reason in favour of life, life, that is, as directly given to the senses, to the force of overpowering feelings. In essence, it was a more radical form of Romanticism which feverishly longed for a life of pure sensation, which desperately strained to get away from the secondary and derivative to the immediate and imaginative. Toward this end one deified instinct in the name of *immediacy*, passion in the name of *purity*, imagination in the name of *unity* and the *infinite*.

The Expressionists' denial of reason was at the same time a glowing affirmation of the mystery of life. Like the Romantics, poets and painters were concerned to shield this mystery from the encroachment of mind, from the pretence of rational knowledge which, analogous to science, explained all things by way of barren meaningless abstractions. Swayed by a sense of awe and wonder, the Expressionists experienced reality as something inherently and indefinably enigmatic, something reason could never hope to penetrate. The world

in their view took on the aspect of a 'magical other' which drew the self into its mysterious orbit. As one put it: ' The whole new life is saturated with the longing for mystery and the desire to comprehend it intimately.'[96] This desire reached out to establish contact with the secret life of things. It perceived in every phenomenon the haunting presence of strangeness and magic. No object, regardless of how insignificant or humble, insisted Kandinsky, was without a 'hidden soul', not even a cigarette butt or a burnt-out matchstick.[97] Franz Marc, similarly, searched for the enigmatic qualities of things in the most trivial and wayward objects and events, convinced that they concealed a mysterious meaning behind their silent outward forms. In the pantheist's universe, of course, all things partake of the divine mystery, serve as a magic cipher mirroring the sacred life of the whole.

Throughout Expressionism the emphasis was again and again on mystery as the ultimate category defining the world. To Max Beckmann, for instance, *Mysterium* was the 'true universal concept ... the one and only reality'.[98] Everything genuine in art, he maintained, originated from man's feeling for the ineffable and unknowable. It did so to Kandinsky who, being deliberately obscure, defined art once as 'the expression of mystery in terms of mystery'.[99] On his part this was a recognition that creation, whether cosmic or artistic, followed a path closed to our finite comprehension. 'Mysterious, infinitely complex', it moved toward ends known only to a divine spirit which used the artist as a vessel for its self-expression and advancement.[100]

Whatever the Expressionists may have understood by the universal mystery pervading all, it essentially concealed a desire to rediscover man's original relationship to things – that primal unity which, once upon a time, embraced the subject and the object, the human and the divine. Their longing for mystery was ultimately a longing for a *magical* reality that was one and undivided. Hence their fascination for the legendary depth of nature, for the twilight world of myth and metamorphosis, their irresistible attraction to

everything primitive, primordial, archaic and elementary right down to the darker regions of the barbarous and the demonic. A prominent characteristic of Expressionism, its various manifestations will require a special and more extensive treatment later.

The Expressionists' pursuit of mystery inevitably fell back on mysticism, on strange occult currents of thought which flourished freely and wildly in the first decade of our century and after. Where the Romantics once sympathized with the mysticism of Master Eckhardt, Tauler and Hemsterhuis, or with the theosophies of Jacob Boehme and Franz von Baader, some modern artists in turn courted and supported the theosophies of Madam Blavatsky and Rudolf Steiner. They indeed courted any occult philosophy, be it from the East or from the West, as long as it offered 'insight' into the cosmic mystery and promised redemption to souls recoiling from an oppressive positivism and an arrogant rationalism. Nor were the Expressionists unaware, of course, of the Romantic heritage in this respect. Many a 'dark' saying of Novalis, Runge and other *Frühromantiker* appeared in the *avant-garde* periodicals of the time nourishing the artist's feeling for the mysterious and occult. It was a time also that witnessed the resurgence of astrology, alchemy, cabalistic sects and cults of magic. Like spectres rising from their half-forgotten graves, their ghostly presence belied the rationalist pretensions of the age. Franz Marc's words that 'mysticism arose in the soul and with it the primordial elements of art'[101] aptly described the mentality of the Expressionist generation. They certainly described Kandinsky's state of mind which was profoundly drawn to the 'supernatural' in any form, an inclination he shared with that other great pioneer of modern art, Mondrian.

Kandinsky's interest in the 'spiritualist sciences' and in 'transcendental phenomena', to use his words, was particularly in evidence prior to the First World War when he began to paint abstractly. Well acquainted with some Gnostic sources, including the writing of Blavatsky and Steiner,[102] he breathed the rarified air of the occult in

defiance often of sound common sense. Thus, to mention only one example, he was convinced that some day the painter might dispense with brush and paint-box altogether and realize his visions directly through a materialization of thought, an idea already entertained by the Romantics.[103] A mystic consciousness generally coloured all of Kandinsky's thoughts and writings. As we shall see, it decidedly influenced his understanding of art. In various degrees, this is true of nearly every Expressionist poet and painter whose works cannot be divorced from his preoccupation with the mystical. While it is often difficult, if not impossible, to determine the precise nature of this mysticism, its artistic effects were all the more pronounced. It drove the artist to explore the hidden and forbidden, the strange, weird and fantastic, explorations in the wake of which art moved from the rational, realistic and objective toward the mysterious, non-realistic and subjective. An aesthetic creed in league with mysticism perforce seeks for the truth on 'the other side' – the title of Alfred Kubin's influential semi-Expressionist novel – on the other side, that is, of sense and reason, on the other side of naturalism, realism and Impressionism.

* * *

In its main orientation Expressionism was undeniably a resurrection of ideas and attitudes which we have come to associate directly with the Romantic movement. This is clear enough from the poets' and painters' nostalgia for union, from their pantheistic desire for fusion which, when unappeased, turned into acute feelings of desolation and despair. The Romantic heritage was no less pronounced in the Expressionists' fierce opposition to mechanistic science, positivism and rationalism, an opposition which was the result of more fundamental longings for immediacy, vitality and an all-pervasive mystic spirituality. No attempt has been made to give an exhaustive account of Expressionism, for the aim of this chapter, next to its comparative intent, has been to provide convenient signposts for further explorations.

Such explorations must take into account the Expressionist's predominantly emotional comprehension of life, his unqualified acceptance of the inner world of man. It generated an art uniquely concerned with moods and feelings, poems and paintings that aspired to be the faithful mirror-image of the human soul. For its revolutionary beginnings we must turn to the Romantics and their aesthetic of inwardness, for it was precisely this aesthetic which dramatically and irrevocably shaped the subsequent development of art.

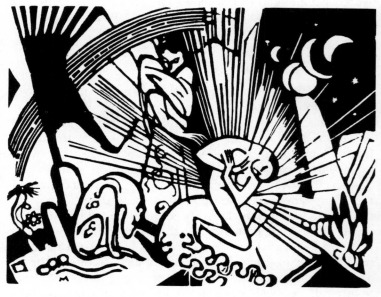

F. Marc: *Reconciliation*

Part Two

Chapter Three
Romanticism and the Aesthetics of Inwardness

I. The Expressive Theory of Art

A.C. Bradley aptly described the dominant characteristic of Romantic poetry and art, when he affirmed that 'the centre of interest is *inward*; it is an interest in emotion, thought, will rather than in scenes, events, actions.'[1] This turning inward was not merely the Romantics' answer to the previous age with its insistence upon the externality of things, but also an awakening to the demands of an inner life and with it a belief in the power and purity of human passion and feeling. Such passion and feeling were considered now the very life and substance of art which henceforth came to be understood primarily as the expression and communication of emotion.

Of course, this understanding of art did not wholly originate with the Romantics. Its first symptoms are to be found in the late seventeenth century, if not before, when critics and poets, reacting against rationalism and restrictive literary rules, had already begun to stress the emotional factor in art. By the mid-eighteenth century the voice of feeling had gained sufficient momentum to demand liberation from the strait-jacket of reason and full recognition in art of man's sentiments. The period – if Rousseau's outpourings of the heart may serve as an example – was indeed an age of sentiments which evolved its own distinct emotionality, an emotionality carried still further by

the youthful rebels of the *Sturm und Drang*. Compared with the Romantics, however, this cult of sentiments was a somewhat stereotyped emotionalism which has been properly described as sentimentalism, not in its modern pejorative sense, but implying a kind of ostentatious presentation of conventional feelings.

By contrast the Romantics' emotionalism was at once more profound and compelling. It was more profound in that it attributed to emotion an unheard-of transcendental or metaphysical significance, of which more later. It was more compelling in its insistence that the poet penetrate to man's innermost feelings. This is partly revealed in Wordsworth's often misunderstood definition of poetry as the 'spontaneous overflow of powerful feelings.'[2] The choice of the words 'spontaneous', 'overflow' and 'powerful' make sense only against the background of the conventional, calculated and frequently affected display of sentiments that characterized the sentimental, as well as the neo-classical poet of the previous age. In reality, of course, his poetry, as that of nearly all Romantics, was neither so spontaneous, nor was it, as the term 'overflow' seems to imply, an indiscriminate gushing forth of feelings. Inevitably, an element of purpose and selection, an element, therefore, of detachment, reason and reflection entered into the poetic process. To quote that other well-worn dictum, poetry was always 'emotion recollected in tranquility'. Nonetheless, and making allowance for any possible qualifications, the principal emphasis in Romanticism was undeniably on inwardness, passions and feelings, on poetry and art as the unique vehicle for the expression and communication of emotion.

This emphasis emerges prominently from the body of Romantic writings. To provide a few instances out of many: 'The genuine source of art and the beautiful', announced Friedrich Schlegel, 'resides in feeling.'[3] Without this inner light (*der Beseelung*), the artist ceased to create anything true and significant. Art and poetry, the *Frühromantiker* insisted without exception, must proceed straight from the heart of man. In Runge's words: 'Out of the inner core of man art

must arise, otherwise it remains merely play.'[4] The cardinal importance of feelings was stressed, above all, by Wackenroder and Ludwig Tieck whose reflections on art were instrumental in fostering an aesthetics pre-eminently grounded in emotion. Art, according to Wackenroder, 'should be named the flower of human feeling', a flower God gave to man for the single purpose of expressing the unsuspected depth, wealth and infinite variety of affections lying dormant in the soul of man.[5] Schleiermacher similarly looked to art and poetry as the divine manifestation of the soul's profoundest feelings. Novalis epitomized the attitude of the *Frühromantiker* in his definition of poetry as the 'representation of the spirit [*Gemüth*], of the inner world in its totality.'[6] This definition made explicit what was so often only implicit in the Romantics' indiscriminate choice of the word 'feeling' as the constitutive element of art. The word covered a wide spectrum of meanings ranging from the murmurs of dreams and the unconscious, the vague longings and passions of the soul, to the moods and premonitions peculiar to visions of the imagination and flashes of intuition. It referred, in short, to every mental manifestation of man's inner life above and beyond the purely and coldly rational.

No privilege of the *Frühromantiker*, the primacy of feeling in poetry and art was emphasized in both French and English Romanticism. Although there were, of course, some differences of opinion as to the manner in which feelings were supposed to be expressed and the ends they should serve, the accent, nevertheless, was consistently on the importance of emotion, the heart in creation. So widespread, in fact, was this expressive point of view that artists not directly associated with the Romantic movement accepted it without the slightest hesitation. Thus Constable, for instance, could write: 'The language of the heart is the only one that is universal . . . Painting with me is but another name for feeling.'[7]

With all the main Romantic writers then the exclusive emphasis was invariably and incessantly on art as the manifestation of emotion, the expression of man's spirituality

and inwardness. The work of art, henceforth, came to be judged in terms of its capacity to embody itself in symbols or images which were the nearest possible equivalents of the states of soul present in the artist's mind. Similarly, the tendency was to grade all the arts according to the extent in which their manner and media permitted undiluted, uncorrupted expressions of mood and feelings. This brought about a new classification of the arts with architecture occupying the lowest rung of the ladder, and music the highest, closely followed by poetry and painting.

Created from and embodying feelings, the work of art was to appeal directly to the soul of man. Art, in A.W. Schlegel's broad definition, was *Gemüthserregungskunst*, an art that stirs the senses and the soul. Its immediate though by no means sole function to the Romantics was to foster, refine and harmonize the sensibility, emotions and sympathies of the perceiver. 'The poet described in *ideal* perfection', wrote Coleridge, 'brings the whole soul of man into activity ... He diffuses a tone of spirit of unity.'[8] According to Wordsworth the true poetic mind must strive 'to rectify men's feelings, to give them new compositions of feeling, to render their feelings more sane, pure, and permanent.'[9] Wordsworth here introduces another criterion of excellence which for many Romantics distinguished art as the expression and communication of emotion. Artists and poets, while expressing their own souls, were able to body forth 'new compositions of feelings'. As De Quincey once put it, the poet, endowed with an intense sensibility and a greater susceptibility to passion, made others 'feel vividly, and with a vital consciousness, emotions which ordinary life rarely or never supplies occasions for exciting and which had previously lain unawakened.'[10] De Quincey's words were echoed by Jean Paul Richter who insisted that the sole measure of genius resided in its ability to communicate 'a new conception of life and the world.'[11] The genuine creator, in other words, not merely transmitted the customary emotions of life, he pushed back horizons, broke new ground which neither pen nor brush had ever trod. Creating new

feelings he extended the range of man's awareness, the scope of human sensibilities. To use a recurrent Romantic metaphor, the man of genius was a kind of musician touched by invisible magic. Playing on the lyre of the human heart he evoked strange melodies which mysteriously disclosed hitherto unknown realms of being.

This expansive pioneering character of art, its drive to new modes of sensing and feeling looms large throughout the corpus of Romantic writings. It expressed itself, of course, in the demand for originality as one of the fundamental laws of artistic creation, an originality which defied all classical models. In part this quest for originality was a kind of 'voraciousness', in Friedrich Schlegel's phrase, to discover and taste the most diverse and wayward forms of sensations and feelings in the name of self-enlargement. Not infrequently, it was a craving for the weird and unusual, the macabre and grotesque – any experience at all so long as it provided novelty, surprise and with it an intensification of feeling. Hence the Romantics' cult of the mysterious and nocturnal, of the marvellous and the fantastic, the diabolical and the grotesque. Friedrich Schlegel expressed it well when he wrote that 'from the Romantic point of view the most curious sorts of poetry, even the eccentric and the monstrous, are of value . . . provided there is in them some grain of originality.'[12] Strange ideals which predictably invited the censure, among others, of Goethe who accused Romantic art of being 'sickly' and 'pathological', a condemnation which, while misleading in some important respects, was not altogether without foundation.

II. Contra Imitation

The expressive theory of art necessarily brought about the decline of the widely accepted doctrine of imitation, a doctrine Portean in scope admitting of numerous and often subtle interpretations. Put simply, imitation was understood as either a faithful transcription of nature into art – realism –

or as a form of *ideal* imitation which selected and combined the most beautiful forms of nature – the credo of neo-Classicism. The Romantics were radically opposed to these doctrines of *mimesis* all of which they considered a travesty of everything that was true, genuine and spontaneous in art. Any theory of imitation, in their view, enslaved the artist to the outer world at the expense of an inner life which remained unheeded. With J. G. Sulzer, an important forerunner and influential critic, the Romantics insisted that the artist should turn 'all his attention to that which goes on in his soul forgetting the outer circumstances which surround him.'[13]

William Blake, showing few inhibitions, vigorously attacked both realism and the neo-classical doctrine of imitation. 'No man of sense', he declared impatiently, 'can think that an imitation of the objects of nature is the art of painting'. Painting, like poetry and music, must be freed from the 'sordid drudgery of facsimile representations of merely mortal perishing substances'. It must be elevated 'into its own proper sphere of invention and visionary conception.'[14] Blake's sentiment succinctly expressed what many modern artists more than a century later proclaimed with equal vigour and impatience. For the neo-classical concept of *ideal* imitation, promoted by Joshua Reynolds and his kind, Blake had nothing but ridicule and contempt. The forms of art, he declared, are not abstracted and compounded from the models of nature, but are innate in the artist's mind. To 'generalize' from the particulars of nature, Blake acidly remarked, 'is to be an Idiot. To Particularize is the Alone Distinction of merit – General Knowledges are those Knowledges that Idiots possess.'[15] A master of insult and injury, Blake's overbearing remark reveals to what extent the theory of imitation ran counter to an understanding of art based on the expression of emotion, in Blake's case on the expression of visionary conceptions.

Among German painters, it was Caspar David Friedrich, a member of the Jena circle of Romantics who in a somewhat more restrained fashion, yet with like assurance, rejected

imitation and pronounced on the proper course to be pursued by the artist. 'Shut your corporeal eye', he advised his fellow painters, 'so that you see first your picture with your spiritual eye. Then bring to light that which you saw in darkness, that it may reflect on others from the outside to the inside.'[16] Friedrich's art, although still dependent on the visible objects of nature, was an art transcending nature, an art addressed to the soul of man as it reached out for fusion with the soul of the world.

Poets and painters were not alone in their rejection of imitation. On philosophical grounds it was Schelling, and before him Kant, who systematically condemned mechanical *mimesis* as stillborn and empty. 'Every one is agreed', wrote Kant, 'on the point of the complete opposition between genius and the *spirit* of imitation.'[17] The artist's role, declared Schelling, was not to copy nature, but to create a second nature expressive of the spirit. To Schelling and the Romantics it was strange indeed that the mechanist and materialist philosophy of their time, having, on the one hand, divested nature of all life and meaning, should yet set it up as a norm and model for art. 'Your lying philosophy has done away with nature, and why do you demand that we should imitate it?'[18] Why indeed!

Schelling's objection has lost none of its cogency and force. It raises a genuine problem, namely on what grounds can a doctrine of imitation be legitimately defended in the face of an external reality reduced by science and reason to an ultimately meaningless conglomeration of material causes and means, a reality stripped bare of all expressive values. If the artist persists in painting a 'dead' nature such as this he will produce no more than childish nonsense, a useless anachronism which consciously deceives by endowing nature on canvas with a soul it does not possess.

Of the various arguments brought forward by the Romantics in favour of the artist's independence from nature, that of A.W. Schlegel coincided with a point of view peculiar to much of modern art. 'Since nature already exists', he wrote, 'it is difficult to understand why art should torture

itself to create a second, similar version.'[19] As Rebecca West
with a dry touch of humour once remarked: 'A copy of the
universe is not what is required of art; one of the damn things
is ample'.[20]

On whatever grounds the Romantics based their denial of
imitation, it followed directly from their insistence that the
principle object of art was to express emotion. This
expressive point of view naturally replaced the time-hallowed
concept of 'truth to nature' with that of 'truth to feeling'. Not
the external world, insisted Caspar David Friedrich, but 'the
artist's feeling is his law'.[21] Baudelaire summed it up lucidly:
'Romanticism is precisely situated neither in choice of subject
nor in exact truth, but in *a mode of feeling*'.[22] Inevitably an art
concerned with feeling, an art, therefore, turned inward,
ceases to be a mirror image of the world without. The
Romantics' worship of emotion, their embrace of inwardness
necessarily drove the artist away from visible nature into the
invisible depths of the self. Novalis stated it succinctly: 'In our
view, to retreat into oneself means to withdraw from the
external world'.[23] In Ludwig Tieck's *Franz Sternbald*, one
artist expressed virtually the same idea: 'Not these trees, not
these mountains do I wish to copy, but my soul, my mood,
which governs me just at this moment'.[24]

Pursuing these ideas in greater detail we are led straight
into the ante-room of twentieth-century art. Elsewhere in the
same novel Tieck anticipated a distinctly modern notion of
painting. Moved by a colourful evening sky, one character
reproaches his artist-friend in these words:

> If only you painters could create something like this. I would
> no longer demand from you history painting, those
> passionate, confused representations composed of
> innumerable figures. My sould would be content and rejoice
> in these *garish colours without connection*. Gladly would I miss
> action, passion and composition ... But, O my friend, you lack
> the colours; and 'meaning', as usually understood, is
> unfortunately a condition of your art.[25]

The last sentence expresses deep regret over painting still

tied to external objects and figures, pictures still forced to illustrate moralizing literature according to predetermined rules of composition. Tieck's daring conception of painting consisting of nothing but 'garish colours without connection' points forward to Turner's semi-abstract, atmospheric visions of nature and to Nolde's storm-tossed cloudscapes and dramatic sunsets.

Other *Frühromantiker* voiced related ideas. They delighted in the 'arabesque' – pictures created by the rhythm and freedom of line. More generally, they used the term to designate paintings which were the products of a sovereign imagination. 'Arabesques constitute pure painting' wrote Friedrich Schlegel.[26] The idea of arabesque painting appeared in Kant's *Critique of Judgment*. Describing examples of 'free beauty' Kant specifically mentioned that

> designs *à la greque*, foliage for framework or on wall papers ... have no intrinsic meaning; they represent nothing – no object under a definite concept ... We may also rank in the same class what in music are called fantasias (without a theme) and, indeed, all music that is not set to words.[27]

Kant quite clearly was entertaining here the notion of a form of art the content of which would fall outside the representation of any concrete object, an art that was free form and free form alone, pleasing directly without interfering associations. Non-objective art would definitely fall under his definition of free or unconditioned beauty. Yet nowhere in the *Third Critique* does Kant urge the painter to pursue an art of free form only, or that painting should strive to eliminate the representation of objects altogether. Nonetheless, he singled out a feature fundamental to modern art, namely that forms, apart from representing anything, can have a stimulating effect on the imagination. This was implied in Mme de Stael's conviction moulded by her German mentors: 'Those who don't like painting in itself attach a great importance to the subject of the picture.'[28] Later in the century Baudelaire was more explicit: 'Painting

is only interesting by virtue of colour and form . . . both make us think and dream; the pleasures resulting from them are . . . absolutely independent of the picture's subject.'[29]

One of the most remarkable Romantic documents concerning the future rise of non-objective art is found in Gottfried Keller's *Der Grüne Heinrich*. Like Tieck's *Franz Sternbald* it is a *Künstlerroman* and, also like the latter, it not only traces the trials and tribulations of a fictitious artist, but wrestles with aesthetic ideas far ahead of their time. At one stage of the novel Keller describes how his painter-hero, intent on representing nature, eventually arrives at an almost non-objective picture, the result of having faithfully followed the dictates of feeling. Amazed and bewildered, the artist stands before the 'colossal scrawl' he has created, convinced nonetheless that this seemingly 'absurd mosaic' of lines, curves and cross-hatchings embodies his 'dreaming consciousness' – what today we would call the unconscious. A critic and fellow-artist mockingly, yet with an unmistakable note of apprehension, reviews the picture at length.

> With this significant work you entered a new phase and began to solve a problem which may become of paramount influence on the development of German art. It has long been unendurable to hear people continually talking and arguing about the free and independent world of beauty, which must not be spoilt by any reality . . . while with the grossest inconsistency, they always make use of men, animals, sky, stars, forest, field and meadow and other such trivial matter to express it . . . You made a quick decision and cast out everything objective, of worthless content. These diligent cross-hatchings are hatchings in the abstract, floating in the perfect freedom of beauty.[30]

The critic calls the picture a 'delightful abstraction' going so far as to rebuke the painter for still adhering to a theme, for having left some unnecessary remnants of nature, of that 'abominable reality' which must be purged from the art of painting. Yet in this prophetic passage Keller indicates that abstraction was the ruin of painting. The critic destroys the

picture. Nevertheless it could be argued that, while accurately and with a wealth of detail and insight describing the artistic and psychological process terminating in abstraction, Keller lacked the courage of his conviction for fear of deviating from accepted aesthetic norms. In any event, and this applies to all Romantic speculations on the subject, painting had not yet reached the point of practicing what the theorists − foremost the poets − preached.

What of the poets and their own art? Here too we meet revolutionary ideas heralding the retreat from the object. Thus Novalis foresaw a form of literature which, beginning modestly in Romanticism, passed down into Symbolism and into modern poetry and prose. 'One can imagine', wrote Novalis,

> tales with no more coherence than the different stages of a dream, poems which are melodious and full of beautiful words but destitute of meaning or connection; at most comprehensible stanzas here and there, like fragments of perfectly unrelated things. This true poetry can, of course, have only an allegorical significance and an indirect effect like music.[31]

By tales or poems 'desitute of meaning or connection' he means a species of poetry divorced from its descriptive and referential function, divorced as well from any rational conception. This, we must assume, was to be a kind of 'psychic writing' glorified by the Surrealists in their exploration of dreams, visions and other subconscious convulsions.

Tieck for his part dreamt of 'great wondrous poems of irridescent splendour and elusive sounds'[32] − tone-poems inspired by music, which, as we shall see shortly, exerted a powerful influence on the art of the Romantics. Like Novalis, Tieck questioned the relevance of traditional subject-matter for poetry. 'It seems to me difficult to decide whether in this realm our art will earn its highest laurels.'[33] He denied that a poem, play or novel must have a 'conclusion', what Aristotle

called a beginning, a middle and an end.'Why should it be the content which makes a poem?'[34] Tieck's poetry indeed reveals little content in terms of action, story and descriptions of external objects and events. A typical example:

Kling nur Bergquell!
Efeuranken
Dich umschwanken,
Riesle durch die Lüfte schnell!
Fliehet, flieht das Leben so fort,
Wandelt hier, dann ist es dort –
Hallt, zerschmilzt, ein luftig Wort.[35]

The poetic value of this stanza is negligible. Yet it testifies to a state of mind turned in upon itself. The poet's mood (*Stimmung*) exclusively determines the meaning and structure of the verse. It is a kind of word-painting, which, like the memory of music fled, traces the movements of a 'flowing soul'. A.W. Schlegel once praised Tieck's poetry for its non-realistic use of language. 'Language has freed itself of everything corporeal and dissolves into a spiritual vapour', into an intimate union of 'sound and soul.'[36] The same observation applies to a large extent to the verse of Novalis, Brentano, and, among English Romantics, to the poetry of Shelley. Here are a few poetically accomplished and compelling lines from *Prometheus Unbound*:

Beneath is a wide plane of billowy mist,
As a lake paving in the morning sky,
With azure waves which burst in silver light,
Some Indian vale. Behold it, rolling on
Under the curdling winds, and islanding
The peak whereon we stand, midway, around,
Encinctured by the dark and blooming forests,
Dim twilight lawns, and stream-illuminated caves,
And wind-enchanted shapes of wandering mist.[37]

The world presented has lost its familiar concreteness. The poet's vast, expansive imagination decomposes nature,

denying its essential otherness. It is an enchanted dream world with emotions floating along winds and waves, lights and mists – the most immaterial of all the elements. This is what the *Frühromantiker* understood by the 'vapourizing' and 'spiritualizing' of language, a process to which it seems not only music but also mathematics showed the way.

When some German Romantics looked to mathematics as a model, they admired it, of course, less for its rational coherence, and more for its complete abstractness and remoteness from the external world. Novalis again provides a particularly provocative example which prophetically foreshadows that excessive self-absorption in their media characteristic of modern poetry and art:

> None know that the peculiarity of language consists in being concerned only with itself ... If only one could make people realize that language is like mathematical formulae. Both constitute a world unto themselves, both only play with themselves and express their own mysterious nature.[38]

In short, language – the poem, the novel – comprises a wholly autonomous universe of discourse. Not subject to the laws and necessities coming to it from the outside world, it concentrates on its inherent expressiveness. As a first step this demanded that the word must be freed from its objective banality, from the sterile conventions of common sense, science and reason. Only thus could it reveal its 'mysterious nature' to which Novalis referred in a cryptic saying: 'As the garments of saints still retain wondrous powers, so many a word is made holy through a glorious memory,'[39] the memory, that is, of a time when it formed a magic complex mediating between man and the inner life of things. How far was this cabbalistic vision of language from Rimbaud's 'alchemie du verbe', from Mallarme's 'immaculate words' unsoiled by mundane meanings, from Kandinsky's 'the word is an inner sound' containing 'unsuspected spiritual properties?'[40] However their poetry differed from each other and from that of the Romantics, common to all was an effort

to recapture the pure, primitive sound of language.

All these various poetic and pictorial conceptions outlined above were audacious anticipations of the flight from externality that distinguished the rise of modern poetry and art. In this context, it is important to realize that long before the appearance of Expressionism and abstract painting the supremacy of art as imitation was boldly challenged in favour of *Seelenbilder*, undiluted, undistorted images of inwardness which ultimately owed no allegiance to the outside world. Beginning with Romanticism the artist's relationship to nature radically and irrevocably changed. Nature ceased to be his master. Independent of it, he fashioned it at his caprice after the forms of his spirit. No longer regarded as something existing in and for itself, external nature was of significance only in so far as it served as a background to human feelings. Moulded and modified by the emotions it was seen as a 'vast storehouse of symbols', a kind of fodder, paraphrasing Baudelaire, to be digested and transformed by a sovereign, imagination which alone bestowed meaning on what existed without.⁴¹ To use a convenient simplification, this new relationship to nature could be stated by way of the following precept: paint not the object, but the passions it arouses in you; describe not the form and features of things, but cast over all phenomena the light and radiance emanating from your own soul.

Some Romantics, especially those who breathed the thin air of Fichte's absolute, were frequently prone to look on the outer world as no more than a kind of *substratum* of no intrinsic worth in itself save that of providing the raw material for their inner other-worldly visions. This approach to things has been rightly called 'Romantic occasionalism' – a state of mind which decomposed the externally given into a purely contingent and accidental series of stimuli to be used and exploited by the experiencing self to assure it of its own freedom, substantiality and existence. In this light the world becomes a mere occasion for the movement and expansion of a restless ego, a spirit which employed the medium of art to appease its perpetual striving for transcendence.

Schopenhauer, and to some extent Nietzsche, raised this form of occasionalism to a philosophic creed according to which the world and the whole of life are justified only as an aesthetic phenomenon, as the grist, that is, for the artist's mill which momentarily releases the soul from its enslavement to the will.

Hegel, describing the Romantic mind and its relationship to nature, made a valid observation, one which hardly required the seal and approval of his delicate dialectical touch for it was clearly visible to all those who could read the temper of the time. The true principle of Romantic art, he wrote, 'is absolute inwardness'. In Romantic art 'the world of inwardness celebrates its triumph over the outer world' which henceforth ceases to exercise any special claims on the human spirit.

> External appearance receives thus the *imprimatur* of an indifferent medium, in which spirit can repose no ultimate trust and in which it can find no dwelling place. The more it conceives the conformation of external reality as unworthy of its fullness the less it becomes able to seek consolation therein.[42]

While Hegel's style may be somewhat tortured, his meaning however is abundantly clear. In Romantic art, a free, self-conscious spirituality stood over everything external. Although still using nature for spiritual expression, it tended to abandon nature altogether to 'live internally', finding the external phenomenon too confining to embody the fullness of inner life. As Coleridge once wrote with a hint of sadness and dejection: 'I may not hope from outward forms to win the passion and the life, whose fountains are within.'[43]

Coleridge here points to a serious problem of which the Romantics were already acutely aware and one that has haunted and troubled poets and painters ever since Romanticism – the problem of how to discover 'objective correlatives' or 'external equivalents' for vast inner visions continually coming into conflict with the limited expressive

potentialities of things. In the twentieth century Rilke gave it a precise focus when he wrote: 'Then you set about that unexampled act of violence, your work, which, more and more impatiently, more and more despairingly, sought among visible things equivalents for the vision within.'[44] From this feeling of impatience and despair it was perhaps only a short step – alas, a fateful one – to jettison the external world completely and soar into the regions of non-objective discourse. Already the Romantics, in particular the poets, were driven to construct fictitious worlds composed of dreams and fancy which stood in a more or less marked opposition to the concrete realities of existence. 'We must seek to create an inner world', wrote Novalis, which 'in every respect shall be opposed to the external world.'[45] Such creations, according to Novalis, affirmed and increased man's freedom vis-à-vis the given. Blake's provocative statement, 'I do not behold the outward creation . . . it is hindrance and not action ... the dirt upon my feet,'[46] was another extreme formulation of the Romantics' tendency to live internally, to retreat from the public world into private visions vouchsafed by the imagination. In Blake this attitude, in part, explains the relative absence in his poetry of passages describing nature. 'Natural objects', he wrote in a marginal note to Wordsworth's poetry, 'always did, and now do weaken, deaden, and obliterate imagination in me.'[47] More than a century later Kandinsky arrived at a similar conclusion: 'Natural forms make boundaries which often are an impediment to [spiritual] expression.'[48]

It would be tempting to interpret the Romantics' relationship to nature as a *total* retreat from reality and leave it at that. It was only one tendency however. While a conspicuous characteristic of visionary poets like Novalis, Blake and others, this relationship could also express itself in the opposite direction by way of a wholehearted devotion to nature's forms and features. This seeming paradox, however, was essentially the two faces of the same pantheistic coin for, to paraphrase Shelley, the Romantic, while capable of resolving the whole universe into his own being, could with

the same ease dissolve his whole being into the universe. Thus nature was only of significance insofar as the soul could make itself a home in it. Without the investment of the human spirit nature was merely a *Schattenwelt*, a miserable and desolate world of matter.

III. Contra Formalism and Universal Aesthetic Norms

Along with the theory of imitation, the Romantics rejected the neo-classical view which located art's excellence in the concept of controlled and self-sufficient form. Form, the Romantics declared, was something finite, the momentary 'concretion' of a spirit of inwardness too vast to be permanently contained in any one particular shape. To seek finality of form was to condemn to extinction all those untold, unfulfilled possibilities dormant in the human heart. Hamann's condemnation of conceptual systems as obstructions of truth was extended by the Romantics to all those attempts which sought to condense the infinite richness of life into the limiting confinement of form. Hence their often excessive anti-formalism, their conviction that exclusive emphasis on form was inimical to feeling, a fetter to the exercise of a free subjectivity which knew itself superior to any material manifestations. Thus in a spirit of impatience the youthful Goethe gave the verdict (one which he much regretted in his later years) that 'any form, even the most felt one, has something untrue about it.'[49] An element of artificiality, in other words, clung to created form, even to those which were the products of the utmost sincerity, since, being bounded and contained, such forms 'froze' and arrested the free, unbounded flow of moods and feelings.

Friedrich Schlegel's conception of poetry as an open-ended process was very much in keeping with an anti-formalist aesthetics of feeling in tune with an evolutionary view of life. Romantic poetry, he wrote, 'is still in the process of evolution: this indeed is its very essence that it is eternally evolving, never completed.'[50] This widely prevailing notion

culminated in the Romantics' elevation of the incomplete, 'the glory of the imperfect'. It opened the path to daring innovations, encouraging the artist to experiment freely with diverse styles and manners of expression. Its immediate result was a new interest in the spontaneous, unfinished and accidental qualities in art. Thus in literature the poetic fragment leaped into sudden prominence. In painting similarly, the sketch and its power to stimulate the imagination was generally praised and recognized. Novalis glorified the force of the fortuitous. In what reads like a declaration of Dadaism and Surrealism he held forth on the 'law' of chance. 'Chance is not unfathomable. It has its own lawfulness.'[51] All these ideas and developments pointed in the direction of modern art.

Schlegel's notion of Romantic poetry as 'eternally evolving, never completed' struck a blow not only at the neo-classical concept of ideal and self-sufficient form, but at the firmly entrenched belief that art obeyed unchanging and universally binding laws and norms. The Romantics gave short shrift to such beliefs. Viewing life as a process of becoming, they insisted that any truth, any established aesthetic norm must in the end prove too narrow to express a reality the essence of which was perpetual change. To look to the past, to the models of antiquity in search for artistic guidance and truth, as was the wont of neo-classical art, was not only a vain endeavour, but a positive hindrance to the spirit's development which at each moment required a response peculiar to itself. 'A different inspiration', declared Schelling, 'belongs to different epochs.'[52] Even more, a different inspiration was the right, the inalienable prerogative of each and every individual. Wackenroder, appealing to divine providence, put it aptly: 'The eternal spirit knows that each man speaks the language He has provided for him, that everyone expresses what is within him as he can and should.'[53] God, Wackenroder piously maintained, looked 'with satisfaction upon each and all', the war music of the primitives, the Greek temple and the Gothic cathedral; pleased, He rejoiced 'in the variety of the mixture',

in the rich diversity of men's creations.

This 'diversitarian' conception, as Arthur Lovejoy has shown, was a fundamental characteristic of the Romantic movement. It derived, of course, from a dynamic view of nature, from the Romantics' vision of the universe as 'vast ever-acting energy'. This vision not only postulated a universe in change. Change was seen as creative and productive of novelties. Living nature everywhere, wrote Karl Friedrich Burdach, 'eternally brings forth the new. Uniformity she suffers in no way.'[54] In this view the artist, in aiming for individuality and originality, merely obeys the voice of nature. Indeed, only by becoming as individual and original as possible could he hope to collaborate with the great 'cosmic mind' who valued novelty and an ever-increasing diversity above everything else at the price even of discord and conflict. To be sure, the ideas of individuality, originality and diversity existed prior to the Romantics. At no time, however, were they emphasized with such enthusiasm, nor – and this indeed was unique to Romanticism – were they ever laid down as the laws or norms for man, laws or norms which nature herself prescribed.

It takes no feat of the imagination to realize that the Romantics here canonized conceptions which have since formed the sacred text of modern art whose health, vigour and vitality seems to be directly measured by its capacity to create startling novelties and an almost self-defeating variety. Driven by a desire for continuous change, contemporary art appears to enjoy a state of 'permanent revolution', a revolution, unfortunately, which quickly devours its own children watched by a sated and indifferent public no longer able to respond to anything new. Little did the Romantics anticipate that their quest for individuality, originality and change by which they hoped to overcome the often sterile uniformity and stifling conventions of neo-classical art, would in turn become the deadliest convention of all.

Although given to excesses, the Romantics' denial of universally valid aesthetic rules and forms was not in itself a plea for anarchy and formlessness. In theory at least, they

possessed their own concept of form, notably the idea of organic form, a potent idea as we shall see more clearly in a later chapter. They also màde use, for instance, of Shaftesbury's notion of 'inner form' which they conceived of as the inner life, the soul and spirit of a poem or painting in contradistinction to its outer material shell. Again they entertained a concept of what today we would call 'open form'. Friedrich Schlegel hinted at it in his definition of the work of art: 'A work is truly fashioned if clearly defined in form it contains an infinite, inexhaustible content.'[55] Content, at any rate, took precedence over form for all Romantics. Romantic art in this respect was pre-eminently a *Gehaltskunst*, an art focusing on content which must not be confused, however, with 'subject-matter' in the narrow sense. It transcended story, plot, description, which merely served as a skeleton to express the inner life in its totality.

Whatever particular solution individual Romantics may have suggested concerning the problem of form, they all agreed that in terms of its origin it must be the natural, spontaneous expression of inwardness. The artist, in short, must not be ruled by form for this leads to sacrifice of content and therefore of feeling. Truth to feeling, not truth to form, should be the animating principle in creation. Schelling's statement sums up the Romantics' hostility to formalism as well as their conception of form as something arising from within: 'Such works of art whose point of departure was form exhibit as a sign of their origin an emptiness that cannot be filled out.'[56] The artist must go 'beyond form', in order to discover it as something 'comprehensible. . .living and truly felt'. This clearly was not a denial of form, but merely a plea that it serve the purpose of expression.

IV. Colour and Music

Nonetheless, it was an almost foregone conclusion that the Romantics, pregnant with feeling, recognizing no master but

moods, should seek their proper expression in media where the fetter of form, the constraint and confinement of clearly defined shape was seemingly least in evidence – in the media, that is, of colour and music, both understood as being uniquely suited to express emotion and inwardness. Thus nearly all Romantic painters escaped from the 'restrictions' of form into the relative 'freedom' of colour. Colour frequently came to be regarded as the final art of an excellence far greater than that possessed by the beauty of form which appealed only to what was rational in man. 'Colour', wrote Runge, 'constitutes the greatest art', an art, he added, which has been and always will be closed to our understanding.[57] Like Goethe, and Kandinsky in the twentieth century, Runge developed his own theory of colours which aimed to show the various correspondences between them. 'The highest painting', declared Friedrich Schlegel, 'consists of nothing but a poem of colours.'[58] The 'poetry of colour' as a value independent of the represented object was praised by nearly all Romantics. It was at the root of their intoxication with Correggio and Venetian art. Washington Allston, the American painter whose work inspired Coleridge to write his essay on art, summed up an aesthetic attitude shared by many Romantics: 'Titian, Tintoretto and Paolo Veronese absolutely enchanted me for they took away all sense of subject'. And in what reads like a description of non-objective painting he wrote:

> I thought of nothing but the gorgeous concert of colour, or rather of the indefinite forms (I cannot call them sensations) of pleasure with which they filled the imagination. It was the poetry of colour which I felt, procreative like nature, giving birth to a thousand things.[59]

Viewed from the history of perception, Romanticism was the birth of a new colour-consciousness which in turn prepared the ground for our appreciation of non-objective art. The Romantics' vision of the world was invariably a 'coloured' one, breaking down all things perceived into manifold

irridescent hues. Theirs was not simply a delight in the sensuous properties of colour characteristic of Rubens, the Venetians and the painters of the Baroque, but an obsession with its quasi-magical and symbolical significance. Pater's words aptly describe it: 'Colour is no mere delightful quality of natural things, but a spirit upon them by which they become expressive to the spirit.'[60]

In painting this new colour sensibility reached its most lyrical and extreme application not in the art of Delacroix, but in Turner's later landscapes and Petworth interiors. Turner's observation on Rembrandt accurately defines his own art: 'He has thrown a veil of matchless colour' over everything, so that the eye 'enthralled ... thinks it a sacrilege to pierce the mystic shell of colour in search of form.'[61] A whole development of art is presaged in these few poetic phrases, and Turner's mature painting signified a radical departure from accepted standards. Traditional relationships were suddenly reversed. Whereas to the neo-classical painter colour was either a sensuous snare, or, at best, a secondary attribute which on canvas had to perform its descriptive function quietly, it now obliterates, virtually swallows up the object and becomes a subject or substance embodying emotions. Turner pioneered what for want of a better term could be called a form of 'first abstraction' which deliberately disengages colours from their usual surroundings, arranging them in accordance with the *plastic* demands of pictorial structure rather than in conformity with the world external to the picture frame. The brilliant tissues of paint have an inherent reality and expressiveness independent of the scene portrayed.

Similarly poets infused language with a chromatic content hitherto unknown. A.W. Schlegel identified the various sounds of vowels with particular colours and feelings. For Tieck, as for other Romatnics, landscape was essentially a manifestation of colour used primarily to produce emotional effects. In his poems, soft reds, golds, blues and forest greens obliterate the clear-cut shape of things, the hard line of difference separating object from object. 'Colour in

isolation', Tieck insisted, was the medium through which appeared the spirit of nature,[62] a spirit that found expression in lines such as these:

> Und heller glänzt der Sonne Licht,
> Die Blumen scheinen trunken,
> Ein Abendroth niedergesunken
> 'Und zwischen den Kornfeldern schweifen
> Sanft irrend blau und goldne Streifen.[63]

Shelley could use colour even more boldly. His evocation of Venetian lagoons conjures up a Turneresque world of luminous hues.

> Lo! the sun upsprings behind,
> Broad, red, radiant, half-reclined
> On the level quivering line
> Of the waters crystalline;
> And before that chasm of light,
> As within a furnace bright,
> Column, tower, and dome, and spire
> Shine like obelisks of fire.[64]

The fire is that of an inner life which, emanating from the poet's own soul, melts down the representative element – colour tower, dome and spire – into a conflagration of light and colour.

For the majority of Romantics the expressiveness of colour was intimately associated with that of music so that the relationship between the two formed an important feature of their aesthetic. Runge contemplated writing a detailed exposition concerning the analogy between colours and tones. Romantic poetry is generally noted for its *audition colorée*, its pictorial colouring and musical feeling in an attempt to fuse the spheres of sight and sound to which brief reference was made in Chapter 1.

As for music itself, it was accorded the highest rank. Following the example of Herder, the *Frühromantiker* proclaimed music to be the *purest* and the *greatest* of the arts.

It was the *purest* because the most remote from earthly things. Excluding compositions based on words or programmes, music by its very nature was innocent of any reference to the world without. It neither duplicated sensible things nor evoked their frequently oppressive presence. 'The musician', wrote Novalis in a tone of envy as well as admiration, 'takes the essence of his art out of himself and not the slightest suspicion of imitation can befall him.'[65] Music at the same time was the *greatest* of the arts because the most immediately expressive of feelings. Moving in the immaterial realm of the soul, it made public man's innermost passions. Unlike speech, which in order to express the inner life had to make use of external objects, 'music', marvelled Wackenroder, 'streams it out before us as it is in itself . . . In the mirror of tones the human heart learns to know itself.'[66]

According to German and other Romantics, music not merely expressed the inner life of man, it pointed beyond this to the life of the universe, to the spirit which dwelled behind the outward show of nature. Rising above the contingent, above time and place, it soared into the sphere of essences. Music dissolved all boundaries, it commemorated, in Friedrich Schlegel's words, the 'infinite unity' of the world. 'Who is there that . . . can express the effect music has on us?' rhapsodized Carlyle. 'A kind of inarticulate unfathomable speech', it leads man 'to the edge of the Infinite, and lets us for moments gaze into that.'[67]

Romantic passages praising the power of music are legion, and their ecstatic tone leaves no doubt as to the phenomenal significance it possessed for them. Music, henceforth, determined the place and comparative merit of all the arts. Its freedom from nature, its seeming ability to express emotions unaltered by their physical medium provided the 'genuine touchstone', in Wackenroder's words, by which to judge the 'excellence' of each and every work. In advance of Pater and the French Symbolists, the Romantic explicitly demanded that art model·itself after music, that each must realize a measure of 'musicality' within its own dimension. Nowhere was this demand more in evidence than in the

realm of poetry, notably of the lyrical kind which claimed a profound affinity with music.

We must be clear what the Romantics understood by the 'musicalization' of poetry for it announced and initiated a development whose influence was not only paramount in Symbolism but also in modern poetry and painting, as we shall see. In the *first* place, and as a minimal condition, musicalization meant no more than that the poet free himself from his reliance on external models. He should direct all his attention to the musings of his inner life in defiance of outer circumstances. This was at the root of Schiller's famous distinction between 'plastic' and 'musical' forms of poetry. The one mirrored emotions through the object; it created in accordance with the precepts of sense and the laws of reason. The other mirrored the subject; originating from within, it gave lasting form to feeling without having recourse to any definitive state or event of the outside world.[68] The distinction, anticipated by Friedrich Schlegel and worked out in greater detail in Bernhardi's *Theory of Language*, was a familiar one to most German Romantics. In short, any poetry non-mimetic in origin and nature was considered to be 'musical'.

In the *second* place, the musicalization of poetry came to be understood as the attainment of an indefinite and rich suggestiveness favourable to the soul's striving and infinite longing. Thus Edgar Allan Poe spoke of the mysterious allusiveness of music as the essence of everything poetic. 'The vagueness of exultation aroused by a sweet air which should be strictly indefinite and never too strongly suggestive is precisely what we should aim at in poetry.'[69]

Thirdly, and more specifically, the musicalization of verse designated the poet's attempt to recapture melody and harmony through a judicious use of rhyme, rhythm, metre, through a more or less abstract arrangement of phonetic patterns which, avoiding accumulations of consonants, concentrated on alliteration and assonance. Musicalization in this context consisted primarily in the effort to achieve rhythmical effects which, strictly speaking, are not

synonymous with melody and harmony in music. Nonetheless, the Romantics were convinced that language, stripped of its overt denotative significance, was inherently musical. Indeed poetry was originally song – the mother tongue of the race and as such the cradle of all music.

Fourthly, the musicalization of poetry could also mean the imitation of musical modes, keys and movements, a tendency which extended to the novel and the play. E.T.A. Hoffmann, for instance, described the plan for his novel *Die Elexiere des Teufels* in musical terms: '*grave sostenuto, andante sostenuto, andante sostenuto e piano*.'[70] Tieck's *Verkehrte Welt* was supposed to be a symphony in words divided into a number of movements. In our time, T.S. Eliot's *Four Quartets* are a conspicuous modern example of such aspirations. Organized according to themes, counter-themes, figures and revolutions developed in various phases and keys, they imitate the external structure of a musical composition.

Whatever other notions the Romantics may have entertained concerning the musicalization of poetry, its consequences were largely and dramatically the same. It necessarily encouraged the creation of poems blissfully unburdened with rational contents and empirical connections, poems whose emphasis throughout was on connotation rather than on denotation; a kind of poetry, in order words, foreseen by Novalis when he advocated songs or tales 'destitute of meaning. . .having only an indirect effect like music'.

In the pictorial arts, musicalization inevitably tended toward painting no longer preoccupied with purely literary and descriptive values but with its own kind of visible beauty – that of colour, shape and rhythm. Runge was clearly thinking of music when he wrote the fateful words that the substance of art resided solely in the expressiveness of the means. 'I am convinced that the significance of art lies in the artistic elements themselves; it is there that we must seek for it.'[71] Such words echoed down the century – an eminently 'musical' century which produced an increasing number of music-minded critics, poets and painters. Baudelaire's

attitude, which derived in part from Delacroix, was symptomatic: 'In certain of its aspects the art of the colourist has an evident affinity with mathematics and music.'[72] Even John Ruskin was forced to admit 'that the arrangement of colours and lines is an art analogous to the composition of music and entirely independent of the representation of facts. Good colouring does not necessarily convey the image of anything but itself.'[73] How strange that no sooner should Ruskin have made this admission than he proceeded to ignore it. Of all Romantics however, none was as consistent, as rigorous and as audacious as Novalis. Identifying painting with visual music, he insisted that the 'truly visual music consists of arabesques, patterns, ornaments'[74] – it consisted, in short, of totally abstract configurations. Yet more than a century was to pass before painting finally surrendered the object in order to create its own kind of 'musical' compositions.

V. Resumé

We are in a position now to redefine the expressive theory in the light of its far wider implications. Stripped of all rhetorical embellishment and in bald general terms, its most essential tenets can be summarized thus: the work of art embodies in permanent iconic form the inner life of its creator. Inherent in and proceeding from the emotional situation of the artist, it is the internal made external, the external made internal, a creative process determined by the force of feelings which demand a material expression characteristic of themselves. This process ignored the claims of imitation, dismissed any pre-existing aesthetic rules and forms in the firm belief that to follow such precepts would distort and falsify the feelings to be expressed and thus result in insincerity and artificiality in the artist's presentation.

It is easy to see that once this expressive point of view began to prevail – as it has increasingly since the Romantics – the artist could justify his most daring inventions on the

grounds that these were the sincere expressions of some urges or passions which compelled him to create. From now on, he merely needed to appeal to an 'inner necessity', an inner prompting to defend the offspring of his mind and heart. Henceforth, the artist subscribed to one and only one aesthetic imperative: 'To thy own self be true!' Follow your genius at all costs. Surrender yourself to yourself. Surrender yourself in particular to your moods and feelings, be they ever so strange and unusual. Listen to the sound of your inner voice, to the faintest whispers of your heart for that is art in you. If, for one inconceivable moment, you should doubt all that is unique and individual in yourself, pause and contemplate the infinite diversity of nature, God's marvellous handiwork which delights in making everything different from everything else. Thus comforted rejoice in your individuality and difference and retreat once more into your own soul where all truth lies. In short, obey no one; be your own judge and self-appointed court of appeal, regardless of how much your opinions deviate from accepted standards. Add your own and the world will be so much the better and the wiser for it.

Although some of the above point of view was anticipated by the rebellious spirit of the *Sturm und Drang*, never before, not even during the late Gothic and the Mannerist period, was artistic sensibility driven inward to feed solely on moods and emotions; never before, though almost consistently since, was the artist's right to follow the call of his feelings and individual conscience emphasized with such force and absolute conviction. Expelled now from the halls of art was the voice of reason whose prudent counsel had insisted that 'genius must not have its excesses condoned', that art, like any other work of man, must submit to a central intelligence governing all, to a 'higher' nature which was reflected in the beauty and design of visible nature. Exempt from such strictures, the artist henceforth occupied a position which he shared with no other living creature. Carlyle expressed it admirably: 'Genius has privileges of its own; it selects an orbit for itself, and be this never so eccentric, . . . we . . . must cease

to cavil at it, and begin to. . .calculate its laws.'[75] And the first law of genius was the command: 'Thou must not imitate; thou must in conscious opposition to the material world create a spiritual world which alone was worthy of habitation'. From here one road led to the crystal palace of art, to the ivory tower of 'aesthetic man' who, disdainful of the concrete realities of existence, performed his holy offices in self-chosen isolation; another far more direct route, however, led straight to the pathos of poets and painters whom we shall discuss next.

Chapter Four

Expressionism and the Aesthetics of Inwardness

I. Art and Emotion

The Romantic expressive theory found its true heir and ultimate fulfilment in Expressionist literature and art. Indeed as the label 'Expressionism' itself implied, this was an art exclusively concerned with human passions and feelings, an art, therefore, whose dominant characteristic was an intense preoccupation with the inner world of man. Theodor Däubler, the Expressionist spokesman not only put it aptly, but in capital letters: 'OUR AGE HAS ONE GREAT TASK BEFORE IT: a new upsurge of the soul!'[1] Lothar Schreyer, another Expressionist, found an even more succinct formulation. Expressionism in his definition was 'the spiritual movement of a time that places inner experience above external life.'[2] As a general proposition, Expressionism could hardly be defined more precisely. This turning inward once more was not only the defiant gesture of a generation in revolt against materialist standards, it also expressed a firm belief that the redemption of the world led through the forgotten inner world of man. 'The world', wrote Franz Werfel, 'begins in man,'[3] in the depths of the self and the emotions which it was the function of art to explore and to express.

This Romantic conception was the unquestioned faith of each and every Expressionist. While to some extent the

expression of emotion has been regarded as one of the principal objects of art ever since Romanticism, with the Expressionists this conception was proclaimed to the exclusion of nearly every other consideration. The evidence lies in their poetry and painting as well as in their more personal confessions all of which testify to the basic theme of art as the instinctive and, above all, powerful expression of deep feeling, or alternatively, as a process of the mind in which instinct, impulse and passion play the crucial part.

The following quotations are wholly typical of this outlook. Thus Kurt Hiller praised the lyrical poetry of Franz Werfel as *'the music of feeling'*, a music welling forth from the 'primal spring' of the heart.[4] To Kasimir Edschmid Expressionism was not an aesthetic movement, 'a programme of style, but a matter of the soul.'[5] It was, wrote Iwan Goll, less a 'form of art' and more a 'form of experience' which painted everything in the light of strong feeling.[6] Profound emotion, Kandinsky reiterated again and again, was the sole 'determining factor', the vital productive principle at the root of all genuine art.[7]

This belief that true art emanated from a state of soul was stressed even by so stern a figure as Ernst Barlach, the dramatist and sculptor. Consumed by primitive religious feelings – as were so many Expressionists – he urged the artist to express all and everything dwelling in the furthest regions of the self. 'You may without shame reveal everything within you, the most extreme, the inmost gesture of piety, because everything … is expressible.'[8] A century earlier Caspar David Friedrich had put it almost identically. 'You should keep sacred every pure impulse of your mind … every pious presentiment because that is art in us.'[9] Ludwig Meidner lucidly summed up these artists' intense preoccupation with the inner world of man.

The greatest aim of my generation, its most burning desire, its most fervent wish, is nothing more than to achieve a way of creating from out of one's inner being, to retrieve all the

faces and melodies which whisper in the human soul, deep within, dark, unrecognizable.[10]

The Expressionists, like the Romantics, had no qualms, of course, in identifying every momentary flicker of the human heart, every subconscious tremor with the life of the spirit itself which made the work of art according to Kandinsky an embodiment of the 'spiritual', or in Novalis' words, a 'representation of the spirit, of the inner world in its totality.'[11] The emphasis, in any event, was incessantly and consistently on emotional inspiration as the mainspring of creation, and, in terms of the finished product, on inwardness as the highest and most enduring quality of art. The individual work as well as the various species of art, in other words, were exclusively judged once more according to their ability to give sincere, uncorrupted expression of the artist's inner moods and feelings. Kandinsky, writing about the programme of the *Blaue Reiter* association, for instance, defined its aim simply thus: 'To reveal the expression of inner aspirations in every form of inwardness – this is the goal the *Blaue Reiter* is striving to attain.'[12] It was the goal also of the *Brücke* painters. 'Everyone', wrote Kirchner, 'belongs to us who portrays his creative impulses honestly and directly'.[13] Naturally, there were profound and fundamental differences in the way in which each artist expressed his creative impulses, differences dependent on personality, place and cultural tradition. In Expressionism the differences ranged from the comparatively crude and primitive presentations of Nolde, Pechstein, Heckel and Schmidt-Rottluff to the more subtle, if not sophisticated, compositions of Marc, Macke, Klee and Kandinsky. A similar stylistic diversity distinguishes Expressionist poetry which could be exceedingly blunt and brutal in its directness of expression as well as openly lyrical and melodious giving vent to unashamedly Romantic feelings. Yet what all these diverse pictorial and poetic manifestations had in common was this 'irresistible desire', in Nolde's words, 'to express a deep spirituality and inwardness.'[14]

What was the function of all this 'inwardness'? In keeping with an expressive aesthetics, the primary object of art was to arouse man's sensibility, to excite, enrich and enoble his passions and susceptibilities. The work of art must nourish the spirit and purify the beholder's feeling. 'Painting', insisted Kandinsky, 'is not a vague production but a power which must be directed toward the development and refinement of the human soul.'[15] The artist's obligation, urged Kandinsky, quoting Robert Schumann the composer, was to 'send light into the darkness of men's hearts.'[16] This high moral tone was characteristic not only of Kandinsky, but of the Expressionists as a whole. Like the Romantics, as we shall see, they looked to art as the salvation of the world.

While unanimously agreed that the artist express his deepest passions, many Expressionists at the same time stressed the creative, pioneering quality of art: its ability to break new ground, its capacity to communicate new ways of feeling. In part this was the inevitable consequence of the Expressionists' feverish desire to participate in all being, to taste any fruit on the tree of life. Wilhelm Lotz, the poet, expressed it thus: 'We pine for unfamiliar excitants. We crave for things we do not know.'[17] The Expressionists' aim was to enjoy a state of 'perpetual excitement,'[18] a condition best described perhaps as a kind of priapism of the soul which dissolves the self and the world into a mass of quivering feelings. Toward this end poets and painters continuously assaulted the senses, strove to create pictures and songs whose hallmark was intensity, novelty and surprise. Hence the often aggressive, explosive energy of Expressionist art, its frequently wild and ecstatic emotional gestures which increasingly had to rely on violence and bold exaggerations to make their desired effect. Hence also its extensive forays into the macabre and grotesque, clearly visible in some works of Kubin, Kirchner, Kokoschka, Nolde and even in the freakish, whimsical humour of Klee. Behind these urges we meet once more the Romantics' drive for self-expansion, an admittedly more impassioned one, in search of exotic and wayward forms of sensations which were supposed to bestow

on the experiencing self a fuller measure of its being. Then as now, such tendencies were bitterly opposed. One critic, for instance, accused the Expressionists of courting the perverse. 'They are interested only in the extraordinary and the abnormal. With an ardent impetuosity they plunge themselves into the tortuously discovered. Sexuality and the pathological wholly encompass their sphere of representation.'[19] This is a harsh and hostile criticism, yet it has just enough substance in it to give pause for reflection. As it stands, it could hardly be applied to the painting of Kandinsky who barely concealed his impatience with the Expressionists' exaggerations. Yet he too demanded that art branch out into the unknown, that it express emotions beyond those we normally experience in life. Indeed, he once made it a specific condition. 'Ask yourself', he addresses the beholder, 'whether the work of art has presented you with a new world. If yes, what more do you desire?'[20] Obviously, this was putting the matter rather crudely since the perceiver may want a good deal more. He may, in fact, find the artist's 'new world' much too trivial to warrant serious consideration. In *Concerning the Spiritual*, Kandinsky was somewhat more explicit. There he spoke of the painter's desire to arouse not definite feelings 'like fear, joy and grief' – coarse sentiments according to Kandinsky – but emotions 'as yet unnamed', moods 'subtle beyond words'.[21]

It is not difficult to grasp Kandinsky's meaning and intentions. His fondest hope was to sensitize the beholder to the highest possible pitch enabling him to respond to the most 'refined' and 'immaterial vibrations' of non-objective art. 'Men', he wrote in a revealing metaphor, 'are like good much-played violins which vibrate at each touch of the bow.'[22] This utmost refinement of human sensibility was, of course, one of the cherished ideals of the Romantics who frequently compared man to an Aeolian harp over which, in Shelley's famous phrase, 'a series of external and internal impressions are driven . . . which move it by their motion to everchanging melody.'[23] A century later Max Pechstein expressed it in nearly identical terms: 'We are only the harps

on which the wind plays its melodies', its surging secretive songs which told of unknown modes of being.[24]

It may well be argued, however, that this desired perfection in sensing and feeling, a sign of superiority to Kandinsky and the Romantics, in reality reduces man to a slave of circumstances, to a form of receptive passivity which makes the self tremble before the most fugitive and fleeting sensations – as those conveyed so often by non-objective art. While an art of this kind may have purified perception, sharpened our senses for the expressiveness of forms and colours, it also engendered a receptivity for the vague, indefinite and elusive in which the self, blind to the world beyond the picture frame, contemplates its own sensorial involvement and ephemeral responses. Non-objective art ultimately generates a 'floating spirituality' which cannot rest on anything concrete. Its seemingly rewarding purity reduces the idea of art as the expression of emotion to an evocation of obscure feelings which no longer possess any real and ideal object. Objectless, they are at home everywhere and nowhere.

II. Beyond Imitation

Driven by an overwhelming desire to create from within, the Expressionists denied all claims for representation in favour of structures 'suggestive of inwardness'. *Los von der Natur* ('Away from nature') was the much-quoted slogan expressing their hostility to copying the surface features of things. In many a programmatic declaration, poets and painters categorically condemned imitation and proclaimed the artist's independence from visible nature. In a manner reminiscent of A.W. Schlegel they denounced the absurdity of reproducing an already existing world, an activity which far from revealing anything about the nature of reality enslaved the spirit to externals. To paint and compose realistically was to perpetuate a materialist point of view and thus remain insensitive to the soul's immaterial strivings.

Kandinsky spelled it out succinctly when, describing the 'revolution in art', he named its 'intensive turn to inner nature' and with it 'a refusal to embellish outer nature' as one of its dominant factors.[25] The revolution in this context clearly dates back to the Romantics.

In Expressionism generally a marked visionary mentality was instinctively opposed to any realistic and naturalistic tendencies in poetry and art. Like Blake who renounced and ridiculed the 'sordid drudgery' of imitation for 'visions of eternity', many Expressionist poets and painters spurned the stubborn world of circumstances to concentrate more fully on their inner visions. Kasimir Edschmid's well-known manifesto of Expressionism paid a glowing tribute to these artists' unrestrained subjectivism which aimed to transform the world from within.

> Their *feeling* expanded beyond measure.
> They did not look.
> They 'envisioned'.
> They did not photograph.
> They had visions.[26]

Edschmid's impassioned polemic was a fanatical dismissal of art as imitation, description or reportage. The artist, swayed by visionary conceptions, recognized no authority but the voice in himself.[27] Truth to feeling, truth to imaginative visions and not submission to external facts was at the root of all genuine art. This by now familiar Romantic credo was strongly emphasized by all Expressionists. Each one insisted that the work of art as an embodiment of emotions was not a window onto the world without. Freed from its representative function, it was first and foremost an autonomous creation, the direct, personal and intimate expression of the artist's inner life. The true artist, wrote one Expressionist, formed not things seen, 'he formed himself, his form stands in the centre of his work. The new art . . .is the way to the soul.'[28]

In Expressionism, as in Romanticism, this understanding of

art as a 'way to the soul' still strove to express itself through
the forms and figures of nature. It was nature, however,
transformed and transfigured in the light of intensely
subjective feelings. In itself the external world was of no
intrinsic worth and significance. It served simply as a pretext,
something to be used and exploited for purely expressive
ends. What mattered was not the external object as such, but
the artist's emotional response to it, the pictorial and poetic
instinct it aroused in him. In Expressionism, Romantic
occasionalism – the tendency to dissolve objective reality into
a series of subjective occasions for creation and experience of
the self – reached new heights which carried the artist's
detachment from the visible world a significant and dramatic
step further.

Thus in many an Expressionist work the link to nature or
the object has become extremely tenuous. In the case of the
poet, his dynamic, agitated diction dissolved, in some
instances virtually 'pulverized', the solid world of things to
make them express the turbulence of powerful emotions.
Words, denuded of their literalness, were charged with
ambiguous multiple meanings. Verbs multiplied and
expanded to add rhythm, movement and speed. Adjectives no
longer predicated objects, they predicated feelings.
Language generally was made 'fluid' and invested with an
energy and restlessness which, emanating from the poet's
own soul, pressed the outer world into the service of the
passions.[29]

The disjointed, dynamic syntax characteristic of
Expressionist poetry and prose was by no means without its
Romantic precursors. In some of his dramas Heinrich von
Kleist, for instance, frequently used language for purely
expressive ends. Gottfried Benn even unearthed such lines of
Goethe as 'toothless jawbones chatter and the tottering
skeleton, intoxicated by the last ray...' ('entzahnte Kiefer
schnattern und das schlotternde Gebein, Trunkener vom
letzten Strahl')[30] to justify the non-representative
expressiveness of the new style. Romantic poetry indeed
provides many other similar examples. The lyrical

manifestations occurring in Expressionist verses often recalled again the stylistic pathos of Hoelderlin's later poems and fragments.

The emotional intensity inherent in Expressionist prose soon drove some poets to invent a new language of meaning far removed from external objects and events. For August Stramm the poem ceased to describe anything objective. It turned into an almost abstract pattern of verb-nouns which aimed to communicate inner experiences directly.[31] Kandinsky's poetic attempts at the time pointed in the same direction. His poems, analogous to his paintings, began to exploit the immediate expressiveness of sounds and words deprived of their material associations. The stress throughout was on connotation rather than on denotation.[32] Hugo Ball, Kandinsky's admirer and one-time collaborator, was to take the final plunge by reducing poetry to strictly phonetic structures consisting of nothing but richly suggestive sounds condensed into drawn-out sequences of melodious vowels. Influenced most likely by Kandinsky, the phonetic poem aspired to be the verbal equivalent of the pure non-representational painting. The link between the two may well have been the optophonetic poem: an arrangement of disconnected letters, signs and syllables thrown into visual relief to appeal to the eye as well as to the ear. As Raoul Housmann, one of its pioneers, put it: 'The optophonetic and the phonetic poem are the first step towards totally non-representational, abstract poetry.'[33]

A similar progression of 'derealization' was at work in Expressionist painting. On canvas twisted and distorted shapes and bodies transformed the objects of the outer world into a mirror image of the artist's inner life. The painter's desire was to melt down the forms of nature into pictorial rhythms and planes which asserted their own expressive independence. Although still depicting recognizable forms, the representative element in most Expressionist paintings was swept along by the inherent energy of lines and colours deployed to express the dynamics of feeling.

Aiming for direct emotional communication, some

Expressionist painters frequently relied on the intrinsic life of the forms and colours themselves, pushing their autonomy to a point which nearly obliterated the representative element itself. Thus, in several of Nolde's seascapes, for example, the subject is so overpowered by structure and movement, by the rhythm of the forms and the luminosity of the colours that little of its relevance remains. Only the title at times provides a bridge to the meaning of such pictures precariously balanced on the borderline between representation and abstraction. It was left, however, to Kandinsky to proclaim the absolute autonomy of the pictorial means and use them for purely 'spiritual expression'. In retrospect it would seem that this momentous historical step was almost forced on the artist. Painting had reached a stage of development where it violated both nature and art: the former through the artist's wholly unprecedented and often wilful distortions; the latter through his retention of natural forms while in the main making his emotional appeal through the immediate expressiveness of lines and colours. As Kandinsky realized, this introduced an intolerable tension between nature and art, between the descriptive element borrowed from without, and the expressive element inherent in the pictorial means. The viewer was pulled in too many directions at once; now lost in the associations peculiar to representation, now in those peculiar to colour, shape and composition. The tension, in Kandinsky's view, could be resolved only by either creating a new form of realism – what he called the 'Great Realistic'[34] to which it seems the art of children and the painting of Henri Rousseau showed the way – or by eliminating the object altogether leaving the painter to evolve a language of expression no longer tied to the object. After long deliberation, Kandinsky chose the latter course. In his case it was the final gesture of a Romantic inwardness which could no longer 'hope from outward forms to win, the passion and the life, whose fountains are within.'

III. Beyond Form and Norm

Determined to express the life of feelings the Expressionist rejected all rules and norms which viewed art primarily in terms of form. Like their Romantic predecessors, poets and painters were more concerned with art as *Gehalt*, than with art as *Gestalt*. To use Schiller's distinction, *Stofftrieb* rather than *Formtrieb* motivated their artistic efforts. The creed once more was profoundly anti-formalistic. As with the Romantics, this pronounced anti-formalism was prone at times to insist on the mendacity of all forms, the inadequacy of any created shape, in the name of an inner life the fullness of which defied containment. Form for some poets, for instance, came to be looked upon as the stumbling block preventing the soul's fusion with the world. In Ernst Stadler's classic lines: 'Form compresses and constrains, yet my being craves to travel on the world's wide lanes.' ('Form will mich verschnüren und verengen, doch ich will mein Sein in alle Weiten drängen').[35] Such pantheistic longings instinctively condemned any attempts to arrive at formal distinctions and clear-cut determinations as a process essentially of negation which denied the claims of the whole. Other poets and painters again demanded the destruction of all rules and forms for the sake of a wholly new beginning. Swayed by messianic visions – of which more later – they regarded every artistic tradition and convention as the accumulated dead wood of a past obstructing man's path into a better future.

Expressionism, as many of its critics were quick to point out, admittedly harboured within itself explosive energies to break free from the 'limitation' of form, yet it never ceased to search for ways and formal means best suited to express its own visionary and vitalist conceptions. Kandinsky's early essay *Concerning the Spiritual* and its companion piece *Concerning the Question of Form* were of great importance in this context for they clarified and reassured what was in the

minds of many who were wrestling with the problem of form.
Kandinsky's argument as it bears on this problem can be
stated simply. It followed the Romantic idea of
comprehending artistic form as the momentary vessel of an
advancing spirit. Kandinsky, like the Romantics, insisted that
all of life was movement, metamorphosis, the unfolding of a
spiritual dynamic which continuously transcended the
already attained. 'Spirit creates its forms and passes on to the
creation of others'.[36] History, to invoke Kandinsky's own
example, was a moving triangle spearheaded by a creative
minority of solitary genius which carried mankind, forming
the base of the triangle, forward and upward towards further
fulfilment.[37] Nothing remained static, nothing timelessly valid
in this process. To declare any artistic norm as final, to cling
to the concept of ideal and universal form was to arrest the
flow of life and thus thwart the creative movement of the
spirit. The same point was once admirably expressed by
Kandinsky's co-worker Marianne Werefkin. 'The finished,
closed and static form', she wrote, 'curdles life and halts
movement. Feelings and thoughts are in continual flux. And
movement is the principle of life.'[38] A recurrent theme in
Expressionism, this 'process-minded' outlook, as we have
called it in a previous chapter, essentially restated Friedrich
Schlegel's idea of art as 'eternally evolving, never completed',
as the expression of a spirit in its historical progression.
Hence Kandinsky's insistence that each age has a freedom
which it must realize in forms appropriate to itself.[39] What
applied to each age applied to every creative individual. The
artist, as Kandinsky put it, possessed in advance 'a tuning fork
in his soul which he cannot tune to another pitch.'[40] Each
artist, in other words, was unique, a creator of forms original
and characteristic of himself. The creation of such forms was
not dictated by formal rules in aesthetics, but by the artist's
innermost feelings. Feeling always ruled over form and not
form over feeling. 'The inner element [i.e. emotion]
determines the form of the work of art.'[41]

 This was Kandinsky's undeviating thesis. Time and again he
warned his fellow painters that an exclusive emphasis on

formal aims killed the soul of art, that, to recall the words of Schelling, a work 'whose point of departure was form' revealed an 'emptiness that cannot be filled out.'[42] Form had to be something spontaneous and positive, the expression of an 'inner necessity' which selected the form most expressive of itself. Kandinsky concluded his analysis by denying all claims of form. 'In principle there is no problem of form.'[43] The artist was free to choose whatever shape best expressed his meaning. Art was to the first and to the last 'a matter of content.'

Kandinsky's didactic proclamations clearly reflected the dominant mood of his Expressionist generation. Poets and painters somewhat contemptuously dismissed questions of form and concentrated solely on content or meaning with the result that their works at times veered toward the formless and anarchic. Their hostility to form was to some extent an understandable reaction against the excessive formalism prevailing at the turn of the century, manifest, for instance, in the principles of *art pour l'art*, as well as in the more idealized version of the sculptor Adolf von Hildebrand and his friend, the aesthetician, Konrad Fiedler. In the same sense that the Romantics in their time reacted against the stifling uniformity and the restrictive canons of neo-classical art, Kandinsky and the Expressionists reacted against any purism which, neglectful of or indifferent to content, looked only for formal perfection.

For some Expressionists the issue became a matter almost of national concern. Thus they sharply contrasted the German emphasis on content, on emotion, with the French and Latin emphasis on sensuous form and appearance. Where painters like Matisse, for instance, strove to create an art 'of equilibrium, of purity and tranquility, without disturbing or preoccupying subject matter', the German's 'destined' role was to portray powerful feelings through subjects deeply stirring and exciting. Kirchner hinted at this duality of vision:

How radically different are German and Latin artistic

creations!...The German creates his form out of phantasy, out of his inner vision...and the form of visible nature is a symbol to him...For the Latin beauty lies in appearance, the other seeks it beyond things.[44]

This Teutonic sentiment predictably made its first appearance with the *Frühromantiker* who similarly stressed the seeming 'soulfulness' of German art with its roots not in the form-conscious tradition of Greece and Rome, but in the native spirituality of Gothic and medieval art. It was just this quality, of course, this Gothic tension between content and form, that attracted Kirchner and the *Brücke* painters to Cranach, Baldung, Dürer and, above all, to Mathis Grünewald whose tortured emotional and religious intensity affected them profoundly. In any event, the tendency of these painters was to equate the French and Mediterranean spirit of art with an awareness of tradition, a love of form and externals, while the Northern or Germanic spirit focused on soul and feeling and on the truth beyond. The occasional chauvinistic overtone implied in this Romantic conception was strongly balanced, however, by the Expressionists' genuine cosmopolitan leanings which on the whole recognized no national frontiers in art. Yet even Kandinsky once confessed that if art was to be rescued – he left no doubt that it was in dire need of redemption – it was not by returning to formal traditions as the French had done, but only by the ability of the Germans and the Russians to descend into the innermost depths.[45]

Given the Expressionists' pronounced anti-formalism, it was not surprising that, like the Romantics, they should have turned to colour as the medium best suited to carry emotional conviction, a medium naturally 'fluid' and resisting the confinement of form. Drawing on Impressionism and notably on Van Gogh and the *Fauves*, these artists were able, of course, to use colour far more dramatically and daringly than the Romantics were in a position to do. Nonetheless their intuitive understanding of colour as a quality immediately expressive of feeling was consistently Romantic.

Its general significance in Expressionist painting hardly requires demonstration. It leaps from their canvases in glowing chromatic planes and rhythms culminating in Kandinsky's 'dramatic' compositions in which colour and form are essentially one. Colour was the Expressionists' original mode of communication. Through it, they hoped to express every mood and passion of the human heart. Its power to evoke was acknowledged in such lavish descriptions as the following:

> Colours in their individual life, weeping and laughing, dream and happiness, hot and holy, like love songs and love-making, like tunes and like magnificent chorales . . . like tinkling silver bells or pealing bronze bells announcing joy, passion, love, soul, blood and death.[46]

This kind of colour-drunkenness was bound to stray from the straight and narrow path of clearly defined lines and shapes. Such an awareness dissolved all boundaries insisting that when colour was at its richest then form was at its purest.

In keeping with an expressive aesthetics and a Romantic point of view, some painters once more looked beyond colour to music as the crown of all the arts, the highest and purest manifestation of human aspirations. To summarize from their various writings, music was again praised for its apparent freedom and ease in expressing the emotions. In music, it seemed to these painters, form and feeling ideally fused and coincided. Innocent of descriptive intentions, its immaterial sounds were said to appeal directly to the soul. 'Music', wrote Feininger, giving voice to such convictions, 'has always been the first influence of my life . . . Without music I cannot see myself as a painter.'[47] Music certainly was a great influence on the painting of Klee, Marc and others. It generally manifested itself in a preference for polyphonic structures, or, more simply, in a desire to achieve rhythmical effects based on a freer use of colour tonalities. Hence their frequent references to the 'melody of colours', the 'music of colours' and similar phrases.

Feininger's words could easily have been written by Kandinsky for whom music was indeed of paramount importance. This is immediately revealed in the numerous musical metaphors he employed in an effort to explain the aims and method of non-objective art. Thus, describing how colours cause vibrations in the perceiver, he used the analogy of the piano which may have derived from Delacroix. 'Colour is the keyboard, the eyes are the hammers, the soul is the piano with many strings. The artist is the hand that plays, touching one key or another purposively, to cause vibrations in the soul.'[48] Kandinsky used the same analogy repeatedly replacing 'colour' by 'form' and 'object'. He also applied musical concepts to label the products of art. Paintings based on simple forms, for instance, he described as 'melodic', those on complex forms, as 'symphonic'. Pictures which were the result of spontaneous and largely unconscious gestations he called 'improvisations', while the major works, products of slow maturation, were given the title 'compositions'.[49]

Revealing as this use of musical language might be it does not really touch, however, on the true significance of music as conceived by Kandinsky. Music was, as he put it, the 'best teacher'. Its non-representative expressiveness provided a model to be emulated by abstract art.

> A painter who finds no satisfaction in mere representation...
> in his longing to express his internal life, cannot but envy the
> ease with which music achieves this end. He naturally seeks
> to apply the means of music to his own art. And from this
> results that modern desire for rhythm in painting, for
> mathematical, abstract construction, for repeated notes of
> colour, for setting colour in motion, and so on.[50]

Forestalling possible misunderstandings, Kandinsky was at pains to point out elsewhere that his aim was not to imitate music. 'For my part I have not tried to paint music, for I consider such painting basically impossible and unobtainable'.[51] The painter studied music to acquaint himself with the elementary rules governing rhythm, contrast and movement. Music here had the decided advantage over

painting because its flowing alchemy of feeling was based on a rigorous algebra of form, on a 'theory of harmony', that is, which gave this art a secure and solid foundation. Non-objective art, Kandinsky urged, was in need of a similar foundation. It required its own 'counterpoint' which enabled the painter to organize his materials with almost mathematical precision. No such counterpoint has as yet been found despite Kandinsky's tireless efforts to arrive at valid laws of composition. While he undoubtedly provided many useful hints concerning the behaviour of forms and colours and their distribution on canvas, no painter familiar with his writing would claim that he produced a comprehensive theory with universal application. Non-objective art still relies on the more or less subjective deliberations of the artist.

Although Kandinsky declared that his aim was not to imitate music, he nonetheless insisted that the 'objectless vibrations' produced by non-objective art were similar in kind to those evoked by music. For obvious reasons Kandinsky's belief has found few defenders. The elements of time, pitch, harmonic progression and modulation, to mention only a few features essential to the expressiveness of music, have no visual counterparts in painting. The tensions peculiar to colour, their advancing and retreating motions on canvas, cannot be compared with any musical motion proper. The same applies to the pull and thrust characteristic of lines and shapes. A non-representational painting may at best resemble a prolonged chord striking a variety of tones at once. Yet even this analogy must not be pressed too far in view of the differences separating visual from auditory perception. In the last analysis, the so-called musical properties of non-objective art reduce themselves to no more than the presence of certain rhythmical qualities in a picture.

Undeterred, Kandinsky clung to his belief that painting possessed the 'same power as music.'[52] He first became convinced of this while listening to Wagner's *Lohengrin* as a student in Moscow. Recalling the experience, he wrote how suddenly all his colours came to life. Wagner's music in his

case acted as a catalyst, making him dimly realize the possibility of non-objective art. Once more we find a close parallel here in Romanticism. It was the influence of music generally, as we have seen, that suggested to Novalis a form of 'musical' painting consisting of arabesques, patterns and ornaments – compositions wholly non-representational and abstract.

What made Kandinsky particularly susceptible to the charms of colour and music was his pronounced synaesthetic disposition. Like Tieck, Runge, E.T.A. Hoffmann, Shelley, Gautier and a great many other Romantic poets and painters, he continuously associated musical sounds with colours and conversely. In *Concerning the Spiritual* he worked out their presumed correspondence in great depth. Whatever the merit of these observations, there can be little doubt that Kandinsky's synaesthesia played a prominent part in his pursuit of the non-representational idiom. The extraordinary perceptual sensitivity of this painter will be treated more extensively in a later chapter.

IV. The Romantic Heritage Acknowledged

The Romantic expressive theory of art clearly provided the foundation of Expressionist poetry and painting. It was the pioneering role of the Romantics proclaiming the priority of the self, the artists' freedom to create from a state of soul independent of nature and the aesthetic rules devised by men, that cleared the path for the advance of modern movements like Expressionism. There is precious little in early modern art which in one form or another does not owe some or at least one of its unquestioned assumptions to the Romantics' cult of soul and sensibility, their glorification of emotion as the mainspring of art. Even so seemingly purist a movement as Suprematism was defined by its founder Malevich as the 'supremacy of pure feeling in art' with feeling understood as being 'always and everywhere the one and the only source of creation.'[53] Nowhere, however, was this deification of

emotion more in evidence than in Expressionism and in the abstract Expressionism of Kandinsky. In origin and meaning, an art of this kind was not so much a revolution, as a heritage continued and enriched, a Romantic tradition carried to its ultimate conclusion.

Some Expressionist poets and painters were well aware of this tradition, acknowledging unreservedly their Romantic roots. Marianne Werefkin once put it aptly: 'The great merit of Romanticism is that it laid the foundation stone for the art of the future. The art of the future is the art of emotion. Having made this prophecy, I feel entitled to be proud of it.'[54] Werefkin's diary, from which this passage is taken, bore witness to her conviction. Every page resurrected the Romantic heritage to an extent bordering almost on defiance. The influence of this astonishing woman on the Munich circle of artists from which the *Blaue Reiter* was to emerge has been curiously ignored. Although her gifts as a painter were overshadowed by others, many of her ideas anticipated Kandinsky's conceptions about colour and form. One critic significantly compared her to Bettina Brentano and Rahel Varnhagen.[55]

Kandinsky was no less outspoken in his affirmation of Romanticism. Indeed it was to form the subject matter of a chapter he meant to include in his essay *Concerning the Spiritual*. In a letter to his friend and biographer, Will Grohmann, he made the following observations:

> Once you referred to 'Romanticism' and I am glad you did. It is no part of my programme to paint with tears or to make people cry ... but Romanticism goes far, far, very far beyond tears ... why should there not be a (or the) Romanticism? ... It is very interesting that the Germans especially are afraid (*afraid!*) of this word. The Russians are, too. On this point at least the somewhat hidden affinity between the two nations emerges. The meaning, the content of art is Romanticism... the coming Romanticism is profound, beautiful . . . meaningful, joy-giving – it is a block of ice, with a burning flame inside.[56]

Kandinsky's metaphor of ice and flame – a peculiarly

Romantic pairing of opposites – was the poetic expression
for what Klee, in turn, called the 'cool Romanticism' of
abstract art.[57] Romantically inspired, this art according to
Klee dispensed with 'storm' and 'pathos', the 'grandiloquent'
gesture of the early Romantics, and strove to embody feelings
in forms calmly worked out in depth and detail. Baudelaire,
defining Delacroix, may have found the suitable expression
of this detached Romantic state of mind: 'Passionately in love
with passion and coldly determined to discover the means of
expressing it.[58] Klee, of course, was intimately acquainted
with the writings of the *Frühromantiker* and his work, in fact,
was strangely reminiscent at times of the fairy-tale world
created by Novalis. In view of this similarity, it was only
fitting perhaps that fifty-one of Klee's drawings should have
been posthumously selected to illustrate the *Lehrlinge zu
Sais*.[59]

The spiritual affinity between Romanticism and
Expressionism was explicitly affirmed by a number of poets
and writers. Thus René Schickele saw the emotional intensity
characteristic of Expressionist art already reflected in the art
and literature of the Romantics. Hence he could say: 'What
today we frequently call Expressionistic, would yesterday
have been called Romantic.[60] More specifically, Kasimir
Edschmid cited Hoelderlin, Grabbe, Lenz and Kleist, as well
as Büchner and Nietzsche, as 'our poets' whose awareness of
existence was similar to the Expressionists' emotional
comprehension of life.[61] The names of Kleist and Hoelderlin
reappeared frequently throughout Expressionism. Both were
acclaimed as the Romantic precursors and spiritual ancestors
of the new poetic style.[62] Further, Theodor Däubler paid a
glowing tribute to Novalis in his essays 'The Messenger's
Flower' and the 'Blue Flower.' Several critics of the period
joined in by referring to Expressionism as the new
Romanticism of modern art. Of Kandinsky, for instance, one
wrote:

> What Romanticism a hundred years ago did not dare to do
> and was not able to do... today has broken out freely in the
> full force of creation. A Russian, with the freedom of a great

barbarian from the East, liberated us from the convention of
mimesis and realized, in his way, Runge's dream of absolute
colour: Kandinsky.[63]

The continuity or similarity between Expressionism and
Romanticism was stressed, of course, not at the expense of
the differences separating these two movements. Certainly in
terms of *form*, Expressionist art and, above all, the art of
Kandinsky went far beyond anything produced by the
Romantics. The Romantics, to be sure, had the vision. Their
expressive aesthetics should have led them straight to a form
of Expressionism, if not to a type of non-objective art. Yet,
with the possible exception of Turner, they lacked the means
to realize their visions. This, as well as the tenacity of the
existing neo-classical conventions, frequently forced the
Romantics to express the 'new' by way of the 'old' to the
benefit of neither. Hence the tension between form and
feeling, imagination and representation which is the hallmark
of many a Romantic poem and painting. Nevertheless, the
germ of Expressionist and abstract art was unmistakably
present in the premise laid down by the Romantics – the
premise, that is, of an aesthetic consciousness which sought in
pure inwardness its essential depth, self-sufficiency and
fulfilment. This inwardness perforce dematerialized the
world. It decomposed the real in order to recompose it in the
light of the ideal.

Part Three

Chapter Five

The Metaphysical Foundation of the Expressive Theory of Art

I. The Philosophical Background

Was the expressive theory of art no more than a defiant subjectivism, a proud egotism which recognized no authority beyond the creative self? Many critics of Romanticism and Expressionism would readily endorse this point of view. Such an interpretation, however, while not without a measure of truth, usually neglects the Romantics' and Expressionists' desire to reach beyond the finite self and achieve fusion with creation. A more important omission was a failure to give serious consideration to these artists' sincere conviction that the creative urge within man reflected the creative urge in the universe without; their belief, in short, that the expression of the *subjective* in a mysterious way merged with and was inseparable from the manifestation of the *objective*. These beliefs, of course, went beyond the immediate confines of art and presupposed a theory of mind which was invoked to justify the artists' freedom to create without constraint.

The Romantics once more laid the ground work of such a theory. They did so by reformulating and revolutionizing the accepted view of the mind's role in perception. While to Locke, Hume and empiricist philosophers generally, the mind was a quiescent receiver of images presented from without, to the Romantics it was active and creative, a transformer which ordered and illuminated the material of

sensation. Following M. H. Abrams'· penetrating study,[1] the mind according to the Romantics was not a 'mirror' passively reflecting an independently existing external world, but a 'lamp', a radiant projector, that shaped and animated what it perceived. As Abrams rightly points out, the distinctive/ feature in this transaction was not just the Romantics' attribution of life, soul and feeling to nature, but their 'repeated formulation of the outer life as a contribution of, or else as in constant reciprocation with, the life and soul of man the observer.[2] As to the exact contribution of mind in perception – the question of what is objectively given and what is subjectively 'made' – the Romantics' position varied widely. It ranged from Coleridge's 'for all we see, hear, feel and touch the substance is and must be in ourselves', to Wordsworth's more modest assertion that the senses only 'half create' what they perceive.[3] To some Romantics the mind projected no more than secondary and tertiary qualities onto the external world; to others, it actively moulded and constituted the object. In either view, however, mind, or more generally the mental activity of man the perceiver, was believed to bestow meaning and purpose on what it perceived.

What thus far we have called the Romantics' theory of the mind was at the same time a theory of the imagination, provided we understand by the imagination, as did the Romantics, not only the faculty productive of poems and paintings, but the supreme power in man which affected, modified and above all unified the disparate elements of sensation into a comprehensive, living and meaningful whole. In this wider sense it was already understood by the German Idealists. While the English Romantics on the whole formulated their views of mind or the imagination independent of Idealist philosophy, the *Frühromantiker*, by contrast, were heavily indebted to it, in particular to the teaching of Kant, Fichte and Schelling. The question of influence which this raises is, of course, a difficult one if analysed in depth, and in the context of each and every individual. Still, some rough and ready outlines can be drawn

concerning German Idealism and its relationship to German Romanticism.

Beginning with Kant, although his name appeared less frequently in the writings of the *Frühromantiker*,[4] the basic theme of the first *Critique*, which proclaimed nature a construction of the human mind, an order the understanding imposes upon phenomena, was a lesson learned by all. In the Romantics' case this lesson was learned at the expense of ignoring Kant's corollary that knowledge of the supernatural was beyond the grasp of reason and the senses. The Romantics readily concurred with Kant in the limited power of reason and the understanding – indeed their very anti-intellectualism stemmed in part from the *Critique's* curtailment of man's rational pretensions – but they disagreed with him in insisting that the supersensible could be hinted at by the concerted efforts of feelings, visions and intuitions.

Nonetheless, it was the Copernican revolution in philosophy, Kant's highly developed epistemological subjectivism with its absolute renunciation of an independently existing external world, that served at once as the starting point of German Idealism and as a vital stimulus to the Romantic imagination. Whatever Kant's philosophy may have accomplished, it certainly succeeded in utterly disrupting man's 'naive' relationship with nature, including that of the artist. Strange as it may sound, the first *Critique* not only undermined man's faith in reason and in the existence of the external world, it also dealt a decisive blow to the mimetic theory of art, for if nature as it appears to us has its essential forms not without, but within the human mind, the imitation of appearances would seem to be a rather pointless effort. Had Kant's philosophy been accepted without qualifications, it would have spelled inexorable estrangement between man and nature. From this conclusion the *Frühromantiker* escaped into the alternative systems developed by his successors.

Kant, nevertheless, laid down the procedure. The tendency of Idealists and Romantics henceforth was progressively to

dematerialize and internalize the external world. In philosophy such tendencies culminated in Fichte's *Wissenschaftslehre*. Eliminating a redundant 'thing-in-itself' – the ghostly relic left over from the first *Critique* – and turning Kant's transcendental ego into a productive metaphysical principle, Fichte arrived at a system of *pure* Idealism which reduced the world as object to the manifestation of a creative 'subject', the product of an active mind or spirit. Fichte's audacious deduction of the world from a divine super-ego immediately influenced the Romantics, especially Friedrich Schlegel and Novalis. In justifying the autonomy and capriciousness of the creative imagination, for instance, both drew freely on the *Wissenschaftslehre* in a way, however, which did not always accord with the intentions of its author. Thus Fichte's absolute ego conceived of as a supra-individual principle, the essence of which was unlimited activity, was not infrequently identified by Novalis and others with the creative activity of the finite ego, the individual self. Fichte repeatedly and explicitly repudiated this identification since, carried to its logical conclusion, it would attribute 'to the individual effects which could certainly not be attributed to it, such as the production of the whole material world.[5] Again Fichte's postulation of nature as a field or instrument for moral action the Romantics interpreted aesthetically so that external reality was simply the clay to be used and exploited for artistic production. Here we must seek the origin of Romantic occasionalism as described in the previous chapter, an occasionalism which Novalis expressed in these words: 'Nothing can be done with the object; it is a *medium*, no more.[6]

It was Novalis who specifically coined the term to 'fichtesize' to denote an aesthetic ego which, analogous to the cosmogonic activity of Fichte's absolute ego, created works of art independent of everything without. In what was once more a bold and brilliant anticipation of modern artistic tendencies, he wrote: 'It is probable that men do and will exist who are far better able to fichtesize than Fichte himself. Marvellous works of art could then be created if one begins

to fichtesize artistically.[7] Fichte's pure metaphysical Idealism has obviously been pressed here into the service of Novalis' 'magical Idealism' in which a sovereign artistic imagination disposes over nature at will or creates objects wholly spun out of its own substance. In fact, Fichte was not altogether blameless for the way in which his ideas were being used and exploited. The inherent ambiguities of his early philosophy lent themselves much too readily to the Romantics' deification of subjectivity and corresponding denigration of the external world.

If Fichte was a source of inspiration for the German Romantics, Schelling was even more so. His influence was profound and all-pervasive. The most Romantic of the German Idealists, he strove to conceptualize Romanticism, to give it the appearance of something approximating a metaphysical system, in his case often abstruse and arbitrary. Schelling's early thoughts, as expressed, for instance, in his *Ideas towards a Philosophy of Nature* and *On the 'World Soul'*, essentially revolved around the idea of oneness grounded in a doctrine of identity. Unlike Fichte who denied ontological existence to the material world, Schelling insisted on the living unity, the absolute identity of spirit within and nature without. There existed, he maintained, a preordained, instinctive harmony between the soul of man and the soul of nature which became aware of itself in and through the human mind. Schelling's philosophy in this respect owed as much to Spinoza as it owed to Fichte. It was indeed an attempt to reconcile these two conflicting standpoints which taken by themselves, in his view, suffered from an extreme one-sidedness. Where Fichte resolved the world of objects into the activity of the subject – a transcendental ego – Spinoza resolved the subject into the activity of the object – a transcendental substance. Schelling aimed to show their mutuality, their reconciliation in an absolute which was a pure identity of subject and object.

His deduction of reality from the absolute can be briefly stated. In the process of unfolding itself, the absolute separated into the objectivity of nature and into the

subjectivity of mind, into a *real* and an *ideal* order. Although outwardly distinct and separate, it was the same absolute, the same divine life which was manifest in both realms. While in nature it expressed itself unconsciously as drive, instinct, force, it was fully conscious of itself in man's mind whose ultimate goal was to awaken the spirit which slumbered in nature to a full knowledge of itself.

Schelling's grand metaphysical construction of the universe as a living totality emanating from an absolute and his idea of nature as unconscious spirit reaching perfection and consciousness of itself in the human spirit found enthusiastic disciples among the German Romantics. This lofty view of the world at once satisfied their craving for union and fusion with the inner life of nature as well as reinforced their belief in the sanctity and superior status of man's soul. Schelling's influence on the *Frühromantiker* did not end here. His apotheosis of art as an immediate manifestation of the absolute was well in tune, as we shall see shortly, with the Romantics' own grandiose conception of artistic creation.

It was from the teachings of Kant, Fichte and Schelling then that the German Romantics in part construed their body of epistemological and metaphysical beliefs, beliefs which in view of the differences existing between these philosophers were often incoherent if not blatantly inconsistent. Thus following Fichte the Romantics could gleefully sacrifice the whole of nature to an egomanic spirit. At the same time, following Schelling and a romanticized Spinoza, they were capable of paying homage to a *Deus Natura* and an absolute which, as Hegel rightly pointed out, obliterated all meaningful distinctions. It was this capacity to move with no sense of contradiction from one viewpoint to another, from a position of extreme solipsism to a kind of formless pantheism, that accounts for the Romantics' complex and many-sided relationship to nature.

Nonetheless, what Fichte and Schelling had in common, and the feature exclusively appropriated by the Romantics, was a conception of man's mind as active and constitutive of

reality, a view of the human spirit as providing the key to the mysterious workings of the universal spirit. While Fichte, Schelling and other Idealists searched for this key in the structure of thought, in the operations of consciousness generally, the Romantics searched for it in the unconscious as well as in the conscious, in the sphere of feelings and in the realm of imagination. For both, it was deep within the human psyche that the universe revealed itself to man.

This was at the root of the Romantics' glorification of emotion. Their cult of feeling was essentially a belief in man's inner life as the organ for transcendental perception. Instead of being a mere repository of sentiments, the human soul was the gateway to the universe. 'The heart is the key to the world and to life.'[8] Schleiermacher put it succinctly: 'In the inner world of man the universe reflects itself, and only through this inner world is the outer world made meaningful.'[9] His words were echoed by many German Romantics, in particular by Novalis who looked on external reality as a 'trope' of man's spirit, as an 'encyclopaedic, systematic index or plan of our minds.' Hence this *Frühromantiker* could reprimand man for dreaming of voyages through outer space, forgetful that its vast dimensions stretched through the inner spaces of the self which demanded exploration.

> We dream of journeys through the universe: is not the whole universe within us? We do not know the depths of the human spirit. Within leads the mysterious way. Within ourselves, and nowhere else, is eternity with all its worlds.[10]

Within leads the mysterious way! Only by turning inward and withdrawing from the world, in other words, will man meet it at its deepest level of being and achieve union and fusion with all existence. This idea of emigrating into the inner life, of retiring away from the outer, in order to come face to face with what 'eternally exists' was the sacred conviction shared by all German Romantics. Under its irresistible spell, they cast forth on a voyage of self-discovery,

purposefully set out to navigate and circumscribe the ocean
of human inwardness in which they believed to have found
the magic writing revealing the mystery that was the self and
the world. 'We search for the world's design: the design is in
ourselves.'[11]

II. Art as Metaphysical Revelation

Given this exalted view of the self, its power to disclose the
meaning and mystery of creation, what was its immediate
bearing on art? Two obvious implications followed from it.
In the first place, it clearly encouraged and philosophically
sanctioned the artist's retreat from nature or the object, on
the grounds that its true being was to be discovered in the
subject. 'For the artist', wrote Schelling, 'nature is no more
than it is for the philosopher – the ideal world manifesting
itself under continual limitations, or the incomplete
reflection of a world that exists, not outside, but within
himself.'[12] This once more was an unmistakable farewell to
imitation and a demand for inner concentration. As Runge
put it with reference to Schelling: 'The philosophers have
already realized that everything must be imagined out of
oneself.'[13]

It was, secondly and most important, an affirmation of art
as a form of metaphysical revelation, for if the truth of things
resided in the artist's innermost self, his expression of that
self was at the same time an expression of the innermost spirit
of the world. Looking inward and creating from the depths
of his own being, the artist embodied universal truth and
being.

In the true creator, according to these Romantics, the
subjective and the *objective* coincided. In him, as in no other
man, the human microcosm faithfully mirrored the outer
macrocosm. He was the intersection between the finite and
the infinite, the point through which a divine creativity
manifested itself to man. No ordinary mortal, the artist was a
superior and privileged being endowed with a special insight

into a reality beyond. His organ of perception was the soul and the creative imagination which, steadily gazing inward, opened the gates to a transcendental world. By virtue of his special intuitions, the artist's role was that of a mediator. 'Every artist', wrote Friedrich Schlegel, 'is a mediator for all others.'[14] He revealed to his less gifted fellow men the infinite in finite form.

This conception was not unique to the *Frühromantiker*. It was characteristic of English Romanticism as well. There were few, if any, Romantics in fact who refrained from investing the artist's emotion and imagination with the power to disclose things unseen before. Even Wordsworth, adamantly opposed to German transcendentalism of which he knew so little, subscribed to the idea of art as revelation. Thus poetry as the spontaneous overflow of powerful feelings had for its ultimate object truth, 'not individual and local but general and operative', a truth not deduced by reason nor relying on external testimony, but directly intuited by the passions. This poetic truth was superior to that of science. 'Poetry is the first and last of all knowledge – it is as immortal as the heart of man.'[15] While Wordsworth discovered the 'mighty scheme of truth' both within man and in 'the beautiful and permanent forms of nature', Blake, more akin to the *Frühromantiker*, searched for it in the imaginative visions of the inner self. He stated his credo with cryptic terseness: 'Vision or Imagination is a Representation of what Eternally Exists Really and Unchangeably.'[16] Coleridge's 'primary imagination' as the 'repetition in the finite mind of the eternal act of creation' likewise carried with it overtones of spiritual and metaphysical revelations. Keats similarly extolled the splendours of the imagination although in his case, as in that of Wordsworth, it was more securely at home in the world of sense. To quote his well-known words: 'What the imagination seizes as beauty must be truth', or more simply: 'Beauty is truth, truth beauty.'[17] Shelley's eloquent panegyric of poetry was straight in line with such conceptions. The poet participated in 'the infinite, the eternal, the one.' He stripped the 'veil of familiarity from the

world', laying bare 'the naked and sleeping beauty which is the spirit of its forms.'[18] This image of the poet removing the veil from visible things to reveal their invisible being was a recurrent one testifying to the Romantics' abiding faith in the mediating power of the emotions and the imagination.

Owing to their metaphysical bent and far greater introversion, the Germans predictably put the highest premium on art as revelation. Aesthetic activity, according to Friedrich Schlegel, raised 'the veil of mortality', it communicated 'the secret of an unseen world in the mirror of a penetrating imagination.'[19] A similar conviction was expressed by his otherwise more sober-minded brother. Romantic art, notwithstanding its imperfections, was closer 'to the secrets of the universe' than classical art in all its outward beauty and perfection. The art of the ancients, faithful to the law of reason, presented each object separately, whereas the art of the moderns obeyed the unifying and mediating force of feeling which could 'perceive all in all at one and the same time.'[20] Novalis stressed even more the truth of the heart and the imagination. The poet's 'inner sense' penetrated the outer shell of nature and revealed her as a living creature. Poetry effected 'the deepest insight and interactivity, the innermost communion of the finite and the infinite.'[21]

The *Frühromantiker* never tired of celebrating the sublime nature of art. Their confidence in its transcendental significance was an absolute as it was often bizarre and extravagant. In the creation and contemplation of art, they insisted, the secret code was to be found which deciphered the wealth and mystery of creation. In studying the artist and his work, one did not study merely the processes and products of art, but the wondrous forces and productions of the universe itself. As Friedrich Schlegel once expressed it: 'If you want to comprehend the essence of physics, become initiated into the mystery of poesy.'[22] Schelling's *System of Transcendental Idealism* was such an attempt to initiate the reader into the immortal marvels of art. In this view, the artist was, without being aware of it, the true metaphysician.

Unlike the philosopher who was condemned to intuit truth only in ideal and abstract form, the artist succeeded in giving it concrete shape. In artistic creation the unconscious soul of nature merged with the conscious soul of man producing works in which nature became spirit and spirit a higher nature. Art was the absolute incarnate. It erased the dividing line between the realms of mind and matter. For this reason it was an 'eternal revelation, the only revelation that exists.'

> For the philosopher, art . . . is the highest manifestation, because it opens the gate to the holy itself where, like a flame, burns that eternal, original oneness [of subject and object] which in nature and history splits into divergent parts. . . Each glorious painting owes its birth [to an act] that removes the invisible wall separating the ideal from the real world.[23]

Enthusiasm could scarcely be carried any further. Not even the Neo-Platonists in their most exalted moments placed art on so lofty a pinnacle where it became a continuous source of awe and wonder. To be sure, all these various high-sounding declarations must be seen in the context in which they appeared. What each Romantic finally came to understand by the eternal verities of art depended not only on his general definition concerning its nature and function, but ultimately on the particular philosophy from which he drew inspiration. Thus Wordsworth's conception of poetic truth was inseparable from his own distinct mystical pantheism, while Shelley, in turn, owed much to a romanticized Neo-Platonism. The Germans, as we have seen, were deeply involved in the abstractions of metaphysical subjectivism or, alternatively, in the flights of aesthetic and transcendental Idealism. Yet whatever philosophy may have fired their imagination, they all agreed in assigning to the creative self the unprecedented function of intuiting the deepest processes of the world. The result was a deification of the artist and his work from which, for better or worse, as will be shown in the following chapter, we have not yet recovered.

III. Art as Religious Revelation

Not only was art of the utmost metaphysical importance to the Romantics, it was of great religious significance as well. This religious emphasis was, of course, hardly surprising. The moment art came to be seen as a manifestation of the infinite, it was seen at the same time as an expression of the divine. For Blake this was indeed self-evident. The creative imagination was synonymous with the 'world of Eternity', or better still, with the 'Divine Body in Every Man.'[24] Less provocatively, the tendency generally among the Romantics was either to insist on a close connection between art and religion, or to plead for their intimate union on the grounds that art, like religion, communicated and interpreted heaven's message to man. Hence A.W. Schlegel's definition of poetry as the 'interpreter of that divine revelation, the language of the gods.'[25] The Germans' pronounced mystical inclinations made them particularly prone to fuse art and religion. All true art, they proclaimed repeatedly, proceeded from a religious inspiration and derived its worth and significance from it. The genuine creator was a religious mediary. 'A true priest of the Highest', the artist, wrote Schleiermacher, brings God 'closer to those who are used to grasping only the finite and the trifling; he presents them with the heavenly and eternal as an object of pleasure and unification.'[26]

Such elevated conceptions found some of their most ecstatic formulations in the outpourings of Wackenroder whose *Herzensergiessungen* and *Phantasien über die Kunst* – the latter arranged and revised by his close friend Tieck – helped to launch the German Romantics' canonization of the artist and his works. Throughout his writings Wackenroder stressed the divine nature of art, its 'profound, eternal holiness.' Aesthetic activity was a pre-eminently sacred one, a sacramental service through which man communed with the deity. To the devout soul of this *Frühromantiker* whose

piousness was proverbial, the artist was indeed the high-priest and the work of art the host divine, to be received and consumed in hallowed silence. 'As in prayer, await the blessed hours in which the grace of heaven bestows on your inner life a higher revelation: only then will your soul achieve union with the artist's creations.'[27] The high regard for art and its numinous significance could hardly be stated more extravagantly, nor more effusively.

Wackenroder's uncritical acceptance of art as religion continued in Tieck and passed on to other Romantics, notably to Runge. Inspired by Jacob Boehme, as were so many of his compatriots, Runge insisted that the artist's soul was of 'divine origin' and what it created 'immortal.' All true art, according to Runge, sprang from man's 'awareness of God.'[28] It was His force and presence that the artist strove to express through symbolic representations depicting the inner life of nature. Such representations could not be understood 'except by means of the deepest mysticism of religion.' Caspar David Friedrich, much more than Runge, succeeded in embodying aspirations of this kind in the form of 'religious landscapes' the object of which, he wrote, was 'the infinite, the eternal, the divine.'[29]

For most Romantics, the deity art was supposed to express defied all traditional labels and descriptions. He was a god both immanent and transcendent. Now identified with nature, he was yet believed to be beyond all finite things. A creative fountainhead, he reconciled in himself Pan, Christ, Orpheus and Holy Ghost.[30] As much a spirit of overflowing love, as a spirit of ceaseless strife, his very being was a source of eternal becoming. Not infrequently, in fact, he was thought of as *ein werdender Gott*. As some *Frühromantiker* realized, this dynamic 'deity in a state of becoming' demanded different symbols altogether, a new universal religion which unified all religions, ancient and modern, pagan and Christian. It demanded, in short, a wholly new mythology the creation of which was one of the foremost tasks of poetry and art. This new mythology for which Friedrich Schlegel, Schelling and Novalis made impassioned

pleas was to be drawn in the words of Schlegel from the 'innermost depths of the spirit' embracing sources as varied as the mysticism of Jacob Boehme, the thoughts of Spinoza, the discoveries of modern physics such as electo-magnetism and, above all, the philosophy of German Idealism.[31] Understandably no such mythology materialized. Schlegel's megalomaniac ambition to follow in the footsteps of Mohammed and Luther by composing a new Bible mercifully came to nothing. Novalis' more serious attempts to create cosmic religious fables – fairy-tales, as he unfortunately called them – remained isolated, unconvincing fragments as they had to be if only because the age was disinclined to accept a new religious gospel.

The Romantics' desire for a world religion explains in part another very important function assigned to the artist: that of prophet. Indeed one of the most frequent associations of art and religion in Romanticism was to elevate the poet to the position of sage and seer whose clairvoyant power spoke of things eternal and sublime. Blake's bard 'Who Present, Past and Future sees: / Whose ears have heard / The Holy Word / That walked among the ancient trees',[32] was a rather commonplace Romantic apparition. We meet the same bard in Shelley's poet as prophet and legislator who, unconsciously and even perhaps against his own will, becomes the voice of God uttering wisdoms too deep for him to understand. 'Poets are the hierophants of an unapprehended inspiration, the mirrors of the gigantic shadows which futurity casts upon the present . . . Poets are the unacknowledged legislators of the world.'[33] For Novalis and his fellow Romantics the poet, of course, was no less. A vessel of divinity, his work communicated the revelations granted to him. 'The feeling for poetry is closely akin to the feeling for prophecy, to religious divination altogether.'[34] The genuine poet was a 'seer of the future' in the light of which he formed and transformed the world through art.

The future revealed to these Romantic poets was nearly always that of a second Golden Age in which mankind, purified and spiritualized, achieved its ultimate union with

the divine. Thus Novalis, Friedrich Schlegel and Schelling confidently predicted the 'holy age of everlasting peace', the millennial era of the Holy Ghost which, redeeming a fallen world, inaugurated the reign of love and the imagination. To announce and hasten its arrival was the sacred task of art. The poet's and painter's mission was messianic: through picture and song they prepared the salvation of the race. 'Art', wrote Friedrich Schlegel, 'aims for the last Messiah', for the spiritual kingdom to come.[35] Its activity, in other words, was a form of eschatology, it related to the 'last things' – the final transfiguration of life. Hence Novalis' crusading words: 'We are engaged on a mission: we are called to fashion the earth.'[36]

This messianic or millennial vision was a salient feature of the Romantic movement. It has been frequently ignored, or attributed only to the Germans, although among the *Frühromantiker* millenarianism admittedly assumed its most mystical and picturesque form. In their case, it not only reflected a profound faith in the mediating and unifying function of art and the creative imagination, but also, and more so, an overwhelming desire for religious renewal and salvation. On a more modest scale, however, millennial preoccupations moved the English Romantics as well and for similar reasons. Not all, to be sure, were as explicit as Blake who declared the nature of his work to be visionary, 'an Endeavour to Restore what the Ancients call'd the Golden Age.'[37] Yet some visions of a new and better future were implicit in their conception of poetry as capable of transforming man. Certainly both Coleridge and Wordsworth believed in the poet's mission of regenerating the world.

Romantic millenarianism in turn was intimately associated with another prominent feature of Romantic art: its attraction to apocalyptic themes. Poets and painters turned time and again to Biblical, mythological or natural events showing the world in various states of catastrophic disruption. The marked preference for such themes concealed a basic messianic code: before the world could be

reborn, it had to pass through the furnace of destruction; the new cosmic dawn was to be preceded by a cosmic night. Wittingly or not, this religious conviction was indeed behind the Romantics' apocalyptic fervour. From Blake's devouring 'cataracts of fire' to Coleridge's 'impatient earthquake' and 'volcanic gales', from Wordsworth's 'characters of the great apocalypse' to Turner's terrifying visions of worlds consumed by light and flames, the Romantics' angel of creation cried first of all – 'Destruction!' The same awesome angel appeared to the *Frühromantiker* in undisguised splendour. 'O that the world-ocean would already redden and the rock gush forth as fragrant flesh.'[38] This was the visionary voice of Novalis, a voice far removed from the popular image of the sentimental Romantic dreamer pining for a sweet 'blue flower.' The flower, as is rarely realized, grew only on the smoking ruins of creation, on a soil which was a shroud of death.[39] Caspar David Friedrich painted such visions in pictures of desolate fields and uprooted trees, in snow-covered, dilapidated graveyards with crosses overthrown, in expansive, brooding landscapes over which towers a crucified Christ transfigured by the rose-coloured light of dusk. An air of apocalyptic expectation pervades all these compositions including the famous *Monk by the Sea*. Of his painting depicting a ruined and decaying cathedral, Friedrich wrote: 'The time of the temple's glory and its servants are gone, and from the ruined whole emerges another time and another demand for clarity and truth.'[40] Runge was similarly moved by premonitions centering on 'judgment Day' and the 'destruction of the world.' A feeling that his generation was the executor of a dying civilization deeply affected him. 'Are we now once more to carry an epoch to the grave?'[41]

The *Frühromantikers'* apocalyptic inclinations occasionally developed into a veritable mystique of destruction which courted chaos and anarchy as the fertile ground for things to come. 'True anarchy', wrote Novalis, 'is the creative element of true religion. It rises from total destruction as the creator of a new world.'[42] Anarchy again, according to Friedrich

Schlegel, was the operative principle at the root of all art. The artist's rightful place, to recall his words, was with the destructive furies of the nether regions.

> To become an artist means nothing less than to dedicate oneself to the deities of the underworld. Only in the enthusiasm of destruction is revealed the sense of divine creation. Only in the midst of death does the flash of eternal life shine.[43]

It is in conceptions such as these that we meet the German Romantics at their most subversive and prophetic best – a kind of Teutonic *furore* in religious dress.

* * *

As we have seen, the Romantics' expressive theory branched out into many layers and directions. At first it appeared to stress no more than the comparatively straightforward idea of art as the expression and communication of emotion. Yet this form of expressive aesthetics was inseparable from a number of epistemological and metaphysical assumptions which enabled the Romantics to view art not only as the manifestation of subjective feelings, but as the medium conveying philosophic and religious truth. The result, unfortunately, did not always make for holiness, but rather for an unholy confusion. This confusion was a consequence not least of the Romantics' indiscriminate, unsystematic use of language which in the case of the Germans was particularly pronounced. Their tortured, convoluted terminology and proliferation of metaphysical complexities repeatedly and deliberately obliterated all hard and fast distinctions which stood in the way of encompassing the whole. Nonetheless, and in its main outline, the various claims made on behalf of art implicitly followed from the Romantics' conception of man's inner life, and primarily that of the artist, as the gateway to the outer life, the key to the mystery of the world. Once this premise is

accepted the artist's expression of the self necessarily becomes the expression of the non-self, i.e. nature, God, the universe. Art, in short, turns into the vehicle of divine and transcendental revelation. The question whether art and the individual work of art fulfilled *in fact* such expectations did not greatly trouble the Romantics. The operative word in their aesthetic speculations was faith. Boundless enthusiasm did the rest.

Chapter Six
Expressionism and its Romantic-Idealist Presuppositions

I. Underlying Assumptions

The foregoing analysis of Romanticism applies almost literally to Expressionism as well. What the Expressionists had in common with the Romantics was their firm belief in the transcendental nature of art, the conviction that the artist's expression of emotion was at the same time a manifestation and revelation of a higher spiritual reality. However, before dealing specifically with such claims again we must deal with the philosophy they presupposed. This philosophy was none other, of course, than a kind of metaphysical subjectivism the main substance of which derived from Romantic and Idealist sources.

The artists themselves were not always conscious of these sources. Unattached to, perhaps even unaware of, intellectual schools and systems, the philosophy they professed was doctrinally innocent. It appeared to be the spontaneous expression of sincerely held beliefs which 'somehow' were then in the air and all-pervasive. As with most pervasive views, those upholding them seldom, if ever, inquired into the origin of their beliefs. On closer inspection however, these pervasive and seemingly self-generated views owed their birth, growth and persuasion to a large extent to the revival of a Romantic-Idealist tradition which, popularized in many forms, indirectly shaped the thinking of the artist.

The Romantic-Idealist heritage in Expressionism was patently present in the poets' and painters' insistence on the outer life as a contribution of, or else as in constant interaction with, the life and soul of man. This generally accepted belief was stated with frequent shifts of emphasis the precise meaning of which does not always allow for drawing neat epistemological distinctions. Unfortunately for the critic, this can hardly be blamed on the artist. His business is art not epistemology. Nonetheless, and taking into account the wide variety of meanings, what clearly emerged once more from the impassioned rhetoric of the Expressionists was a view of man's mind and soul as a power which affected, modified and unified whatever existed without. The human spirit, by shaping and illuminating the externally given, participated in all forms and beings. To the Expressionist, as to the Romantics and Idealists, in other words, the object conformed to, and was somehow dependent on, the subject.

The creed embraced was often a kind of anthropocentrism which insisted that man was the centre and circumference, the meaning and fulfilment of the cosmos. In Unruh's words:

> And if Copernicus tossed this earth out of its central position into the whirling dance of the universe among dust particles and suns: we put man back into the heart of creation. The suns are in us – in us dwells the power to move slumbering worlds.[1]

What prevented this anthropocentric outlook from lapsing into sheer anthropomorphism was its Idealist foundation. This Idealism was frequently expressed in a spirit reminiscent of Fichte, a spirit that seemed to resolve all being into a product of the ego. 'The ego', wrote Theodor Däubler in a passage obviously derived from the *Wissenschaftslehre*, 'has determined its paths by means of an original resolution [*Urbeschluss*] ... This ego will ultimately constitute the whole of creation.'[2] It did just that in Gerrit Engelke's poem entitled '*Schöpfung*' in which a kind of Fichtean super-ego creates the world expressionistically – with a good deal of noise and

hollow pathos.[3] Fichte's ghost appeared again in Gottfried Benn's puffed-up description of Expressionism as the penetration of reality to the 'a-causal eternal silence of the absolute ego.'[4]

Even when they refrained from directly invoking the authority of a generally misunderstood Fichte, many Expressionists seemed to be preaching the gospel of a freely interpreted and mystically consummated pure Idealism. This is clear enough from statements like Kokoschka's 'consciousness is the cause of all things', or even from Kandinsky's categorical assertion: 'It is the spirit that rules over matter and not the other way round.'[5] In other instances, however, the indebtedness to pure Idealism revealed itself more specifically in the emphasis placed on the constitutive activity of the subject in relation to the object. 'What we call real, the world about us', wrote Otto Flake, 'exists in my mind only as I acknowledge it and will it to be.'[6] The attitude expressed here is a metaphysical subjectivism bordering on solipsism. Expressionist writing abounds with testimony of this kind which, wittingly or not, reduces the external world to a projection of the self, or if not that, then to an extension of a universal spirit which advanced in and through the human spirit. One enthusiastic critic of Expressionism, defending what he called the 'imperialism of the spirit' summed up an attitude shared by many artists.

> The human ego of the new generation has raised itself from the scientific sufferance of objects to the pure unbounded feeling . . . of its own immutable sovereignty. Ideas and things, who endows them with value, proportions and form, if not man?[7]

The reason for this somewhat pompous 'egotism' of the spirit is, of course, not difficult to find. It was, as pointed out previously, the violent reaction to an oppressive positivism and materialism which turned man into an object, subject to the laws and behaviour of the material world. Some Expressionists went to the other extreme by embracing an

egocentric Idealism which in their formulation was just as arrogant and dogmatic as the determinist and materialistic *Weltanschauung* it strove to dislodge.

Its immediate effect on art was predictably pronounced and far-reaching. Thus the sovereignty staked out on behalf of the self was the sovereignty sealing the autonomy, the unbounded freedom of the artist. No longer the slave of appearances, he could rule now over nature at will. Why should he feel bound to the object whose essential being depended on the life and activity of the subject? The artist's task indeed was to destroy the seeming objectivity or 'otherness' of nature by subjecting it to the demands of man's spirit. One Expressionist put it aptly, 'The new art manifests itself in subordinating empirical to spiritual reality and subsuming all earthly appearances to ideas born of our will alone.[8] Once more reality in this passage has been made directly dependent on the activity of the human will, the perceptions of the finite ego which the Expressionists deliberately, or out of ignorance, confused with a mystically conceived absolute ego as originally posited by Fichte. The ideas of pure Idealism, in other words, were put to the service again of art just as they had been by Novalis and other Romantics to justify the independence of the artist and the autonomy of the creative imagination *vis-à-vis* the object.

The Expressionists' relationship to the object was by no means confined, however, to this crude Fichtean perspective. Like the Romantics, poets and painters availed themselves as eagerly of a Schellingian point of view which insisted on the 'one life' within and without, i.e., the absolute identity of subject and object. The Expressionists' vision of unity described in a previous chapter was based on such a doctrine of identity, on the presumed correspondence between spirit and matter, self and things, soul and universe. Kandinsky acknowledged this correspondence when he wrote: 'The inmost being of man remains in constant contact with the inmost being of the world.[9] Marc, Macke, Nolde, Klee implied or expressed similar convictions. And so did the poets. 'Their heart, a brother to all things', wrote Kasimir

Edschmid, 'beats in rhythm with the world.'[10]

Recognizing something existing outside the self, this attitude compared favourably with the solipsistic, anthropocentric tendencies inherent in Expressionism. What it recognized, of course, was not an object existing in and for itself, but a presence confederate with the currents of man's soul, a spirit that became aware of itself in and through the human spirit. The emphasis was still on the self – the transcendental self – as the gateway to something beyond, the gateway, that is, to transcendental being. 'We must peer deeper and deeper into its discovery', declared Max Beckmann, 'for the self is the great veiled mystery of the world.'[11] This was manifestly written under the influence of Novalis, as was Gottfried Benn's conviction that 'poetry is always an enquiry into the ego and all the sphinxes and images of Sais weave themselves into the answer.'[12]

Benn and Beckmann merely made explicit what was one of the informing themes of much Expressionist writing – the theme of man's inner life as the key to the universe, the light illuminating the first principles of the world. To the Expressionist, as to the Romantic, the truth of things was to be found deep within the human soul into the depths of which man must retreat if he was to advance toward a vision of the one and all. Novalis' motto, 'Within leads the mysterious way', repeated itself in the Expressionists' declaration: 'All our ways must not lead away from us, but back into ourselves.'[13] The window to the world again faced inward. 'The new art seeks the cosmos and the law not outside man but within himself.'[14]

II. Art revealing Being

Predictably, this view once more looked to the artist and his work with the greatest expectations. If, in Beckmann's words, the self was 'the great veiled mystery of the world', then art in its purest, deepest and most intense expression succeeded – if only momentarily – in removing the veil from the face of

creation laying bare its invisible meaning. The artist descending into his own being, touched upon final unknowable truths which he embodied in picture or song. His work, proceeding wholly from within revealed a fragment of what really existed without. Nearly all Expressionists comprehended art in a manner such as this. They sanctioned the artist's right to self-expression on the grounds that it carried with it cosmic and spiritual implications. Like the Romantics, they regarded art as the supreme medium for divine and transcendental revelations. Hugo Ball, the high priest of Dada and close friend of Kandinsky, once put it well: 'At the time it looked as though philosophy had been taken over by the artist, as though they had become the prophets of rebirth',[15] i.e. the metaphysicians whose busy pen and brush disclosed the ultimate secrets of life. Indeed, that is as it appeared judging by the professed intentions of these poets, painters and writers. Their faith in the transcendental significance of art was as absolute, as arbitrary and fanciful, as was that of the Romantics in the previous century.

Thus, according to Kurt Pinthus, Expressionist poetry aimed to reveal the nature of 'being itself', the essence behind appearances. The new poetry was the form the spirit assumed to achieve consciousness of itself. ('Gestalt des sich selbstbewusst werdenden, wollenden, formenden Geistes.')[16] This definition clearly betrays its Romantic-Idealist origins. It owed more to Schelling and A.W. Schlegel, however, than to Hegel, as a cursory reading might at first suggest. A similar grandiose conception was expressed by Kasimir Edschmid. The artist's function was to penetrate to the centre of life, to the very source of creation. 'To discover and recreate it in its last tremor, in its essential core, this is the highest task of art.'[17] Expressionist art, wrote Theodor Däubler, was no 'flight from reality' as its naturalistic critics accused it to be. It was, on the contrary, 'a making visible of the immanent and the transcendent.' This, he concluded sweepingly, was 'the new metaphysics . . . collectively known as Expressionism.'[18]

Benn's explanation of Expressionism, to which brief

reference was made in the previous pages, provides a particularly good example of the Expressionists' metaphysical ambitions voiced, as a rule, in a style so convoluted and complex as almost to defy translation. The new art, according to Benn, was unified in its basic intention

> to shatter reality, to go to the very roots of things ruthlessly until they are no longer individually or sensuously coloured or falsified or displaced in a changed and weakened form in the psychological process, but instead await the rare summons of the creative spirit in the a-causal, eternal silence of the absolute ego.'[19]

Other poets and writers of the period expressed similar semi-mystical convictions in a diction just as turgid, laboured and tortured, convictions all of which commemorated art as the instrument communicating the highest spiritual truth. 'Everything produced by Expressionism', wrote Wilhelm Hausenstein, 'was knowingly or not a bridge to the metaphysical.' He adds quite rightly that the artist believed himself to be closer to the metaphysical the more he abstracted from the physical.[20]

The painters for their part eulogized the artist and his work in no less elevated terms. Art, declared Franz Marc, 'is metaphysical throughout'; it was concerned with the 'deepest things', and its objective was to disclose the world's 'inner mystical construction', the 'unearthly being' which dwelt behind all things.[21] The artist's reluctance to portray nature's features was neither caprice nor a craving for originality, but went far deeper. It was part 'of a determination common to this generation – to investigate philosophical laws formerly a closed book to all but philosophers.'[22] The artist in this context is given the title of philosopher, a dubious title or distinction if only because Marc and his fellow painters expressing such lofty aspirations kept conspicuously silent as to the laws art was supposed to discover and explore. To the mystic, of course, objections of this kind would seem to be both petty and irrelevant.

Klee was somewhat more restrained in explaining the transcendental nature of art. In his view, the present-day painter was concerned with reality rather than the merely visible which was only one finite, transient link in the infinite chain of evolution stretching from the past to the future. Unlike the painter of previous ages captivated by appearances, the modern artist looked under the surface of things to discern their concealed structures and genetic forces. The artist, wrote Klee, dissolved reality 'in order to reveal what lies behind and inside it.' Art made 'visible' the 'invisible.'[23] It made visible the dynamic potential implicit in creation of which the artist knew himself to be a lawful part and an extension on the level of the spirit.

Nearly all the major Expressionist painters offered their own particular conception of what they considered to be the essential metaphysical nature of art. To Nolde's darker visionary mentality, for instance, art was a marriage, or rather the reunion of man's instincts and impulses and nature's chthonian depths. Towards such depths he was irresistibly drawn. 'I paint and draw to grasp something of the primal essence [Urwesen].'[24] Ernst Ludwig Kirchner, borrowing the Romantics' concept of the 'hieroglyph' to describe his paintings, defined them as 'symbols expressive of reality experienced and apprehended in its very source of energy.'[25] Few people looking at Kirchner's paintings would perceive anything of the sort.

Kandinsky's panegyric of painting proved no exception. Indeed, his various essays, including *Concerning the Spiritual in Art*, helped to create a climate favourable to the artist's exalted view of himself and his work. True art, Kandinsky proclaimed, proceeded from an 'inner necessity', a concept central to his theory. This concept appeared with a frequency so repetitious as to become not only monotonous but well-nigh meaningless at times. Inasmuch as Kandinsky explains his meaning, 'inner necessity' was the driving force which compelled the artist to create. Its origin was spiritual. It was the voice of an 'abstract spirit' which used the medium of art to advance towards new manifestations of itself. Hence

Kandinsky's definition of the work of art as 'spirit communicating, revealing and propagating itself through form' ('Das Kunstwerk ist der durch die Form redende, sich offenbarende und weiterbefruchtende Geist').[26] This definition is almost identical with Kurt Pinthus' previously quoted conception of Expressionist poetry – a case in point of how the poets' and painters' understanding of art could coincide.

Kandinsky made additional and more specific claims concerning the transcendental nature of art and its power to reveal the secrets of creation. The laws of art and nature, he was convinced, would ultimately lead toward comprehending the structure of the cosmos.

> The laws of the two great realms – art and nature – separated and living independently will finally lead to the understanding of the whole body of the laws of the world-composition and clarify the independent activity of each toward a higher synthetic order: external and inner.[27]

High claims indeed, all of which hark back to the Romantics, for it was only with the advent of Romanticism that the creative act came to be conceived as a raid on the absolute with the work of art its revelation.

The Expressionists' vision of art as a mediating power was essentially a revival of the Romantics' notion of the imagination as the organ for transcendental perception, the means for apprehending a superior reality. There are, however, very few references to be found in Expressionist writing which specifically glorify the imagination as such. Kubin's 'the world is imagination' was rather an exception. The term fell somewhat into disuse toward the end of the nineteenth century, partly through the overexposure it suffered at the hands of the Romantics and the Symbolists. Although the name itself disappeared from the vocabulary of the artist, the creative, mediating functions once attributed to this 'queen of the faculties' remained. They were simply transferred by the Expressionists to the self, the soul, the spirit.

III. Art as Religious Manifestation

In keeping with the Romantics, the Expressionists'
metaphysical leanings were often inseparable, if not
indistinguishable, from their religious aspirations which
viewed art in relation not only to some ultimate source, but
in relation to God. Art, declared one Expressionist, 'is the
final human expression of the eternal, the cosmic, the
divine.'[28] One little-known Expressionist painter put it thus: 'I
want to capture in colour the God who made the world, the
strength that bears the earth.'[29] This view was shared by
others who insisted that truly creative art was religious in
kind and derivation. The tendency once more was to fuse art
and religion, to cast the artist in the role of priest and
prophet who performed a sacred function. The
Expressionists, wrote Kasimir Edschmid, 'surrender
themselves to the divine.' Unlike the majority of men they
alone realized that art was 'only a stepping stone on the road
to God.'[30]

The difficulty begins in trying to understand the
Expressionists' God who had little in common with organized
religion. Like the Romantics' deity, he assumed various
shapes at once. He was the prime mover, the fertile source at
the centre of life, the spiritual bond which united all things
into a whole which was holy and ceaselessly evolving. To
some, embracing the creed of an ecstatic religious humanism,
God was immanent in man, striving through man toward
ultimate fulfilment. This idea bore a marked resemblance to
the Romantic-Idealist notion of a 'God in a state of
becoming' realizing himself through mankind. Yet neither
view seemed to exclude a belief in a transcendent and wholly
personal deity. Whatever the Expressionists' vision of God, it
strongly inclined to mysticism exhibiting at times those
paradoxical leaps of thought peculiar to the religious
visionary. To quote from the foreword of Kokoschka's *Orbis
Pictus*, it begins with the words: 'God is not one, but all are in

God. Everything is divine', and concludes with the exclamation: 'Kyrie Eleison, Pan is risen, the Infant Jesus and all the spirits and fairies.'[31] This strange pantheon of resurrected gods was dear to the Romantics and to such mystics as Jacob Boehme, Tauler and Angelus Silesius, all of whom enjoyed some popularity at the time of the Romantic reawakening.

A pronounced religious and mystical awareness pervaded the entire generation. Poets and painters readily invoked the name of God, the presence of a supreme power and being. Klee was driven 'deep down into the primal source [Urgrund].'[32] They all were to some extent – of which more later. Describing how forms arise from within the artist's innermost self, Klee could write: 'A kind of stillness illumines the ground. / From something vague / a something shines, / not from here, / not from me, / but of God.'[33] It is hard to imagine Matisse or Picasso writing in this vein. Such religious sentiments were rooted in the Romantic heart of Central Europe, and also flourished further east among Russian painters.

A profound religious impulse, for instance, pervaded the work of Alexi von Jawlensky whose Byzantine heads, which significantly bore such titles as *Faces of the Saviour* and *Meditations*, strove to recapture the mystery and oriental colours characteristic of icons. In his view, great art could only be painted with deep religious feeling. Artistic creation was a sacramental service. The artist expressed the 'divinity he found in himself.' He made God visible through figures and forms. Art in its very nature was 'a yearning for God.' With the childlike simplicity and piety of Wackenroder, Jawlensky approached the act of painting through rites of religious contemplation. 'I desired no more than to withdraw into the depths of myself in order to pray and prepare my soul.'[34] Jawlensky's greatest desire was to create pure symbols of religious meditation, modern icons which induced in the beholder a feeling of reverence and devotion. To make his intentions understood he occasionally constructed his faces over the sign of the Slavic double cross.

Jawlensky's close companion Marianne von Werefkin proclaimed a similar, though somewhat more sophisticated version of art as religion. 'Genius', she wrote, 'is a part of God.'[35] This view was clearly related to Schelling's idea of genius as a fragment of divinity stripping the veil from the face of the deity.

Werefkin and Jawlensky perpetuated the Romantic tradition in more self-conscious and obvious ways. Both painters played a leading role among a group of Russian artists living in Munich in the first decade of this century. Their spiritual ethos – an exalted Romantic elevation of man's soul and sensibility combined with a marked streak of religious Messianism – soon strove for more collective action by forming an artistic association known as the *Lukasbruderschaft*. In name as well as in aim it deliberately evoked the Romantic *Lukasbruderschaft* founded in Vienna in 1809 by two young painters, Overbeck and Pforr. The 'Brothers of St Luke', or the 'Nazarenes' as they were half-mockingly called, was a semi-monastic order which strove to bring about a religious revival of painting by returning to the Christian art of the Italian Primitives and the German Middle Ages. Their religious and artistic ideals were prefigured to a large extent in Wackenroder's *Effusions from the Heart of an Art-Loving Monk* and in Runge's dream to set up medieval guilds of artists working for the glory of God and the purification of man.[36].

The Romantic brotherhood of Nazarenes may have influenced other Expressionists as well. Thus it has been plausibly suggested that the painters of the *Brücke*, notably Erich Heckel, were inspired by their example when forming their own association. They certainly shared with the latter a love for the German art of the late Middle Ages and a strong desire to organise themselves into a closely knit community whose aim was not only to paint pictures, but to transform life. The communal urge was indeed a conspicuous feature of the *Brücke* painters since, more than any other artistic group at the time, they longed to realize the medieval ideal of the guild shop. These artists not only lived and worked together,

but shared almost everything alike. So pronounced was their *Bauhüttengeist* in fact that they frequently refrained from signing their own pictures when exhibiting as a group. A deep religious sense characterised some of its members. Erich Heckel, Karl Schmidt-Rottluff and, above all, Emil Nolde turned repeatedly to painting Biblical themes. A primitive religiosity emanates from all these pictures which made no concessions to conventional piety and churchly decor. Despite the immense stylistic and emotional differences separating them, the *Brücke* painters' attitude toward religion was not unlike that of the Nazarenes. Both looked to art as the medium communicating religious truth, as the instrument effecting a spiritual renaissance.

A similar Romantic dream preoccupied Franz Marc. True art, according to him, was inseparable from religion. Without it, the artist produced empty, artificial forms. When will man realize, Marc pleaded zealously, 'that great and pure art cannot exist apart from religion.'[37] The immediate problem of art, he urged, was to embody a new 'religious content', to create symbols that would occupy a sacred place 'on the altars of the future spiritual religion.'[38]

What he in fact demanded was the creation of a wholly new mythology, as had been already envisaged by Friedrich Schlegel, Schelling and Novalis. In Marc's case, this new mythology was supposed to be compounded once more from Gnostic and mystical sources as well as from the insights derived from subatomic physics as it penetrated into layers of reality beyond the material and visible. Marc spoke with glowing expectation of this art to come, an art which, sweeping away the false gods of science and technology, would move man to the core of his being and to a realization of the divine. 'Art will become the great God once more. Indeed the concepts of God, art and religion will return. New symbols and legends will fill our shattered hearts.'[39]

In literature, Theodor Däubler's voluminous *Nordlicht* was such an attempt to create new symbols and legends, partly through revitalizing the myths of old in the light of modern man's spiritual awareness. Cosmic in breadth and meaning,

Däubler's voluble epic strove to transform all religions into a new universal mythology which once more would reconcile the self and things, the human and the divine, Pan and Holy Ghost. In scope and aspiration, though not in outward form, it recalls Novalis' *Heinrich von Ofterdingen* and *Hymnen an die Nacht* which similarly aimed to mythologize and 'sacralize' the whole of life, man's past and future, the world's beginning and its end.

Not surprisingly, it was in Kandinsky that many of these religious and mystical tendencies met and fused. His vision of art was inextricably bound up with religion, the religion in his case being a strange blend of Eastern Christianity (Graeco-Russian Orthodoxy) and, as we have seen, pronounced leanings toward the occult, including theosophy and anthroposophy. For his Slavic soul art was indeed the vessel of the divine, and the artist its chosen priest and prophet. As prophet, the artist was endowed with a 'secretly implanted power of vision.'[40] Kandinsky compared him to an 'invisible Moses' – Shelley's 'unacknowledged legislator of the world' – leading mankind into a better future.

To understand Kandinsky's religious conception of art we must briefly touch on his eschatological interpretation of history to which he alluded in his German autobiography. As is evident from the various scattered references, Kandinsky conceived of history as *Heilsgeschichte*, as a history of salvation, that is, consisting of three main periods. The first was that of the Old Testament characterized by the dominant ideas of law and authority. In the Trinitarian theology, this was the age of the Father identified with the God of creation. The second period was that of the New Testament commencing with the coming of Christ, the Son. It was characterized by freedom and an inner spirituality which incessantly strove for greater purification. In this urge of the spirit to purify itself Kandinsky perceived 'the root of the continuous ... revaluation of all values' including those of art.[41] The third period was a synthesis of the preceding two, a harmony of law, freedom and spirituality. It was the age of the Holy Spirit, characterized by the reign of a divine love

which united all of mankind into one spiritual community. This eschatological conception had numerous precursors, both Romantic and medieval. It recalls the messianic myth of Joachim of Floris whose tripartite division of history appeared transformed in Schelling's eschatology with its Petrine, Pauline and Johannine periods. Kandinsky's immediate inspiration, however, may well have been a form of Christian historiography immensely popular among some recent Russian philosophers. Thinkers such as Bulgakov, Father Florenski, Vladimir Soloviev and, at the turn of this century, writers like Krasinsky with his *Third Kingdom of the Spirit* and, above all, Merejkowsky, author of *The Christianity of the Third Testament*,[42] all viewed history as a march towards spiritual salvation, an interpretation which in turn was greatly indebted to the theosophical speculations of Franz von Baader and the later Schelling whose influence on Russian thought in its messianic forms was indeed profound.

Whatever his sources, Kandinsky was convinced that the third age, the millennial period, was about to dawn. Man stood on the threshold of a world epoch, the epoch of the Holy Spirit. 'The day of a millenarian revelation has arrived.'[43] The revelation, he believed, was already visible in art, especially in abstract painting, the function of which was to act as midwife assisting the second theogony or birth of God as spirit. The painter's mission, in other words, was messianic. His non-objective forms and colours announced the coming of the Holy Ghost. Strange as it may sound to Western ears, this elevated conception was consistent not only with a Romantic point of view, but also with the pneumacentric tradition of the Eastern Church and its view of religious art as an essentially theurgic manifestation. On a more primitive level, we meet this view, of course, in the Russians' touching faith in the sacred significance of icons.

At the Bauhaus some ten years after his pre-war speculations, Kandinsky it seems still assigned to abstract art the same religious function. According to Lothar Schreyer, a teacher there, Kandinsky still conceived of his task as an attempt 'to proclaim the flowing light of the Godhead, the

Holy Spirit.' This spirit apparently could no longer be expressed 'objectively', that is, through representations of Christ, but only 'non-objectively.'[44] Schreyer's reminiscences may have erred in the matter of details, yet they have a ring of truth about them when seen against Kandinsky's own involvement in the mysteries of the Eastern Orthodox religion.

There was something of the genuine Gnostic in Kandinsky. Judging by the result on canvas, his vision of the Godhead must have been one drunk on the spectacle of disembodied forms and colours, an experience not unknown to the mystic. In any event, there can be little doubt that Kandinsky's religious orientation, his identification of art with a divine spirit, influenced his decision to paint in the non-objective manner. Some critics tend to minimize his religious zeal, understandably since they are moved by a desire to make Kandinsky's painting not only more acceptable and respectable, but also more intelligible and 'rational.' Such interpretations, however, distort both the man and his work. Any explanation of Kandinsky's art must take into account his religious convictions which do indeed illuminate some of the deeper impulses behind his painting.

Kandinsky's millenarian expectations and messianic conception of art were by no means unique. In one form or another, leaving aside the specific Christian interpretation, they were shared by a great many poets and painters. These artists were haunted by visions of a new age to come, visions that spoke of a new humanity, a mankind purified and spiritualized. In this respect, they were manifestly the heirs of the Romantics. Marc explicitly acknowledged the Romantic heritage.

> We believe that we stand today at the turning-point between two eras. This feeling is not new: the call was heard even clearer as long as a century ago. At that time it was supposed that the new era was close at hand.[45]

Emphatically Romantic again was the Expressionists'

conviction that the new age to come was to be preceded by catastrophic commotions on a cosmic scale, that man's spiritual salvation must occur through the crucible of world-destruction. Their era, they believed, was preparing for an epochal event, a primeval upheaval out of whose cinder and ashes would arise a new world and purer mankind. Hence their preoccupation with themes of devastation, a preoccupation as characteristic of Expressionist art as it was of Romantic art.

An apocalyptic fury pervades the works of most Expressionist poets. In Däubler's *Nordlicht* page after page revels in cosmic eruptions. Man is presented as partaking of an elemental chaos about to transform a dark silent planet into a new star of light and love. The poets Becher, Werfel, Goll, to mention a few, composed various hymns which celebrated the 'healing chaos', the climactic dissolution of the earth preceding spiritual rebirth. Novalis's prayer, for instance, 'O that the world-ocean would already redden and the rock gush forth as fragrant flesh', appeared again in Becher's untranslatable lines: 'Wie sehne ich mich Felsgeschwür nach Meer/Darin ich untertauchend mich versenke',[46] and in Werfel's incantation: 'Arrive, deluge of the soul, grieve, infinite ray!/Destroy the pales, the dam and the vale!'[47] Kurt Pinthus' famous anthology of Expressionist poetry was fittingly entitled *Twilight of Mankind*. Yet this twilight of man was at the same time the birth of a new humanity born on the ruins of an old corrupt world.

A similar apocalyptic frenzy pervades Expressionist painting. It hangs over the works of Meidner, Marc, Kandinsky, Kubin, Beckmann, Kirchner and Nolde. 'Day and night', wrote Meidner, 'I painted my oppressive feelings on love, Last Judgements, the destruction of the world.'[48] Meidner's paintings prior to the First World War were variants of one basic theme: the apocalypse. It was the title of several of his explosive landscapes full of doom and despair and a restless yearning for another world. Marc painted related subjects though without Meidner's tortured, anguished and uncontrolled brush. His *Animal Destinies*, for

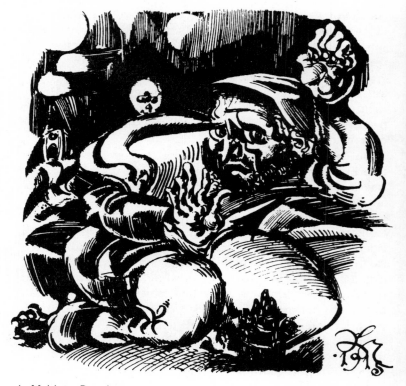

L. Meidner: *Drawing*

which Klee suggested the name, depicts a forest-world torn
and uprooted by cataclysmic forces. To quote his own
description: 'The trees bared their rings and the animals their
veins.' On the back of the picture Marc wrote: 'And all being
is flaming sorrow'; all of life, that is, was a waiting for
deliverance and salvation, a craving to return to the original
sources of creation. In his painting *Tyrol* Marc shows a
mountainous landscape crumbling under the fury of cosmic
storms, yet in the midst of this upheaval he has placed the

W. Kandinsky: *Woodcut*

figure of a peasant virgin mother as symbol of the world's rebirth and final redemption.[49]

Kandinsky's art of the 'dramatic period' was similarly riddled with apocalyptic and chiliastic allusions. Frenzied riders, harbingers, we must assume, of heavenly tidings, storm through spaces or along vast horizons already radiant with, to borrow one of Kandinsky's phrases, 'the premonition of resurrection.'[50] The riders may additionally be meant to symbolize the artist as prophet announcing the world's transfiguration. Apocalyptic allusions are present not only in Kandinsky's numerous *Improvisations* and *All Saints* pictures,

but also in his major *Compositions* which bear such subtitles as *The Last Judgment (Composition V)* and *Deluge (Composition VI)*. Although Kandinsky warned that paintings of this kind should not be read as illustrations to Biblical events, by using such titles he clearly appealed to associations deeply buried in the religious conscience of man. At the end of a purely formal analysis of the *Deluge* Kandinsky himself revealed some of the ideas which may have moved him while painting this picture: 'What appears to be an event of great destruction is in reality just as much a complete and uniquely resounding song of praise as is the hymn of creation which follows destruction.'[51] This 'song of praise' recalls Friedrich Schlegel's and the German Romantics' intoxication with destruction as a process pregnant with 'the sense of divine creation.' The theme was a popular one among Expressionists. It soon indeed ceased to matter altogether whether the artist predicted the world's beginning or its end. Both events were seen to merge into one. In the words of the poet Wilhelm Klemm: 'Creation and destruction forever clasp each other's hands' ('Aufgang und Untergang reichen sich unendliche Hände.')[52]

Throughout Expressionism we witness the resurgence of powerful religious feelings. Like that of the Romantics, the artists' vision once more was cosmic, his conception of events apocalyptic, his expectations messianic and chiliastic. The resurgence of such impulses spoke eloquently of the poets' and painters' longing to participate in an order beyond the factual and the visibly given. Just as these artists sought to reawaken man's lost metaphysical self, so they strove to rediscover man's forgotten instinct for the sacred. Toward this end they proclaimed themselves the mediators of the holy and appropriated to themselves the heritage of religion promising man's rebirth, the world's salvation and redemption.

It was a short-lived, ephemeral promise aptly summed up by Max Brod: 'Your childish ways aimed at a premature kingdom of God' ('Verfrühtem Himmelreich galt euer Kinderwesen').[53] The ardent desire of the Expressionist to

return to man's cultic and religious sources was destined to fail. The old gods to which he appealed were dead and buried, the new ones for which he yearned were as yet unborn, while the still extant Christian deities were a pale shadow of their former numinous selves. Gods no longer moved the collective heart of man. In any event, long since past were the times when the holy, which encompassed the whole, prescribed the poet's and painter's place in the world, and enabled him to create compelling and generally understood symbols of the divine.[54] Born into an age with shrinking religious horizons, the Expressionist artist was forced to commission himself, uncertain of whether God or man approved of his commission. He lived in, and created out of, a spiritual and mystical twilight which, real and true as it may have been for him, failed to push back the doors of heaven. Instead of embodying the presence of the divine, the artist merely succeeded in expressing his longing for it, a longing which looked to an idealized past and future for ultimate fulfilment.

This, of course, was already the 'fate' of the Romantics. When A.W. Schlegel wrote that the new poetry was a manifestation of 'longing' oscillating between 'remembrance and premonition', a poetry clearly opposed to that of the ancients whose art was one of 'possession' firmly rooted in the living reality of faith, he caught in these few pregnant phrases the religious dilemma of the Romantics. They knew well – and none better than Hoelderlin – that the gods concealed their face from man. The poet was condemned to live in a transitional age from which all divinities had nearly vanished. In this situation he had but one choice: to appoint himself the guardian of a temporarily absent deity, a guardian who, watching over a silent tomb, waited for an impending resurrection. In the meantime all he could do was to sing and dream of past and future glories, of a new epiphany – the triumphant return of the god.

No god returned! Both the Romantics and the Expressionists soon tired of the waiting. Their millenarian zeal burnt itself out within the period of one or two decades,

and in those cases where it persisted it eventually sought refuge in secular movements or organized religions.

IV. Critical Reflections

An art nourished on such high-minded metaphysical and religious pretensions was, of course, a perilous undertaking and subject to confusion, if not outright delusion. The confusion set in with an indiscriminate and in the main unqualified identification of the creative self with the creative soul of the world, an identification which made it possible to subsume the most wayward forms of subjectivity under some higher metaphysical objectivity alternatively called 'spirit', 'being', or 'God.' Romantic art, notably that of the Germans, already demonstrated this wholly illegitimate procedure. Often this art was the stammering expression merely of private, intensely personal moods and emotions which had little in common with the 'motions' of the universe, nor with a divine creative spirit of which it claimed to be a revelation. The *Frühromantiker*, always turned inward, easily lost himself in the cavernous depth of the imagination where he chased every fleeting shadow and illusion mistaking them for the substance of the holy, the reality of the transcendent. The purely subjective masqueraded as the objective making for a mock spirituality which decimated and reduced the spirit to the blindness of instinct, to the rashness of impulse, to the vastness and vagueness of indefinable feelings. Hence the expansiveness and waywardness that is one of the hallmarks of German Romantic art. This is not to deny that now and then the *Frühromantiker* succeeded in giving a true voice to the feelings of the heart – the human heart, however, and not that of the world.

The same criticism applies with even greater force to the Expressionist poet and painter. Searching for the 'runic script' of the universe deep within his own being, he abandoned himself wholeheartedly to the ebullience of his

blood, to the dark murmurs of his unconscious, all of which he merrily identified with the music of the spheres or the pulse of creation. Did not man's deepest inwardness coincide and harmonize with the deepest inwardness of the world? Were not the heart and mind of the human creator assimilated to that greater universal mind, the divine creator? An evasive and convenient belief! It permitted the artist to defend every whim and caprice, to pass on the responsibility of his creations − in fact their very authorship − to some divine agency or world spirit which he evoked as the ultimate cause of his production. As Kandinsky once put it: 'The work is cosmic in character . . . The originator . . . therefore, the spirit.'[55] No spirit was present to reply!

The pitfalls of such a metaphysically grounded aesthetics are all too apparent. There lurked the ever-present danger of confusing the primitive and savage with the 'soulful' and spiritual, the dark and mysterious with genuine depth, the demoniac with the divine. In Expressionist art and poetry a harsh strident sensuality not infrequently posed as a cosmic *eros*, and a feeling for the obscure and indefinite passed itself off as a true understanding of the infinite. At its best, this art combined vigorous strength with deep emotions that movingly expressed man's longing for fusion with creation. At its worst, it fell victim to an intense, unredeemed bathos wallowing in its own pathetic convulsions. Of such convulsions there were many examples. A dark and often undisciplined emotionality drove the Expressionist artist into wild frenzies of feeling which momentarily stunned the spectator but for lack of meaningful form and restraint, failed to convince him. Some recognized the danger of seeking in emotions man's sole avenue to salvation. Thus Walter Hasenclever prayed for the liberation of the spirit from the yoke of oppressive instincts and feelings.

Kehr mir zurück mein Geist, im Blut verrieben;
Was du gelöst das sammle wieder fest.
Und halte mir das Gleichgewicht beim Lieben
Sonst sterb ich am Gefühl, wie an der Pest.[56]

Such outcries, however, were exceptions. The Expressionist generally was the willing slave to his own passionate intensity which, just because it kept him in a state of perpetual excitement, he mistook for a kind of cosmic energy or for the spiritual dynamic of life itself. Stylistically, it was this intensity that forced the poet and writer into hyperbole, into unprecedented rhetorical excesses which deliriously feasted on words like 'God', 'spirit', 'being', 'cosmos' and 'chaos' until only unrecognizable bones remained. An inflated diction reflected an inflated inner life which required constant stimulation.

What of the abstract Expressionist painter such as Kandinsky? He too, of course, was inclined to confuse intensity and purely private fantasies with great metaphysical depth. In quest of 'spiritualized sensation' he strove to create non-objective configurations that were supposed to express the mysterious life and rhythm of some universal spirit. Yet the only life and rhythm such paintings convey is that inherent in the forms and colours themselves, their arrangement and combination vaguely telling us something of the state of mind of the artist who produced them. Who in front of Kandinsky's pictures can honestly confess to being in touch with the spirit – Holy or otherwise? To having caught a glimmer of a supersensible reality? Whatever the emotions aroused by these paintings, their mood or tone forms no actual or symbolic bridge to the realm of the transcendent. Abstract Expressionism, including its American variety, where it aspired to catch the tail end of the infinite, the cosmic, the divine, has surely turned out to be the 'medium' failing, for once, to deliver the 'message', which does not preclude its being an emotional 'massage.' It can well be that! Nevertheless, so much of this art, while admittedly titillating the senses and strongly affecting the feelings, at the same time tantalizes the mind in search of less ephemeral and more enduring tokens of the spirit.

Yet, ever since its inception, artists and critics have waged a nearly successful campaign to condition the public to respond to the most weird and wayward sensations produced

by non-representational art. We have been persuaded to perceive in the most insignificant scrawls and flourishes some spiritual vibration of the artists' soul and through it of the 'world soul' itself. Thus Will Grohmann, Kandinsky's biographer, believes this painter's persistent theme to be 'the absolute in the seriousness of its world-creating play.'[57] This is much too serious as well as misleading. One of the dangers of interpretations of this kind is that they are frequently mistaken for the *reality* or the *content* of the paintings themselves, a mistake quite common not only with regard to Kandinsky's art, but with non-representational art in general. Our high-priests of non-objective painting are much too eager to invoke God or the absolute or the infinite to explain the artists' endeavours, with the result that purely metaphysical attributes serve often as the sole criterion of this kind of art.

Critical efforts in this respect frequently border on the absurd. The following example aptly demonstrates the sophistry that passes sometimes under the name of informed art criticism. Discussing Willem de Kooning's work, one renowned explorer of American Abstract Expressionism remarked: 'De Kooning's paintings are based on contradictions kept contradictory in order to reveal the clarity of ambiguities, the concrete reality of unanswered questions ... He aims straight at the mark – to grab the real by the throat.'[58] This specious metaphysical lore has unfortunately become the cherished bait to attract a bewildered public, and the damage inflicted in this respect may be beyond repair. Who among those truly concerned to understand modern art is capable of approaching it without a 'prepared' frame of mind? Subtle persuaders have already begun to prejudice our viewing it. Here indeed we do encounter a contradiction: on the one hand, critics and artists firmly insist that we look at paintings for their own sake and not read material or immaterial associations into them; on the other, they do their very best to endow the work of art with a metaphysical halo whose dense fog makes a 'disinterested seeing' in the Kantian sense as difficult as

object-oriented perception. It makes it even more difficult, since this spiritual fog cast over the work of art is often as impenetrable as it is elusive.

This is by no means to denigrate the part played by ideals in the making of art. In Kandinsky's case, as in that of others, it is undoubtedly true, as we have seen, that a Romantic Idealism and with it a cosmic feeling with pronounced religious overtones inspired much of his production. This Romantic Idealism to some extent determined the 'how' of his art driving him toward abstraction, as we shall see more clearly later. Yet it does not tell us much about the 'what' of his painting. To come anywhere near the centre of what is expressed would have required on the artist's part a more or less coherent symbolism which conveyed its intended meaning. Nor, again in this context, should one ignore the obvious: the inevitable discrepancy between the finished work of art and the numerous and often unrecognized factors which contribute to its birth and existence. To paraphrase T.S. Eliot, between the artist's conception and his creation falls the shadow, the shadow, that is, of unconscious drives and motives, of more or less realized skills, the shadow of time, place, personality, the shadow, not least, of brush, paintbox and a four-cornered canvas. Far too many variables, in short, intervene to permit decoding the completed work in terms of the artist's intentions. Even if this were possible, Kandinsky's paintings and others of its kind would still have to be judged by criteria peculiar not to 'spiritual cosmology', but to art. They stand and fall as paintings, and not as a form of painted metaphysics.

That an art such as this should have seduced critics and artists to search for mysterious, recondite meanings was surely not due to its alleged metaphysical content, but rather to its suggestive, indefinite 'openness' which provides few sign-posts for exploration. Much can be read into it. Much has been read into it. The Freudian libido as well as the singing of the stars has been evoked to decipher its elusive meaning. Considering the wide range of proposed readings one conclusion would seem to be self-evident: abstract

Expressionism does not contain the key to its own interpretation. For this reason, to speak with Ortega y Gasset, it has produced 'only ambiguous values.'

Part Four

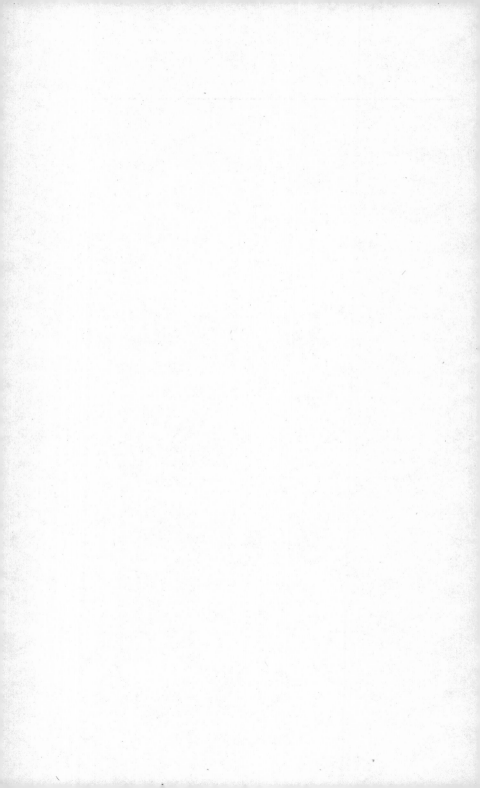

Chapter Seven

Romanticism and the Organic Theory of Art

I. General Outline

The Romantic expressive theory was but one important contribution to the aesthetics of Expressionism and modern art. An equally prominent contribution to this aesthetics was the Romantics' organic theory. Since it is eminently complex no attempt will be made here to analyse it in great depth. The following treatment rather aims to isolate some of its essential characteristics and implications, all of which re-appear in the preoccupations of modern art.

Between these two theories, the expressive and the organic, there existed obvious points of contact. Nothing in Romanticism ever stood by itself. As we shall see, they shared a number of basic assumptions. Yet, despite having certain features in common, there was one fundamental difference between the two theories, a difference revealed in their respective approach to the phenomenon of art. While the expressive theory in the main set out from and concentrated on the creative subjectivity of the self, the organic proceeded from and focused on the creative objectivity of nature and the absolute of which the creative self was said to be a part. In other words, the emphasis with the organic theory shifted from a purely 'egocentric' explanation of artistic creation to a 'cosmocentric' understanding which strove to comprehend the being and function of art in relation to the universe and

its creative ground.

This switch from the inner to the outer – from an Idealism of the self to an Idealism of nature, was a legitimate procedure according to the Romantics. If the inner, as they believed, mirrored the outer, the outer conversely mirrored the inner. 'Intuition of the self and intuition of the universe', wrote Schleiermacher, 'are reciprocal concepts.' Novalis expressed the same idea with reference to particular schools of thought. 'It is *one and the same* whether I posit the universe in myself or myself in the universe. Spinoza posits everything without. Fichte everything within.'[1] Both approaches, one locating the world in the self, the other the self in the world, bore a measure of truth. They corresponded in fact to the Romantic's pantheistic state of mind which enabled him to move with seemingly effortless ease from the individual soul to the world soul and back, from a metaphysically inflated transcendental ego to an act of 'egocide' or self-obliteration in which the 'I', streaming forth into its other, nature, merged and fused with all that lived.[2] The organic theory of artistic invention was clearly a reflection of the latter.

To understand the theory it is necessary to touch briefly on the *Weltanschauung* that it presupposed: a philosophy of organicism which viewed the world as a living totality permeated by a unitary life. Historically, the idea of organicism did not originate with the Romantics. Rather its philosophical ancestry can be traced as far back as the pre-Socratics, Plato, Aristotle and Plotinus, and it emerged later in the system of Spinoza and in the speculations of Herder. More immediately relevant to the Romantics was Schelling's and Coleridge's metaphysically refined organic conception of reality, and it was to Schelling and Coleridge mainly that the Romantics were indebted for their philosophy of organicsm. They also owed something to Goethe whose morphological vision of nature based on a detailed scientific study of organic phenomena was a significant milestone on the road towards a *genetic* understanding of reality which came about in the wake of the Romantic movement. There were other sources of influence as well, from eighteenth-century poets and not

least from Kant, as we shall see.

Organicism in its Romantic connotation has been defined as 'the philosophy whose major categories are derived metaphorically from the attributes of living and growing things.'[3] The Romantics would have challenged this definition. In their view, the words 'organic' and 'organism' were not deduced primarily from the observation of growing things and then subsequently extended to the whole of creation; they were suggested rather by a contemplation of creation in its wholeness and its supreme organization, which manifested itself particularly well in such instances as trees or plants. It was the universe or nature, therefore, which for the Romantics marked the starting point for their philosophy of organicism.

Schematically, the Romantics' vision of nature was that of a self-determining, evolving organism consisting of successively graded and inter-related series which, proceeding from matter, ascended toward manifestations of mind as in man. This self-determination or autonomy was reflected in all the parts or members making up the whole. Secondly, because it was evolving, nature continuously changed and expanded. We have already touched on the Romantics' dynamic, evolutionary conception of nature, their belief that the universe was 'infinite in essence, infinite, therefore, in its expression.' In postulating a growing universe – one in a state of *becoming* – the Romantics put forward a decisively different organology from older ones, in which creation and change were always limited to a predetermined set of type-forms and species.

While a definition of organicism in its purely theoretical meaning poses no problem, it requires a touch of poetry to do justice to the Romantics' deep emotional attachment to nature. Theirs was a genuine organic feeling for life which could perceive in all natural phenomena 'organic harps diversely framed' over which, in Coleridge's words, swept one vast 'intellectural breeze', the soul of all and God of each.[4] Nature was alive; it was a spirit akin to or identical with the spirit of man. This spirit found continuous

embodiment in the infinite wealth of natural forms, each one an exemplary model of unity and integration, each one – right down to nature's crudest rocks and metals – obeying its own law of becoming which was that of a self-generated, spontaneous growth from within, resulting in the completion of 'living form.' To apprehend living form as something grown from within, and through it to commune with the creative universal spirit, was the Romantics' boundless aspiration. Schiller once gave voice to this Romantic longing. Referring to plants, minerals, animals and landscapes, he spoke of how they aroused love and reverence in man solely because they were embodiments of the spirit of nature. 'What we love in them is their calmly productive life, their serenity and spontaneity, their existence in conformity with their own laws, their inner necessity, their internal consistency with themselves.'[5] Schiller concluded his remarks by calling such organic forms the 'time-images of our ideal of supreme perfection.'

What effect had such an understanding of nature on the theorists and practitioners of art? In their enthusiasm for living and growing things they immediately proceeded to compare the becoming and being of the work of art to the becoming and being of organic forms of nature. In more general terms, the peculiar characteristics which hitherto had been predicated primarily of plants or any other organically evolved entity were employed now to define the essential attributes of artist and art. Thus the younger Goethe characterized true genius as one 'out of whose soul the parts emerge, grown together into an eternal whole.' The works of genius, such as the Strasbourg Minster, he described as something 'living and undivided.' 'As in the works of eternal nature everything, down to the tiniest fibre, is form [*Gestalt*], everything contributes functionally to the whole.'[6] Praised, henceforth, was the work which, like Wordsworth's meadow-flower and grandeur of the forest tree, 'comes not by casting in a formal mould / But from its own *divine* vitality.'[7] This organic comprehension of artistic creation with its emphasis on spontaneous generation and growth from within was

already clearly expressed by Edward Young, the mid-eighteenth-century poet whose influence on the *Frühromantiker* was profound.

> An original may be said to be of a vegetable nature; it rises spontaneously from the vital root of genius; it grows, it is not made. Imitations are often a sort of manufacture wrought up by those mechanics, art and labour, out of pre-existent materials not their own.[8]

Half a century later Romantics and Idealists availed themselves of similar, though frequently more subtle distinctions. Like Young they identified imitation with manufacture, using the word 'mechanic' (i.e. mechanical) in a pejorative sense, not only to discredit what Coleridge called the 'brick and mortar thinking' of mechanist philosophy, but also, and more specifically, to indict the neo-classical theory of art which insisted that the poet and painter obey generally approved rules of composition. Such rules, for instance, decreed that 'each object must be fixed in due place' until 'we find one perfect whole of all the pieces joined.'[9] Precepts of this kind to the Romantics spelled the death of art. Time and again they drew a sharp distinction between mechanical making and organic growth, between *fabrication* – the unproductive, barren recording of pre-existent shapes as they existed in external nature – and *creation* – the vital emergence of individual living form arising from the artist's innermost self. The emphasis was consistently on the work of art as the coming-into-being of a self-generated autonomously evolved and internally constituted system characterized by an organic interdependence of parts, none of which admitted change or removal without drastically affecting the life of the whole.

In a neat antithesis, Coleridge, leaning heavily on A.W. Schlegel's twenty-second Vienna lecture, compressed the principles operative in both mechanical production and organic growth thus:

> The form is mechanic when on any given material we impress

a predetermined form ... The organic form, on the contrary, is innate, it shapes as it develops itself from within, and the fullness of its development is one and the same with the perfection of its outward form.[10]

To condense even further, in organic creation the form is *ab intra* and evolved; in fabrication *ab extra* and imposed. True artistic form is an organic event! 'A well-fashioned work', declared Schelling, 'can only come into being where it has risen into flower from seed to root according to the laws of its development.'[11] In the provinces of both art and nature, insisted A.W. Schlegel, 'all genuine forms are organic.'[12]

Formulated into a general principle the organic concept of artistic creation yielded an aesthetic imperative of the utmost importance. This imperative decreed that art must not create *from*, but *like* nature. 'That means it must – creating autonomously like nature, itself organized and organizing – form living works which are not set in motion through an alien mechanism ... but through an in-dwelling power.'[13] The power, that is, which the artist imparted to his works from his own being.

This understanding of artistic creation had momentous repercussions. By definition it was in immediate, head-on collision once more with the doctrine of imitation which the Romantics had dismissed already as being inimical to the presentation of feelings. The work of art as an organic event was an autonomous production. Although, like a plant, dependent on a given 'soil' and 'climate' – the artist's personality and cultural environment from which it assimilated diverse elements for its nourishment and growth – it was an independent creation developing in accordance with its own innate law of becoming. To demand of the work of art that it imitate nature was in this interpretation synonymous with demanding that a tree copy the environment surrounding it, i.e. the air, the earth and the water from which it derived the materials necessary for its growth.

The Romantic precept that the function of art was to

create like nature has been occasionally attributed to Aristotle and Thomas Aquinas. Thus Aristotle spoke of art – his example was the art of medicine – as imitating the operations of nature, while Aquinas' view on the subject is usually summed up in the saying, 'ars imitatur naturam in operando, non in repraesentando' ('Art imitates nature in operation rather than in representation').[14] Yet, even allowing for considerable exegetical freedom, statements of this kind fall far short of the Romantics' conception of the matter. Nowhere in Aristotle and Aquinas was this view proclaimed at the expense of imitation, nor would either philosopher have endorsed the Romantics' dynamic evolutionary interpretation of nature and its corresponding bearing on the processes of art.

More recently the above view has also been attributed to the Chinese philosophy of art. However, what is loosely described as Eastern aesthetics is in reality no more than a collection of artistic maxims unsupported in the main by a systematic point of view. Curiously enough, some modern artists, often under the spell of Zen and other Eastern fads, have invoked the apparent Chinese origin of the Romantic principle in question. Picasso, for instance, has been credited with the following remark: 'As I've often said, I don't try to express nature; rather, as the Chinese put it, to work like nature.'[15] In our present context, this would earn Picasso the additional title of Chinese Romantic.

The organic theory as formulated by the Romantics was not only opposed to the doctrine of imitation, but also to the idea of art as a process subject to rational deliberation. This touches directly on our previous discussion of the role of the unconscious in art. What the theory in effect denied was the established view of the artist as a *conscious* maker supremely in control of his craft, manipulating materials in accordance with rules which enabled him to calculate in advance the ends to be achieved. What the organic theory affirmed was the very opposite: a view of artistic invention which, analogous to a plant, operated spontaneously, free from any external restrictions, free indeed from the controlling intelligence,

producing effects wholly unforeseen by the artist. Shelley put it thus: 'A great statue or picture grows under the power of the artist as a child in the mother's womb; and the very mind which directs the hands in formation is incapable of accounting to itself for the origin, the gradations ... of the process.'[16]

Taken literally, this account of artistic creation as an involuntary, unpremeditated process entailed rather unfortunate consequences. It fostered the idea of the artist being no more than a kind of 'vegetative automaton' – not unlike the Surrealists' concept of the ideal self – which, at the mercy of inner promptings and compulsions, operated unconsciously without any awareness of its actions. The result would have been another form of determinism which substituted for the blind necessity of mechanism the equally blind necessity of vegetative or instinctual organicism. Some Romantics tried to anticipate such consequences by insisting on the essential presence of consciousness in artistic creation. Yet, as we have seen, they left few doubts as to the over-riding significance of the unconscious in art.

II. Aesthetic Organicism and its Presuppositions

The Romantics' organic aesthetics could conveniently invoke the authority of Kant's *Critique of Teleological Judgment* which probed into the workings of both art and nature. Impressed by the seeming spontaneity, the unconscious yet immanently teleological activity taking place in the products of the fine arts, Kant suggested that in the artist and his work we encountered something closely approximating natural growth. Genius, the creative imagination, Kant provisionally defined as the medium through which nature prescribed indefinable rules for art. It was the agency, in other words, through which nature once more appeared in the mind of man. Hence Kant's more general, though tentative, hypothesis of art and nature as comprising parallel phenomena emanating from a common ground where spirit

and matter were originally one.

Kant's ideas, suggesting a close kinship between art and nature, were eagerly seized upon by his contemporaries, including those not generally predisposed to accept his outlook. Thus Goethe, on reading this third *Critique*, praised its author for placing art and nature side by side and granting each 'the right to act in accordance with great principles without purpose.'[17] As Goethe understood Kant, both art and nature developed in keeping with ends inherent in their respective productions. What ruled artistic and natural processes alike was not an external, but an essentially internal teleology.

Kant's cautiously planted and carefully qualified hypothesis concerning art's inner relationship to nature was turned by the Romantics into a boldly unqualified assertion that received its philosophical blessing in the speculations of Schelling and Coleridge. Fortunately, we need not plunge into great metaphysical depths to retrieve the basic assumptions embedded in their organic aesthetics. Some will sound familiar enough from the foregoing and the arguments of preceding chapters. Summarized and simplified, they can be stated as follows.

The creativity which brought forth independent and organically evolved works of art was given to the artist by 'great creative nature', the productive force or originating spirit at the centre of life. The artist could create *like* nature, because, being a force of this creative nature, he possessed in his soul an unconscious formative power which enabled him to identify himself with the formative energies of the world. Such identification took place through the artist's feelings, visions, intuitions and his imagination generally, which was one with the germinal causes of nature. In the true creator, according to Coleridge, the imagination was 'essentially vital'; it generated and produced a 'form of its own' and its rules were 'the very powers of growth and production.'[18] The creative subjectivity of the artist and the creative objectivity of nature, in other words, met on a common ground. In creation, the poet's soul throbbed in harmony

with the world soul. As Wordsworth wrote in the *Prelude*: he stood in 'nature's presence ... a *creative* soul' endowed with a power matching nature's own.[19]

Both art and nature, in this view, were seen to be autonomous yet parallel processes, two related streams, as it were, flowing from the same cosmic source which the *Frühromantiker* called the *Urgrund* and Schelling the absolute. The absolute was manifest in both spheres. It was active in the production of the crystal and the bone, the leaf and the rock as well as in generating the poem and the painting, the sculptured figure and the configurations of music. 'The ideal world of art and the real one of objects', wrote Schelling, 'are products of the same activity.'[20] They occupied strictly analogous positions at different levels of the system, each one reflecting some of the essential operations of the other, each one growing out into their self-generated wholes and drawing upon the structural potentialities of that 'higher nature' from which they both emerged.

Concerned generally to demonstrate a close connection between art and nature, Romantics and Idealists were not blind to what separated these two realms. Although emerging from a common source and developing in like manner, art, they insisted, was yet superior to nature. It was superior, according to Schelling, because it raised into consciousness the unity of spirit and matter which in nature operated below the threshold of awareness. Nature was but the unconscious 'poetry of the spirit', art its conscious consummation. It was only through art that the instinctual and purposive process of nature achieved clear knowledge of itself. This was at the root of Schelling's previously mentioned apotheosis of art as the highest and most supreme objectification of the absolute. It was the highest, because it reconciled the real with the ideal, the unconsciousness and necessity of nature with the consciousness and freedom of the mind.

While not all Romantics followed or understood Schelling's involved metaphysical deduction of art as the immediate manifestation of the absolute, with few exceptions,

however, they did endorse a view of artistic invention as a process of cosmic creativity in the mind of man. To restate this theme, nearly all embraced the belief that art was nature reborn on a higher plane – that of the spirit. Art indeed created *like* nature in its innate drive toward living, self-sufficient form, but *unlike* nature it produced in its creations something 'spiritually organic.' In and through its *Gestalt* (form), the work of art expressed *Gehalt* (import, meaning) which raised it above the works of nature. Goethe summed it up lucidly when, making use of a triple distinction, he wrote that art was at once 'natural' (*natürlich*) and 'above nature' (*übernatürlich*); yet while 'above nature', it was not 'out of nature' (*aussernatürlich*).[21] It always produced works in harmony with the creative force of life.

III. Emphasis on Lawful Creation

It was this conviction which explains the Romantics' and the Idealists' frequent and passionate emphasis on the intrinsic lawfulness of all artistic creations. When Novalis wrote 'alles Schaffen ist gesetzmässig' he expressed the belief that art, although free and legislating its own rules, was yet a process consonant with nature, a process invariably subject to the laws of all formative becoming. This understanding of art as at once autonomous yet in harmony with nature seemed to provide the solution to a puzzling problem which sharply divided – and still does divide – theorists and practitioners of art. Then as now various critics argued against granting the artist the fullest measure of freedom and the right to originality on the grounds that to do so would invite lawlessness and license. If the artist was to be his own authority, his own law-giver, what was to prevent him from fabricating nonsense? For the Romantics and Idealists this presumed conflict between freedom and lawlessness, autonomy and license, was a falsely conceived dilemma which could not arise in fact. Art as a 'living power' perforce conformed to rules. In the same sense that a plant or tree in

the material world grew independently of externally imposed controls, yet in strict obedience to the laws of its development, so the work of art, a parallel organic event in the mental world, developed in accordance with the norms inherent in its own production. 'Imagine not I am about to oppose genius to rules', wrote Coleridge defending Shakespeare's 'free and rival originality.' The spirit of poetry differed in no way from any other productive agency. 'It must embody in order to reveal itself; but a living body is of necessity an organized one.' Thus Coleridge's confident conclusion:

> No work of true genius dare want its appropriate form; neither indeed is there any danger of this. As it must not, so neither can it be lawless. For it is even this that constitutes its genius – the power of acting creatively under laws of its own origination.[22]

Acting under laws of his own making, the true artist need never fear to stray from the path of true creation. A wisdom 'deeper than consciousness' guided his imagination which, as Coleridge reminds us elsewhere, was at one with the very powers of growth and production. Typical of this explanation justifying the artists' free originality was the appeal to nature's creativity. 'Nature, the prime genial artist, inexhaustible in diverse powers, is equally inexhaustible in forms.'[23]

Goethe was even more emphatic in insisting on the lawfulness of all genuine art. Unique among his contemporaries in being both a poet of genius and an unusually gifted natural scientist, he brought to his aesthetic observations the highest qualifications. As a dedicated biologist with an eye sharpened by his insights into plant morphology, Goethe's interest in the process and products of art was persistently genetic. He looked upon art as he looked upon nature, convinced that the laws active in one complemented the laws active in the other. Artists, he wrote

in a passage reminiscent of Coleridge, 'form the rules out of themselves according to laws of art which lie just as truly in the nature of the formative genius as the great universal nature maintains its organic laws.'[24] Contrary to some critics' interpretations, Goethe's aim was not to identify art with nature. The relation between these two realms, as we have seen, was one of likeness as well as difference. Yet Goethe never doubted that in the last analysis the same formative drive was present in both. His much-quoted words applauding the architectural products of classical antiquity must be seen in the light of such beliefs. 'These high works of art, like the highest works of nature, were produced by men according to true and natural laws. Everything arbitrary, fanciful falls together: here is necessity, here is God.'[25]

From this view it was only a short step to the conviction that art not only proceeded in accordance with universal laws, but also that it made manifest such laws, the credo of the artist providing through his work a revelation of the secret laws of nature. In the same context we meet the additional claim that in its becoming and being, the work of art supplied an analogue of the creation. Romantics and Idealists frequently and with few inhibitions compared, indeed equated, the productions of art not merely with those of nature, but also with the production of that supremely fashioned organic work of art – the universe itself. The creative act of the artist, in other words, recapitulated the original cosmogony, the primal act of creation. 'Poesy', wrote one German Romantic, 'is the magic power of the spirit which in the form of free beauty repeats the creation of the All.'[26] This parallel between the poetic process and the cosmogony was implied in Coleridge's concept of the 'primary imagination' as 'a repetition in the finite mind of the eternal act of creation.' Schelling spelled it out when he declared all art to be the direct imitation of the world's 'absolute production' ('Alle Kunst ist unmittelbares Nachbild der absoluten Produktion').[27]

IV. Art Creating Being

We must attend to some of the implications of the organic theory of art. Two features in particular require more extended consideration: one, concerning the ontological status of art and the individual work of art; the other, the artist's relationship to nature. The latter will be treated in the next section.

As an emanation from the absolute creating parallel to nature, art according to Romantics and Idealists created 'spiritual-organic' wholes which occupied their rightful place in the hierarchy of being. No longer aspiring to duplicate reality, the poets' and painters' immediate purpose was to give birth to something which hitherto had not existed before. Paraphrasing Addison, another important influence on the Romantics, one of the primary functions of art was to make *additions* to nature and thus multiply God's handiwork. 'Poetry is procreation', wrote Novalis, 'every poem must be a living individual.'[28] This point was provocatively stated by Goethe. 'No one will realize', he wrote to his composer friend Zelter, 'that the highest and sole operation of nature and art is forming [*Gestaltung*] and that the form [*Gestalt*] is the specification in order that each thing may become, be and remain a particular and significant entity.'[29] As we shall see, the idea of art as being first and foremost *Gestaltung* – a self-generated, self-propagating process resulting in the completion of significant form the sole end of which was to be, to exist – has become a cornerstone of non-objective art.

The Romantic-Idealist conception that art realized new orders of being brought about the substitution of aesthetic categories which greatly affected the psychology of artistic invention. The most obvious and the most important substitution was that which replaced the concept of art as a 'mirror of nature' with that of the work of art as a 'second nature', a 'heterocosm', created as we have seen in an act analogous to nature's productions or to God's creation of the

world.[30] The idea of the work of art as a heterocosm directly determined its mode of being which, using A.W. Schlegel's phrase, was that of a 'world within the world' whose existence, like the existence of any natural form, was an end in itself. Being an end in itself, the poem or painting, therefore, had to be judged by its own laws and criteria and not by considerations extrinsic to its existence. As Constable once expressed it, a truly original painting 'is a separate study and governed by laws of its own.'[31] Tieck extended this principle to the various arts each of which, he insisted, 'moves in its own sphere in keeping with its unique truth which knows no other outside of itself.'[32] The highest art, Tieck wrote elsewhere, 'can only explain itself.'[33] It possessed a logic all its own which could not be tested by the standards people apply in their dealings with the world at large.

This view of art constituting a world in itself endowed with its own laws and reasons to which the beholder must conform in order to understand its being was greatly indebted to Kant. It was in fact an elaboration on Kant's basic formula that the artists' creations exhibited a 'purposiveness without a purpose', that every work of art, in other words, carried its truth and reason for being within itself. As Goethe, interpreting Kant's meaning, put it: 'A work of art must be treated like a work of nature, a work of nature like a work of art and the value of each must be developed out of itself and regarded in itself.'[34] Kant's concern was indeed to emancipate art from all non-artistic considerations. The contemplation of beauty was 'disinterested', divorced from any concept bearing on moral, theoretical and utilitarian ends. Faithfulness to nature, conformity to empirical truth, was not only irrelevant, but a positive hindrance to a proper understanding of art and beauty. The poem or painting in being was not a replica of the sensory world, nor was it a product to edify and to instruct. It was a universe of its own, a 'second nature' made by a sovereign imagination into something 'surpassing nature.'

Kant's separation of the world of art from the world of empirical reality was characteristic of all Romantics and

Idealists and was inevitable, given their concept of the genius as a free creator who worked independently of the rules of the mind (*Verstand*) and the law of association. As Coleridge insisted repeatedly and with great force, it was precisely the freedom from the law of association that distinguished the creative imagination from mere fancy. The latter was strictly a *reproductive* faculty which received its materials ready-made from sense and memory; the former was a spontaneous, self-sufficing *productive* power which generated and produced forms of its own where there existed no prior examples in either nature or art. The one and only test such forms had to pass was the requirement that they conform to the demands of inner coherence and consistency, to the law of fully organized structure. Of the work of art, in other words, it was not required that it be true to nature, nor true to anything else, but only that it be true to itself. This conclusion, the natural concomitant of an organic aesthetics, anticipated and defined what has come to be regarded as an essentially modern point of view.

V. Artist and Nature

In Chapter III brief reference was made to the Romantics' complex and many-sided relationship to nature, which, in the light of their organic aesthetics, can now be analysed in greater depth. It indeed followed implicitly from the premises already laid down. Thus the poets' and painters' relationship to nature was obviously not determined by imitation, by the creation of facsimile reproductions or ideal replicas of what existed without. No longer concerned with appearances as such, the artist was drawn to nature as essence, as force, process, becoming; he was attracted, in other words, to *inner* productive nature in which he perceived a kindred spirit, a creativeness similar to his own. Inner nature provided a model, and held up a mirror, as it were, to the artists' activity, a mirror he must not ignore or neglect. Hence the Romantics' and the and Idealists' repeated

insistence that the poet and painter should study nature's operations so as to gain insight into the creative urge at work in the world. Coleridge stated it succinctly by having recourse to neo-Platonic distinctions which achieved great prominence in the philosophy of Spinoza. 'If the artist', he declared, 'copies the mere nature, the *natura naturata*, what idle rivalry.' His first and foremost duty was not to ape appearances, but 'to master the essence, the *natura naturans*' to create forms on equal terms with nature.[35] Only by penetrating into 'the workshop of nature', wrote one German Romantic, was the artist's spirit capable of 'awakening in her a second inward, but nature-like creation.'[36] The artist's kinship with inner productive nature and the reason he should diligently study it was clearly expressed by Goethe. 'Ultimately in the practice of art we can only vie with nature when we have at least to some extent learnt from her the process that she pursues in the formation of her works.'[37]

The artist's purpose in studying nature's operations was not, of course, in order to emulate it in poetry and painting. This simply would have reinstated the doctrine of imitation. To be more precise, it would have brought about the substitution of one mimetic model for another. Instead of imitating nature's products, the artist now would imitate nature's process. Although Romantics and Idealists spoke at times of the artist 'copying' or 'imitating' nature's way of working they certainly did not interpret it in this literal sense. The artist contemplated nature with two aims in mind: to set in motion that true bit of *natura naturans* which was his own soul and to acquaint himself with the 'alphabet of creation' which, once learned, helped him to produce something as spontaneous, autonomous and organic in the sphere of art as anything produced in the realm of the natural world. In other words, the devout contemplation of nature's mysterious writing at one and the same time stirred into action the artist's creativity and taught him the ability to form an individual language of expression which in its own way continued the original act of creation. Krause put it thus:

'Once the human soul comprehends the whole world in its many-sided life it generates out of itself the intimate and beautiful world of poesy in whose formations the spirit imitates God's spontaneous creation of the All.'[38]

Thus far we have described the artists's relationship to inner productive nature. The Romantics, notably the Germans, strove beyond this for union and communion with primal nature, the creative substratum or *Urgrund* out of which emerged both art and nature. It was toward this *Urgrund* that the *Frühromantikers'* feelings of obedience and reverence were primarily directed. To mingle and fuse with its being, conceived as an eternal becoming, was the poets' and painters' burning desire. This desire swayed nearly all German Romantics. It swayed them to the extent of begetting an *Urgrund*-mania which spilled over into rhapsodic prose and song. The primal source was celebrated often under different names. Thus it was said to be the 'energy divine', the absolute prior to its separation into subject and object, the 'womb of nature', the 'central deep'; above all, it was the 'chaos', the 'holy chaos' into which man must descend not only to discover the wholeness and holiness of life, but also the well-springs of creation which enabled him to create in its image. 'Chaos and *eros*', declared Friedrich Schlegel, 'best explain what is Romantic'; or again: 'Poesy must be derived from love and the chaos.'[39]

The *Frühromantikers'* intoxication with a procreative chaos or primal source engendered a revolutionary conception of art. August Wilhelm Schlegel expressed it aptly in his well-known comparison between Classical and Romantic art, and his words deserve quoting at length:

> The whole of ancient poetry and art is, as it were, a rhythmical nomos, an harmonious promulgation of the permanently established legislation of a world submitted to a beautiful order ... Romantic poetry, on the other hand, is the expression of the secret attraction to a chaos which lies concealed in the very bosom of the ordered universe, and is perpetually striving after new and marvellous birth. The life-

giving spirit of primal love broods here anew on the face of the waters.[40]

This bold passage, whose significance has been vastly underrated by many commentators, clearly signalled the end of the *logos* in art which once reflected man's belief in a stable, harmonious universe. Romantic art instead was drawn to the originating forces of life. The artist no longer contemplated creation as cosmos but as chaos or genesis in whose powers he shared and whose infinite life he longed to express. 'The chaos', wrote Novalis, 'must radiate from every poem.'[41] Schlegel's words presaged and characterized artistic intentions coming to the fore in Expressionist and abstract Expressionist art, intentions which, compared to those professed by the German Romantics, strove far more forcefully to make chaos triumph over cosmos. The chapter after next will demonstrate the explosive potential and possible forms an art, at once *Urgrund-krank* and 'chaos-drunk', contained within itself.

* * *

In its main force and numerous implications the organic theory decisively changed the meaning and understanding of art. Insisting on artistic creation as a process parallel to nature, it sealed and sanctioned the freedom and autonomy of art to an extent unheard of before. Flowing directly from the absolute, art, henceforth, was to be its own end or purpose, its own justification. From this belief it was only a short distance to the chimerical credo of art for art's sake and the idea of pure poetry and pure painting.

The Romantics' demand that art must not create from, but like, nature cut the bonds once more which tied the artist to the external world. It not only freed him from the pressures brought on him by the doctrine of *mimesis*, it ultimately relieved him from any responsibility to reality as such. Creating like nature, the artist produced forms from within his own being independent of everything without. The world

surrounding him ceased to have any special claims on him but merely provided the nourishment for his productions. Henceforth his work needed only to exhibit that inner coherence and consistency which determined and distinguished the composition of any organically evolved set or system.

By firmly rooting the creative act in the artist's own being the organic theory plainly complemented the expressive theory of art. To the inwardness of feeling proclaimed by the latter it added the inwardness or innateness of form. For both theories the exclusive emphasis, therefore, was on delegating the mainsprings of art to the dimensions of man's inner life. The truth of art, in both, resided not in the object but in the subject.

Within the confines of the organic theory, this insistence on the autonomy of the subject was strikingly in evidence where the Romantics compared the creative act of the artist to the creative act of God. There were, of course, obvious and recognized differences. The artist, unlike God, could not create *ex nihilo*; he depended on the matter supplied by nature. Nonetheless he could create *de novo*, producing new creations which, Prometheus-like, formed the common clay of the earth into something surpassing nature.

Not unexpectedly, Romantics and Idealists in their glorification of the artist's freedom revived the myth of Prometheus, and exploited Shaftesbury's concept of the artist as a *'second maker'*, a Platonic demiurge who formed a whole 'coherent and proportioned in itself.' The drawing of such parallels between the artist and divine prototypes perforce favoured and encouraged artistic products which owed little, if anything, to pre-existing models, be they of nature or art. It especially favoured the *poetic* species of the 'fantastic', the 'visionary', the 'marvellous', the non-realistic inventiveness of which went far beyond the bounds of nature and the known. In this *genre* Romantic poetry excelled. However much its sister art, painting, may have lagged behind, the poetic urge of the Romantics paved long ago the way to an art which called 'shadowy substances and unreal objects into existence',

to an art, in short, which moved toward the non-representational and abstract. Franz Marc's complaint a century later that the freedom of the poet to indulge in non-realistic inventions should by rights be extended to the painter was not without its justification.

Chapter Eight

The Organic Principle in Expressionism and Modern Art

I. General Outline

The organic theory as formulated by the Romantics and the Idealists leads us straight into Expressionist painting. It was at the root of those deliberations and reflections seeking to locate art within a larger cosmic setting of which the self – the creative self – was said to be a lawful and reproductive part. Among Expressionist painters an organic conception expressed itself as always in the choices of metaphors and analogies derived from animate nature. What they reveal is a deep-seated philosophy of organicism which instinctively turned to plants, trees or any other growing thing to assess and explain the process and products of art.

Thus it was Nolde's ambition to emulate the spontaneity and inner necessity he saw at work in natural growth. 'My aim was that colours should be transmitted to the canvas, through myself as the painter, with the same inevitability as when nature herself is creating forms, just as minerals and crystals are formed, just as moss and seaweed grow.'[1] Typical of his primitivism in painting, Nolde selects rather primitive organisms from the world of nature. 'Nature', demanded August Macke, 'must be born in us anew.' Macke's model for artistic creation was the organism's ability to assimilate and react to the environment spontaneously. 'Viewed as a reaction to the events around us, the creating of a work

seems to me to take place exactly the same way flowers open and close in response to the rays of the sun.'[2] Macke urged the painter to study plants and animals, to acquaint himself with the rhythm of life 'which grows out of us into forms we create.'[3]

A pronounced organic sensibility also characterized Kandinsky's aesthetics. In his case, as in that of other Expressionists, organic thinking was by no means confined only to art. It penetrated all aspects of his thought from morality and religion to philosophy and science. The aim of science should be 'to find the living, to make its pulsation perceptible and to discover where the living conforms to law.'[4] An organic vision was behind Kandinsky's quest for unity and synthesis, his idea of nature as a living organism analogous to a plant. As he wrote in one of his later essays, 'there is no difference between the plant of "nature" and nature in its most comprehensive sense.'[5] All of life and art, Kandinsky insisted, was 'but the organic development of older wisdoms.' The same applied to the rise of abstract art which Kandinsky saw as the emergence of a new branch on the tree of spiritual evolution. 'When a new branch grows on a tree, the trunk does not become superfluous, for it must feed the growing branch. And the latter is but a new part of the true trunk from which it sprang.' Every expression of the spirit was the 'inevitable development of the same body which, in its entirety, forms the green mass of the tree itself.'[6]

Turning to the process of artistic invention, Kandinsky repeatedly used organic analogies to explain the birth and being of *pure* abstract paintings. 'Born in the artist', such pictures were said to 'grow, like nature, out of themselves and by themselves.'[7] Each individual painting in turn was a 'spiritual organism' subject to the principles of organic being. 'The work of art, like the work of nature, obeys the same law of construction: the individual parts receive their life only from the whole.'[8] Kandinsky here as elsewhere draws attention to the fact that in a work of art, as in a natural organism, the organization takes place according to the principle of subordination. The relationship governing

the elements is never that of mere succession or co-existence. Each part not only determines, but is determined by, all the others and all are subordinated to a dominant principle which is more than their simple agglomeration. The whole, in short, is always more than, and different from, the sum of its parts. Kandinsky made many similar observations in his *Point, Line to Plane* where he analysed the pictorial organism in relation to the organic products of nature.

This coupling of art and biology was characteristic of Klee. It is in his writings, in fact, that we witness one of the most sustained efforts to substitute an organic for a mechanistic explanation of the process and products of artistic invention. More than any other painter of the period, Klee's mode of thinking was uniquely modelled on the prototype of a growing plant. His mind invariably revolved round the ideas of development and metamorphosis. Form was something essentially alive. It was a biomorphic and biodynamic principle capable of infinite modifications, undergoing sudden and unexpected mutations. To Klee there existed no such operation as the *making* of a picture. All true art was a growth and becoming, with the work being spun out from the artist's inner being in a constant organic interaction of mind and material. 'Like nature', Klee wrote, 'the work has to grow.'[9] Its greatest possession was to be 'inwardly full of form.'[10] This 'inner form' was not something distinct and separate from the picture's outward shape or shell. It was both kernel and shell, the completion of that whole mysterious operation whereby form, feeling and matter fused into an indissoluble union. Klee's emphasis was incessantly on form as innate and evolved. He stated this theme with many subtle variations and frequent shifts of meaning. A typical example: 'We learn to look down on formalism and to avoid taking over finished form ... Formation determines form ... thus form may never be regarded as solution, result, end, but should be regarded as genesis, growth, essence.'[11] True form, in other words, was an organic event. It was at once incarnate and incarnation, begotten from within, its germinal seed grew into completion in the finished work of art according to

laws inherent in its own becoming.

Alternatively Klee saw the artist as a budding tree or plant. The true creator, to choose his well-known parable, was like the trunk of a tree. He collected and transmitted the forces from the depths. 'From the roots the sap rises up into the artist, flows through him and his eyes.'[12] The artist's work was like the crown of the tree spread out in space and time. As the crown was different from the roots of the tree, so the artist's creation was different from the environment out of which it grew. Klee's parable was not only a rejection of art as representation, but also an affirmation of the artist's rootedness in a larger whole. As such the metaphor was a recurrent Romantic image. In Runge's words: 'The blossoms we raise from the consciousness of our origin, which draw the sap from this stem of the world, these blossoms ripen to fruit. Every man is a branch of this great tree and only through the stem can we obtain the sap from this eternal, immortal fruit' – the work of art.[13] Unlike Runge, however, Klee was keenly interested in exploring the mystery of organic form and formation.

Klee's highly developed organic aesthetics made explicit what was implicit in the conviction of his fellow artists – that art was an autonomous, self-organizing process creating living forms. Such convictions were intrinsically hostile to imitation. The function of art was to create as does nature itself. Klee expressed it well:

> Our work is given form in order that it may be a functioning organism. To achieve the same as nature, though only in parallel. Not to compete with nature, but to produce something that says it is *as* in nature . . . There is no copying or reproducing, but rather transformation and new creation.[14]

In addition, this fundamentally Romantic principle of artistic creation provided the starting point for artists not usually associated with Expressionism. It epitomized an aesthetic attitude basic indeed to much of modern art, even

though rarely reaching explicit formulation. We have come
across it in Picasso's already quoted remark: 'I don't try to
express nature but rather . . . work like nature.' We meet it
again in a well-nigh classic example by Hans Arp whose links
to Expressionist poets and painters were admittedly very
close. Arp stated his creed in *On My Way*:

> We do not want to copy nature, we do not want to reproduce,
> we want to produce, we want to produce like a plant that
> produces a fruit and not to reproduce. We want to produce
> directly and not through interpretation.[15]

When Arp wrote of producing 'directly and not through
interpretation' he not only meant an art freed from reliance
on external models, but also an art freed from any
mechanical rules and rational precepts, a form of artistic
creativity which, unwilled and unpremeditated, emanated
from regions of the mind beyond awareness and control.
Like Shelley, Arp looked to art as a 'fruit that grows in man
like a child in its mother's womb.'[16] He frequently pushed
organicism to extremes by not only comparing, but virtually
equating artistic creation with the unconscious growth taking
place in a plant. Of his own organic gestations, for instance,
he wrote: 'What can I do? It grows out of me like toenails. I
have to cut it off and then it grows again.'[17] (Not surprisingly,
Arp was handy with scissors). Completely identifying himself
with the unconscious purposiveness of nature, Arp's greatest
desire was to *become* nature. Art, he stressed repeatedly, was
not opposed to nature. It was of 'natural origin', itself nature.
Yet Arp made the significant qualification that it was nature
'sublimated and spiritualized' through man.[18]

The concept of artistic creation as unpremeditated and
unconscious growth was, as we have seen, one of the
important ramifications of the organic theory as formulated
by Romantics and Idealists. Even then it fostered the idea of
the artist as a kind of procreative organism spontaneously
and automatically begetting offsprings – his works of art. It
was this implication which Walter Pater attacked in
Coleridge's organicism on the grounds that it made the

creative act 'look like some blindly organic process of assimilation.' Indeed, the Dadaists and Surrealists in our century appear to have subscribed to such an explanation of artistic invention. Defining art as 'pure psychic automatism', a complete surrender to the unconscious, they conceived of the artist as a creator of 'locomotive organisms capable of being turned in any direction by the limpid wind of momentary sensation.'[19] The Dadaist and Surrealist doctrine of total artistic automatism not only implied the grossest form of determinism – a determinism paradoxically proclaimed in the name of man's freedom – it also reduced art to a merely natural phenomenon.

While the concept of art as unconscious growth has gained nearly universal acceptance among modern painters, the corresponding idea of art as nature and *nothing but* nature has not, even though it would seem to follow from the former. Of course, there are non-objective artists who most readily identify the process and products of art with the unconscious purposiveness of nature. Even Kandinsky once hinted at such an identification in one of his essays written in the 1930s. 'Who knows, our abstract forms may be altogether forms of nature, but no "objects for use". Such . . . forms are "non-purposive" and for this reason they speak with a purer voice.'[20] Kandinsky, unfortunately, did not make it clear whether the 'non-purposive' character he singled out as being peculiar to non-objective works was a cause or a consequence of their being 'forms of nature.'

Other non-objective painters were less reticent. According to the French artist Camille Bryen, for instance, non-representational painting was not merely like nature, 'it is nature.'[21] Some modern critics have taken such statements too literally and have tried to demonstrate the spontaneous reappearance of nature's operations in the free configurations of non-objective art.[22] What militates against this much too facile identification of art with nature is the testimony of the artists themselves. On closer inspection the alleged identify resolved itself into no more than a relation of likeness as well as difference.

II. Implicit Assumptions

A more general consideration of these artists' views will clarify some of the ambiguities concerning art's relationship to nature. Implicit in their understanding of these two orders of being was a body of metaphysical beliefs which in one form or another resurrected the Romantic-Idealist tradition. In keeping with that tradition, they thought of art and nature as parallel phenomena, emanating from a common ground which, like the Romantics, some called the *Urgrund*. The creative spirit of the *Urgrund* was seen again to manifest itself in both realms, in the work of art as well as in the work of nature. The generating and evolving principles active in one were also those active in the other. The same creative force engendered and enveloped both. Theodor Däubler expressed it in verse: at the root of all being and becoming was 'one life' or 'Leidenschaft die Bäume, Träume, Bilder zeitigt / und stets verschiedenes aus dem gleichen Trieb erwirbt.'[23] To cite a more recent painter, Hans Hartung: 'Our organic knowledge [informs us] that what we create is . . . an equivalent of the power present in the tree trunk and in the pulsing of the blood.'[24] The artist, in short, participated in the universal process; he created alongside and in harmony with nature.

Kandinsky's often tortuous and obscure arguments added nothing more startling or significant to this Romantic-Idealist conception. Its main force centred on art as an autonomous yet parallel process to nature. As autonomous, art was wholly independent from nature. Each sphere pursued its productions in obedience to norms inherent in themselves. 'Nature creates its form according to its ends; art creates its form according to its own.'[25] As a parallel activity, however, art created in the likeness of nature's operations; 'both domains produce their works in a similar or like manner.'[26] What Kandinsky presumably meant was that there existed a kind of psycho-natural parallelism according to which some

of the essential forces of the universe have a duplicate subsistence in the mind of the painter. Such forces appeared in the organizing principles the artist employed unconsciously in the construction of his pictures. In any event, the similarity between art and nature consisted in the fact that in both spheres production was spontaneous and autonomous. The work of art, like the work of nature, was something wholly self-generated and self-evolved; each one followed its own 'inner necessity' and conformity with laws of its own; each one grew into a fully developed organic being. To this extent at least, art performed in the likeness of nature. With art constituting one process, nature another, both presupposed a common ground. Kandinsky referred to it as the 'one universal root' from which derived the diversity of all spiritual and material existence.[27]

Kandinsky may have intended to say more, but if he did it is hopelessly shrouded in mystery. What he did mean to convey, however, was an idea of art, and in particular of non-objective art, as a direct manifestation of a creative spirit at the centre of all.

Klee's explanation, by contrast, was explicit and frequently poetic. He never wavered in his conviction that art was an activity complementing nature, an activity which, as he was fond of repeating, moved parallel to creation. 'The relation of art to creation is symbolic [*gleichnisartig*]. Art is an example, just as the earthly is an example of the cosmic.'[28] The painter's task, to recall his words, was to create a 'functioning organism', a living form which said: 'It is *as* in nature.' The artist could create like nature because he was charged with the same creative energy. Closely following in the footsteps of the Romantics, Klee envisaged the artist as living near the *Urgrund*, the 'powerhouse of all time and space – call it the brain or heart of creation.'[29] It was this primal power implicit in all evolution which in the last resort guided the artist's hand in formation. Hence Klee could write: 'My hand is entirely the instrument of a distant sphere. I must have friends there, bright ones as well as dark. But I find them very kind.'[30] Klee insisted that no rational analysis

could disclose the painter's participation in the universal process of creation. Only the 'initiate' divined the 'primordial living point' and succeeded in bringing about a true 'rebirth of nature.' Klee anticipated that his credo would raise cries of indignation accusing him of 'Romanticism, "cosmism", mysticism.'[31] Being closely attached to the Romantics, he carried such labels lightly, if not with an air of distinction.

The theme of art as a process creating alongside and in harmony with nature can be detected in the sayings and writings of nearly all Expressionist painters. It was implied, for instance, in August Macke's statement that the work of art was not an imitation, but a 'parable of nature.'[32] Marc, Kirchner, Nolde used virtually the same expression. Each one again insisted on the 'naturalness' of art, a recurrent phrase which, above and beyond its usual connotation, expressed the painter's belief that his creations exhibited some of the pivotal properties characteristic of nature's creations.

While they stressed art's similarity to productive nature, none of these painters failed to ignore the differences separating these two realms. Indeed, there was never really any question of identifying the one with the other. On the contrary! Like the Romantics before them, they just as often comprehended art as something distinct from and surpassing nature. Kandinsky pointed to some obvious differences between the organizing principles guiding the painter's constructions and the formative drive at work in natural forms. The most important difference, of course, was the power of art to produce forms expressive of feeling. The artist, in Kandinsky's words, created a 'spiritual organism' which spoke directly from 'spirit to spirit.'[33] Kandinsky cites with approval the saying of Oscar Wilde that 'art begins where nature leaves off.' He also – and significantly – quotes Goethe's remark that the artist stands above nature treating her according to his higher purposes:

> He is both her lord and servant. Her servant, for he must use earthly means . . . Her lord, because he may make these earthly means subservient to his higher intentions. He would

present to the world a whole, yet this whole he cannot find in nature. It is a product of his own spirit, or, if you like, of a divine spirit.[34]

Klee expressed similar views. Art was indeed the 'rebirth of nature', but it was a rebirth on the level of the spirit. The artist's creations differed from those of nature by exhibiting a far greater frugality of means and singleness of purpose. As Klee put it: 'Nature can afford to be prodigal in all things, the artist must be thrifty in every detail. Nature can be loquacious to the point of confusion, let the artist be silent and orderly.'[35] Art, elaborating on Klee's meaning, created a 'higher nature' purged, as it were, from the accidents and impurities of actual nature. It presented images of supreme unity and order through which man caught a glimpse of another order – that of the spirit.

Franz Marc's seemingly paradoxical aphorisms hinted at the same conception:

> Nature glows in our pictures as in every form of art. Nature is everywhere, in us and outside us; there is only one thing that is not altogether nature, but rather the overcoming and interpreting of nature: art. Art always has been and is the boldest departure from nature . . . It is the bridge into the spirit world . . . the necromancy of the human race.[36]

What emerges from the various testimonies of all these artists can easily be summed up again in Goethe's notion of art being at once 'natural' and 'above nature'; natural, since like nature it purposefully strove to realize itself in organic fulfilment; above nature, since its activity served ends not natural, but spiritual. If we may add the third term, even while it was above nature, art was not 'out of nature' for it implicitly obeyed the laws inherent in all formative becoming. 'In everything we do', wrote Klee, 'the claim of the absolute is unchanging.'[37]

III. Universal Law and Artistic Creation

The view of art conforming to law was nowhere expressed
with more passionate conviction than in the school of non-
objective painting. Pursuing an art with no direct links to the
visible world, its adherents eagerly appealed to the norms
and principles of the cosmic world. Having abandoned
nature, they all the more invoked the laws of nature, the 'laws
of the cosmos' in order to justify their own productions.
Thus Kandinsky persistently and almost pathetically
summoned the support of the 'cosmic' to purchase
comprehension for an art in dire need of recognition. His
argument – such as it is – seldom varied. Abstract art,
although autonomous and creating its own means of
expression, proceeded nonetheless in strict obedience to
universal laws. Its very success, in fact, depended on its ability
to submit to such laws. 'Art can achieve greatness only if it
directly relates to cosmic laws to which it subordinates
itself.'[38] Describing the painter's approach to non-objective
creations, Kandinsky wrote:

> The construction will not be dictated to him by 'sections of
> nature', but by nature's laws in general, the laws of nature
> which rule over the cosmos. That is why abstract art is a
> 'pure' art and that is why the perceptive viewer frequently
> receives a cosmic impression from abstract pictures . . .
> abstract art can do without nature; it is still subject, however,
> to the laws of nature. To listen to and to obey nature's voice is
> the artist's greatest joy.[39]

The precise logic of this passage is far from clear. Kandinsky
seems to be saying that non-objective art, by submitting
wholly and willingly to natural laws, achieves thereby a purity
of expression which immediately relates to cosmic life and
rhythms. This purity of expression was denied to
representational art. Tied to objects or 'sections of nature' it

either obscured the 'cosmic element' or failed to convey it altogether.

What were the laws of nature coming to the fore in abstract art? Kandinsky is not very illuminating on the subject, but he mentions the principle of polarity, nature's constant alternation of opposites. 'Nature operates with opposites without which it would be dull and dead. Art does likewise.'[40] The principle of polarity was far better understood by the Romantics and the Idealists. Coleridge referred to it as the 'great law of nature' according to which 'opposites tend to attract and temper each other.' In the great poet it expressed itself in the 'balance, counteraction, intermodification, and final harmony of differents.'[41]

Kandinsky also mentioned the biological law of ascending progress or increasing differentiation which he applied to the future evolution of non-objective painting. Abstract art, he insisted, proceeded as did nature formerly: from comparatively undifferentiated cells and protoplasms it gradually advanced towards higher and more complex organisms.'Abstract art today is also creating . . . more or less primary art organisms whose further development the present-day painter can only surmise.' Kandinsky concludes by warning the critic: 'Those who question the future of abstract art reckon with the evolutionary state of the amphibians which . . . do not represent the end result of creation but, rather its beginning.'[42]

As Kandinsky's last remark indicates, the practice of vindicating non-representational painting by repeated appeals to the laws of nature was in part a direct response to accusations of lawlessness and license levelled against an art of this kind. The issue involved here was essentially the same which faced the Romantics once art achieved complete autonomy. Like the latter, the modern painter was called upon to disprove that the alternative to creative freedom was not anarchy or wanton caprice, but fidelity to law. In keeping with an organic aesthetics, the only possible way to counter such accusations was to insist that as a formative power art inexorably conformed with the formative drive which

throughout the universe sustained the living order of creation. Kandinsky repeatedly strove to demonstrate this conformity by investigating the various principles governing natural and artistic structures. He confidently proclaimed: 'Today we can already assume with certainty that the root of the laws of composition is the same in art and nature.'[43] Inspired by this conviction Kandinsky could in turn claim that non-representational painting signified no break with nature. 'In time it will be incontestably shown that abstract art does not exclude a link with nature, but, on the contrary, that this link is stronger and closer than ever in recent times.'[44]

Klee shared a similar vision. The laws of art, he insisted, were not a denial, but an affirmation of the laws of nature. His conviction may well have been influenced by Goethe's morphological approach to art and nature, by his refusal to treat the laws active in both in isolation from one another. As Goethe wrote, during his epochal Italian journey, these great architectural works of antiquity were produced 'like the highest works of nature according to true and natural laws.' Klee reached the same conclusion when he visited Italy as a young man. Looking at some great buildings there, he became suddenly aware that 'the visibly calculable relationship of one part to another and to the whole correspond to hidden numerical relationships which govern the form of other artistic and natural organisms.'[45] Again who would not be reminded of Goethe's famous study of plant metamorphosis in view of Klee's remark that the structural law which governs the whole of nature was 'repeated in the smallest, outermost leaves?'[46] Klee's faith in the lawfulness of art was occasionally stated in a language reminiscent of the Romantics and the Idealists.

> As creation is related to the creator, so is the work of art related to the law inherent in it. The work grows in its own way on the basis of common, universal rules, but it is not the rule, not universal *a priori*. The work is not law, it is above the law.[47]

Although Klee does not elaborate much on the above, his

contention would seem to be this: every work of art implicitly obeys the general rules of growth. Such rules, however, cannot be subsumed under any scientific precept. No law as yet exists which explains the genesis and the becoming of the work of art. Like the work of nature it develops in accordance with ends inherent in itself. In this sense the work of art is above the law.

The problem was first given clear focus by Kant who suggested that fine art must be regarded as the art of genius and genius as the medium through which nature prescribed indefinable rules for art. Genius was not an aptitude that could be taught and communicated, but a 'talent for producing that for which no definite rule can be given.'[48] Creating works at once original and exemplary, the genius supplied the norms by which his creations were to be judged. Klee formulated it similarly. 'Genius cannot be taught, because it is not a norm, but an exception . . . It has no other law than itself.'[49] Klee made it plain that the law of genius was at the same time the law of creation.

The theme of art conforming to law, the certainty that in its becoming and being it was invariably subject to an inner necessity going beyond subjective whim or fancy, helps to explain these painters' corollary tenet that the true artist not only produced in harmony with nature, but also that through his work he revealed something of the secrets of nature. We have already touched on Kandinsky's notion of art as a second revelation of the cosmos, his belief that the study of the laws of art and nature would ultimately lead to an understanding of the 'world's composition', to what Marc called its 'inner mystical construction.' We also met this belief in Klee's claim that art made visible the invisible. It made visible the concealed forms and forces of the world. All these claims, including abstract art's alleged obedience to universal laws, can be understood only, as we have seen, in terms of the Romantic-Idealist doctrine of identity, i.e. the presumed correspondence between the inner and the outer, between the artist's urge to form and the creative urge of nature which in and through art achieved awareness of itself.

IV. 'The Creation of a Work is the Creation of a World'

In order to understand fully the extent to which Expressionist and modern painters were committed to an organic aesthetics we must once more return to its central thesis, that of art as a self-generated, self-organizing process which, creating parallel to nature, produced another nature. This view of art was pressed home by the modern artist not only with force and conviction, but also with a clear awareness of its ontological implications.

Reduced to its simplest terms, the aspirations of these artists could be described as an effort to realize new forms of being. The painter's task, we are told in so many different formulations, was not to imitate reality, but to initiate reality. In this respect they were manifestly the heirs of the Romantics. They shared with them a vision of art which Delacroix expressed once in a tone near religious awe. The inspired painter according to Delacroix succeeded in imparting to his work 'that breath whose effect is that a painting ceases to be a painting in order to become a being, an *object* that occupies its own place in the creation, nevermore to perish.'[50] It was a similar sentiment of awe and wonder in the artist's ability to conjure up new beings from a state of non-being which overcame Nolde. 'To draw out of nothingness what was not there before – a wonderful feeling of godlike power.'[51]

Naturally, these painters did not imagine that they created out of nothing. What they understood by creation was the coming-into-being of an entity which heretofore had enjoyed no actual existence. This understanding of creation did not exclude the use of the representative element in art. Painters like Nolde and other Expressionists demonstrably depicted the forms and figures of nature in a manner admittedly much distorted but recognizable nonetheless. Yet even while representing familiar features of the external world they never believed that representation was the exclusive goal of

art. While creating a picture, all their attention was directed toward realizing a self-contained pictorial being which included the representative element as but one of its constituent members in an organic complex of parts and relations making up the whole. This whole or unit existed in its own right and not by virtue of those sections which bore a resemblance to nature. Kirchner expressed it simply: 'My pictures are not representations of things, but independent organisms composed of lines, planes and colours.'[52] Above and beyond its representative function, the painting, in other words, was a self-subsistent organized structure the aim of which was to provide a fitting object for contemplation.

Nonetheless, it was, of course, in non-objective art that this organic conception was carried to its ultimate conclusion. Ostensibly free from nature, the abstract painter gloried in his power to create another nature. In a tone of jubilation Kandinsky wrote: 'The creation of a work is the creation of a world' ('Werkschöpfung ist Weltschöpfung').[53] And a world thus created announced its unquestionable right to exist. 'Every serious work', Kandinsky insisted, 'resembles in poise the quiet phrase: "I am here." Like or dislike for the work disappears, but the sound of that phrase is eternal.'[54] Behind this exultation in the painter's power to cause pictorial objects does there not loom the cosmogonic analogue of the *Deus Creator* who fashioned heaven and earth for the sole, though somewhat insufficient reason, that something should *be* rather than *not be*? In any event, it comes as no surprise that Kandinsky, like the Romantics and the Idealists, should have compared artistic creation with the original divine creation. He stated it with the pomp and grandeur characteristic of the Expressionist.

> Painting is the vast thunderous clash of many worlds, destined through a mighty struggle to erupt into a totally new world, which is creation. And the birth of a creation is much akin to that of the cosmos. There is the same vast and cataclysmic quality belonging to that mighty symphony – the music of the spheres.[55]

Klee, as a rule more restrained, used similar parallels to illuminate the process as well as the products of artistic invention. Of the finished work he demanded that it be a 'formal cosmos which shall so completely resemble the great work of the creator that breath alone will suffice to turn an expression of religious sentiments into reality.'[56] The artist in turn Klee declared to be a 'child of the creator' whose playground was the universe and its productive forces. 'Just as a child imitates us in playing, we in our playing imitate the forces which created and create the world.'[57] Friedrich Schlegel a century earlier employed an almost identical comparison. 'All the sacred play of art is but a distant copying of the infinite play of the world, that work of art which is eternally fashioning itself.'[58]

Whatever analogues Kandinsky, Klee and others may have chosen – whether they evoked organic nature or the cosmogony to describe the birth and being of non-objective works – one of their main concerns was to stress the idea of abstract art as a generative power initiating new and self-sufficient forms whose final cause was to be, to exist and thereby contribute to being. As Klee put it: 'My hieroglyphs are not consciously conceived carriers of meanings. They are formations: autonomous forms among forms with a life of their own.'[59] This notion of art was at the root of their unsuccessful attempts to rid themselves of the label 'abstract.' Time and agin they insisted that their activity was not a process of *abstraction* as this is ordinarily understood; it was, on the contrary, a process of *concretion* in the sense that the non-imitative forms engendered in the artist's mind grew as spontaneously and lawfully into an organized whole as any natural form grew from its germinal state into a fully complete being. 'As there is not the slightest trace of abstraction in this art', wrote Hans Arp, 'we call it concrete.'[60] Hence Arp's designation of his sculptures as 'concretions' which he defined as the 'natural process of condensation, hardening, coagulating, thickening, growing together . . . Concretion is something that has grown.'[61] Kandinsky likewise urged the spectator to look on so-called

abstract art as a concrete art which made additions to nature. Appealing once more to the cosmos and its relationship to non-objective painting he wrote:

> Abstract art places next to the 'real' world a new one which externally bears no resemblance to 'reality.' Internally, however, it is subject to the universal laws of the 'cosmic world.' In this way a 'world of art' is placed side by side with the 'world of nature' – an equally real world, a concrete one. For this reason I prefer to name so-called abstract art *concrete art*.[62]

Elsewhere Kandinsky referred to abstract painting as a 'pure realism' for, unlike the conventional realism of representational art, it created new realities.

That abstraction is creation, the coming-into-being of unique concrete individuals which could be considered so many additions to nature, has become a cornerstone of non-objective art. The painter, wrote Braque, 'does not aim to produce an anecdote, but create a pictorial fact.'[63] The Cubist co-workers Gleizes and Metzinger stressed the same idea. 'Let the picture imitate nothing and let it present nakedly its *raison d'être*!'

> Essentially independent, necessarily complete, it . . . should lead (the mind) toward the imaginative depths where burns the light of organization. It does not harmonize with this or that ensemble, it harmonizes with the totality of things, with the universe: it is an organism.[64]

Wittingly or not, this passage resurrects the essentially Romantic-Idealist creed by proclaiming the freedom and autonomy of art; its generative power to produce living pictorial objects; its seeming capacity to convey a glimpse of the source of creation 'where burns the light of organization;' its explicit rejection of imitation and yet its harmony and inner relationship with the cosmos and its creativity of which, we can assume, it was supposed to be an emanation.

What remains is to draw some obvious inferences from the above conceptions. As an organism the work of art was a world on its own, a world whose existence was an end in itself and whose value was its intrinsic worth alone. Each painting was a self-sufficient system of internal relations governed by its own laws. Its truth and significance, in other words, rested not in its correspondence with external models, but with itself. To be judged and understood, therefore, it had to be perceived in and through itself with the spectator submitting to its life and laws while suspending for the time being the beliefs, customs and expectations which governed his life in the world of everyday. 'The key to the understanding of modern art is acceptance of the autonomy of the picture. This means that every consideration must be subordinated to the requirements of the picture itself.'[65] All such notions, seemingly initiative of twentieth-century art and criticism, were the natural concomitant of an organic aesthetics as originally formulated by Romantics and Idealists.

V. Artist and Nature

The organic theory helps us to understand some features of the artist's relationship to nature. In the case of Kandinsky, Klee and other Expressionists this relationship was none other than a magnified Romanticism whose path, briefly stated, led from external phenomena – outer nature – into inner living and productive nature, to primal nature or the *Urgrund* which each painter, as we shall see in the next chapter, comprehended in a manner peculiar to himself.

As for outer nature, it ceased to have any special hold over the artist. It supplied the stimulus and the raw material for his production, no more. The artist was far more concerned with inner productive nature to which he turned for confirmation and reassurance of his own endeavours. An 'intensive turn to inner nature' and with it a 'refusal to embellish outer nature' was one of the distinct hallmarks, in Kandinsky's view, of the 'revolution' in art.[66] The painter of

the new generation, declared Franz Marc, was no longer concerned with forms on their external side. He 'destroyed' them in order to discover the essence of nature, the spirit which dwelled within. 'We look for this inner spiritual aspect of nature . . . not from whim or caprice to be different, but because we can see it', as clearly indeed, Marc insisted, as the Impressionists could see nature's external coloration.[67] Klee expressed the artist's shift from outer to inner nature most succinctly. The painter 'does not attach such intense importance to natural form',

> he places more value on the powers which do the forming than on the final forms themselves . . . he is impressed by the one essential image of creation itself, as genesis, rather than by the image of nature, the finished product.[68]

These artists' relationship to inner nature warrants a more detailed treatment not only to reveal its essentially Romantic orientation, but also because it has become the source of much confusion, if not outright misunderstanding, insofar as they were frequently accused of being indifferent and hostile to nature. Marc repudiated such charges in the strongest terms. 'There is no more stupid, more absurd line of attack against us than the charge that we are cold or indifferent to nature.'[69] Quite the contrary! 'Dialogue with nature', demanded Klee, must remain a *sine qua non* for the artist.[70] Kandinsky was no less emphatic. 'The flight from the object does not mean the flight from nature in general. All art is subject to her laws.'[71]

What did such dialogue with nature involve? Kandinsky and, above all, Klee provide numerous examples. Dialogue with nature followed the familiar pattern of the artist immersing himself in the mysteries of natural growth and becoming. Both Klee and Kandinsky urged the painter to study intensively the laws and operations nature employed in the creation of forms. 'The knowledge of such laws', wrote Kandinsky, 'is indispensable for the painter.' It formed the foundation of his philosophical education culminating in 'the

recognition of the creative principle of nature and its inner relationship with art.[72] Kandinsky, as was remarked previously, put such precepts into practice by probing into the structures of diverse kinds of organisms ranging from cellular forms to spiders' webs and the skeletal basis of more complex organic formations.

Klee went even further. 'Busy as a bee collecting forms and perspectives from nature' reads an early entry in his diary.[73] Klee loved to surround himself with mosses, lichen, molluscs, crystals, shells, seed pods, stones, petrified plants, beetles, butterflies, all of which he studied with an eye intent on discovering how form comes into being. He called it 'journeying along the path of natural creation' from which much could be learned.

Klee described in great detail and with subtle ingenuity the path the painter must pursue. The path led always straight into the 'workshop of creation. That is where the secret lies.' He never failed to tell his students to measure everything by the natural process and its law. He would encourage them to contemplate an apple tree in blossom together with its roots, its flowing sap and rising trunk and then attempt to depict such interplay of states of growth on the plane of pictorial construction.[74] 'Lead your students to nature, into nature', he admonished a fellow art-teacher; show them 'how a bud is formed, how a tree grows, how a butterfly opens its wings, so that they will become as rich, as versatile, as capricious as nature herself.' The same painter he advised: 'Follow the ways of natural creation, the becoming, the functioning of forms. Then perhaps . . . you will achieve formations of your own, and one day you may even become like nature yourself and start creating.'[75]

An intimate dialogue with nature was maintained by other Expressionists. Nolde's statement expressed a sentiment shared by many. 'Whenever I felt that my feet were no longer on the ground, creating my Romantic-fantastic forms, I would get back to nature, put down my roots in the soil and humbly use my eyes to render what I saw.'[76] Each one of these artists practiced in his own way what Marc insisted the

painter must do, 'penetrate into the organic structure of things.' As his friend Macke put it: 'To look at plants and animals is to feel their mystery . . . To understand the language of form is to come closer to the mystery.'[77]

While Marc, Macke, Nolde, Kirchner and other Expressionists communicated with nature primarily by way of feelings and intuitions, Klee and Kandinsky at the same time studied nature with a cool scientific interest. The goal, as Kandinsky once expressed it, was the ability 'to *feel* and finally to *understand* the seemingly fragmented appearances in their organic interconnections.'[78] In this emphasis on feeling as well as on understanding nature as an organic manifestation, both Klee and Kandinsky were closer in spirit to Novalis, if not perhaps to Goethe. Novalis certainly was this unusual Romantic combination of the impassioned poet and the detached, dedicated naturalist.

Yet what precisely did the painter, notably the abstract painter, hope to gain from his naturalistic studies? Klee gave several answers. 'We learn to see what flows beneath . . . We learn organism.' Elsewhere he stated that the painter preoccupied himself with plant morphology, microscopy and palaeontology 'only for purposes of comparison, only in the exercise of his mobility of mind.'[79] Theoretical knowledge of nature's formative energies, insisted Kandinsky, provided the painter with the possibility of comparing 'principles of parallel and principles of contrasting developments' in art and nature.[80] Yet this is only half the answer. In a wider and more indefinable sense the artist not only looked to nature as an instructive example, but also as the medium kindling creative intuition. Kandinsky put it simply: 'If the artist has inner and outer eyes for nature she repays him in the form of inspiration.'[81] Klee was more expansive. The artist's intuitive understanding of nature's operations, his mastering of 'the essence, the *natura naturans*', in Coleridge's phrase, engendered a philosophical view of the world which served as the necessary basis for the creation of free and composite structures.

As the painter learns to observe and look deeply into nature he finds that the more he aspires to a metaphysical conception of the universe the more he is able to indulge in free creation of abstract images which go beyond something deliberately schematic and achieve a new naturalness, the naturalness of the picture itself. Then he has created something which is parallel to the work of God.[82]

Klee has given us a suggestive diagram in his essay 'Ways of Studying Nature.' It maps out the artist's progress in seeing and contemplating the world adding a few significant features beyond those which have been mentioned so far.

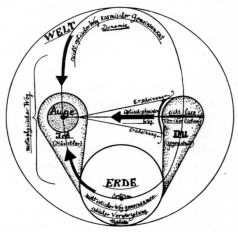

Auge	eye
Centrum	centre
Du (Gegenstand)	thou (the object)
Dynamik	dynamics
Erde	earth
Erscheinung	appearance
Ich (Künstler)	I (the artist)
metaphysischer Weg	metaphysical way
nicht optischer Weg	non-optical way
gemeinsamer irdischer Verwurzelung	of shared terrestial roots
kosmischer Gemeinsamkeit	of cosmic community
optisch-physischer Weg	optical-physical way
sichtbare Verinnerlichung	visible intensity
Statik	statics
Welt	cosmos

Klee's diagram represents a unity of subject, object, earth and universe. The unity was the result of the artist's more penetrating awareness of things. While the Impressionist's relationship to appearances (indicated in the horizontal arrow) was a purely 'optico-physical' one – from phenomena to the eye – the modern painter's perception, according to Klee, embraced the internal as well as the external existence of things. 'The object grows beyond its appearance through our knowledge of its inner being',[83] a knowledge which, as we have seen, the artist acquired by deeply probing into the forms and formations of nature. But, adds Klee, 'there are other ways of looking into the object which go still further, which lead to a humanisation of the object and create between the "I" and the object a resonance surpassing all optical foundations.'[84] Klee means that between the perceiver and the perceived an invisible bond, a relation of resonance, was set up by virtue of their mutual rootedness in the earth. Something flows into the artist from the elemental realm of nature. As Klee's diagram shows a 'non-optical way' leads from the perceived object to the communal depths, the centre of the earth, reaching the artist's eye from below which, aware now of the object's origins, related to it as a 'thou', a kindred spirit. Perception has become communication and communion, the recognition of one life pervading the terrestrial world.

While part of the earth and related to the object by kinship, the artist was yet part of something transcending the earth. His sympathetic communion with things led not only downward to shared roots, but also upward to the stars, the heavens and beyond. From things earth-bound the artist passed to those moving in the cosmos. He dimly realized the presence of one vast 'cosmic community' which extended to infinity. 'There is the non-optical contact through the cosmic bond that reaches the artist's eye from above.'[85] What reached the artist's eye from above was something spiritual. It expressed itself in his longing for liberation, his desire to achieve pure mobility. Both ways, the earthly and the cosmic, the way down and the way up, eventually fused at the

crossroad of the eye leading to a synthesis of outward sight and inner contemplation, to a metaphysical view of the world which inspired the artist to form objects in the image of creation.

Klee's diagram is a compelling demonstration of what was extensively treated in Chapters I and II – the artist's quest for wholeness. It reveals an organic sensibility which finds fulfilment only in a vision of unity encompassing spirit and matter, subject and object, things finite and infinite. Kandinsky's essay, 'Two Currents', should be read as a companion piece to Klee's explanation. Like Klee, Kandinsky focuses on the artist's intuitive perception of reality, what he calls 'the experience of the great and small connections which are of a microcosmic and macrocosmic nature.'[86] This experience terminated in the painter's awareness of the totality which Kandinsky declared to be essential for the production of non-objective art.

What Klee did not, nor perhaps could have shown in a diagram of this kind, was how the artist in and through studying nature's operations, in and through a vision of the whole, reached yet further to establish contact with the life-force itself, the primal source sustaining all. The latter was the final destination. In the last analysis all ways must lead to the original sources of creation. Klee is his own best, brief expositor. 'Our pounding heart drives us down, deep down into the *Urgrund*.' Not all, however, were destined to reach it.

> Chosen are those artists who penetrate to the region of that secret place where primeval power nurtures all evolution. There, where the powerhouse of all time and space – call it brain or heart of creation – activates every function; who is the artist who would not dwell there? In the womb of nature, at the source of creation, where the secret key to all lies guarded.[87]

Such aspirations bear eloquent witness to the rebirth of Romanticism in modern art. We shall deal presently with the artists' desire to live near the heart of creation for with it we

touch on one of the fundamental themes of Expressionism and abstract art.

* * *

To conclude this chapter, the resurgence of an organic aesthetics among the painters discussed testifies to the enduring Romantic heritage in Expressionism and modern art. Then as now, categories fundamental to organicism fostered characteristic and important criteria of evaluation and description; then as now, the artist was inspired to create like nature, to realize forms which owed their progressive determination not to an external, but an internal source of motion. The Romantic-Idealist heritage was no less in evidence in these artists' metaphysical beliefs according to which art was an autonomous yet eminently lawful activity co-extensive with the formative energies productive of the world. The artist participated in the universal process which through him achieved new levels of organization. As we have seen, this lofty view was ideally suited to support the enterprise of non-objective art.

The Romantic heritage in Expressionism does not end here. All-pervasive, it was present not least in the poet's and painter's fascination for things elementary and primeval which forms the subject of the next and final chapter. It is this fascination which provides a larger context for these artists' pronounced religious and philosophical preoccupations previously discussed. It is also this fascination which bears more directly on the pictures and poems themselves.

Part Five

Chapter Nine
The Attraction of the Primordial

I. The Metaphysically Primordial

Klee's urge to merge with the *Urgrund*, his longing to live near to the centres of Creation, reverberated throughout the Expressionist generation. It spoke of a deep religious need to be at one with the pristine forces of the world, forces freqently identified with God. 'Overflowing with God [*Gottüberströmt*]', wrote Heynicke, 'I set out to find the source of sources [*Ursprung*].'[1] Man, these artists urged, must advance toward the depth of existence in order to be reborn in the spirit. While they all longed to live near the sources of creation for the sake of spiritual salvation, some artists strove to express the life of the *Urgrund* itself. Their aim, more specifically, was to create primal images (*Urbilder*) of 'cosmic becoming', images which were supposed to conjure up visions of a fertile chaos believed to be at the heart of the world. Such intentions were present in both literature and painting.

Iwan Goll's poem entitled '*Schöpfung*' provides a typical example of the Expressionist poet's attraction to the primeval powers of creation.

Irgendwo zerbrach die Himmelsschale,
Und die Sonne wie verwundet,
Flatterte, Gold und Lava blutend
Um die aufgerissene Erde.[2]

This still retains a somewhat lyrical ring unlike Becher's orgiastic celebration of the chaos or *Urgrund* in lines such as these:

Bis ins letzte Glied der Welten züngelnd,
Körperkrampf und dionysische Orgie . . .
Heroische Aufbrüche. Himmelfahrten.
Untergänge
Und elektrische Sprialen-Sprünge kreuzweise
durchs schweflichte Chaos.[3]

The religious element with all these poets was never far from the surface. 'We are called to illuminate the primal source', wrote Däubler. 'Primal lust must lead us to the primal glow.'[4] In Däubler's poetry all strains back to the world of first creation. Overcome by cosmogonic visions, he piles words upon words until language 'explodes' like the chaos it seeks to evoke.

Und Sturm und Wogen klommen jäh empor auf Lavahängen.
Und Lustsuchtwucht und Ursprungsqual erstürmten starre
Risse
Die Blitze mussten Dunst und Nacht mit einemal zersprengen:
Ganz athemlos kam ein Orkan . . .
 Und alles drang nach oben.[5]

This turgid rhetoric is spread over ten thousand verses assaulting and finally drowning the senses in a deluge of words. Violent, volcanic, anarchic, Däubler's poetry was an art truly chaos-drunk and *Urgrund-krank*. Only here and there did it succeed in conveying some kind of cosmic vision.

An intoxication with the primordial characterized Expressionist painting as well. To recall Nolde's words: 'I draw and paint to grasp something of the primal essence.' Everything primeval, he added, captivated his imagination.[6] Nolde invariably associated the *Urgrund* with the elements of nature and with the mythical regions of Norse legend peopled with giants and goblins, witches and earth demons ruled over by ancient Pan – that Pan which in some pictures

E. Nolde: *Before Dusk*

miraculously turns into the figure of a crude, peasant Christ. A true pantheist, Nolde looked to the sea, the winds and the skies for the original powers of creation. His archaic seascapes and storm-tossed oceans seem to reach far back to the world's first dawn.

It is possible to relate Nolde's sea and cloud pieces to Turner's atmospheric visions of nature. Both painters were drawn to the fury of the elements. Both became increasingly preoccupied not with painting landscapes, but with painting visionary statements about nature's creative and destructive forces underlying natural appearances. It is as though each one strained to return to the primal flux of things which negates the separate identity of objects. William Hazlitt's shrewd observation concerning Turner's painting of his middle period could just as well have applied to Nolde. 'They are pictures of the elements of air, earth and water.'

The artist delights to go back to the first chaos of the world, or to that state of things, when the waters were separated from the dry land, and light from darkness, but as yet no living thing . . . was seen on the face of the earth. All is without form and void. Someone said of his landscapes that they were *pictures of nothing and very like*.[7]

The last sentence has a familiar ring. It sums up what many a hostile critic remarked about Nolde and other Expressionists who veered toward the elementary and the abstract.

Nolde's various pictures of the sky and the flat plains of his native Schleswig-Holstein are also reminiscent of some paintings of Caspar David Friedrich (*Ill.* page 2). He shared with Friedrich a mystical or 'oceanic' feeling for the majesty and magnitude of nature. Over their compositions of vast expanses and unbounded horizons hangs the brooding presence of a 'Northern infinite' which obliterates everything particular and finite. Individual existence is lost in the depth of the universe, in the contemplation of its procreative forces.

Nolde's ecstatic religiosity, his primitive obsession with the 'Panic' element of nature separates him from both Turner and Friedrich. 'I believe in the flame that burns inside the earth, and its relationship to human beings. It seethes and boils with eruptions and earthquakes.'[8] The same 'flame' transfigured his representation of man. Nolde shows him with a mask-like, hallucinated face prey to primitive passions and feelings. He shows figures of dancers stamping the earth, their bodies shaken by uncontrollable convulsions. Such paintings corresponded with the desire for 'absolute authenticity, the intense and often grotesque expression of force, and life forms simplified to the utmost.'[9]

Nolde represented a type of man that Heine once attacked in the German Romantic, a creature as he put it, who 'will form an alliance with the chthonic powers of nature', who 'knows how to invoke the daemonic powers of German pantheism.'[10] In Nolde's art we have indeed German Expressionism at its most Teutonic. Of barbaric strength and vigour, it was an art born of passion, instinct and memories

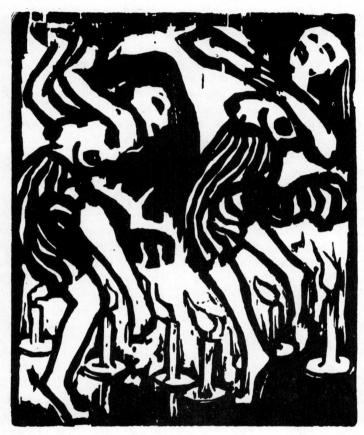

E. Nolde: *Candle Dancers*

which longed for the land of myth, the legendary depths of nature. It made few concessions to sensual charms. Harsh, strident forms and colours aim to re-enact the fury, clash and violence believed to be at the core of things. 'Nolde', wrote Klee, 'that primeval soul, he is more than just primordial, he is also the demon of this region.' Although Klee believed he himself belonged 'somewhere else' he always sensed in him

the 'cousin of the deep.' In the final reckoning, he acknowledged, it was the same 'heart of creation' which was 'beating for all.'[11]

In Klee's case it was beating, of course, in harmony with nature's mobility and infinite versatility. If this painter had any distinct visions of the *Urgrund*, the 'secret place where primeval power nurtures all evolution', it was surely in the form of a fecund cosmic cell from which sprouted exotic poetic worlds in rich profusion. In Klee's works the recurrent images are nearly always related to growth and becoming, with growth thought of as 'a spread of energies . . . on all sides.'[12] Klee's aim on canvas was always to transform substances into processes – flowers into 'flowering', blooms into 'blooming' – through a pictorial transaction which fused the inner and the outer, emotion and motion into a living new creation. Even his titles sometimes provide a bridge to his intentions. Drawings and paintings carry such poetic captions as *Face of a Blossom, Ringing of the Silver Moon, Tree Rhythm, Spiral Blossoms, Flower Myth, Botanical Theatre, How it all grows*. How it all grows! This phrase sums up Klee's utter enchantment with the inventiveness of nature, the inexhaustible genetic force active in creation. It was this genetic force that he tried to capture in his pictures, pictures commemorating 'genesis eternal.'

As we have seen, an art such as this was not concerned with representation. The artist was more impressed with the powers of creation than with 'the image of nature, the finished product.' The same applied, of course, to the human form, the image of man. Although part of nature, man to Klee was merely 'a cosmic point', a tiny leaf on the growing tree of evolution. The painter, following the path of evolution, looked beyond the world of man. 'Flying off into the infinite', he cast off all earthly bonds, escaped from 'constraint into pure mobility' from which he contemplated life as an eternal becoming emanating from a 'sancta ratio chaotica' as Klee once named the primal centre of creation.[13]

Klee realized he stood on the shoulders of the Romantics. He well knew their desire to live near 'the womb of nature',

P. Klee: *Botanical Garden*

to create from the depths of the *Urgrund*. He praised them for having transcended the 'earthbound' sphere and the constraining 'forces of gravity.' Yet he wanted to go further, 'as far as the cosmic . . . to the Romanticism that opens up the universe' – to the 'cool Romanticism' of abstract art which hinted at the forces that created and create the world.[14]

Unlike Klee's conception of the *Urgrund* as a source of eternal becoming ceaselessly creating new and marvellous forms, Franz Marc's vision of the primal force was more akin to the 'blessed unity' of the mystic, the original oneness of creation to which all things returned after exile in the particular. For him it was the form beyond all forms, the 'indivisible . . . unearthly being' which knew no bounds or limits, no division or separation. At one stage of his brief life Marc associated 'indivisible being' with the being of the creature, the animal. This phase culminated in his well-known 'animalization' of art which was an important step on his way toward abstraction.

To understand Marc's artistic development from the objective to the non-objective we must briefly touch on his view of man and beast. Of the two he preferred the beast. Human kind stirred little kindness, let alone affection, in him. Indeed, Marc found man 'ugly', because man of all living creatures was prone to vanity, prone to subscribe to a cult of individuality which made him insist on his separate, exclusive identity. Implicit in Marc's view was also a kind of metaphysical despair over man's exclusion from the unity of creation. Man's very being, as it were, caused a split in being. Forced to bifurcate things into 'subject' and 'object', driven to multiply distinctions, man constantly dissolved the unity for which he yearned into an impotent plurality.

How unlike the animals, Marc proclaimed! Their life was a being at one with things. To these innocent, unself-conscious creatures was given the gift denied to man: to behold the world's primeval light, to move with the rhythm of creation, to live in a warm immediacy undisturbed by the mediation of reflection. 'With nature never do *they* wage a foolish strife', wrote Wordsworth.[15] Predictably this envy for the animals' seeming inclusion in being begins with the Romantics. Then and now it was part of a desire to fuse with plants and trees to escape exclusion and with it isolation.

Among Marc's contemporaries, Rilke provided a poetic parallel to what this painter strove to express in his various pictures of cows, bulls, deers and horses.

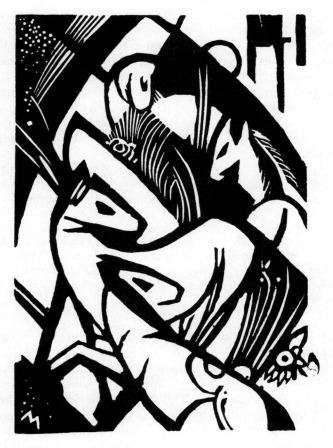

F. Marc: *Jumping Ponies*

With all its eyes the creature-world
beholds the open. But our eyes, as though reversed,
encircle it on every side, like traps
set round its unobstructed path to freedom.
What *is* outside, we know from the animal's
 face alone.[16]

Yet Marc was soon to become disenchanted with idealizing the beast as 'confidant of the whole.' Although far better and purer than man, even animals, he sadly mused, carried the curse of vanity, the disease of 'individuality' which prevented their participation in the unity of creation. No earthly form and being, in Marc's view, was in the end capable of hinting at the 'unearthly being' which lived behind all things. To evoke its presence, the painter had to discard all representational forms for the far more meaningful and suggestive forms of non-objective art.

In a remarkably revealing passage Marc summed up his reasons for turning from the impure, corrupt world of man and beast to the purity and freedom of abstraction.

> Quite early in life I began to feel that man was ugly, beasts seemed far more lovely to me. Yet even in the beast I found so much that was ugly and repulsive, that an inner urge instinctively caused my representations to be more and more schematic and abstract.[17]

Marc's dissatisfaction with the world of things ultimately extended to flowers, trees, to everything on the earth which progressively showed him their 'ugly and repulsive sides until suddenly I became fully conscious of the ugliness and uncleanness of nature.'[18] This was not the voice of a grim-faced misanthropist projecting his hatred and contempt for man onto nature, but the mystic's lament over the privation and imperfection of created material being. This kind of mysticism can never rest content with the world as it is. It views all finite forms as carrying the cross of particularity. 'Everything is constrained and in bondage', wrote Marc. 'It is not true that the chair stands; it is held; otherwise it would fly away and unite with the spirit.'[19] Man's fate and that of things was to 'disbecome', to shake off the fetters of determination in order to merge once more with that absolute non-determination which was the world's source and sovereign good. A similar vision made the Romantic Gotthilf Heinrich

Schubert deplore the frailty and ungainliness of determinate being. All things had to be led back to their beginning where, 'not yet broken into particular, finite form', they revealed 'the divine primordial life' of the *Urgrund* 'and not the impotent life that belongs to merely individual, symbolic existence.'[20] Such visions were not entirely unrelated to the Neo-Platonist's conception of the soul on its way home from the dark world of corporeal being to the ethereal light of the 'supreme one', the 'primal fountain of life.'

It was in response to longings of this kind that Marc's art became increasingly 'schematic and abstract', devoid of recognizable forms and objects. Influenced by Delaunay, he aimed at a form of pictorial 'Orphism' which strove to distil suggestive ciphers of the world's 'inner mystical construction.' His picture series of 'playful', 'broken', 'serene' and 'battling' forms shows him rather unsuccessfully groping for such ciphers.

Marc's life was cut short at Verdun. As with so many other poets and painters who perished in the First World War, his work remained incomplete, a promise. His very last drawings sketched while serving at the front concentrate on cosmogonic events. Never before was a theme so vast compressed into so modest a scale. Some of these pencil studies like the two versions of *Strife* depict the conflict and convulsions of matter as yet untouched by a divine spirit. In his writings of the time he speaks of visionary experiences which occasioned drawings such as these.

> Strange forms all around me, and what I saw I drew: harsh evil forms of black, steel-blue, and green, colliding head on. It was excruciating. All things were fighting with one another, contorted with suffering. It was a terrible sight.[21]

The majority of these sketches for future compositions are joyous in spirit, however. They return to a world of first creation free from the pain of finitude and separation. There is even a kind of progression in this pencilled cosmogony in

F. Marc: *Arsenal for a Creation* *Magic Moment*

miniature. Thus the *Arsenal for a Creation* points to the *Magic Moment*, that of the almighty *fiat*, which awakens the *Sleeping Forms* of the chaos to life. Light begins to triumph over the dark forces at the heart of things. *Plant Life Coming into Being* – a drawing remarkably close to Klee's poetic pictorial fantasy – and *The Days of Creation* continue the cosmogonic cycle of the world's original beginning. *Easter* was inspired by messianic expectations, the belief in resurrection and salvation.

In scope and meaning, Marc's lofty visions recall the ambitious project of the Romantic painter Philipp Otto Runge to paint the 'Cosmic Source' and the 'Times' symbolizing man's seasons and those of the world in their recurrent cycle of dying and becoming. Like Marc, Runge left behind only fragments. Unlike Marc, he still expressed his

theme in the form of traditional Christian symbols. With Kandinsky's painting of the 'dramatic' period we reach the peak of an art wedded to the primordial. Whatever notions this painter entertained 'concerning the spiritual in art', it certainly included a concept of painting creating paradigms of *Welten*, pictures orchestrating a world in the throes of violent becoming. To be sure, Kandinsky was not as explicit on this point as were both Marc and Klee. Frequently, his intentions have to be pieced together from various sources. He provided one clue, of course, when comparing the coming-into-being of the work of art with the coming-into-being of the world. This comparison expressed Kandinsky's belief that the artist's creation re-enacted unconsciously the drama and struggle of cosmis creation, the 'vast and catalysmic quality', as he put it, 'belonging to that mighty symphony – the music of the spheres.'[22] Another important clue is found again in a previously quoted passage where Kandinsky in his description of *Deluge* (Composition VI) held forth on the universal forces of creation and destruction. It is fitting to recall those words: 'What appears to be an event of great destruction is in reality just as much a complete and uniquely resounding song of praise as is the hymn of creation which follows destruction.'[23] Next to its apocalyptic and messianic implications already discussed, this passage clearly worships the spirit of creation itself, a spirit at home in the chaos which it ceaselessly forms into a new cosmos.

Numerous pictures of the 'dramatic' period would seem to be efforts to embody visions of this kind. They reveal Kandinsky at his 'chaotic' best. In all these works, the plane on the canvas has become the scene of a barely restrained violence. Darting, restless lines and shapes, swelling and contracting fields of colour defy any resolution or definition into recognizeable forms. Memories of objects have been blotted out with the exception, perhaps, of some chance associations here and there. The earthly appears to have given way to something vaguely cosmic. 'These pictures', wrote Grohmann, 'leave no doubt that Kandinsky regarded

the execution of a painting as a cosmic event',[24] an event supposed to communicate visions of elemental powers set free, of cataclysmic collisions, of titanic forces moulding a kind of primal flux. Most critics of the time indeed interpreted Kandinsky's paintings in this way. In front of these pictures the viewer was invited to witness a divine energy at work in the vast laboratories of creation. One spellbound critic, reviewing an abstract wood-cut of Kandinsky, was moved to the following effusions:

> Steaming powers rise from unknown depths, a brightness burns from unknown heights; a wildness circles through an eternal storm; the Great attacks the retreating Small; masses wrestle for air and space; . . . The earth turns into a shining firmament, a conflagration of world creation . . . [through which mankind] knows itself to be at one with that primal power which at the beginning raised mountains.[25]

This gushing reverie reminiscent of Daübler's turgid style was rather common, and to this day has not disappeared altogether. Kandinsky's paintings still elicit verbal ecstasies among contemporary critics. Marcel Brion, the French high-priest of non-objective art, describes this painter's dramatic compositions, for instance, by deliberately leaning on the pen of the Psalmist. 'It was', he wrote, 'as though Kandinsky had unleashed natural forces like volcanoes, hurricanes and tidal waves and disciplined them through his spiritual authority, taming and freezing them in their seething nostalgia for the infinite.'[26] The nostalgia in this context was surely that of the critic transferring his yearning onto the painting. The blame for such Romantic effusions rests with Kandinsky. His writings with their repeated and often unspecified references to both the cosmic and spiritual greatly encouraged interpretations of this kind.

Even after the sound and fury of Kandinsky's compositions prior to the First World War gave way to the more calculated imagery of the so-called 'calm period', the 'period of circles' and the 'Romantic period of concrete art', this painter still

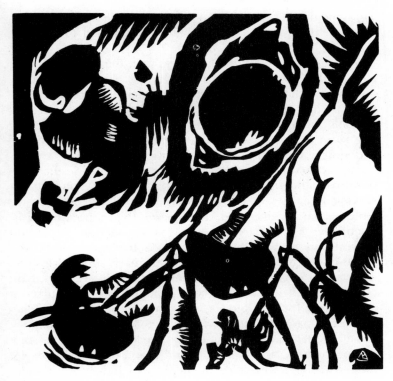

W. Kandinsky: *Woodcut*

understood his work as hinting at the primordial forms and forces of the world. The circle, for instance, of which he made excessive use at one stage, was seen as pointing 'most clearly to the fourth dimension.'[27] It was a cosmic figure, perhaps for no other reason than that it reminded Kandinsky of the music of the spheres. During his 'Romantic period' again Kandinsky stressed the total submission of non-objective art to the laws which govern the cosmos. Hence the viewer was said to receive 'a cosmic impression.' This was the time Kandinsky was dreaming of the 'coming Romanticism'

as something beautiful and joy-giving – Klee's 'cool
Romanticism' presumably, which was supposed to disclose
the inner forces of the world.[28]

To sum up, with all these painters then the movement was
backward to the sources, to the beginning, to what each in his
own way believed to be the primordial powers active in
things. Their aim was to realize Runge's dream to 'create
symbols of our thoughts of the great forces of the world.'[29] In
one form or another each one applied what A.W. Schlegel
laid down as the informing impulse of Romantic art: its
'secret attraction to a chaos which lies concealed in the very
bosom of the universe', a chaos or *Urgrund* 'perpetually
striving after new and marvellous births.'[30] In the case of
Nolde, Marc, Klee and Kandinsky this attraction was
essentially a progression from representation to non-
representation, from the object, that is, to the non-objective.
It was based on the assumption that to reach and express the
'heart of creation' meant to transcend visible creation. Not
every work produced by these painters was, of course, a
conscious effort to glorify the powers of creation. The
individual paintings themselves were often occasioned by
something far more mundane – an impression received from
nature, or a particular earthbound mood or feeling. Yet in
their form and formation such pictures indeed aspired to
express the cosmic.

To what extent, if any, were such aspirations crowned with
success? Klee perhaps comes closest to conveying something
of the genetic versatility and mobility of nature in images that
are poetic, fantastic, weird and whimsical. As to Marc's
'Orphic' type-forms and Kandinsky's 'cosmic landscapes'
they will, no doubt, conjure up an *Urgrund*, or 'holy chaos',
to some – to all those in dire need of one. In this context, it
becomes necessary once more to isolate vision from
representation, promise from performance. What is clearly
evident with pictures of this kind is the glaring disparity
between the artist's lofty aims and the work of art itself, the
disparity, in other words, between so humble a thing as a
painting and its exorbitant claim to express a primordial

cosmic force. Whatever the aesthetic merit of such paintings, we must separate it from the artist's professed metaphysical intentions which only lead the spectator to search for cosmogonic meanings instead of concentrating on the qualities of the forms and colours themselves. As was stressed previously, works of this kind should be perceived *as* paintings and not as cosmic revelations.

What of the artist's intentions themselves? In the hostile critic they may well prompt a reply such as this:

> You have seen the primal being . . . But you have stopped there. You have not seen the order of the earth and the heavens blossom forth from the mixture of this universal mud . . . No origin is beautiful, true beauty is at the end of things.[31]

The words are those of Charles Maurras, uttered once in opposition to the Symbolist's search for the mysterious sources of creation. The creed expressed is a kind of militant classicism fiercely opposed to the Romantics' retreat from the finite. Discounting its doctrinal assertion that true beauty was to be found only at the end of things, Maurras' criticism of exclusively searching for the truth of the world at its sources or beginnings has lost none of its force. It certainly applies to the Expressionsts' one-sided worship of creation as genesis at the expense of man and nature, the created products.

II. Aesthetic and Cultural Primitivism

The Expressionists' attraction to the primordial leaves a wide field for speculation and conjecture. Where it took a dramatic and apocalyptic form, some critics, for instance, have explained it even as a premonition of the First World War. Such readings are particularly common with regard to some works of Meidner, Marc and Kandinsky. The violence and fury these painters created on canvas was supposed to

have foreshadowed the fury and destruction of events to come. Unless one is prepared to accept the artist as prophet and seer for which there is precious little evidence in fact, explanations of this kind lack all conviction. A more fruitful approach may be found in interpreting these poets' and painters' attraction to the primordial as part of a larger cultural dynamic, a dynamic which, crudely sketched, expresses itself in the following way.

Whenever old forms and symbols have become stale, when life has retreated to the surface of things, when man finds himself a stranger to his fellow men, to himself and to the universe in which he lives, a compelling urge drives him to seek out the chthonian, the primeval. Memories and instincts deeper than thought thrust him toward a chaos from which he hopes to wrest a new cosmos, a new sense of being and belonging. This return to mythic origins, to the deeps of the *Urgrund,* can be observed sporadically throughout history. It is particularly evident in periods of cultural transitions or when civilizations reach a marked degree of complexity. Although prominent in such periods it was usually kept at bay, however, by the opposing forces of Graeco-Latin humanism, the innate tendency of which was to strive for harmony and integration. It is only with the coming of the Romantics that man began to respond wholeheartedly to the calls of the *Urgrund.* In the wake of Romanticism this fascination with the hidden depths of existence reached a prominence and significance never enjoyed to that extent before. It crystallized into a new metaphysical conception, the daring projection of a 'world ground' no longer envisaged as *logos*, form, idea, but as an a-logical, formless energy, a creative chaos at once sinister and sacred, demoniac and divine. The chaos henceforth was conceived, in the words of Jacob Boehme, as the *mysterium magnum*, the source from which flowed all light and darkness in an eternal procession. Schelling identified it with the absolute itself. 'The absolute . . . is the original chaos', a coincidence of 'absolute form and formlessness.'[32] Whatever its metaphysical ramifications, foremost of which was the substitution of a

philosophy of becoming for a philosophy of being, psychologically this conception baptized instincts, passions and feelings in the name of powers pristine and primeval. It unlocked the 'night side' to man's nature, to all those formerly repressed or contained drives and propensities which craved for consummation with the boundless, the formless and the primeval. Their triumph in Romanticism signalled the end of the classicist's and humanists' cosmos, the belief in an ordered harmonious universe in which man, master of himself, dominated the non-human forces surrounding him. This view of man and the world was never to return again.

In wedding man to a chaos, the Romantics wedded man to the chthonian element in himself and in nature without, to everything that was primordial in existence. They looked for it in the torrents of the sea, atop icy mountain heights, in storms, moonlight, mystery and magic, as well as in the cavernous regions of the unconscious and in the violent stirrings of primitive passions and feelings. In all these potencies they recognized the presence of the primordial, the power of the 'original chaos' that constituted the world. It was an altogether new way of perceiving reality. It instinctively gravitated toward the depth, the mysterious core and centre of things, the elementary forces of creation, the *Urwelt* in all its awesome and sublime splendour.

Ever since Romanticism poets, painters and writers have increasingly turned to this *Urwelt* whenever they felt the springs of life were drying up. Loti, Conrad and Melville, for instance, sought it in the wildness and vastness of the sea, Gauguin in the primitive forests of Tahiti, Van Gogh in gyrating, primordial suns, Wagner in Nordic myth and in an oceanic kind of music. A group of German poets known as the *Chaotiker* appealed to it directly in verse and song. The list is far from complete. Among German artists the lure of the primordial was felt more keenly. Rootless in their own culture, not noted generally for being securely at home in this world, they strained back to an *Urwelt* to get a new bearing on life. Hermann Hesse expressed it lucidly in one of

his essays soon after the First World War.

> [We must] accept the chaos that is to come. We must return to
> the realms of disorder, of the unconscious, of formless
> existence, of brute life and far beyond brute life to the
> beginning of all things . . . in order to be able to bring about
> a new creation, valuation and distribution of life.[33]

This note was sounded throughout Expressionism. It was the
craving to start afresh 'with a new innocence, a new
unconsciousness.' Expressionism in this respect was a 'flight
into primal conditions.' It was a flight into primal conditions
not only in the restricted sense of searching for the cosmic
and the cosmogonic, but in the far wider sense of the poet
and painter trying to shake off the 'fetters' of civilization in
order to recapture more immediate and original modes of
vision, sensing and feeling. This flight into primal conditions
revealed itself not least in the Expressionists' fascination for
the prefix '*ur*'. With the exception of the Romantics, never
before was this prefix endowed with such magic splendour.
Attached to various meanings, it was supposed to evoke the
archaic, the archetypal, the quintessential, the exotic, the
primitive, the mythical, the divine, as well as the biblical Ur of
Chaldea which is its etymological root.

 This fascination for everything primordial could express
itself in one and only one form: as aesthetic and cultural
primitivism, a primitivism which was based on the assumption
that the eminently complex surface patterns of modern life
were reducible into something far more simple, basic and
elementary, something not only more pristine and original,
but also more emotionally compelling. To use Robert J.
Goldwater's description of primitivism in modern painting, it
was the widely accepted belief 'that the further one goes back
historically, psychologically, or aesthetically the simpler
things become, and because they are simpler they are the
more interesting, more important and more valuable.'[34]

 Stylistically, aesthetic primitivism in Expressionist painting
was distinguished for its use of simple, basic, often savage

forms and rhythms applied without deliberate concessions to artfulness or sophistication. The painter tended frequently to rely on blunt, linear and heavy shapes, on flat, broad areas of bright, contrasting colour which defied traditional perspective. Simplicity, basicness, directness were the key words in this artistic transaction. Klee, although at times his art seems to belie such objectives, spoke of 'reduction' as the 'ultimate professional insight.' Marc, Macke, Kirchner, Kokoschka, each strove, in the words of Nolde, for 'intense . . . expression of force and life forms simplified to the utmost.' Kandinsky once praised some Persian drawings for their 'simplicity to the point of barbarity.' This phrase sums up much of Expressionist painting. According to Kandinsky, one of the reasons for the rise of abstract geometric painting was the artist's effort 'to reach back to the elementary, and to seek this elementary not alone in itself, but in its structure as well.' He insisted that this attitude of seeking for the elementary was characteristic of the 'new individual.'[35] Simplicity and directness were also the aims of the Expressionist poets. 'They are direct. They are primitive. They are simple, because simplicity is far more difficult to achieve than complexity and leads to the greatest revelations.'[36] In short, what is simplest and most immediate is also the most expressive and revealing.

Iconographically, the primitivism in Expressionist painting went beyond its metaphysical manifestation previously discussed; it extended to other forms of subject matter, to representations of still life, animals, landscapes and man. Whatever subject the artist selected, one of his aims was to evoke some original or mythical state of the object presented on canvas. When they painted nature, for instance, it was nearly always a pristine nature of forests, lakes, plains, mountains and seas – a rural or maritime habitat, in short, divorced from the artifice and complications of a technoid culture, a primitive environment which still enveloped and protected man. We see this theme expressed in Nolde's brooding landscapes and earthbound, frenzied dancers, in those numerous scenes of bathers beloved by the painters of

E. L. Kirchner: *Woodcut*

the *Brücke*. An admittedly common theme ever since Cézanne
and the *Fauves*, it is treated now with a frankly pantheistic
intent. The figures are wholly absorbed in the landscape and
its particular mood. Nothing separates them from their
setting. They fuse with the foliage of the trees or with the

swelling curves of hills and dunes. Bodies and faces lack any formal and psychological differentiation. Their unself-conscious nudity hints at a desire to return to a primitive purity when man and nature were one.

As early as 1908 Franz Marc wrote: 'Now I paint nothing but the simplest things for in them alone lies the symbolism, the pathos and mystery of nature.'[37] As we have seen, Marc at one stage searched for the pathos and mystery of nature in the beast. Who but a Romantic primitivist would attempt to interpret the world *sub specie animalis?* 'How wretched, how soulless, our convention of placing animals in a landscape which belongs to *our* eyes, instead of sinking ourselves in the soul of the animal in order to intuit its own sphere of being.'[38] Like all true primitivists, Marc does not represent the individual horse, cow, deer or tiger, but a generalized form, a kind of mythological archetype possessing a quasi-totemic meaning. The animal becomes the link through which man establishes a mystical rapport with the universe.

The same primitivizing tendency comes to the fore in these artists' treatment of religious themes. The event depicted concentrates on the essential supernatural emotion and not on the natural circumstances surrounding it. Bodies are drawn with a stark, monumental simplicity reminiscent of Romanesque or Byzantine models. The heads are large, the faces depicted frontally and schematized, the features contorted and dominated by dilated pupils staring inward and beyond to a drama which transfigures their whole being. It is the world seen through the eye of the ecstatic visionary, apostle, prophet, saint and repentent sinner – the world we associate with primitive Christianity. (*Ill.* page 220).

But what of the many city-subjects found in Expressionist painting – cafes, street scene, prostitutes, clowns and nudes? If we look closer and beyond their aesthetic surface, the primitive here consists in the artist's often brutal effort to strip down surface layers of conventions, to paint the life of the city and its people nakedly.[39] Men and women are either shown as corrupted by false refinements and artificial desires, or they are shown free from the artifice and decadence of

K. Schmidt-Rottluff: *Christ and Adultress*

civility, creatures of compassion as well as of impulse and
unbridled sexual passions. Implicit in this humanistic subject-
matter was invariably a view of man as natural, spontaneous
and capable of powerful feelings not yet diluted by the
ennervating influence of civilization.

In form and substance then, primitivism appears as a
decisive feature of Expressionist painting. The same is true of
Expressionist poetry. It was not a consistent, nor uniform
primitivism by any means. That of the *Brücke* painters, for
instance, was far more direct, spontaneous and violent
compared with the more subtle elementarism of the *Blaue
Reiter* which admitted of greater internal differentiation in
theme as well as in technical execution. No sharp boundaries,
however, can be drawn. In the last analysis, each artist
pursued the primordial in his own way through forms and

subjects best suited to his temperament and general conception of the world.

Not surprisingly, the aesthetic and cultural primitivism prevailing among Expressionists frequently merged with *chronological* primitivism, i.e. the glorification of a distant past conceived as an original state in which man lived in an instinctive, unbroken harmony with nature. Hence Hermann Hesse's definition of Expressionism as the memory of man's 'primordial home.' In Gottfried Benn, as we saw, it expressed itself as a craving to return to the 'prehistory of reality', to a realm of pure sensation as it existed before the beginning of time. 'O that we might be our ancestor's ancestors. / A little ball of slime in a tepid moor.'[40] Naturally, few Expressionists desired to turn into amoebae to experience the sensate bliss of mindless being. Yet nearly all of them felt the pull of the prehistoric past and were troubled, in Alfred Doeblin's words, 'by the powers of ancient times.'[41] The knowledge of eras long gone lay heavy on their restless minds. 'We have crevices in ourselves some of which go back to the Ice Ages; others which coincide with the birth of Christ . . . through our fathers and mothers we descend from far back.'[42]

It was precisely this historical awareness, of course, which was the fateful wedge preventing the Expressionist from becoming the new, unself-conscious modern primitive. Unable to blunt the sharp edge of consciousness, unable to abolish time and the knowledge acquired by civilization, he turned into a primitive voyager endlessly travelling between the metropolis and ancient Atlantis, 'longingly oscillating', as one put it, 'between city and jungle', at home in neither.[43]

III. Primitive Art

The Expressionists' search for primordial sources predictably led to a preoccupation with primitive art. It throws some additional light on these artists' longing to recapture a new innocence. Their preoccupation with primitive art embraced

not only its archaic manifestations, the artifacts of aboriginal man and the creations of peoples remote in time and place, but also the art of children and peasants. Primitive art in its narrow sense exerted a powerful influence on the painters of the *Brücke*. Kirchner and Nolde were deeply moved by African and Oceanic sculpture as well as by forms of Oriental art. Nolde spoke rhapsodically of the 'insight' gained and the 'liberation' achieved by them. 'We no longer looked on these creations as curiosities', he wrote 'but as an austere primal art giving joy.'[44] What the *Brücke* painters admired in primitive art was its power of expression, its direct emotional appeal. Its external appearance pointed the way to a new elemental simplicity, or if not that, it suggested different and unconventional solutions to compositional problems. On its symbolic side, its remoteness, mystery and magic appealed to the artist's own sensibility, his desire to restore a magical cosmos in which self and things, God and man were reconciled once more.

The *Brücke* painters were frequently accused of creating a forced archaic style. Where this took place, as one suspects it occasionally did in the case of Pechstein, it was, to put it mildly, a contradiction in terms, for while the artifacts of primitive man sprang directly and unself-consciously from cultic and religious sources, the modern artist pursued it as 'art' which required laborious and self-conscious manipulations. On the whole, however, there can be little doubt as to the genuine primitivistic character of their works all of which, in Max Dessoir's phrase, expressed a desire for 'rootedness, spontaneity and untrammelled self-expression.'[45]

The influence of primitive art on the painters associated with the *Blaue Reiter* was, if anything, more pronounced. Its significance can easily be measured by the space it occupied in the almanac or year book from which the association took its name. In this ambitious manifesto edited by Kandinsky and Franz Marc we find side by side with their own works and those of other modern artists illustrations of artifacts, figures, masks, designs and emblems drawn from an extraordinary variety of periods and places: from Egypt, Africa, Alaska and

ancient Greece; from Persia, China and Japan; from Borneo, Brazil, Cameroon, the Easter Islands, New Caledonia and the Malay Peninsula. In addition, we also find reproductions of German medieval wood-cuts and sculptures, Byzantine mosaics, Bavarian glass painting, Russian folk art, votive pictures and children's drawings. As the startling diversity of selections indicates the 'primitive' here has been given a far wider meaning. It embraced everything, in Kandinsky's words, 'suggestive of inwardness', every form of art, that is, which was the natural and unself-conscious expression of sincere feelings.

In comparison with painters of the *Brücke*, the *Blaue Reiter* artists were not only better informed about the art of primitives, peasants and children, they also pondered more deeply about its origins and its significance in relation to their own works. Franz Marc set the tone when he wrote of the 'new mysticism' that 'awoke in the soul and with it the primordial elements of art.'[46] Marc was overwhelmed by what he found in the Ethnographic Museum in Berlin. In a letter to his friend August Macke he conveyed his own characteristic brand of cultural primitivism inspired by his excitement for African and Peruvian sculpture.

> We must be brave and turn our backs on almost everything that until now good Europeans like ourselves have thought precious and indispensable. Our ideas and ideals must be clad in hairshirts, they must be fed on locusts and wild honey, not on history, if we are ever to escape the exhaustion of our European bad taste.[47]

Macke responded in kind in the article he contributed for the *Blaue Reiter* almanac. There he praised the art of children and of aborigines 'who have their own form, strong as the form of thunder.' Macke sincerely believed that their own paintings were 'similar in kind to the carved and painted pillar in a Negro hut.'[48] This naive faith alone would earn him a place of honour in the primitivist's pantheon.

Marc's longing to return to a state of innocence free from

the disastrous influence of European civilization has a curious parallel in an early entry in Klee's diary. 'I want to be as though new-born, knowing nothing about Europe, nothing, knowing no pictures, entirely.without impulse, almost in an original state.'[49] Klee looked for the primitive springs of art in ethnographic objects, in folk art and above all in children's drawings. Indeed his own works have been frequently and not always favourably compared with the latter.

> Child's play! Those gentlemen, the critics, often say that my pictures resemble the scribbles and messes of children. I hope they do! The pictures that my little boy Felix paints are often better than mine, because mine have often been filtered through the brain.[50]

Klee, of course, was well aware that painting was not simply a question of scribbling or untrammelled self-expression. To regain the pure naivety, the fresh and spontaneous quality which distinguished the art of gifted children, the adult painter had to submit to a rigorous process of training which concentrated on essentials. Hence his less-quoted statement:

> If my pictures sometimes make a primitive impression, it is because of my discipline in reducing everything to a few steps. It is only economy, or if you like, the highest professional sensitivity; in fact, the precise opposite of true primitivism.[51]

In this context Klee does not so much refute the idea of primitivism in painting as the idea which indiscriminately equates it with simple-mindedness, with an unreflective, merely instinctual way of working. His art, in any event, makes it abundantly clear that the child-like effect he achieved in some pictures – what elsewhere he called their 'schematic fairy-tale quality' – was the result of a highly refined and sophisticated form of primitivism.

Kandinsky's relationship to 'primitive' art forms was many-sided and characterized by a catholic taste. It was no doubt he who selected the majority of the previously mentioned illustrations in the *Blaue Reiter* almanac. Like Klee, Kandinsky

glorified the seemingly 'unconscious and enormous strength in the child' to portray the inner truth of things. He greatly admired Russian folk art which he came to know intimately on his government-sponsored trip to Vologda province in Siberia while still a student of law at the University of Moscow. It was, however, the African collection in the Ethnographic Museum in Berlin – the same museum which moved Marc to raptures – that left an indelible impression on Kandinsky. As he recalled the experience many years later, 'the decisive fact was the salutary shock I received from Negro art.'[52] During his fruitful stay at Murnau before the First World War, Kandinsky again was noticeably inspired by Bavarian glass painting and popular votive pictures. He also 'discovered' the neo-primitive Henri Rousseau whose childlike, naive rendering of the object, he believed, marked the beginning of a magical 'new realism.' 'Henri Rousseau, who can be designated the father of this realism, has shown the way . . . for the new possibilities of simplicity . . . his versatile talent is, at the moment, the most important to us.'[53] In *Concerning the Spiritual in Art* Kandinsky explicitly acknowledges the spiritual affinity between the modern painter and the primitive. 'Like ourselves, these pure artists sought to express only inner and essential feelings in their works.' He qualified his remarks, however, by insisting that 'the primitive phase, through which we are now passing in its present derivative form, must be short-lived.'[54] Kandinsky does not make it clear whether primitivism as such will disappear from painting or only its derivative manifestations.

Judging by their mature works, no direct borrowings of primitive forms and subject-matter can be detected in the paintings of the *Blaue Reiter*. Their primitivism, as that of most *Brücke* painters, was in the main not a consequence of their acquaintance with primitive art; it was the result rather of an all-pervasive urge to penetrate to the essentials of form and feeling. At the same time, it can, of course, hardly be denied that the attachment of these painters to prehistoric and exotic styles, to the arts of children, folk and peasants greatly stimulated their efforts to achieve direct emotional effects by

comparatively simple means. Nor can it be denied that the presumed mystical quality which they perceived in primitive art encouraged their own desire to create similar magically efficacious objects, through which man was supposed to commune with the demonic and divine forces of the world.

In all these tendencies the Romantic heritage can easily be discerned. One need only think of Wordsworth's cultural primitivism, his praise of peasants, children and idiot boys, or of Novalis' 'magical realism', a form of art which he cunningly declared to be 'in the service of fetishism.'[55] The Romantics, it is true, knew little about archaic and exotic kinds of art. Although their passionate interest in remote cultures laid the foundation for future historical research, no ethnographic collections existed at the time. However, in the medium they knew best, poetry, the Romantics were just as much attracted to primitive sources as the above-mentioned painters were in terms of visual art. Their desire, for instance, to rediscover the original *alchemie du verbe*, to borrow Rimbaud's phrase, anticipated to a large extent what Kandinsky, Benn and other Expressionist poets hoped to achieve by exploiting the primitive property of words divorced from any rational and utilitarian meaning. The connection between Romantic and Expressionist primitivism was quite early, though not very clearly, perceived by one contemporary critic.

> Expressionism reveals itself as a Romantic movement through its drive toward the elemental. Once again artistic intentions aim to grasp the primitive and the primeval, the things that are removed in space and time. Only these are believed to be capable of expressing undistorted powerful passions and feelings. Where the Romantics looked to the Middle Ages . . . the artists of today look to the East, the Ice Ages, to the art of Negroes, peasants and children.[56]

It would be easy to dismiss these artists' preoccupations with archaic and related styles as a sentimental, nostalgic form of primitivism were it not for its persistent recurrence and

vitality throughout modern art. From Van Gogh and
Gauguin to Matisse and Picasso, from Brancusi and Henry
Moore to Modigliani and Miro, modern artists have looked to
primitive art for inspiration and confirmation of their own
endeavours. Gauguin's example hardly requires reiteration.
Compelled by an inner urge to go 'far back, farther back
than the horses of the Parthenon' to the rocking-horse of his
childhood, he turned to Polynesian art and culture to
revitalize painting. 'Civilization makes you suffer. Barbarism
for me is a form of rejuvenation.'[57] Both Henry Moore and
Brancusi were profoundly moved by what Moore called the
'elemental simplicity' of Cycladic sculpture which each
aspired to emulate in some of his own works. Joan Miro's
attachment to archaic art and to primitivism generally is
revealed in his desire to create 'a kind of secret language
composed of magic runes that exists before words and
springs from that era when what men imagined and divined
was far more real and true than what they saw.'[58] Even
Malevich liked to compare the Suprematist's square and the
combinations derived from it 'to the primitive marks
(symbols) of the aboriginal man.'[59] This naive aesthetic and
cultural primitivism pervaded and still pervades the
enterprise of modern art. What is at work here is a powerful
impulse driving the artist toward the mythical springs of life.
Gottfried Benn once strove to give it formulation when he
defined Expressionism as the 'difficult path within to the
creative centres, to the primal images, to the sources of
myths.'[60] In a dramatic play written in 1948 Benn was more
precise:

> The primeval world with its secret forces lies still stored in our
> own brains. Every now and then, these forces break out
> through cracks and fissures in our consciousness: in
> drunkenness, dreams or trances, in some form of mental
> illness. At all times the old world is there – all those ages and
> states of being in which the external and internal were not yet
> divided, God and matter were still one, the unbearable
> tension between the ego and the universe had not yet come
> about.[61]

As with the Romantics, one must distinguish in this context between a pastoral or Arcadian primitivism as glorified by Rousseau's cult of the 'noble savage', and an authentic or genuine primitivism which forces the artist, often despite himself, to seek out a forgotten *Urwelt* in an attempt to retrieve new life-giving symbols. Both forms of primitivism, admittedly, can be found in one and the same artist, as in Gauguin for instance. In such cases, however, Arcadian primitivism was simply a by-product of the artist's general retreat into primal conditions.

IV. Perceptual Primitivism

The Expressionists' retreat into primal conditions was at the same time a descent into primary vision. The reality of this vision requires a brief epistemological explanation. Reduced to its simplest terms, it can be described as a form of 'pure' perception which, free from theoretical and practical concerns, experiences the immediate expressiveness of things. Primary vision can also be described as 'physiognomic' perception. Physiognomic in this context relates to the external features of objects as an index of their inner life and being. To the Expressionists, primary or physiognomic vision was more original than 'natural' or 'objective' perception, the mode of awareness peculiar to science and to our everyday vision in general. So-called objective perception, in this view, conjured up a world merely of hard and isolated objects, a soulless *Dingwelt* ruled by the categories of causality and utility. Man, driven by scientific or utilitarian interests, invariably viewed things as either causes or means. In both cases he lost sight of the individuality, the concrete beauty and expressiveness of sensible phenomena. Primary vision, by contrast, embraced the unique expressive properties of things. Cutting through the lifeless, encrusted surface world of objects given to us in ordinary perception, it restored the original *Ausdruckswelt*, the vibrant, living world of sounds, forms and colours

pregnant with feeling, permeated with 'soul.'

This in barest outline defines the epistemological creed of the Expressionist. We shall presently develop the theme further when dealing with the views of particular painters.

Historically, primary vision cannot be dissociated from the Romantic movement. Indeed if we look upon the history of art and poetry as a history first and foremost of perception, then the advent of Romanticism marked a decisive turning-point in our awareness of the object. It was the Romantics' fierce craving for immediacy that reactivated man's forgotten feeling for the magical, many-coloured world of primitive perception. Time and again they attacked the intellectual and pragmatic elements of ordinary cognition as pernicious to perceiving the unitary life of the whole. 'Our meddling intellect', in Wordsworth's famous lines, 'mis-shapes the beauteous form of things: / We murder to dissect.' The 'corporeal eye', clad in the rags of memory and dominated by the blind instincts of daily life viewed objects 'in disconnection, dead and spiritless.' The 'innocent eye' shaking off these debilitating functions reached out and established contact with the pristine mystery of all. It was the innocent eye, or primary vision, which made Wordsworth write that every rock, fruit and flower, including even the loose stones dispersed over the highway, 'Lay embedded in a quickening soul and all that I beheld respired with an inward meaning.'[62] It was the innocent eye, according to one critic, which strove beyond the 'mere outside surface of things', beyond their definable empirical determinations, in order to perceive 'an image of the thing itself in the concrete, with all that is lovable, hateable . . . sad or solemn or pathetic in it.'[63] The object here is no longer apprehended as an inert centre of definitive causal relations, but as an active nexus of meaning, a carrier of expressive or tertiary qualities, what Coleridge called the 'very spirit which gives the physiognomic expression to all the works of nature.'[64] Romantic art and poetry were primarily rooted in the reality revealed to primitive perception. Their object was not the *Dingwelt*, but the *Ausdruckswelt* in its reassuring yet also

awesome magic and splendour.

In praise of primary vision, or 'unmediated vision' as one recent critic has well described it, the Romantics extolled the vision of primeval man, Wordsworth's first inhabitant of the earth whose 'undisordered sight' perceived in forests, clouds, caves and dales the 'mighty' spirit of nature. In praise of primary vision the Romantics launched the cult of the child which shows no signs of abating. 'When we were children', wrote Shelley, what a 'distinct and intense apprehension we had of ourselves! . . . We less habitually distinguished all that we saw and felt from ourselves. They seemed, as it were, to constitute one mass.'[65]

Turning to the Expressionists now, their abiding faith in primary vision was expressed in ways reminiscent of the Romantics. Like them they frequently appealed to the 'syncretistic' vision of the child which, impervious to component detail, perceived reality as a living whole. They also evoked the original perception of primitive man. 'The eye', wrote Kokoschka – he means the innocent eye – 'has its own philosophy and metaphysics . . . Man has developed round it, it has accumulated its own tradition from the time of the cave-dwelling.'[66] The uncorrupted eye secured man's instinctive harmony with nature, a harmony disrupted with the rise of science and reason in the wake of which phenomena came to be seen as essentially fixed and dead. Man, pleaded Franz Marc, had to be given back his pristine sight which established contact with the life and soul of things. 'There is will and form in all things. They have their own speech – why must we interrupt them?' Why, Marc insisted, must we press them into the mould of our rational and scientific preconceptions? Only the artist was still capable of divining the true face of the world. 'We grasp it intuitively to the degree of our artistic powers.'[67] As Marc's words reveal, primary vision was predominantly mystic communication with the forms and figures of nature. 'Everywhere I looked', wrote the young Nolde, 'nature was alive, in the sky, in the clouds, atop every stone, and between

the branches of every tree.'⁶⁸ Out of such experiences arose
Nolde's mythology with its goblins and ogres, gods and
demons.

One of the clearest statements concerning the nature and
function of primary vision was formulated by Willi
Baumeister, a colleague of Klee and Kandinsky at the
Bauhaus. Like the *Frühromantiker*, Baumeister called it *das
Schauen* which he sharply contrasted with our customary
pragmatic conception of the world.

> Prior to our bodily and utilitarian sight there exists an
> original state of vision. One could call it 'concrete vision'
> [*Schauen*]. It transcends the intellect and comprehends all
> appearances as purely visual phenomena . . . Utilitarian sight
> is driven by ends and gains. Beyond this sight the artist
> possesses the ability to perceive things in a
> 'dematerialized' . . . non-objective way [*ohne Gegenständlich-
> keit*]. The world seen thus assumes a strange depth and vast-
> ness, an awesome neutrality, as it were, which reveals being it-
> self, the oneness of all.⁶⁹

Primary vision, in other words, 'dematerializes' reality.
Things lose their solidity and 'otherness.' Appearances have
not yet hardened into 'objects', into 'fixed' quantities,
qualities, modalities and relations. Instead they present
themselves as visually expressive shapes which directly
involve the viewer. Primary vision, Baumeister suggests,
cancels the division between the subject and the object,
between the animate and the inanimate. The artist becomes
aware of the reality of 'being', the 'unity' of creation. This, of
course, is just what the Romantics claimed *das Schauen*
accomplished. It was not merely visual experience, but
visionary experience, a non-mediated knowledge of the one
life pervading all.

Kandinsky provides a particularly striking instance of
primary vision developed to the highest possible pitch. It
dominated his perceptual awareness to a degree bordering
perhaps on the abnormal. Any critic trying to understand
this painter must be prepared to forego the familiar world of
objects and plunge into the allusive reality of emotional

perception. Not only Kandinsky's art, but his writing testify
to a sensibility acutely conscious of the expressive qualities of
objects.

> All things were revealed to me: not only the oft-sung flowers
> and woods, the stars and the moon but many, many more – a
> cigarette-butt, stiff and frozen on an ashtray, the blankly
> patient, round button peeping from a puddle . . . All these
> opened to me . . . their secret meanings, which are mostly
> silent and unobserved.[70]

Like the Romantics, Kandinsky could become wholly
absorbed by the spectacles of nature. Recalling a Moscow
sunset, for instance, he glowingly describes the scenes in
these words:

> All Moscow responds like the 'fortissimo' of a gigantic
> orchestra. Houses – rose, lilac, white, azure, blue, flame-
> red . . . Churches – each alive like a separate bright song; the
> green madness of the grass, the murmuring humming of the
> tree; and, in winter, the thousand-voiced song of the snow,
> the brisk allegretto of bare branches . . . And crowning the
> long white neck, stretched heavenwards as if in eternal
> yearning, the resplendent golden head – the very sun of
> Moscow.[71]

Everything described in this passage carries emotional
connotations. It is a typical example of pure physiognomic
vision. Sensations are fraught with sentiments saturated with
feelings. As always in Kandinsky, the visual and auditory sense
are jointly active in perception. The sphere of sight and
sound, of colour and tone, have not yet emerged as clear and
distinct sensations. As he put it once: 'You "hear" the colour
and you "see" the tone.'[72] This synaesthetic awareness is a
phenomenon intimately associated with perceptual
experience as it occurs on the level of primary vision.

 The same primitive sensitivity characterized Kandinsky's
response to the pictorial means. Each line and point to him
was a 'living being', possessed a 'sound' and 'soul' uniquely

its own. Every form was as 'sensitive as a cloud of smoke.' Surpassing all was the superhuman power of colour, the inexhaustible life contained already in the paints. 'Those strange mysterious beings we call paints. Thoughtful, all-engrossing, grave.' Yet also 'brightly, bubblingly mischievous. With a sigh as if of relief', they materialize from their little tubes 'beings, self-contained, independent, endowed with all the attributes of individual existence.' Spread out on the painter's palette they patiently waited to form themselves into a 'vast array of new universes', into pictorial organisms quivering with an inner life and meaning.[73]

Kandinsky undoubtedly was a genuine *physiognomic* and perceptual primitive exclusively at home in the world of audio-visual immediacy. It was precisely this awareness of the expressiveness of phenomena, he insisted, that made him realize with his 'whole being . . . the possibility and the reality of the art . . . called non-objective.'[74] To this form of sensibility nothing remained mute. A point on the canvas was as meaningful to Kandinsky as a human face, a sharp-angled triangle touching a circle as expressive as God stretching out his hand to reach the fingers of Adam in Michelangelo's famous fresco on the Sistine ceiling. Preposterous as this may sound on first reading, in terms of primary vision such claims can be defended on the grounds that at the level of this vision, sensibility responds less to relatively complex patterns, like faces and figures both of which are charged with non-visual, ideational meanings; it responds primarily to form as expressive shape.

For Kandinsky primary vision, of course, was not merely aesthetic perception in its purity. It was the mode of vision communicating the highest spiritual truth. To the 'inner sight' as Kandinsky called it, 'the world resonds. It is a cosmos of spiritually active beings. Thus is dead matter living spirit.'[75] Philosophically what is espoused here and elsewhere in Expressionism is a form of primitive magical realism which maintains that in the perception of expressive phenomena man stands in the presence of the *real* which in turn then

becomes identified with the *spiritual* or divine element in the world. Pure perception provides us with truth and being, whereas natural vision, which is ruled by a utilitarian intellect, hides the true reality of things. In Kandinsky's words, 'the functional meaning of an action', or object, 'negates its abstract [spiritual] meaning.'[76]

Some interpreters of Kandinsky have invoked Bergson to lend metaphysical support to this neo-Romantic conception. 'Between nature and ourselves', wrote Bergson, 'a veil is interposed . . . We do not see the actual things themselves, in most cases we confine ourselves to reading the labels affixed to them.' The sole function of art was to 'brush aside the utilitarian symbols, the conventional and socially accepted generalities, in short, everything that veils reality from us, in order to bring us face to face with reality itself.'[77] The artist was uniquely suited to this task for in him pure perception was active in its most potent and compelling force. Bergson's argument is admittedly far more complex. Nonetheless, it awakens the suspicion that he, like the Romantics and the neo-Romantics of Expressionism, simply identified primary vision with ontological intuition. Whatever ontological intuition may imply, it cannot rest content with the immediacy of pure perception. It must include as well the realities mediated by the mind. In any case, no inference can be drawn from the nature of primary vision to the nature of reality itself.

V. The Dissociation of Sensibility

Given these artists' touching faith in primary vision, what was its immediate bearing on art? The paintings here convey their own compelling message. Rich in affective or tertiary qualities they thrust us back into the world of original perception. It is characteristic of this world that colour takes precedence over form not only because of its greater evocative power, but also for its tendency to melt down the hard, localized objects of the *Dingwelt* into the allusive

patterns of the *Ausdruckswelt*. Frequently, and in keeping with the glorification of the child's vision, the painter appeals directly to this form of awareness, an awareness which 'humanizes' all objects. Examples abound: the moon smiles or frowns, the rocks and clouds beckon or threaten, the forest at dusk stares at us with a thousand black-eyed faces. Klee painted a series of what he called 'physiognomic' pictures which involve us on the level of such visual responses. So does the art of Gabriele Münter. Her landscapes, still lifes and interiors conjure up the reality of childlike innocence and wonder. In all these paintings the artist's progression away from representation was either a deliberate or a spontaneous regression to the various stages of a child's 'low-level differentiation' of the world.

One inevitable, yet far-reaching consequence was implicit in the painter's pursuit of primary vision. Its restoration in art demanded that natural perception had to be dislodged. Primary vision, in other words, required the intermission of ordinary vision, the 'dissociation of sensibility' to use a phrase currently in vogue. As used here it means the poet's and painter's attempt to liberate the senses from the 'tyranny' of the object and its unrelenting chain of associations. It means the destruction of visual habits, the breaking-up of perceptual as well as conceptual codes by way of suspending all those functions from the act of perception that directly bear on practical and theoretical ends. Wittingly or not, the Expressionists, the abstract Expressionists, and a good many modern artists besides, practised dissociation, aimed at disrupting man's senses almost as a matter of principle. It could be argued, of course, that the modern art of the past has always interfered with orthodox standards of sensing and seeing. Indeed, any art conveying anything new must needs deviate from conventional perceptual norms if only to refresh vision dulled by custom. Yet whenever such deviations occurred they were accepted as an enrichment of existing traditions. This is true even of the Mannerist painters who rather self-consciously strove to turn Renaissance rules on their head. It led to unprecedented distortions which were

far removed, however, from the resolute destructiveness and self-professed primitivism of Expressionism and much of modern art.

Predictably, it is once more the Romantic who must be given the dubious credit of having pioneered the dissociation of sensibility, or that prodigious derangement of all the senses on which Rimbaud was to embark with such passion later in the century. The Romantics used any means, including opium or laudanum at times, to confuse and break down normal perception to attain to a state of 'unmediated vision' in which the soul, delivered from the cares and burdens of this world, communed with its deity. 'The doors of perception', Blake insisted, had to be 'cleansed' if man was to catch a vision of the infinite. Novalis advocated his own method of dissociation when he demanded that the world must be 'romanticized by giving a lofty meaning to the commonplace, a mysterious appearance to the ordinary, the dignity of the unknown to what is known, the semblance of infinity to the finite . . . The fact that we cannot see ourselves in a faerie world is due only to the weakness of our physical organs and perceptions.'[78] The Surrealists – freely acknowledging their debt to Novalis, Blake and other Romantics – were to put such precepts into practice by estranging the familiar object from its customary setting, by evoking a 'surreality' in which the constraining laws of reason and adult perception held no sway.

In Expressionism dissociation followed a more spontaneous pattern of severing sensibility from its attachment to an external world. The poets, notably those of the *Sturm* circle, for instance, effectively disrupted habitual modes of thinking, sensing and feeling by making use of daring innovations of speech. Frequently dropping articles, conjunctions, inflections, expletives and concentrating on nouns, verbs and adjectives, they stripped the sentence of any definite denotative significance. The aim was to undermine the conventional subject-predicate logic of semantic structure thus preventing the mind's leap from words to things and their customary associations.

The word receives a different force. It ceases to describe, to circle round the outside of things . . . Instead, it turns into an arrow penetrating to the core of the object which endows it with life. Crystalline, the word becomes the true image of the thing itself.
Now the expletives vanish.
The verb expands and gains an intense poignancy permitting clear, distinct expression. The adjective fuses with the expressive force of the word. It too must not describe, but express concisely the essential, and *only* the essential.[79]

Benn advocated the use of 'magic pronunciation' of certain key words and nouns, others stressed the element of repetition similar to Kandinsky's suggestion that a word revealed its non-material, primordial meaning through constant reiteration. The tendency generally was to move away from a purely object-centred language towards a multi-evocative use of speech which retained words as expressive ciphers. These were supposed to communicate their meaning directly without recourse to common sense, logic and causality.

Among the painters, dissociation was accomplished by two comparatively primitive means: wilful and sometimes grotesque distortions of forms and figures and glaring, clashing colours. The latter was the more effective. Expressionist colours are deliberately unreal and fantastic. Thrown into bold conjunctions or into violent oppositions they are meant to attack sensibility directly, if only in their capacity as brute sensations. Whatever the 'spiritual' meaning of blood-red, or purple-green faces and figures, of orange and violet hair, of blue, red, yellow cows, deers and horses, they certainly prevent the viewer for a time from forming associations derived from his experience with the world at large.

Kandinsky rejected this form of dissociation not only because of its gross distortions and its often implausible exaggerations, but also because the object, however twisted on canvas, still carried with it a host of non-visual associations. The object, Kandinsky was fond of repeating,

created a 'secondary tone' which 'cannot be supressed.' It conjured up a wide range of memories. The viewer on being presented with houses and mountains, faces and figures invariably perceived these entities in accordance with norms and expectations peculiar to their kind. The represented object, in short, activated man's natural or casual perception and, in doing so, it interfered with the expressiveness of the pictorial means. After long deliberation, Kandinsky drew the inevitable conclusion: the object had to go; nature must be ousted from art. The most effective dissociation of sensibility, in other words, was to create non-objectively, thus forcing sight to respond on the level of primary vision. At this moment painting finally became a mode of pure perception.

The gain in pure perception was bought at a considerable loss and this leads us to introduce some critical considerations. Relying solely on the direct expressiveness of lines, forms and colours, abstract art necessarily excludes from its domain all *ideational* meanings be they objective, intellectual, religious or drawn from the realm of myth. All such meanings depend for their being on the mind's active mediation. Establishing its claims on the plane primarily of immediacy, non-objective art thus bypasses the world which is the domain of mind and spirit and becomes an object solely for indefinable sensations and ephemeral feelings.[80]

At the same time, abstract art has without doubt revitalized vision. It has made us extraordinarily sensitive to the inherent life of forms and colours and beyond that to the general physiognomic characteristics of things. In this respect it can claim, in Blake's phrase, to have cleansed the doors of perception. Sharpening our senses, it has caused us to look at the world afresh with fewer interfering preconceptions. Could it not be argued that this is sufficient reward in itself justifying the existence of non-objective art? It is if we are prepared to purge everything conceptual from perception and concentrate wholly on the expressiveness of form and colour. Yet as the history of art demonstrates with many convincing examples, there is no reason to assume that this expressiveness noticeably decreases when combined, or

rather fused, with more objective form and content. Both can easily and harmoniously be blended in a work of art to the enrichment of perception. That such objective forms and contents should suddenly have been considered harmful to art was in part an understandable reaction in view of the excessive intellectualism, literalism and anecdotalism which ruled artistic creation. Although understandable, it does not alter the fact that in the last analysis the abstract painter's exclusive emphasis on non-objective forms and colours was, and still is, as one-sided in its own way as was the emphasis of preceding periods which judged art in terms only of its descriptive meaning, its conceptual content. The latter practice harboured the danger of turning art into mere 'literature', into 'painted conceptualizations' which denied the uniqueness of the medium; the former, while affirming the medium to the extent of raising it to an end in itself, runs the constant risk of reducing art to the mindless, aimless exercise of 'empty' sensibilities.

This risk is a serious one indeed considering the artists' materials. Depending solely on the mood and movement of, forms and colours, the abstract painter has to rely on a language of expression riddled with imprecisions and subjective factors. Hence Kandinsky's desperate attempt to formulate a pictorial grammar based on more or less objective values. His efforts have not met with universal approval. There are critics who flatly deny that any such grammar or syntax can be compounded from the primitive expressive characteristics of both forms and colours. 'Concentration on the physiognomic properties', wrote Ernst Gombrich, 'will never yield a theory of artistic expression.'[81] Only extensive research into perception will decide this issue, if then. Despite numerous experiments already made, the field is still largely unexplored.

In the meantime, and ending on a more positive note, abstract art has undeniably fulfilled a salutary function. While not exactly communicating the spirit or the music of the spheres, its sensual richness has effectively acted as a kind of visual therapy heightening our perceptual awareness.[82]

According to Salvador Dali it may also have whetted our appetites for new forms of representational art to come. 'We are all hungry and thirsty for concrete images. Abstract art will have been good for one thing: to restore its exact virginity to figurative art.'[83] Dali's prognosis could easily turn out to be the most astute prophecy of all.

VI. Conclusion and Political Postscript

This chapter has centred on one basic theme: the artist's flight into primal conditions, his pursuit of primitivism as the avenue to spiritual salvation. In whatever form this primitivism manifested itself – whether perceptual, cultural, aesthetic or metaphysical – it was essentially a regression to more fundamental or primordial modes of being. Some may well view such regressive tendencies as a sign of degeneration, a deliberate relapse into barbarism which, in the name ironically of the spirit, sacrifices all that hitherto has been considered spiritual in man. Others, on the contrary, may see it as a process of regeneration, a timely return to health, vigour and vitality in the face of a materialist

civilization characterized by symbolic destitution, by cultural failure and fatigue.

While primitivism may have been necessary to throw into sharp relief forgotten aspects of man's being, its promise to revitalize art and, beyond that, to redeem culture itself, remains but a dream. Its very logic, moreover, entails consequences which few dare contemplate with any peace of mind. Thus attracted to origins, primitivism must perforce negate the greater part of man's cultural and intellectual achievements. It has succeeded in this respect to an alarming extent − to the extent that in art we have instinctively learned to prefer an African fertility god to the Apollo of Belvedere, the paintings of ancient caves to the compositions of the Renaissance, a bloated, sightless, prehistoric Venus to that other Venus of classical Greece whose humanity stands clearly opposed to the non-human forces of nature. Primitivism has thoroughly alienated us from our classical and humanist roots, from our spiritual and cultural traditions. If that way redemption lies, so also lies a measure of darkness, if not madness. 'When reason sleeps', Goya once wrote under one of his paintings, 'monsters are born.' Once consciousness is delivered over to the unconscious, once primitive instincts, drives and feelings rule supreme, then the furies of the nether world awake and Dionysus begins to ravage the land. This indeed is the peril of primitivism when pursued with passion and conviction. Responding to the calls of the deep, it destroys everything in its wake.

If this interpretation is valid, far more troublesome questions intrude. For instance, was primitivism confined only to the arts or was it part of a much larger cultural, political and ideological pattern? Was it historically a mere chance event that it should have roughly coincided with the rise of Germanic *racial* primitivism as well as with *erotic* primitivism which arose in response to the misunderstood and distorted teachings of Freud? Diverse as these ideologies were in their respective orientation, they nonetheless shared one basic feature: their reduction of 'civilized man' to a kind of superior 'natural man.' To the Teutonic racialist this

natural man was, of course, Aryan or Nordic man. Better, purer and stronger by nature than non-Aryan peoples, he lived in instinctive harmony with the earth and was, therefore, less corrupted by a hedonistic, effeminate civilization. To the eroticist, natural man was the libidinously liberated man, the sensually and sexually atuned creature living a life of energy and passion defying civilized mores and social conventions.

In the context of this book, the connections between Expressionism and Teutonic racialism are of special importance. On the surface, both movements had nothing whatever in common. Ideologically, they stood at opposite ends. The ethos of Expressionism, rhetorical and muddled though it was at times, cannot and must not be compared to the primitive philosophy of National Socialism. Where the Expressionists preached love, compassion and justice for all of mankind, the National Socialists bred hate and intolerance for humanity not descended from Aryan stock. Where the Expressionists longed for religious renewal and cosmic integration, the National Socialists yearned for geographical expansion and political domination under the German heel. Not surprisingly, the Expressionists were among the first victims to feel the force of that heel. Accused and condemned as cultural Bolsheviks, they were marched down the *via dolorosa* to their ultimate crucifixion. Their paintings were destroyed or declared degenerate, their books defiled and committed to the flames — those flames which before long consumed an entire nation. In view of this tragic evidence, how can one — indeed should one — seek for similarities between these two movements?

Yet similarities do exist. Despite fundamental differences, National Socialism and Expressionism are not without some common features. They are to be found in the more mystical and peculiarly Germanic aspects of the Expressionist *Weltanschauung*: its unique emphasis on soul and inwardness, its ecstatic vitalism and correspondingly militant irrationalism, its primitive pantheism and apocalyptic idealism, and, pervading all, its irresistible fascination for the

primordial. In one form or another, each one of these features figured prominently in the ideology of Nazism.

On first sight, it does seem strange, if not preposterous, to connect the Expressionists' emphasis on soul and inwardness with National Socialism. Considering the unspeakable crimes and horrors perpetrated on its behalf one's first reaction is to deny the latter any human feelings whatsoever. Yet this is patently untrue. It is also to ignore a distinctly Teutonic trait of character which the Nazis shared: its unwordly, introspective nature. Ever since the *Frühromantiker*, inwardness and with it an inevitable *Weltfremdheit* have played a decisive part in the development of German culture and the German mind. The Expressionists, unfortunately, greatly reinforced such tendencies, adding some new dimensions. It played well into the hands of those out to exploit it and exploit it they did to the fullest. The brute and incontestable fact is that National Socialism thrived on a cult of inwardness. It brimmed over with appeals to the German soul, its power to transform the world, its historic mission to regenerate the earth. 'Through German kind should the world again redemption find.'[84] It was indeed redeemed of German kind, though not in the way intended. The Expressionists' contribution to this nourishing of the German soul at the expense of hard concrete realities was recognized even by Goebbels. In his one and only novel, written and published in the 1920s, we read:

> The inner structure of our decade is Expressionistic to the core. We contemporaries are all Expressionists – men who want to form the world from within their own being. Expressionism creates a new world from within. Its secret and power is its passionate fervor. [Inbrunst].[85]

This acknowledgement that Germans are Expressionist brothers under the skin cannot, of course, be taken at its face value, or only with the proviso that their fraternal relationship broke down into scheming, murderous Cains and innocent, unsuspecting Abels. All the same, Goebbels

diagnosed one of the underlying impulses of Expressionism correctly. It was its passionate inwardness which helped to till the soil of things to come. The sad truth is that National Socialism was swept to political and ideological victory on the waves of 'soulful' passions and bottomless seas of German *Innerlichkeit* which lacked meaning and direction. Within a comparatively short time, soulful passion was to turn into destructive violence, inwardness into sloppy and primitive feelings, making for that eerie mixture of brutality and loathsome sentimentality characteristic of some 'supermen.'

The Expressionists' anti-intellectual vitalism and pantheism forms another bridge to National Socialism. In the last analysis, both movements cannot be fully understood without taking into account their inordinate longing for a simpler, less inhibited and 'brain-devoured' form of existence which knew itself to be at one with things. Some Expressionists, disenchanted with an empty, ineffectual cosmopolitanism and a somewhat starry-eyed 'cosmism', soon focused their vitalist and pantheistic cravings on something seemingly more concrete: the earth and the people. As early as 1920 Kurt Heynicke, the Expressionist poet, composed these verses: 'The people never dies! / From it alone a new mankind is born / Not from the pallid masks of today's *literati* / Who, dated already now, are arrayed against us – against youth.'[86] The brown-shirts whom Heynicke was to join a decade later found it easy to capitalize on such feelings. They had no trouble identifying 'the people' with the new 'folk-community' and the pale-faced literati with the Jews and the Jewish intellect which was looked upon as the cancerous growth sapping the strength of the Teutonic race destined to revitalize Europe. German youth had to be saved from the ennervating effects of a disembodied reason. Strength lay in the blood not in the brain, in the vitals and the scrotum which possessed their own instinctive wisdom. In National Socialism the tension between 'head' and 'heart', mind and soul, reason and instinct which originated with the Romantics and continued in Expressionism was finally and brutally resolved in favour of man's biological, instinctual and primitive

emotional endowment. The motto of the Expressionist Gustav Sack, 'I would rather be barbarized than intellectualized', was to become a terrible reality.

Vitalist cravings and hatred of a civilization ruled by an inhuman technology and utilitarian reason forced Benn into temporary alliance with the Nazi Party. Trying to justify his conversion, Benn spoke of the deadening, 'de-souling' influence of metropolitanism, industrialism, intellectualism and nihilism which rendered existence meaningless. What was left in a world devoid of any purpose and direction? 'There are moments when this whole tortured life vanishes and nothing remains but the wide plains, the seasons, the earth, simple words – folk. This is the reason why I placed myself at the disposal of those to whom Europe . . . denies recognition.'[87] From this position it was a short step to accept the essentially ludicrous yet sinister myth of 'blood and soil', the creed of a biologically superior people whom providence selected to rejuvenate and rule the earth.

In retrospect, it was no small tragedy that National Socialism was able to draw upon the heritage of that ancient 'German pantheism', in Heine's phrase, which was so much a part of Expressionism. Indeed almost any statement made by the Expressionists in this respect was basically reconcilable with the Northern pantheism proclaimed by Aryan man. When Franz Marc, for instance, wrote of his desire – innocent enough – to heighten his 'feelings for the organic rhythm of all things, to achieve pantheistic empathy with the throbbing and flowing of nature's bloodstream',[88] he voiced sentiments dear to the Germans, dearer still to their new masters even though they lacked the aesthetic sensitivity to appreciate an art born on such feelings. The same applies with even greater force to the frequently demonic pantheism of Däubler's poetry and Nolde's paintings of oceans, of witches and gnomes dancing to nature's primitive tunes. The historic irony is that an art such as this could easily have provided a poetic and pictorial analogue to Nazi mythology – that part at least which glorified the soil, the seasons and the chthonian or regenerative forces of the earth.[89] Both forms of

pantheism were irresistibly drawn toward the depths, the primordial powers of nature seen through the misty light of Northern myth and legends. In fact, the Nazis incredibly expressed themselves by way of a bastardized, affected neo-Classicism whose hallmark was a crude, soulless strength, and a Romantically-inspired insipid neo-Realism which sentimentalized the folk, the fields and forests of the German land. At the same time (without noticing the incongruity) their propaganda art frequently made use of stylistic features which unmistakably derived from Expressionism and abstract painting.[90]

If the vitalist and pantheistic elements of Expressionism helped to create conditions favourable to the rise of National Socialism, so did its pronounced messianic idealism. As we have seen, poets and painters entertained lofty dreams of a spiritual kingdom to come, of a new humanity to be reborn from the chaos of an old corrupt world. Their works flowed over with apocalyptic allusions and messianic anticipations. The Expressionists' messiah, of course, bore no resemblance to Hitler and his hordes. Nor did their apocalyptic visions include the destructive fury that soon was to reduce a continent into smoldering ruins and ashes. All the same, the Expressionists undeniably contributed to the formation of a historical consciousness ready for sudden, dramatic and violent change, ready, that is, to make some kind of revolutionary gesture. They raised all those hopes and desires which hungered for transformation and renewal – come what may! One need not delve at all into the particular utopianism of this or that artist here in order to show its effect on his contemporaries. It was the very urgency, the passionate chiliastic rhetoric of Expressionism which left its marks on a generation already at odds with existing political and economic conditions. All those numerous invocations of the 'twilight of man' and the 'beginning of a new dawn', those countless pious appeals to a mysterious 'world spirit', a transcendent *Zeitgeist* – phrases altogether treacherous for their uncanny power to sway the German mind —prepared a people to live in anticipation of epochal events to come.

Having tasted the bitter fruits of messianic and millennial idealism it is difficult for us to comprehend how a generation in the face of judgments more prudent and wiser could sincerely believe that the 'hour of destiny' had struck, that an inexorable 'historical necessity' was upon them determining the course of events and shaping the life of each and every individual. Yet this is just what pervaded the minds of many Expressionists and their fellow men. Well the Nazis knew it. Cunningly and demagogically, they enlisted and manipulated for their own ignoble ends what were, in essence, primitive religious longings for renewal and salvation. Nazism, like Communism, owed its triumph in no small measure to the presence of these apocalyptic and messianic expectations. Without them, the brown pest could not have spread and reaped its gruesome harvest. Few Germans were courageous and clear-sighted enough to foresee the turn Nazism was to take once it assumed power. Many closed their eyes, hoping against hope. Their desperate willingness to embrace a 'holy cause', their naive faith in the cultural mission entrusted to the German people by the 'spirit' blinded their reason into accepting a false messiah and his counterfeit prophets. No nation paid more for its Romantic dreams, its spiritual voraciousness and suicidal urges to reform the world.

Primitivism, in short, was the common basis of Expressionism and National Socialism. Caught in its snares, some Expressionists could with no sense of contradiction commit the worst kind of *trahison des clercs*. What drove Benn, Johst, Bronnen, Heynicke, Klemm and Nolde to condone for a time, if not to foster, the Nazi spirit was precisely their desire to recapture more primordial modes of sensing, feeling and being, their longing to partake of a new 'cultic order' rooted to the earth, the soil and the people. The same longing drove untold numbers of their contemporaries into the arms of National Socialism. What we witness here is nothing else than the resurgence of an ancient *mythic* awareness intent to interpret and explain the world once more in accordance with the norms peculiar to myth. Future historians may yet come to view the phenomenon of Nazism

in a similar light, for Nazism, whatever else it may have been, was in its own barbaric way the unmistakable recrudescence of a primitive cult-conscious and myth-minded imagination, despite the fact that its actual myth of 'blood and soil' was a fabricated, inhuman superstition, a mental aberration.

There was a vital difference, of course, between the primitivism of the Expressionists and that of National Socialism. The one, mercifully, was confined to the arts that occasionally produced compelling poetry and painting. It was a primitivism, moreover, often painfully conscious of its own inherent ambiguities and contradictions. Nonetheless, Nazism serves as a blunt reminder of the evils implicit in primitivism, the threat that arises once man begins to court the primordial with a passion blind to reason.

> He who would make the descent into the lower regions runs the risk of succumbing to what the primitives call 'the perils of the soul' – the unknown Titans that lie within, below the surface of our selves. To ascend again from the darkness of Avernus is, as the Latin poet tells us, the difficult thing, and he who would make the descent had better secure his lines of communication with the surface.[91]

The Expressionists secured theirs – just. Nazism, defiantly cutting all lifelines with civilization, succumbed to the forces it unleashed.

Its fall sealed the fate as well of the Romantic spirit. Submitting to the harness of a monstrous creed, passing over in silence the gross indecencies perpetrated in its name, it condemned itself to exile, exile for a legacy fouled, a purity stained, an innocence irretrievably lost.

<div align="right">Irretrievably?</div>

Footnotes

Whenever possible standard editions have been cited. The small number of paperbacks quoted in the sections on Expressionism are for the most part reprints of editions deleted long ago or anthologies which contain essential sources that are unavailable or difficult to obtain. The documentary value of these texts is undisputed.

The following abbreviations have been used:

EKLB: *Expressionismus. Der Kampf um eine literarische Bewegung* (documents).

EKK: *Essays über Kunst und Künstler* by Wassily Kandinsky.

UELD: *Über den Expressionismus in der Literatur und die neue Dichtung. Tribüne der Kunst und Zeit* ed. K. Edschmid.

MD: *Menschheitsdämmerung. Ein Dokument des Expressionismus* (documents).

CSA: *Concerning the Spiritual in Art* by Wassily Kandinsky.

Biogr. Lt.: Biographia Literaria by S. T. Coleridge.

Chapter 1

1. F. Hoelderlin 'Hyperion' *Sämtliche Werke,* ed. N.v. Hellingrath, F. Seebass and L. V. Pigenot, II, p. 91
2. F. Schleiermacher *Monologen* ed. F. M. Schiele, p. 73
3. Goethe's poem 'Eins und Alles' in *Sämtliche Werke* II, p. 244
4. Novalis 'Heinrich v. Ofterdingen, Die Erfüllung' *Novalis Schriften* ed. P. Kluckhohn and R. Samuel, I, p. 319

5. P.O. Runge *Hinterlassene Schriften* ed. by his brother Daniel Runge, I, p. 9. This letter of 9 March, 1802 may well be considered Runge's artistic manifesto.
6. Wordsworth 'Lines composed a few miles above Tintern Abbey' *The Poetical Works of William Wordsworth* ed. E. de Selincourt and H. Darbishire, II, p. 259.
7. F. W. J. Schelling 'Über das Verhältnis der bildenden Künste zu der Natur' *Schellings Werke* ed. M. Schröter, III, Ergänzungsband, p. 402. H. Read provides a translation of Schellings essay in *The True Voice of Feeling* (London: Faber and Faber 1953) p. 323-58. Another translation is in *What is Art? Aesthetic Theory from Plato to Tolstoy* ed. A. Sesonske (Oxford University Press 1965) p. 275 ff.
8. Novalis 'Studien zur Bildenden Kunst' *Schriften* II, p. 650
9. Novalis 'Paralipomena zum H. v. Ofterdingen' *Schriften* I, p. 347
10. Runge *Hinterlassene Schriften* I, p. 11
11. A. W. Schlegel *Vorlesungem über schöne Litteratur und Kunst, Deutsche Litteraturdenkmale des 18. und 19. Jahrhunderts* I, p. 103
12. A. W. Schlegel, *Vorlesungen über philosophische Kunstlehre* ed. A. Wünsche, p. 37
13. F. Schlegel 'Athenäums-Fragmente' *Kritische Schriften* ed. W. Rasch, p. 37
14. A. W. Schlegel *Vorlesungen über dramatische Kunst und Literatur* in *Kritische Schriften und Briefe* ed. E. Lohner, VI, p. 112
15. A. W. Schlegel 'Die Gemälde' *Athenäeum* II p. 50
16. Coleridge *Biographia Literaria* ed. J. Shawcross, II, p. 103
17. Runge *Hinterlassene Schriften* II, p. 202
18. F. Schlegel *Kritische Schriften* p. 93
19. L. Klages *Mensch und Erde* p. 43
20. Novalis 'Materialien zur Enzyklopädistik' *Schriften* III, p. 248
21. F. Baader *Vom Wärmestoff* p. 39
22. A. W. Schlegel *Vorlesungen über dramatische Kunst und Literatur* in *Kritische Schriften und Briefe* V (part I), p. 25: 'Die Poesie der Alten war dies des Besitzes, die unsere ist die der Sehnsucht jene steht fest auf dem Boden der Gegenwart, diese wiegt sich zwischen Erinnerung und Ahnung.'
23. F. Schlegel 'Lucinde' *Kritische Friedrich Schlegel Ausgabe* ed. E. Behler, J. J. Anstett and H. Eichner, V, p. 78
24. Goethe 'Dichtung und Wahrheit' *Sämtliche Werke* XXIV, 53-4
25. Novalis, 'Hymnen an die Nacht' *Schriften* I, p. 145

26. Keats 'Lamia' *Poems of John Keats* ed. M. Allot, p. 616
27. T. Campbell 'To the Rainbow' quoted in M. H. Abrams *The Mirror and the Lamp* p. 308
28. Wordsworth 'The Tables Turned' *Poetical Works* IV, p. 57
29. Novalis 'Letter to A. W. Schlegel' *Werke und Briefe* ed. E. Wasmuth IV, p. 229
30. Coleridge 'Joan of Arc' revised as 'The Destiny of Nations' in his *Complete Poetical Works* ed. E. H. Coleridge, I, p.147
31. J. Barzun 'Romanticism: Definition of a Period' *Magazine of Art* XLII, 1949, p. 243
32. Schelling 'Über das Verhältnis der bildenden Künste zu der Natur *Werke* III, Ergänzungsband, p. 427
33. Runge *Hinterlassene Schriften* I, p. 11
34. Hoelderlin 'Hyperion' *Sämtliche Werke* II, p. 92
35. H. v. Kleist, letter to O. A. R. von Lilienstern, 31 Aug. 1806 *Kleists Werke* ed. E. Schmidt, V, p. 328
36. Keats *The Letters of John Keats* ed. M. B. Forman, p. 49
37. G. W. F. Hegel 'Preface' *The Phenomenology of Mind* translated by J. B. Ballie (London, New York: MacMillan 1910) p. 44
38. I. Babbitt *Rousseau and Romanticism* p. 148
39. A. W. Schlegel *Vorlesungen über dramatische Kunst und Literatur* in *Kritische Schriften und Briefe* VI, p. 112
40. Novalis 'Lehrlinge zu Sais' *Schriften* I, p. 96
41. *Ibid*.
42. K. G. Carus *Romantische Naturphilosophie* ed. W. Rössle (Jena, 1926), p. XVI
43. Novalis 'Poeticismen', *Schriften* II, p. 537
44. A. W. Schlegel *Vorlesungen über schöne Litteratur und Kunst Deutsche Litteraturdenkmale des 18. und 19. Jahrh.* II, pp. 69 and 70
45. F. Schlegel *Kritische Schriften* p. 101
46. Novalis *Schriften* ed. J. Minor (Jena, 1907) IV, p. 66
47. Wordsworth *The Prelude* Books XII and VI. pp. 448 and 209
48. A. W. Schlegel *Vorlesungen über schöne Litteratur und Kunst* I, p. 83
49. Jean Paul Richter *Vorschule der Ästhetik* ed.J. Müller, Part I, p. 53
50. F. Schlegel *Kritische Schriften* p. 311-12
51. Bob Richenberg *IT IS: A Magazine for Abstract Art (1959),* quoted in S. Rodman *The Insiders* (Louisiana State University Press, 1960) p. 31

Chapter II

1. A. Wolfenstein, poem 'Das Herz' *Menschlicher Kämpfer.
 Ein Buch Ausgewählter Gedichte* (Berlin: S. Fischer Verlag, 1919)
 p. 63
2. G. Engelke, poem 'Mensch zu Mensch' *Das Gesamtwerk* ed. H.
 Blome (München: Paul List Verlag, 1960) p. 46
3. A. Stramm, poem 'Erinnerung' *Das Werk* ed. R. Radrizzani,
 p. 40
4. I. Goll, poem: Der Panama Kanal' (Zweite Fassung) *Gedichte,* ed.
 R. A. Strasser (Meilen, Schweitz: Magica Verlag p. 52.
5. E.Toller, poem 'An alle Gefangenen' *Vormorgen* (Potsdam,1924)
 p. 39. See also 'Pfade zur Welt *Gedichte der Gerfangenen*
 (München: Kurt Wolff Verlag, 1921) p. 20
6. H. Hesse 'Zu Expressionismus in der Dichtung' *Expressionismus
 Der Kampf um eine Literarische Bewegung* ed. P. Raabe, p. 111:
 'Denn für mich, in meiner ganz privaten Theologie und
 Mythologie, nenne ich Expressionismus das Erklingen des
 Kosmischen, die Erinnerung an Urheimat, das zeitlose
 Weltgefühl, das lyrische Reden des einzelnen mit der Welt, das
 Sichselbstbekennen und Sichselbsterleben in beliebigem
 Gleichnis.'
7. R. Musil 'Expressionismus' *EKLB* p. 162
8. W. Kandinsky 'Über die Formfrage' *Essays über Kunst und
 Künstler* ed. M. Bill, p. 40. This essay, originally published in the
 Blue Rider Almanac (1912), has been translated at last by K.
 Lindsay as one of the contributions to *Theories of Modern Art* ed.
 H. B. Chipp (University of California Press, 1969) pp. 155-70.
 Another translation appears in *Voices of German Expressionism* ed
 V. H. Miesel (New York: Prentice Hall Spectrum Books, 1970)
 pp. 46-64.
9. Kandinsky 'Text Artista' *Wassily Kandinsky Memorial* (New
 York: S. R. Guggenheim Foundation, 1945) p. 52
10. E. Nolde *Das Eigene Leben*, p. 98
11. F. Marc, in W. Hess *dokumente zum verständis der modernen maleri*
 (Hamburg: Rowohlt, 1956) p. 78
12. *Tagebücher von Paul Klee 1898-1918* ed. Felix Klee (Köln: Verlag
 M. DuMont Schauberg, 1957), entry no. 1008. Klee's *Tagebücher*
 have been translated into English: *The Diaries of Paul
 Klee. 1898-1918.*

13. L. Meidner, quoted by L. G. Bucheim *Graphik des deutschen Expressionismus* p. 60
14. K. Edschmid 'Über den Expressionismus in der Literatur und die neue Dichtung'. *Tribüne der Kunst und Zeit* I, ed. K. Edschmid. p. 53.
15. Kandinsky 'Text Artista' *Wassily Kandinsky Memorial* p. 64
16. T. Däubler, poem 'Der Geist; *Dichtungen und Schriften* ed. Friedhelm Kemp, p. 672.
17. F. Werfel, poem 'An den Leser' *Gesammelte Werke, Das Lyrische Werk* ed. A. D. Klarmann, p. 62.
18. 'Kandinsky, the Painter' by L. Grote in *Wassily Kandinsky* ed. M. Bill, p. 160. See also Kandinsky's remark in 'Text Artista', p. 70: 'As mountains gradually but surely crumble, are worn down and washed away, so will the many barriers between the peoples of the world diminish and eventually cease to exist. Then "humanity" will no longer be an empty and meaningless word.'
19. Klee 'Ways of Nature Study' *The Thinking Eye, The Notebooks of Paul Klee,* ed. J. Spiller, transl. R. Manheim, pp. 63-71
20. *Ibid.* p. 67
21. Marc *Briefe, Aufzeichnungen und Aphorismen* I p. 99
22. A. W. Schlegel *Vorlesungen über schöne Litteratur und Kunst, Deutsche Litteraturdenkmale des 18. und 19. Jahrh.* I, p. 103
23. Kandinsky 'Fragen und Antworten' (1935) *EKK* p. 155
24. Kandinsky 'Zwei Richtungen' (1935) *EEK* p. 193
25. *Ibid.*
26. *Ibid.* 'Fragen und Antworten' p. 155
27. Klee 'On Modern Art' *The Thinking Eye* p. 95
28. Runge *Hinterlassene Schriften* II, p. 388
29. Klee *The Thinking Eye* p. 521. See also Klee's remark, *Ibid.*: 'I believe that the [colour] theory of Philipp Otto Runge, which is sure to be taken over from others, is closest to us painters.' Klee expounds his theory of colour in *The Thinking Eye* pp. 467-511.
30. R. Sorge, play 'Der Bettler' *Werke* ed. H. G. Rotzer, II, Act I, 23.
31. F. Werfel, poem 'Das Mass der Dinge' *Das Lyrische Werk* p. 320
32. M. Werefkin *Briefe an einen Unbekannten. Aus den Tagebüchern von Marianne Werefkin,* ed. and transl. C. Weiler (Köln: Verlag DuMont Schauberg, 1960) p. 50
33. Marc, quoted in W. Haftman *Painting in the Twentieth Century* I, p. 122: 'Je cherche à me mettre dans un état de grand amour'.
34. Nolde *Das Eigene Leben* p. 52

35. K. Pinthus 'Introduction' *Menschheitsdämmerung*. *Ein Dokument des Expressionismus* ed. K. Pinthus, p. 29
36. Klee *The Thinking Eye* pp. 67 and 93
37. Marc in W. Hess *dokumente* p. 79
38. Kandinsky 'Zugang zur Kunst' (1937) *EEK* p. 209
39. Kandinsky *Concerning the Spiritual in Art* p. 58
40. Marc, letter to August Macke, Dec. 1910 *August Macke/Franz Marc Briefwechsel* p. 28.
41. E. Lasker-Schüler, poem 'Gebet' *Gesammelte Werke* ed. Friedhelm Kemp, I, p. 288
42. G. Trakl, poems 'In den Nachmittag Geflüstert' and 'Der Herbst des Einsamen' *Dichtungen und Briefe* W. Killy and H. Szklenar, I, pp. 54 and 109
43. G. Heym, poems 'Deine Wimpern . . .' and 'Alle Landschaften . . .' *Dichtungen und Schriften* ed. Karl Ludwig Schneider, I, pp. 337 and 315
44. W. Klemm, poem 'Bekenntnis' *MD* p. 144; J. Becher, poem 'Klage und Frage' *Um Gott* (Insel Verlag, Leipzig, 1921) p. 89. See also I. Goll's poem 'Das blaue Gesicht' *Gedichte* p. 29.
45. R. Schickele, poem 'Lobsprüche' *Lyrik des expressionistischen Jahrzehnts* intr. by Gottfried Benn (München: Taschenb. Verlag, 1966) p. 43
46. A good example of how Benn uses the colour blue is found in 'Querschnitt' *Gesammelte Werke* ed. D. Wellershoff, II, p. 77. See Reinhold Grimm *Gottfried Benn*. *Die farbliche Chiffre in der Dichtung*. 2. durchgesehene Auflage 1962 Hans Carl (Erlanger Beiträge z. Sprach – und Kunstwissenschaft 1). I owe this reference to an anonymous reader in California.
47. Kandinsky, letter to G. Münter, 11 March 1915 J. Eichner *Kandinsky und Gabrielle Münter* p. 167. For the student of Kandinsky, Eichner's study is of the greatest interest since it makes use of hitherto unpublished sources, notably Kandinsky's numerous letters to G. Münter and his projected 'Cologne lecture' of 1914 which was never delivered.
48. I. Goll, poem 'Karawane der Sehnsucht; in *MD* p. 187
49. Kandinsky letter to G. Münter, 1 Feb. 1903 *Eichner* p. 121.
50. Kandinsky *Über das Geistige in der Kunst* p. 94. Cf. Kandinsky *CSA* p. 59. I slightly altered the Wittenborn translation used here to approximate the original which reads: 'da der Mensch als ein Element des Weltalls zu ständiger, vielleicht ewiger Bewegung geschaffen ist.'

51. *Goethe's Gespräche* ed. W. V. Biedermann, III, 8
52. Hoelderlin, ode 'Stimme des Volkes' (Zweite Fassung, 1801)
53. Kandinsky 'Cologne Lecture' *Eichner* p. 114: 'Und das ist die kosmische Tragik, in der das Menschliche nur ein Klang ist, nur eine einzige mitsprechende Stimme, und in der das Zentrum in eine Sphäre verschoben wird, die sich dem Göttlichen nähert.' The precise logic of this passage goes begging since Kandinsky does not make it clear how man's 'cosmic tragedy' is related to the sphere of the divine.
54. Klee *The Thinking Eye* p. 407
55. Marc, letter quoted in K. Lankheit *Franz Marc* p. 8: 'Sie [painting] muss mich befreien . . . von meiner Angst; ich kann so oft eine sinnbetörende Angst empfinden auf dieser Welt zu sein; ich glaube, es ist etwas wie der Panschrecken der über einen kommt. man muss sich Götter schaffen, zu denen man beten kann . . .'
56. Kandinsky 'Text Artista' *Wassily Kandinsky Memorial* p. 55
57. Klee *The Thinking Eye,* p. 463; *Diaries* entry no. 951
58. Pinthus in 'Introduction' *MD* p. 21
59. Werfel, poem 'Wie Nichts Erkennend' *Das Lyrische Werk* p. 95. Cf. also poem 'Fremde sind wir auf der Erde Alle' p. 170
60. Benn, poem 'Terzett und Tenorsolo' *Gesammelte Werke (Gedichte)* III, p. 143. A similar painful admission can be found in 'Das Letzte Ich', *Werke* II, p. 99.
61. Novalis 'Vermischte Bemerkungen' *Schriften* II, 412: 'Wir suchen überall das Unbedingte, und *finden* immer nur Dinge.'
62. Lasker-Schüler, poem 'Weltende' *Gesammelte Werke* I, p. 149
63. See Chapter IX
64. Benn 'Urgesichte' *Gesammelte Werke* II, 116. This and other essays of Benn have been translated under the name of *Primal Vision* ed. E. B. Ashton. Benn frequently pours scorn on positivism, materialism and technology; see, for instance, 'Nach dem Nihilismus' *Ges. Werke* I, pp. 151-61.
65. Kandinsky in *CSA* p. 24
66. *Ibid.,* p. 30
67. Kandinsky 'Text Artista' *Wassily Kandinsky Memorial,* p. 55
68. Kandinsky 'Der Wert eines Werkes der konkreten Kunst' (1938) *EKK* pp. 245-6
69. Marc, letter 12 April 1915 *Briefe, Aufzeichnungen und Aphorismen* I, pp. 49-51
70. *Ibid.* pp. 126-32

71 Kandinsky *Punkt und Linie zu Fläche* ed. M. Bill. p. 49.
72. Marc *Briefe, Aufzeichnungen und Aphorismen* I, p. 102
73. *Ibid.* p. 125
74. Kandinsky 'Über die Formfrage' (1912) *EKK* p. 46
75. Kandinsky *CSA* p. 32
76. Marc *Briefe, Aufzeichnungen und Aphorismen* I, pp. 129-32
77. Marc, quoted in Haftmann *Painting in the Twentieth Century* i, pp. 122-3
78. Marc *Briefe, Aufzeichnungen und Aphorismen* in W. Hess *dokumente* p. 80
79. Kandinsky *CSA* p. 68: 'When we remember ... that spiritual experience is quickening, that positive science, the firmest basis of human thought, is tottering, that dissolution of matter is imminent, we have reason to hope that the hour of pure composition is not far away.'
80. Benn 'Nach dem Nihilismus' *Gesammelte Werke* I, p. 160
81. Klee *The Thinking Eye* p. 191. See also Klee's diary entry no. 941: 'Ingres is said to have created an artistic order out of rest; I should like to create an order of motion beyond pathos. (The new Romanticism.)'
82. F. Schlegel *Philosophische Vorlesungen* in *Kritische Ausgabe* XII, p. 410
83. L. Klages *Grundlagen der Characterkunde* p. 157. Klages' main work was significantly entitled *Der Geist als Widersacher der Seele*. This colourful, neo-Romantic figure has been curiously ignored in the history of philosophy despite the fact that certain of his writings contain brilliant interpretations in the field of perception. Some of E. Cassiere's analysis in *The Language of Symbolic Forms* was already anticipated by him. Klage's relationship to Expressionism itself, notably to Benn, would make a fascinating study. Thus Benn's historical pessimism of the 1920s, his belief that man's progressive *Vehirnung* spelled degeneration leading to nihilism was clearly indebted to Klages and the related views of Theodor Lessing, Oswald Spengler and Arthur Bonus, an almost forgotten writer whose influence on the 'New Romanticism' was profound.
84. Arp, *On My Way, poetry and Essays 1912-1947* pp. 72 and 49
85. G. Sack, quoted in W. H. Sokel *The Writer in Extremis* p. 96. This is a thoughtful and provocative study of Expressionist literature.
86. Pechstein 'Schöpferische Konfession' *Tribüne der Kunst und Zeit*

vol. XIII, ed. K. Edschmid. An English translation is available in
Voices of German Expressionism pp. 180-1
87. Nolde *Das Eigene Leben* p. 200.
88. Benn, 'Ithaka' *Gesammelte Werke* II, p. 300. Benn ends by
evoking the mindless intoxication of Dionysos: 'Seele, klaftere
die Flügel weit; ja, Seele! Seele! Wir wollen den Traum. Wir
wollen den Rausch. Wir rufen Dionysos und Ithaka!' *Ibid.* p.
303.
89. Benn 'Gesänge' *Gesammelte Werke* (Gedichte) III, p. 25. See also
Benn's poem 'Ikarus' p. 46.
90. W. H. Sokel *Writer in Extremis* pp.83-118
91. Nolde, letter to Ada, 21 August 1901 *Briefe aus den Jahren 1894-
1926* ed. M. Sauerlandt. Cf. also *Jahre der Kämpfe* p. 185.
92. Kandinsky 'Über Kunstverstehen' *Der Sturm* III, no. 129
October 1912, pp. 157-8
93. Kandinsky 'Leere Leinwand unsweiter' (1935) *EEK* p. 179 and
CSA p. 66.
94. Werefkin *Briefe an einen Unbekannten* p.58.
95. Kandinsky *CSA* p. 77
96. V. Hofman 'Der Geist der Umwandlung in der bildenden
Kunst' *Der Sturm* IV, nos. 190-1, p. 146.
97. Kandinsky 'Text Artista' *Wassily Kandinsky Memorial* p. 52.
98. Beckmann in W. Hess *dokumente* p. 108. See also E. L. Kirchner's
letter to Grisebach, 1 Dec 1917 *Maler des Expressionismus im
Briefwechsel mit Eberhard Grisebach* (Hamburg, 1962) pp. 76 ff.
99. Kandinsky. Preface to the catalogue of the second exhibition of
the 'Neue Künstlervereinigung München' (Sept. 1910) in W.
Grohmann, *Wassily Kandinsky, Life and Work* p. 64.
100. Kandinsky 'Text Artista' *Wassily Kandinsky Memorial* p. 63
101. Marc 'Die "Wilden" Deutschlands' *Der Blaue Reiter* W.
Kandinsky and F. Marc p. 30
102. According to Mme Nina Kandinsky (in a personal interview
with me) her husband met Rudolf Steiner and was invited by
him to participate actively in the Anthroposophical Society.
Kandinsky it seems declined the offer. Nonetheless he was full
of praise for occult movements of this kind since they presaged
'deliverance to opressed and gloomy hearts' smarting under
the yoke of positivism and materialism. See *CSA* pp. 32-3.
103. W. Grohmann *Wassily Kandinsky, Life and Work* p. 85. Cf. also J.
Eichner *Kandinsky und Gabrielle Münter* p. 19. Among
Romantics, Novalis speculated on this subject; for instance in

'Poeticismen' *Schriften* II, p. 541: 'Nur der Geist sieht, hört – und fühlt – So lange das Auge, das Ohr und die *Haut!!!* noch *afficirt* sind von den *Medien* ihrer Gegenstände – den Incitamenten – so lange sie noch nicht rein *leiten* – *heraus* und hinein – so lange sieht und hört und fühlt der Geist noch nicht ordentlich. Erst wenn die Erregung vorbey – und das Organ vollkommener Leiter geworden ist – etc.' This passage seems to imply only the possibility of thought transference. Elsewhere however Novalis speaks of the 'galvanization' of thought.

Chapter III

1. A. C. Bradley *Oxford Lectures on Poetry* p. 183
2. Wordsworth 'Preface to Lyrical Ballads' *Literary Criticism* ed. N. C. Smith, p. 15
3. F. Schlegel 'Aufforderung an die Maler' *Kritische Schriften* pp. 407-8
4. Runge *Hinterlassene Schriften* I, p. 14
5. Wackenroder 'Herzensergiessungen eines kunstliebenden Klosterbruders' *Werke und Briefe Wakenroders* p. 52
6. Novalis 'Fragmente und Studien' *Schriften* III, p. 650
7. Constable in C. R. Leslie *Memoirs of the Life of John Constable* ed. J. Mayne, pp. 85 and 121
8. Coleridge *Biographia Literaria* II, p. 12
9. Wordsworth *Literary Criticism* p. 7
10. De Quincey 'To a Young Man whose education has been neglected' Letter III *Works* ed. D. Masson (Edinburgh, 1889), X, p. 48. Similarly Shelley: Poetry 'awakens and enlarges the mind itself by rendering it the receptacle of a thousand unapprehended combinations of thought' *Defence of Poetry*.
11. Jean Paul Richter *Vorschule der Aesthetik* part I, p. 57
12. F. Schlegel 'Athaneums-Fragmente' *Kritische Schriften* p. 41. See also Novalis in *Schriften* II, p. 535.
13. J. G. Sulzer *Allgemeine Theorie der schönen Künste* (Leipzig; Neue vermehrte zweite Auflage, 1792), I, p. 609
14. Blake 'A Descriptive Catalogue' *Poetry and Prose of William Blake* ed. G. Keynes, p. 607
15. *Ibid.* 'Marginalia', p. 777
16. C. D. Friedrich *Bekenntnisse* selected and edited by K. K. Eberlein, p. 121. See also P. O Runge's letter to his friend Böhndel, Sept,

1801 in *Hinterlassene Schriften* II, p. 82. 'Es ist nichts und führt nur geradeswegs zum Verfall der Kunst, von aussen nach innen wirken zu wollen.'

17. Kant 'Analytic of the Sublime' *Critique of Judgement* transl. and ed. J. C. Meredith paragraph 47, p. 169

18. Schelling 'Über das Verhältnis der bildenden Künste zu der Natur' *Werke* 3, Ergänzungsband, p. 393. Schelling is quoting the words of J. G. Hamann.

19. A. W. Schlegel 'Über das Verhältnis der schönen Künste zur Natur' *Sämtliche Werke* ed. E. Böcking IX, pp. 294 and 296

20. Quoted in M.H. Abrams *The Mirror and the Lamp* p. 100

21. C. D. Friedrich *Bekenntnisse* p.110

22. Baudelaire 'What is Romanticism' *Art in Paris, 1845-1862* transl. and ed. J. Mayne, p. 46

23. Novalis 'Blüthenstaub' *Schriften* II, p. 430

24. Tieck *Franz Sternbald* in *Werke* ed. M. Thalmann, I p. 894

25. *Ibid.* I, p. 907

26. F. Schlegel 'Fragmente I' *Literary Notebooks of 1797-1801* ed. H. Eichner, fragment no. 977, p. 107. A similar idea is conveyed in Schlegel's fragment no. 2117, p. 210; 'Es muss eine indische Mahlerei gegeben haben und zwar sehr gross Reine Pic(tur) nichts als Arab(eske). Man müsste hieroglyphisch malen können, ohne Mythologie. Eine philosophische Mahlerei.' Schlegel presumably means a kind of ornamental painting which consists of curves, lines and patterns suggesting the infinite.

27. Kant 'Analytic of the Beautiful' *Critique of Judgement* paragraph 16, p. 72.

Kant's analysis of beauty has been regretfully omitted since it comprises a highly complex network of discussions. Nonetheless some guide posts can be provided. Philosophically and historically, Kant's compressed exposition was the first sustained effort to free art and beauty from all extraneous associations. Kant's main concern throughout was to separate sharply the faculties of knowing, willing and feeling – faculties corresponding respectively to the realms of truth, goodness and beauty. At the mercy of this rigid compartmentalization of human faculties, Kant's search was directed to formulate a pure aesthetic judgement as one completely distinct and *sui generis*. In the course of his exposition Kant laid down the category of *disinterestedness* as fundamental to aesthetic contemplation. The delight we feel in the beautiful, he argued, did not involve

interest and desire as did our awareness of the agreeable and the good. It was a free 'disinterested' pleasure untainted by wants or needs. In the sight of beauty we take an interest but we are not driven by an interest. Kant likewise dissociated the aesthetic judgement from the jurisdiction of an interfering reason. To judge the beautiful by any definite concept of the understanding was to judge it by something extrinsic to it. The beautiful was in no need of any reflective idea. Having separated the aesthetic consciousness from the regions of abstract intellect, on the one hand, and from the domains of purely sensuous gratification and moral satisfaction on the other, Kant proceeded to give the aesthetic judgement and its object, the beautiful, a somewhat more positive definition. The beautiful, he suggested, exhibited a 'purposiveness without a purpose', a purposiveness, that is, without the idea of an end. By this paradoxical phrase Kant meant that unlike most objects the explanation of which presupposes the conception of an end or purpose to which the objects were subservient, the judgement of the beautiful presupposed no such conceptions of ends. Non-purposive in this sense, its purposivenesss consisted of the stimulation of man's mind and imagination. Put differently, beauty was apprehended as absolute and not as instrumental to something else. Kant opposed all those views which made beauty *solely* dependent on function, on utility and ideas. This forced him to draw a clear distinction between two forms of beauty. 'There are two kinds of beauty: free beauty, or beauty which is merely dependent. The first presupposes no concept of what the object should be; the second does presuppose such a concept and, with it, an answering perfection of the object.' Architecture in this view was an example of dependent beauty. At the opposite pole of independent beauty was music without words and theme. The fine arts as falling in between architecture and music Kant held were free within certain limits. Yet, he argued, some were more free than others, that is less restricted by an object. It is in this context that Kant mentioned painting which has no theme, arabesque configurations that required no objects. Meredith, Kant's translator and interpreter, writing at the beginning of this century, was firmly convinced that Whistler's conception of painting understood primarily as a combination of forms and colours was 'the conception of painting as it ought to be conceived according to Kant's view'. What can be said with

certainty is that Kant conceived of pure beauty in terms of free form divorced from all utilitarian and ideational meanings and associations. This view provided the basis for Schiller's own theory that art was the result of a 'play-impulse', a free play without ulterior ends culminating in forms that abolished all content. Kant's understanding of pure beuty as free form likewise anticipated the seemingly revolutionary gospel of 'significant form' propounded by Clive Bell and Roger Fry in an effort to provide an aesthetics supporting non-objective art.

28. Mme de Stael *De l'Allemagne* ed. F. Charpentier p. 406.

29. Baudelaire *The Painter of Modern Life* transl. and ed. J. Mayne p. 62. Of Delacroix, Baudelaire remarked in *Art in Paris* . . . it seems to me that M. Delacroix's colour *thinks for itself*, independently of the objects which it clothes,' p. 141

30. G. Keller *Der Grüne Heinrich* transl. A. M. Holt pp. 498-502. One early Expressionist critic was quick to spot the relevance of this passage for non-objective art. See 'Die Jüngsten' by Karl Scheffler in *Kunst und Künstler* XI, 1913, p. 408, a monthly periodical edited by Karl Scheffler published by Bruno Cassirer, Berlin (1908-33). There is another reference to *Green Henry* in the same volume, p. 435.

31. Novalis 'Fragmente und Studien' *Schriften* III, p. 572.

32. Tieck *Franz Sternbald* in *Werke* I, p. 854.

33. *Ibid.* 1. p. 908

34. *Ibid,* I, p. 861

35. *Ibid.* I, p. 855

36. A. W. Schlegel *Sämtliche Werke* ed E. Böcking, XII, p. 34

37. Shelley 'Prometheus Unbound' (Scene III) *The Complete Poetical Works* ed. T. Hutchinson, p. 234

38. Novalis 'Monolog' *Schriften* II p. 672. Novalis extended this idea to forms, lines and colours, *Schriften* III, p. 244: 'Schwarze Kreide, Farben, Striche, Worte sind *ächte* Elemente, wie Mathematische Linien und Flächen'.

39. Novalis *Schriften* ed. J. Minor III, p. 176

40. Kandinsky *CSA* p. 34

41. Baudelaire 'The Governance of the Imagination' *Art in Paris* p. 162

42. Hegel on 'Romantic Art' *Vorlesungen über die Aesthetik* vol. 2, *Sämtliche Werke* ed. H. Glockner, XIII, pp. 130-3

43. Coleridge 'Dejection: An Ode' *Complete Poetical Works* I, p. 365

44. R. M. Rilke 'Die Aufzeichnungen des Malte Laurids Brigge' *Sämtliche Werke* 6 vols., ed. Rilke-Archiv (Frankfurt am Main:

Insel Verlag 1966) VI, p. 785
45. Novalis 'Merckwürdige Bemerkungen bey der Lectüre der Wissenschaftslehre' *Schriften* II, pp. 287-8
46. Blake 'Vision of the Last Judgement' *Poetry and Prose*' pp. 651-2
47. *Ibid.* 'Annotations to "Poems" by W. Wordsworth' p. 821
48. Kandinsky in *CSA* p. 73
49. 'Aus Goethes Brieftasche' *Werke* ed. on behalf of the Grand Duchess Sophie von Sachsen (Weimar, 1896), XXXVII, p. 313. This passage seems to have been omitted from the Jubiläumsausgabe.
50. F. Schlegel 'Athäneums-Fragmente" *Kritische Schriften* pp. 37-38
51. Novalis, 'Das Allgemeine Brouillon" *Schriften* III, 414.
52. Schelling 'Über das Verhältnis der bildenden Künste zu der Natur' *Werke* 3, Ergänzungsband, p. 427
53. Wackenroder 'Herzensergiessungen' *Werke und Briefe* p. 52
54. Karl Friedrich Burdach *Romantische Naturphilosophie* ed. W. Rössle, p. 216
55. F. Schlegel 'Athäneums-Fragmente' *Kritische Schriften* p. 58
56. Schelling 'Über das Verhältnis der bildenden Künste zu der Natur' *Werke* 3, Ergänzungsband, p. 396. Coleridge, leaning on Schelling's essay, expressed this notion admirably: 'Yes, not to acquire cold notions – lifeless technical rules – but living and life-producing ideas, which shall contain their own evidence, the certainty that they are essentially one with the germinal causes in nature.' 'On Poesy or Art' *Biogr. Lit. II,* pp. 258-9
57. Runge *Hinterlassene Schriften* I, p. 17
58. F. Schlegel *Kritische Ausgabe* XVIII, p. 255
59. W. Allston *The Life and Letters of W. Allston* (New York: Scribner, 1892), quoted in W. E. Suida, *Kunst und Geschichte* (Köln: Phaidon Verlag, 1969), p. 105
60. Pater *The Renaissance* p. 62.
61. Turner's lectures are preserved in the Brit. Museum. Add. MS.46151. The most perceptive of recent studies of Turner, including source material, are the following works: L. Gowing, *Turner: Imagination and Reality;* J. Gage *Colour in Turner;* J. Ziff 'Backgrounds, Introduction of Architecture and Landscape, a Lecture by J. M. W. Turner'*Journal of the Warburg and Courtauld Institutes* XXVI, 1963, pp. 124-47. Cf. by the same author: 'J. M. W. Turner on Poetry and Painting' *Studies in Romanticism* III, 1964. Turner's position in the history of painting has become a subject of controversy. Was he indeed a forerunner

not only of Impressionism but also of abstract Expressionism? The answer to these questions must be found in his art and writing. To deal briefly with the 'Impressionist' aspects of Turner's painting, in his use and understanding of atmospheric gradations, Turner to some extent anticipated the Impressionists. In an observation which was to touch on the very core of their art, Turner wrote of the 'ruling principles of diurnal variations', of the 'pure combinations of aerial colours' as manifest in 'the grey dawn, the yellow morning sun rise and red departing ray in every changing combination.' Several decades later Monet embodied just such aerial colours in their diurnal variations in his picture series of haystacks one of which shocked Kandinsky into the realization that painting need not represent objects to make its effect.

Although Turner pioneered the Impressionist technique of breaking light down into luminous specks of colour, the end such techniques served was wholly opposed to that of the Impressionists. Unlike the latter who strove to create a purely 'retinal' art, Turner was a visionary who breathed into his atmospheric hues a glow and fire uniquely romantic. This visionary conception of light and colour points foward to the exploding suns of Van Gogh as well as to the brilliant seascapes of Nolde.

While extremely sensitive to colour as an embodiment of light, Turner at the same time proved unusually perceptive of the inherent expressive quality of colour as paint. His numerous watercolours and sketches, notably those he concealed from the public, reveal a sensitivity to colour which is distinctly modern. With these pictures, we reach the borderland of abstraction and representation. Was Turner then a precursor of Abstract Expressionism? He was in the restricted sense of having recognised the independent value of colour which required no object to produce an emotional effect. Yet Turner did not aim at abstraction for its own sake. Where it occurred in his art, it was invariably the by-product of a pantheistic vision which looked to light and colour as primeval phenomena. As Turner's vision of such phenomena grew more all-embracing, his pictures gradually emptied themselves of definable forms and figures. A similar progression, as we shall see, can be observed in the art of Kandinsky, Klee, Marc and Nolde. In each case, a form of cosmological mysticism provided one of the motive forces

pushing their painting toward the non-representational and abstract. In other words, their abstractness was to some extent a consequence not an operative principle.

62. Tieck 'Phantasien über die Kunst' *Werke und Briefe von W. H. Wackenroder* p. 190
63. Tieck 'Der Getreue Eckhart' *Werke* II, p. 44
64. Shelley 'Lines written among the Euganean Hills' *The Complete Poetical Works* p. 555
65. Novalis 'Anekdoten' *Schriften* II p. 574
66. Wackenroder 'Das eigentümliche innere Wesen der Tonkunst' in 'Phantasien über die Kunst' *Werke und Briefe* p. 223.
67. T. Carlyle *Heroes and Hero-Worship* in *Works* ed. H. D. Traill, V, p. 83
68. F. Schiller 'Über Naive und Sentimentalische Dichtung' *Werke* ed. L. Bellermann, VIII, p. 356
69. E. A. Poe, letter to J. R. Lowell, 2 July, 1844 *Letters of E. A. Poe* ed. J. Ostrom, I, pp. 257-8
70. E. T. A. Hoffmann, letter to Kunz, 24 March 1814 *Hoffmanns Dichtungen und Schriften* ed. W. Harich, XV, 121
71. Runge *Hinterlassene Schriften* I, p. 16.
72. Baudelaire *Art in Paris* p. 160
73. J. Ruskin *The Art Criticism of John Ruskin* selected and edited by R. L. Herbert, p. 2. The quotation is taken from *Stones of Venice* II, p. 215
74. Novalis 'Ästhetische Fragmente' *Werke* ed. A. Friedmann, part III, p. 205. Novalis was unusual among Romantics in that he placed painting higher than music. See *Schriften* II, p. 575.
75. Carlyle 'Jean Paul Richter' *Critical and Miscellaneous Essays I* in *Works* XXVI, p. 20.

Chapter IV

1. Däubler *Der Neue Standpunkt* p. 137
2. L. Schreyer, quoted in R. Samuel and R. H. Thomas *Expressionism in German Life, Literature and the Theatre* p. 18
3. Werfel, poem 'Lächeln Atmen Schreiten' *Das Lyrische Werk* pp. 141-2
4. K. Hiller 'Zur neuen Lyrik' (1913) EKLB p. 31
5. Edschmid *UELD* p. 70
6. I. Goll, introduction to Gedichtband *Films* (Berlin: Verlag der expressionistischen Hefte, 1914). See also Goll's 'Der

Expressionismus stirbt' (1921) *EKLB* p. 180.

7. Kandinsky 'Malerei als reine Kunst' (1918) *EEK* pp. 63 ff. For similar testimony see E. L. Kirchner, letter to Curt Valentin (1937), quoted in B. S. Myers *Expressionism. A Generation in Revolt* p. 120. 'Postkarten und Briefe von Christian Rohlfs' *Das Kunstblatt* ed. Paul Westheim, 1930, p. 19. K. Schmidt-Rottluff and Erich Heckel 'Das Neue Programm' *Kunst und Künstler* XII, 1914, pp. 308-9. See also L. Feininger 'Ein Brief' *Das Kunstblatt* 1931, pp. 216-7, as well as the Museum of Modern Art catalogue to the 'Lyonel Feininger-Marsden Hartley' exhibition (New York, 1944).

8. E. Barlach *Ein selbsterzähltes Leben* p. 41

9. C. D. Friedrich *Bekenntnisse* p. 103

10. L. Meidner, quoted by L. G. Buchheim, *Graphik des deutschen Expressionismus* p. 60

11. Novalis 'Fragmente und Studien' *Schriften* III, p. 650

12. Kandinsky, catalogue to the first *Blaue Reiter* exhibition at the Sturm gallery (Berlin, 12 March 1912), quoted in W. Grohmann *Wassily Kandinsky. Life and Work* p. 67. Grohmann adds that Kandinsky was beyond doubt the author of this text.

13. Kirchner 'Manifesto of Künstlergruppe Brücke' (1902). The text of the manifesto was cut in wood and printed by hand. For a reproduction of the original typography see P. Selz *German Expressionist Painting* p. 95. Professor Selz's penetrating study is still the most comprehensive treatment of Expressionist painting.

14. Nolde *Jahre der Kämpfe* pp. 104 and 44

15. Kandinsky *CSA* p. 74

16. *Ibid.* p. 25

17. E. Lotz, poem 'Hart stossen sich die Wände in den Strassen' *Gedichte des Expressionismus* ed. D. Bode, pp. 51-2

18. Edschmid *UELD* p. 52: 'dauernde Erregung'. Edschmid's programmatic manifesto conjures up the ecstasy, the feverish passion, intensity and visionary pathos characteristic of Expressionism.

19. F. Herwig 'Vom literarischen Expressionismus' (1916) in *EKLB* p. 83. For another far more devastating, though frequently unfair, criticism of Expressionism see F. Gundolf 'Über das neue Pathos und den Expressionismus' *Ibid.* pp. 163-70.

20. Kandinsky 'Der Wert eines Werkes der Konkreten Kunst' (1938) *EEK* p. 247

21. Kandinsky *CSA* p. 24.
22. *Ibid.* p. 45
23. Shelley 'Defence of Poetry' *Prose* p. 277
24. Pechstein *Berliner Tageblatt* 21 Dec. 1922
25. Kandinsky, catalogue to the first *Blaue Reiter* exhibition at the Sturm gallery (Berlin, 12 March 1912) quoted in W, Grohmann *Wassily Kandinsky. Life and Work* p. 67.
26. Edschmid *UELD* p. 52
27. Edschmid 'Expressionismus in der Dichtung' *EKLB* p. 105
28. K. Heynicke 'Seele zur Kunst' *Das Kunstblatt* (Erster Jahgang) 1917, p. 348
29. The following features roughly characterize the Expressionists' use of language: (1) A strong tendency to impart to nouns (and therefore to things) an active quality. One of the ways to achieve this was to form nouns out of verbs, adjectives and infinitives. (2) A massing of verbs to dramatize and intensify the inner and outer life. New verbs were frequently formed in a novel fashion from nouns as well as adjectives. For example: *ich flamme* from *Flamme, maule* from *Maul, steilen* from *steil*. August Stramm's poetry and that of the Sturm circle provide numerous examples of a free and often arbitrary use of the intransitive verb (see note 31). (3) A frequent reversal of the adjectival function: instead of describing objects or feelings, the adjective becomes a substantive (see 1) or an unattached quality used as an independent means of expression. (4) A marked predilection for superlatives. This contributed to a rather hollow-sounding rhetoric at times. (5) A tendency to connect words to cosmic phenomena already discussed in Chapter II. (6) New word-formations or neologisms. (7) Frequent repetition of words or phrases for 'magical' or 'incantatory' purposes. (8) An effort generally to penetrate to the 'primitive' layers of language stripped of its grammatical refinement. In the words of one Expressionist essayist: 'Nicht wiederlegt, nicht gestäupt wird Demagoge Grammatik. Der macht noch heute in uralten Formen denken: Subjekt, Prädikat, in den Formen der Wilden, die vom Donnern auf den Donnerer schliessen ... Neuem Menschen genügt nicht alte Voraussetzung ... Wie der Urmensch bemächtigt er sich der tönenden Welt in Tönen ... Die Sophismen der Grammatik belächelt er ... Expressionismus will dem erleben abgestorbener Sprache aus Erleben neu gebären'. Oswald Pander in *Das Junge Deutschland* I, 1918, no. 5,

pp. 147-8.)
30. Benn 'Bekenntnis zum Expressionismus *Gesammelte Werke* I, p. 244; also published in *EKLB*. An English translation of this famous essay appears in *Voices of German Expressionism* pp. 192-203. In the same passage, appealing to precursors, Benn also mentions Kleist's *Penthesilea* without however referring to any specific examples. He could have easily done so, for this heroic, barbarous tragedy abounds with blank verse that clearly contains Expressionist features. In his study *Writer in Extremis*, p.177 Sokel goes so far as to maintain that Kleist's play can be called Expressionist in every sense of the term
31. A typical example is the poem 'Schwermut' *Das Werk* p.24:
Schreiten Streben
Leben sehnt
Schauern Stehen
Blicke suchen
Sterben wächst
das Kommen schreit!
Tief
stummen
wir.
32. Some of Kandinsky's poems are reproduced and translated into English in *CSA*. Cf. the following poem entitled 'Seeing':
Blue, blue arose and fell.
Sharp, thin, whistled and pentrated, but did not pierce through.
Everywhere a rumbling.
Thick brown hovered seemingly for all eternity
Seemingly. Seemingly.
Spread your arms wider.
Wider. Wider.
And cover your red face with a cloth.
And perhaps it is not yet displaced at all: only you have displaced yourself.
White chink after white chink.
And in this white chink a white chink. In every white chink a white chink.
It is not good that you fail to see the turbid: it is precisely in the turbid
that it dwells.
And that is where everything begins –

– there was a crash.
What is the subject-matter of the poem? One looks in vain for
any rational meaning. No logical link seems to connect the
various lines. It is possible however to interpret the poem as
relating to an elementary state of the world, a kind of cosmic
landscape in the process of becoming. Grammatically verbs and
adjectival nouns predominate. Unattached to a subject or an
object, they are used as a direct means of expression. The
apparent concreteness of lines six, seven and eight implying
opposite actions – 'Spread your arms wider . . . And cover your
face with a red cloth' – only serve to heighten the abstract
character of the poem. We also meet the previously mentioned
device of repeating certain words and phrases not only for
purposes of emphasis, but also in order to practice a form of
'magical pronunciation'. Kandinsky believed that frequent
repetition of a word deprived it of its 'external reference'. Freed
from this reference the word, he insisted, contained
'unsuspected spiritual properties' (*CSA* p. 34). What is the
general impression of the poem? The sensations and emotions
evoked in the reader are of a peculiarly elusive fluidity which
resists condensation into coherent patterns. On reading these
lines we are transported, as it were, into an 'infra-world' of pre-
predicative experience (parallel to Kandinsky's painting), a
world consisting not of separate things and events, but
composed of colours, sounds and movements which make up a
field of 'expressional' phenomena encompassing the subject and
object alike. See Chapter IX, Section 5.

33. R. Hausmann 'Courrier Dada' H. Richter's *Dada. Art and Anti-Art*
(London: Thames and Hudson, 1965), p.121
34. See Kandinsky's essay 'Über die Formfrage' *EKK*
35. Stadler, poem 'Form ist Wollust' *Dichtungen* ed. Karl Ludwig
Schneider, I, p. 127
36. Kandinsky 'Über die Formfrage' *EEK* p.26
37. Kandinsky *CSA* pp. 27-40
38. Werefkin *Briefe an einen Unbekannten* p. 15
39. Kandinsky *CSA* p. 36 'Über die Formfrage' *EEK* pp. 20-7; the
essay entitled 'Und' *EEK* p. 102
40. Presumably the opening words of Kandinsky's projected
'Cologne lecture' quoted in Grohmann's *Wassily Kandinsky. Life
and Work* p. 52
41. Kandinsky 'Malerei als reine Kunst' (1918) *EEK* pp. 63-4.

42. Schelling 'Über das Verhältnis der bildenden Künste zu der Natur' *Werke* 3. Ergänzungsband, p. 396

43. Kandinsky 'Über die Formfrage' *EEK* p. 36: 'Abstrakt gesgagt: *Es gibt keine Frage der Form im Prinzip.*'

44. Kirchner *Künstlerbekenntnisse* ed. P. Westheim, p.232. See also Kirchner's *Davoser Tagebuch* ed. L. Grisebach, entry 434, 1925, p. 83: 'Der deutsche Künstler schafft aus der Phantasie, aus dem Geiste, im Gegensatz zum Künstler romanischen Stammes, der aus der Anschauung gestaltet. Germanische Kunst ist Religion im weitesten Sinne des Wortes, romanische ist Abbild, Schilderung, Beschreibung oder Umschreibung der Natur. Der Deutsche malt das "Was", der Franzose das "Wie". Three years later (diary entry 463, p. 178) Kirchner rejected this somewhat simple-minded comparison calling it 'nonsense'. Cf. also Nolde's remarks to Fehr pleading for a separation of French and German art: 'Wir haben die Pflicht, uns von den Franzosen abzulösen. Die Zeit einer selbstständigen deutschen Kunst ist gekommen,' *Emil Nolde. Ein Buch der Freundschaft* by H. Fehr, pp. 62, 97, 135-6; also *Jahre der Kampfe* pp. 164, 174, 234-5. In a letter to Fehr published in Paul Westheim, *Künstlerbekenntnisse* (pp. 233-4), Nolde implicitly contrasts his painting to Matisse's 'armchair' conception of art, 'an art of balance, of purity and serenity devoid of troubling or depressing subject-matter, an art ... like a good armchair in which to rest from physical fatigue.' (Notes of a Painter). Nolde's view of his etchings was diametrically opposed to this: 'Die Radierungen ... sind voller Leben, ein Rausch, ein Tanz ... Sie gehören nicht zu der Kunst, welche gemächlich im Lehnstuhl genossen werden kann, sie verlangen, dass der Beschauer im Rausche mitspringt.

45. Kandinsky *Punkt und Linie zu Fläche* p. 67 (note). Kandinsky was more forthcoming in 'Abstrakte Kunst', an essay he wrote for *Der Cicerone* XVII. 1925, p. 639. There he identified French art from Impressionism to Cubism with formalism and a preoccupation with the physical, whereas German and, even more, Russian art concentrated on the resurrection of the spiritual. Like so many of his countrymen Kandinsky believed that the regeneration of man was a mission entrusted to the Slavic people.

46. Nolde *Jahre der Kämpfe* p.181; translation from *Voices of German Expressionism* p.36

47. Feininger, quoted in the Museum of Modern Art catalogue to

the Feininger and Hartley exhibition (New York, 1944)
48. Kandinsky *CSA* p. 45. Novalis used a similar analogy to describe the poet's task: 'Der Poet braucht die Dinge und Worte wie *Tasten* und die ganze Poesie beruht auf thätiger Ideenassociation — auf selbsthätiger, absichtlicher, idealischer *Zufallsproduktion*. ('Das Allgemeine Broullion' *Schriften* III, p. 451)
49. *Ibid.* p. 76
50. *Ibid.,* p. 40
51. Catalogue to the first *Blaue Reiter* exhibition, quoted in *Eichner* p. 128. See also 'Cologne lecture' *Eichner* p. 116: 'Ich will keine Musik malen.'
52. Kandinsky 'Text Artista' *Wassily Kandinsky Memorial* p. 54. See also Franz Marc's remark in *Briefe, Aufzeichnungen und Aphorismen* I, p. 57: 'Musik und Malerei sind doch ganz gleich.' And Paul Klee, on intimate terms with music, wrote in his diary (entry no. 640): 'Immer mehr dringen sich mir Parallelen zwischen Musik und bildender Kunst auf.'
53. Malevich 'Suprematism' *Modern Artists on Art* ed. R. L. Herbert (New York: Prentice Hall Spectrum Book, 1964), p. 93
54. Werefkin *Briefe an einen Unbekannten* p. 58.
55. Clemens Weiler in his commentary to *Briefe an einen Unbekannten,* p. 53. Werefkin's spiritual affinity with the Romantics can easily be seen in pronouncements such as these: 'Man muss sein unbewusstes Ich an den Platz stellen, sein Genie. Durch es hindurch sieht man alles schön, und die Realität lässt sich dann wie in einer Kaspel von Illusionen verschlingen.' (p. 14) 'Ich bin unersättlich im abstrakten Leben. Ich will den Gleichklang (unison) den Stil.' (p. 15). 'Die Künstlerische Schöpfung ist der einzige Horizont in der Plattheit des menschlichen Lebens.' (p. 18). 'Ich liebe die Liebe, die nicht ist . . . eine Liebe die . . . den Kopf mit Wunderbildern füllt . . . die alle Wesen zur Vollendung treibt.' (p. 19). 'Ich liebe nur die Seele. Die Körper sind mir gleichgültig. Die Analyse tötet das Herz.' (pp. 20, 21) 'Als Künstler wird das Ich zum Weisen . . . Gibt es jetzt Kunst, so ist es die lyrische, subjectiv und philosophisch.' (p. 22). 'Lebend in der winzigen Zeit denken wir immer an das Unbegrenzte, das Ewige. Diese Fähigkeit des menschlichen Gehirns, sich an die Stelle der Realität der Dinge zu setzen . . . ist das wahre Prinzip der Kunst . . . Die Kunst ist dazu da, damit das Leben entschwindet.' (pp. 26, 27.) Ich liebe nicht das Leben, ich liebe den Traum.' (p. 28.) 'Das Leben

erreicht niemals die Erwartung der Imagination und scheint Kopie ... Das Leben ist nur der Ausgangspunkt fur die Wege des schöpferischen Genies.' (p. 29). 'Nur das hat Wert was Sehnsucht weckt. Niemals hat etwas mein innerstes Denken und Empfinden besser ausgedrückt ... Je mehr Formeln des Wirklichen in Formeln des Unwirklichen verwandelt sind, um so grösser ist das Werk.' (p. 42) It comes as no great surprise that Werefkin should refer to her letters as 'blaue Geschichten', tales of 'blue' inspired by a 'blue bird'.

56. Kandinsky, letter to W. Grohmann, 21 Nov. 1925, reproduced in Grohmann *Wassily Kandinsky. Life and Work* pp. 179-180

57. Klee *The Thinking Eye* p. 463; and *Diary* entry nos. 951, 941

58. Baudelaire 'The Work and Life of Eugène Delacroix' *The Painter of Modern Life* p. 45

49. Among the artists discussed, Klee was undoubtedly the most familiar with the thoughts of the Romantics. Judging by the entries in his diary, his list of readings included Novalis's *'Hymns to the Night'* which he read more than once, E. T. A. Hoffmann, Edgar Allan Poe, Baudelaire, Hebbel's diaries, Rousseau's *Confessions* as well as Goethe's *Wahlverwandtschaften* and *Wanderjahre*. Will Grohmann calls Klee a direct descendant of Philipp Otto Runge. He also interprets Klee's painting *'Blue Night'* (1927) as a 'homage à Novalis'.

60. Schickele 'Antwort an Otto Flake' (1916) *EKLB* p. 67

61. Edschmid, in *UELD* p.22 Edschmid frequently evoked Romanticism: 'Seit der Romantik war Stagnation'. *Ibid.* p. 43. Beginning with *Sturm und Drang* in which he locates the origin of German cultural life, he paid glowing tribute to its successor: 'Wieder eine Ballung, wieder ein grosser Versuch zum geistigen Ausdruck: Die Romantik. Da erhoben junge Leute sich zur Höhe des Gefühls. Da trugen Schwärmende durch die Strecke vom Hirn gesäuberter phantasieloser Jahre, durch Jahre vertrocknet von Aufklärung, das Herz vor sich hin. Gelösten Schrittes ... in mittelalterlicher Bewegtheit, zog sich die Buntheit ihres Rhytmus zu den mystischen Quellen des Blutes ... Der letzte grosse Versuch zum geistigen deutschen Stil verflammte hier ... Von da ab kein grosser geistiger Zug mehr ... Schwingt nicht ein Regenbogen? Läuft die Brücke des Geistes nicht ehern, von den magischen Punkten der Zeit zueinander gestellt? Steht nicht, über solche Epoche aufgeschleudert, der Bogen zu Füssen Bettinas, Tiecks und

Brentanos? Steht auf dem Aufprall des anderen Bogens nicht Jugend von heute, Herzschlag empfindend tief auf magischer Nacht verflossenen Jahrhunderts?' *Ibid* pp. 15-18.

62. Hoelderlin's influence was notably present in the poetry of Trakl and Benn. Wilhelm Michel devoted one essay to this poet in the series *Die Silbergäule* (Hanover), Vol. XXXIII-XXXIIIa (1920); and another entitled 'Hoelderlins Wiederkunft' *Die Neue Rundschau* April, 1924. See also C. F. Reinhold 'Kleist und der Expressionismus' *Vossische Zeitung* 18 Sept 1919, which maintained that the Expressionists' precepts were prefigured in Kleist's writings such as the 'Brief eines jungen Dichters an einen jungen Maler'.

63. P. F. Schmidt *Philipp Otto Runge* p. 97; translation from P. Selz *German Expressionist Painting* p. 21. See also Schmidt, pp. 98, 93, 5, 8; and by the same author 'Romantik und Gegenwart' *Feuer* III, 1922, pp. 222 and 225; 'Runge und die Gegenwart' *Der Cicerone* XV, 1923, p. 458, and 'Das Recht auf Romantik' *Das Kunstblatt* 1920, pp. 321-5.

Karl Scheffler may have been the first critic to relate Expressionism to the Romantic movement in his review of the 'Berlin Secession'. See *Kunst and Künstler* X 1912, p. 433. Additional references to Romanticism can be found in the following essays: 'Philipp Otto Runge im Spiegel unserer Zeit' by Gustav Pauli in *Kunst und Künstler* XIV 1915-16, pp. 433-49; a cogently reasoned essay 'Der Kunstliterat' by Grete Ring in *Kunst und Künstler,* XVIII 1919-20, pp. 265-73; T. Volbehr's essay 'Von Herder zu Kandinsky in *Die Kunst für Alle* XLI 1925-6, where this critic derived Kandinsky's creative credo, his concept of 'inner necessity' from Herder's view of history and art; 'Expressionismus und Romantik' by K. W. Goldschmidt in *Die Romantik* ed. K. Bock, (Berlin), II, Heft 2, 1919-20, pp. 10-14. The periodical *Die Romantik* which appeared 1918-25 had for its aim the revival of Romanticism.

For more recent studies concerning the Romantic influence consult: K. Lankheit 'Die Frühromantik und die Grundlagen der "gegenstandslosen" Malerei' *Neue Heidelberger Jahrbücher* 1951; C. Grützmacher *Novalis und Philipp Otto Runge*, O. Stelzer *Die Vorgeschichte der abstrakten Kunst* München, 1964; L. Pesch *Die Romantische Rebellion in der Modernen Literatur und Kunst,* W. Paulsen (ed.) *Das Nachleben der Romantik, 1969,* R. Rosenblum *Modern Painting and the Northern Romantic Tradition,* 1975, U.

Finke *German Painting from Romanticism to Expressionism,* 1975.

Chapter V

1. M. H. Abrams *The Mirror and the Lamp*
2. *Ibid.* p.64
3. Coleridge 'On Posey or Art' *Biographia Literaria* II, pp. 258-9; Wordsworth 'Lines Composed a few miles above Tintern Abbey' *Poetical Works* II, p. 259
4. This must be understood in a comparative sense. There are numerous, sometimes hostile, references to Kant in the writings of Novalis and Fr. Schlegel. The names of Fichte and Schelling however appear more frequently.
5. Fichte 'Die Thatsachen des Bewusstseyns' *Sämtliche Werke* ed. J. H. Fichte II, p. 607
6. Novalis 'Philosophische Studien der Jahre 1795-96' 'Schriften II, p.142
7. *Ibid.* 'Logologische Fragmente (I)' *Schriften* II, p. 524
8. *Ibid.* 'Teplitzer Fragmente' *Schriften* II, p. 606
9. Schleiermacher *Über die Religion* ed. H. J. Rothert, p. 49
10. Novalis 'Glauben und Liebe' *Schriften* II, pp. 417-8, 583 and 600
11. Novalis 'Poesie' *Schriften* II, p. 541; similar remark *ibid.* p. 548
12. Schelling *System des Tranzendentalen Idealismus* in *Werke* II, p. 628
13. Runge *Hinterlassene Schriften* I, p.16
14. F. Schlegel 'Ideen' *Kritische Schriften* p. 91
15. Wordsworth 'Preface to Lyrical Ballads' *Literary Criticism* pp. 25 and 28
16. Blake 'Vision of the Last Judgement' *Poetry and Prose* p. 637
17. Keats, letter to Benjamin Bailey, 22 Nov. 1817 *The Letters of John Keats* ed. M. B. Forman p. 67; also 'Ode on a Grecian Urn'
18. Shelley 'Defence of Poetry' *Shelley's Prose* ed. D. L. Clark, p. 279
19. F. Schlegel 'Geschichte der Alten und Neuen Literatur' *Kritische Ausgabe* VI, Lecture XII, p. 282
20. A. W. Schlegel *Vorlesungen über dramatische Kunst und Literatur* in *Kritische Schriften und Briefe* VI, p.112
21. Novalis 'Poesie' *Schriften* II, p. 533. For a similar treatment see L. R. Furst *Romanticism in Perspective* pp. 117-47
22. F. Schlegel 'Ideen' *Kritische Schriften* p. 97
23. Schelling *System des Tranzendentalen Idealismus* in *Werke* II, p. 628
24. Blake 'Vision of the Last Judgement' and 'Annotations to

Berkeley's 'Siris' *Poetry and Prose* pp. 639 and 818
25. A. W. Schlegel *Sämtliche Werke* ed. E. Böcking, I, p. 263
26. Schleiermacher *Über die Religion* I, Rede, p. 7. Transl. L. R. Furst *Romanticism in Perspective* p. 335
27. Wackenroder 'Herzensergiessungen' *Werke und Briefe* p. 80
28. Runge *Hinterlassene Schriften* I, p.13
29. C. D. Friedrich *Bekenntnisse p. 104:* 'So ist der Mensch dem Menschen nicht als unbedingtes Vorbild gesetzt, sondern das Göttliche, Unendliche ist sein Zeil.' As Friedrich's famous 'Monk by the Sea' reveals, such sentiments signalled the end of humanism in art in favour of a religious 'cosmism' which strained beyond the finite and objective. Runge expressed a similar idea: 'Zuerst bannten die Menschen die Elemente und die Naturkräfte in die menschliche Gestalt hinein ... jetzt fällt der Sinn mehr auf das Gegenteil.' *Hinterlassene Schriften* I, pp. 16 and 24
30. Novalis' projected conclusion of H. v. Ofterdingen, for instance was supposed to inaugurate a new spiritual epoch in which 'the Christian religion is reconcilled with the pagan. The legends of Orpheus, Psyche, will be sung.' *Schriften* I, p. 368
31. F. Schlegel 'Rede über die Mythologie' *Kritische Schriften* pp. 308-13; see also *ibid.,* p. 88
32. Blake 'Songs of Experience' *Poetry and Prose* p. 65
33. Shelley 'Defence of Poetry' *Shelley's Prose* p. 297
34. Novalis 'Fragmente und Studien 1799-1800' *Schriften* III p. 686.
35. F. Schlegel 'Philosophische Fragmente' *Kritische Ausgabe* XVIII, p. 398
36. Novalis 'Vermischte Bemerkungen' and 'Blüthenstaub' *Schriften* II, p. 426
37. Blake 'Vision of the Last Judgement' *Poetry and Prose* p. 639
38. Novalis 'Geistliche Lieder, Hymne' *Schriften,* I, p.167
39. Novalis 'H.v.Ofterdingen, Die Erfüllung' *Schriften* I, p. 313: 'Das grosse Geheimnis ist allen offenbart und bleibt ewig unergründlich. Aus Schmerzen wird die neue Welt geboren, und in Tränen wird die Asche zum Trank des ewigen Lebens aufgelöst.' See also p. 312 where Fable, approaching his human habitation, meets but a ruin covered in ivy.
40. C. D. Friedrich *Bekenntnisse* p. 144
41. Runge *Hinterlassene Schriften* I, p. 9
42. Novalis 'Die Christenheit oder Europa' *Schriften* III, p.517
43. F. Schlegel 'Ideen' *Kritische Schriften, p. 101*

Chapter VI

1. F. v. Unruh 'Reden' (Frankfurt am Main: Frankfurter
 Societäts Druckerei, 1924), p. 29
2. Däubler 'Die Selbstdeutung' *Dichtungen und Schriften* p. 541. See
 also· Däubler's essay 'Delos' *ibid*, p. 429, where he specifically
 refers to Kant's 'thing-in-itself', and to Fichte's 'creative ego'.
3. Engelke 'Schöpfung' *Das Gesamtwerk* p. 41:
 Nicht Raum, nicht Zeit, nur Nacht und Nacht.
 Nur Nacht, von Nacht noch überdacht.
 Ein trächtig Sausen wogend schwoll –

 Da! plötzlichgross ein donnernd 'Ich'! erscholl –
 Da: Er! – Er sass in Nacht
 Und er – Er war die Nacht.
 Der Anfang war erwacht.

 Da scholl es wieder fürchterlich:
 Das All-Gebär-Gebrüll: 'Ich'!
 Da riss Er auf mit Händekrallen Seine Stirn:
 Und offen lag in Dampf: das rote Feuer-Hirn!

4. Benn 'Bekenntnis zum Expressionismus' *Gesammelte Werke* I,
 p. 243; *EKLB* p. 237
5. O. Kokoschka 'Von der Natur der Gesichte' *Oskar Kokoschka
 Schriften* ed. H. M. Wingler, pp. 337-41. Kandinsky 'Text Artista'
 Wassily Kandinsky Memorial p. 64. Cf. also W. Hausenstein's
 defence of Kandinsky in which he maintained that the latter
 strove 'die malerische Form gleichsam rein darzustellen:
 gleichsam eine Kritik der reinen Anschauung zu geben (Ein
 witziger Skeptiker machte das Bonmot: Kant und Kandinsky)
 . . . Kandinsky is im Grund nichts als ein Representant eines neuen
 Idealismus.' 'Für Kandinsky' *Der Sturm* no. 150-151, March,
 1913)."
 A more general claim was made by Walter Rheiner, a little-
 known Expressionist critic. Speaking of the new art he wrote:
 'Dem Materialismus . . . setzt sie . . . in künstlerischer, politischer
 und praktischer Tat ihren *prinzipiellen Idealismus* entgegen . . .
 Dieser Idealismus heisst in Literatur, Malerei, Musik und Kritik
 Expressionismus. Also ist Expressionismus kein rein technisches

oder Formproblem, sondern vor allem eine geistige (erkenntnistheoretische, metaphysische, ethische) Haltung.' (From an advertising pamphlet introducing the monthly periodical *Menschen*; republished in the catalogue to *Expressionismus Literatur und Kunst 1910-1923, Eine Ausstellung des Deutschen Literaturarchivs im Schiller-National-museum Marbach a.N. 1960* catalogue ed. P. Raabe and H. L. Greve, p. 267; the catalogue contains useful excerpts from documents difficult to obtain.)

6. Flake 'Souveränität' *Die Erhebung: Jahrbuch für neue Dichtung und Wertung* ed. A. Wolfenstein, I, p. 342. As a critic, Flake frequently distanced himself from Expressionism. Yet he succeeded in clarifying some of its basic assumptions. See also 'Subjektivismus' by Rudolf Kayser *ibid.* pp. 347-52; and 'Rede für die Zukunft' by Kurt Pinthus *ibid.* pp. 398-422

7. F. M. Hübner 'Das Neue in Zeit und Kunst' *Das Kunstblatt* 1917, pp. 284-5

8. R. Kayser 'Literatur in Berlin' *Das Junge Deutschland: Monatsschrift für Theater und Literatur, hrsg. vom Deutschen Theater* eds. A. Kahane and H. Herald, I 1918, no. 2, pp. 41-2; *EKLB* p. 138

9. Kandinsky in *Im Kampf um die Kunst, Die Antwort auf den 'Protest deutscher Künstler'*, ed. W. Heymel (München: R. Piper, 1911) p. 73. A pamphlet protesting against the attack on French art by the Worpsweder Vinnen and his circle.

10. Edschmid *UELD*, p. 53

11. Beckmann 'On My Painting' *Modern Artists on Art* p. 135. Many of this painter's pronouncements reveal a familiarity with the Romantics. He was enchanted with E.T.A. Hoffman, read Jean Paul, Mörike and Blake. Textual comparisons betray, above all, the influence of Novalis; for instance 'Ich suche nach der Brücke, die vom Sichtbaren ins Unsichtbare führt'. Like Novalis, Beckmann subscribed to the belief 'an eine eigene Individualität und seine transzendenten Möglichkeiten ... das ich zu finden, das nur *eine* Gestalt hat und unsterblich ist – es zu finden in Tieren, in Himmel und Hölle, die zusammen die Welt bilden, in der wir leben.' Novalis' projected unification of algebra and the artistic imagination was expressed by Beckmann in these words: 'Den optischen Eindruck von der Welt der Gegenstände durch eine transzendente Arithmetik meines Inneren zu verändern, so lautet das Gebot.' See W. Hess *dokumente* pp. 108-10; O. Stelzer

Die Vorgeschichte der abstrakten Kunst pp.127-8.
12. Benn 'Soll die Dichtung das Leben bessern?' *Gessammelte Werke* I, p. 592
13. Pinthus 'Zur jüngsten Dichtung' (1915) *EKLB* p. 70
14. H. Kuhn 'Das Gegenständliche des Expressionistischen Dramas' *Die neue Schaubühne* I, 1919, p. 205
15. H. Ball *Die Flucht aus der Zeit* p. 10
16. Pinthus 'Rede für die Zukunft' *Die Erhebung* I, p. 414
17. Edschmid *UELD* pp. 56-7
18. Däubler 'Acht Jahre "Sturm"' *Das Kunstblatt* 1917, p. 46
19. Benn 'Bekenntnis zum Expressionismus' *Gesammelte Werke* I, p. 243; *EKLB*, p. 237
20. Hausenstein 'Vom Expressionismus in der Malerei' *Tribüne der Kunst und Zeit, Eine Schriftensammlung* ed. K. Edschmid, II, 41-51. In the same essay Hausenstein refers to Expressionism as 'expressionistischer Neuromantik'.
21. Marc *Briefe, Aufzeichnungen und Aphorismen* pp. 88 and 123; W. Hess *documente* pp. 78-80; 'Geistige Güter' *Der Blaue Reiter* p. 23
22. Marc, 'Constructive Ideas in the New Art' This essay has been translated by N. Guterman and republished in *Franz Marc. Watercolours, Drawings, Writings*, text and notes by Klaus Lankheit (London: Thames and Hudson, 1960).
23. Klee *The Thinking Eye* pp. 76 and 69
24. Nolde in W. Hess *documente* p. 45. See also *Jahre der Kämpfe*, 1934, p. 177
25. Kirchner writing under the pseudonym Louis de Marsalle for the periodical *Genius* to which he contributed two essays: 'Zeichnungen von E. L. Kirchner' and 'Über Kirchners Graphik' See *Genius* Jahrg. 1920, 2. Buch, p. 216 and Jahrg. 1921. 3. Buch, p. 250 See also W. Hess *documente* p. 48, and E. L. Kirchner *Davoser Tagebuch* pp.184-96.
26. Kandinsky 'Über Kunstverstehen' *Der Sturm* 3, no. 129, 1912, pp. 157-8
27. Kandinsky *Point and Line to Plane* p. 103
28. W. Przygode, as quoted by H. Kassack 'Wolf Przygode und *Die Dichtung*' *Expressionismus. Aufzeichnungen und Erinnerungen der Zeitgenossen* eds. P. Raabe and K. L. Schneider (Olten und Freiburg im Breisgau: Walter-Verlag, 1965), p. 217
29. Wilhelm Morgner, quoted in Franz Roh *German Art in the Twentieth Century* (London: Thames and Hudson, 1968), p. 69
30. Edschmid *UELD* pp. 67-8

31. Kokoschka 'Vom Bewusstsein der Gesichte' *Schriften* pp. 342 and 352. For a general treatment of the religious element in Expressionism see G. F. Hartlaub *Kunst und Religion* (Vol. 2 of *Das Neue Bild)*, ed. C. G. Heise; E. Von Sydow 'Das religiöse Bewusstsein des Expressionismus' *Neue Blätter für Kunst und Dichtung* I 1918-19, pp. 193-9; H. Kauders, 'Das Religiöse in der Kunst' *Das Kunstblatt* 1918, pp. 179-85

32. Klee *The Thinking Eye* p. 93

33. Klee *Tagebücher* entry no. 948

34. Jawlensky, letter to Father Willibrod Verkade; reproduced in L. G. Buchheim *Der Blaue Reiter und die 'Neue Künstlervereinigung München'* pp. 226-30. See also Meidner 'Von wahrer Kunst' P. Westheim *Künstlerbekenntnisse* pp. 255-7

35. Werefkin *Briefe an einen Unbekannten* p. 47

36. The example set by the Nazarenes may well have reached Jawlensky and his circle by way of the Beuron School of religious painting headed by Father Desiderius Lenz (a pupil of Cornelius). One of its painter-monks, the ex-Nabi Dom Willibrod Verkade, was well acquainted with Jawlensky. Verkade's book *Unruhe zu Gott,* translated as *Yesterdays of an Artist-Monk,* provides another interesting document concerning the religious and mystical tendencies rampant among artists at the time. There is no evidence that Kandinsky ever met Verkade. Yet he cannot have been unaware of the religious painting associated with his name and the monastic school of Beuron. Significantly, Kandinsky mentions Burne-Jones who continued the tradition of the Nazarenes, as one of the precursors of the 'spiritual' in art.

37. Marc *Briefe, Aufzeichnungen und Aphorismen* I, p. 125.

38. *Ibid.* p. 129 and 'Die "Wilden" Deutschlands' *Der Blaue Reiter* p. 31

39. Marc *Briefe, Aufzeichnungen und Aphorismen* 1, p. 125

40. Kandinsky *CSA* pp. 29 and 26

41. Kandinsky 'Text Artista' *Wassily Kandinsky Memorial* p. 69; *Rückblick,* p. 31

42. See Bernhard Schultze *Russische Denker. Ihre Stellung zu Christus Kirche und Papsttum* (Wein: T. Morus-Presse, 1950), p. 245. See also Nicolas Berdyaev, *The Russian Idea* (London, 1947), chapters IX and X. Merejkowsky's work inspired Moeller van den Bruck's notorius *The Third Reich.* During his Parisien stay (1901-05) Moeller enjoyed the friendly patronage of this enigmatic

Russian Mystic. Some years later Alfred Rosenberg, the Nazi ideologist, was to become another protege of his. Moeller, in turn, befriended a number of Expressionists, notably Theodor Däubler whose *Nordlicht* owed much to his assistance. See Däubler *Dichtungen und Schriften* pp. 868-9 and Ernst Barlach *Ein selbsterzähltes Leben* pp. 68-9.

43. Kandinsky *Rückblick* p. 29. See also Meidner's reply to 'Ein neuer Naturalismus' *Das Kunstblatt* 1922, p.382 'eine Epoche der Religion hebt von neuem an ... eine grosse Gnadenzeit läutet an der Horizonten. Das Reich Gottes ist nahe herbeigekommen' Meidner was to become a deeply religious painter.

44. Schreyer *Erinnerungen an Sturm und Bauhaus* The relevant passages of Schreyer's reminiscences read as follows (Kandinsky to Schreyer): 'Erschrecken Sie nicht, wenn ich Ihnen jetzt sage, dass ich meine eigenen Bilder, besonders seit ich ungegenständlich male und je älter ich werde, als christliche Bilder erkenne. Das ist mir vor zehn Jahren unabweisbar deutlich geworden ... Ich sehe das Reich des Geistes im Lichte heraufziehen und will es, soweit ich es mit meiner Kunst vermag, verkünden. Darum male ich keine Christusbilder, male nicht den Menschensohn, der menschlich darstellbar ist. Der Heilige Geist ist nicht gegenständlich zu erfassen, sondern nur ungegenständlich. Das ist mein Ziel: Licht vom Lichte, das fliessende Licht der Gottheit, den Heiligen Geist zu verkünden. Vermögen die Menschen die Verkündigung aufzunehmen, das Licht zu schauen?'
Kandinsky, it seems, also touched on the importance of icons. (To Schreyer): 'Sie wissen doch, dass die Ikonen heilige Bilder sind, nicht nur Heiligenbilder, sondern leibhaftig heilige Bilder ... Ich schätze keine Malerei so hoch wie unsere Ikonen. Das Beste was ich gelernt habe, habe ich an unseren Ikonen gelernt, nicht nur das Künstlerische, sondern auch das Religiöse.' (p.230.) Once more, this sounds credible enough considering Kandinsky's religious painting on glass between 1909 and 1914 which in form and content are strongly reminiscent of icons. 'Not only of the early ones in Novgorod', according to Grohman, 'but also of the later ones, which are narrative in character.' (Grohmann *Wassily Kandinsky. Life and Work* pp. 83 and 84).

45. Marc, 'Zwei Bilder' *Der Blaue Reiter* p.33

46. Becher, poem 'Die Insel der Verzweiflung' *MD* p. 313

47. Werfel, poem 'Revolutions-Aufruf' *Das Lyrische Werk* p.165; also in *MD* p.252
48. Meidner 'Junge Kunst', Band 4, Leipzig 1919. See also Alfred Kubin's autobiography attached to his fantastic novel *The Other Side: FROM THE START* I had found keen pleasure in dwelling in imagination on catastrophe and the upsurge of primeval forces; it was like an intoxication, accompanied by a prickly feeling along my spine. A thunder storm, a conflagration, a flood caused by a mountain stream – to observe these was one of my greatest joys.' In Kubin's case an apocalyptic consciousness turned into a compulsive preoccupation with corpses, birds of prey, animal monstrosities, a Kafkaesque nightmare world of oppression in line with Hieronymus Bosch, Goya, Fuseli, Ensor and Redon. Kubin's autobiography and novel have now appeared in English (London: Victor Gollancz, 1970).
49. The religious impulse behind such pictures calls to mind the art of Caspar David Friedrich. Although a tremendous stylistic distance separates these two painters, both interpreted nature in the light of apocalyptic premonitions. Even a formal comparison between Marc's *Animal Destinies* and Friedrich's *Arctic Sea*, or between the formers *Tyrol* and the latters '*Cross in the Mountain*', for instance, reveals a certain spiritual affinity and similarity of vision. In the first pair of pictures the emphasis is on death and desolation, on nature forsaken and ravaged by the potencies of destruction. In the second pair the centre of interest ultimately comes to focus on the deity as the redeemer of creation. Unlike as these paintings are in form and feeling they express the artist's craving for a world beyond material existence. Critics as a rule compare Friedrich's painting with that of Lyonel Feininger. The comparison does indeed yield some striking *formal* similarities. However, Friedrich's art, like that of Marc, has a profound religious and metaphysical dimension absent from the painting of Feininger one of whose principal objectives was to formalize space in a manner reminiscent of Cubist perspective.
50. See also Kandinsky's remark in *CSA* p. 72: 'The tortuous paths of the new world will lead through dark primeval forests and over bottomless chasms.'
51. Kandinsky *Rückblick* p.40.
52. Klemm, poem 'Ausgleich' *MD* p.167. Also his poem 'Einheit' *ibid*. p.326.

53. Brod, poem 'Bete' *Vom Jüngsten Tag* Almanac (1916)
54. One critic at the time put it thus 'Der geistige Sternenhimmel, der sich ehemals glänzend und unverückbar über der glaübigen Menschheit auspannte, ist erloschen .. . Die Wegweiser nach dem Jenseits sind verrückt oder liegen umgestürzt am Boden. Das menschliche Streben überschreitet, oft wahl – und orientierungslos die Grenzen des Irdischen. Wer weiss, was er uns von seinen Fahrten ins Geisterreich heimbringt? Oft genug Schatten, Gespenster, fragwürdige Zwischenwesen. Urzeitliche Furcht statt Himmelstrost.' (H. Kauders 'Das Religiöse in der Kunst' *Das Kunstblatt* 1918, p.181).
55. Kandinsky 'Cologne lecture *Eichner* p.110. Kandinsky went even further, claiming that the work of art enjoys an abstract existence prior to its actual embodiment on canvas.
56. Hasenclever, poem 'Kehr mir zurück, mein Geist' *MD* p.130
57. Grohmann *Wassily Kandinsky. Life and Work* p.11. Half a century earlier another critic insisted that Kandinsky's aim was to express Platonic ideas in their purity. See H. Kuhn 'Kandinsky, Für I' *Das Kunstblatt* 1919, p.178
58. Thomas B. Hess *Willem de Kooning* (New York: George Braziller Inc. 1959), p.7

Chapter VII

1. Novalis 'Das Allgemeine Brouillon' *Schriften* III, p.382. Elsewhere (*Schriften* II, Anekdoten, p. 589) Novalis put it far more briefly: 'Sich nach Dingen, oder die Dinge nach sich *richten* – ist Eins.'
2. This aspect is rarely made sufficiently clear by most critics who single out one or other tendency as characteristic of the Romantic movement. Romanticism, however was the tension between a glorified cult of the self and a 'self-less' cosmism – the tension roughly between F. Schlegel's notion of individuality as the primary and eternal element in man. To develop this individuality as the highest vocation would be a divine egotism', ('Ideen' *Kritische Schriften* p.93) and Novalis' maxim according to which 'The genuine philisophical deed is self-obliteration *(Selbsttödtung)*. This is the beginning of all true philosophy.' ('Fragmentblatt' *Schriften* II, p.395.) Schleiermacher psychologized the issue: 'Each human soul . . . has its existence

chiefly in two opposing drives. Following the one . . . it draws everything around it into itself, weaving it into its own life . . . The other drive is . . . the yearning to surrender oneself and be absorbed in the [whole], to be taken hold of and contained.' (*Über die Religion* I, Rede, p.4.) How the individual Romantics oscillated between these two drives would require a detailed and lengthy study.

3. Abrams *The Mirror and the Lamp* p. 168
4. Coleridge 'The Eolian Harp' *Complete Poetical Works* I, p. 100
5. Schiller 'Über Naive und Sentimentalische Dichtung' *Werke* VIII, p. 310
6. Goethe 'Von Deutscher Baukunst' *Sämtliche Werke* XXXIII pp. 9 and 5
7. Wordsworth, sonnet 'A Poet! . . . He hath put his heart to school' *Poetical Works* III, p.52
8. E. Young *Conjectures on Original Composition* ed. E. Morley, pp. 6, 11, 21
9. Boileau as translated by Dryden; quoted in M. H. Abrams *The Mirror and the Lamp* p. 175
10. Coleridge *Shakespearean Criticism* ed. T. M. Raysor I, p.198. Some critics may well prefer A. W. Schlegel's more subtle formulation of the organic principle' 'Form is mechanical when, through external force, it is imparted to any material merely as an accidental addition without reference to its quality . . . Organic form, again, is innate; it unfolds itself from within, and acquires its determination comtemporaneously with the perfect development of the germ.' (A. W. Schlegel *Lectures on Dramatic Art and Literature* transl. J. Black and revised by A. J. W. Morrison (London, 1894), p. 340.)
11. Schelling 'Über das Verhältnis der bildenden Künste zu der Natur' *Werke* 3. Ergänzungsband, p. 424
12. A. W. Schlegel *Vorlesungen über dramatische Kunst und Literatur* in *Kritische Schriften und Briefe* VI, p. 110
13. A. W. Schlegel *Vorlesungen über schöne Litteratur und Kunst Deutsche Litteraturdenkmale des 18. und 19. Jahrunderts* I, p. 102. On the next page Schlegel continues: 'Wo aber soll der Künstler seine erhabne Meisterin, die schaffende Natur, finden, um sich mit ihr gleichsam zu berathen, da sie in keiner äusseren Erscheinung enthalten ist? In seinem eignen Inneren, im Mittelpunkt seines Wesens durch geistige Anschauung, kann er es nur, oder nirgends.'

14. Thomas Aquinas, quoted in Etienne Gilson *Painting and Reality*
15. F. Gilot and C. Lake *Life with Picasso* (London: T. Nelson, 1954), p. 253; also p. 254: Painting isn't a question of sensibility; its a matter of seizing the power, taking over from nature.'
16. Shelley 'Defence of Poetry' *Prose* p.294. Shelley and other aesthetic organicists clearly overstate their case. That there is a flaw in the fabric is well born out by his own reference to one of his greatest poems as 'springing from the agony and bloody sweat of intellectual travail' Even Coleridge who has provided us with the paradigm of a completely spontaneous and automatic piece of poetic writing hinted that the customary process of composition was not *Kubla Khan* but the *Ancient Mariner* and *Christabel*.
17. Goethe, letter to Zelter, 29 Jan. 1830 *Briefwechsel zwischen Goethe und Zelter* ed. M. Hecker (Leipzig: Insel Velag, 1918), III, p.249; see also Kampagne in Frankreich' *Sämtliche Werke* XXXVIII, p. 122 and 'Einwirkung der neueren Philosophie' XXXIX, pp.29-32
18. Coleridge *Biog. Lit.* I, p. 202; II, p.65; *Miscellaneous Criticism* ed. T. M. Raysor, pp.387-8
19. Wordsworth *The Prelude* (Book XII) ed. E. de Selincourt and H. Darbishire, p. 445
20. Schelling *System des Transzendentalen Idealismus* in *Werke* II, p.349
21. Goethe 'Über Wahrheit und Wahrscheinlichkeit der Kunstwerke' *Sämtliche Werke* XXXIII, p. 90: 'Warum erscheint auch mir ein volkommenes Kunstwerk als ein Naturwerk? ... Weil ... es *übernatürlich, aber nicht aussernatürlich* ist: Ein vollkommenes Kunstwerk ist ein Werk des menschlichen Geistes, und in diesem Sinne auch ein Werk der Natur' *ibid.* p. 108 'Einleitung in die Propyläen'). Goethe here speaks of that rare artist who 'sowohl in die Tiefe der Gegenstände als in die Tiefe seines eignen Gemüts zu dringen vermag, um in seinen Werken nicht bloss etwas leicht und oberflächlich Wirkendes, sondern, wetteifernd mit der Natur, etwas Geistig-Organisches hervorzubrigen und seinem Kunstwerk einen solchen Gehalt, eine solche Form zu geben, wodurch es *natürlich* zugleich und *übernatürlich* erscheint'. [my italic].
22. Coleridge *Shakespearean Criticism* I, pp. 197-8
23. Coleridge *Shakespearean Criticism* I p. 198
24. Goethe 'Diderots Versuch über die Malerei' *Sämtliche Werke* XXXIII, p. 213. Goethe's understanding of the reign of law in art

and nature was far more comprehensive than that of his Romantic contemporaries. Indeed he accused the latter of offending against the laws of nature. As envisaged by Goethe, formation *(Gestaltung)* was an interweaving, interdependent process of metamorphosis and specification, of polarity and ascending progress *(Steigerung).* The Romantics, he insisted, erred on the side of specification. Their creations tended toward the formless and artificial. Hence Geothe's condemnation: 'Das Romantische ist kein Natürliches, Ursprüngliches, sondern ein Gemachtes, ein Gesuchtes, *Gesteigertes,* Übertriebenes, Bizzarres, bis ins Fratzenhafte und Karrikaturartige.' (Conversation with Riemer, 28 Aug. 1808.) At the same time Goethe accused the Romantics of having forsaken the real for the ideal, of embracing an empty transcendentalism which lost sight of the object. In a prophetic passage which could still provide a basis concerning the relevance of non-objective art Goethe held forth on the loss of concrete reality which came about in the wake of Idealism and the Romantic movement. 'Das Ideale im Menschen, wenn diesem die Objekte genommen oder verkümmert werden, zieht sich in sich, feinert und steigert sich, dass es sich gleichsam übertrumpft. Die meisten Menschen im Norden haben viel mehr Ideales in sich, als sie brauchen können, daher die sonderbare Erscheinungen von Sentimentalität, Religiosität, Mysticismus und so weiter.' (Conversation with Riemer, 1808, *Goethes Gespräche* ed. W. V. Biedermann (Leipzig, 1889), II, pp. 213, 215.)

25. Goethe 'Italienische Reise' 6 Sept. 1787 *Sämtliche Werke* XXVII, p. 108
26. K. C. F. Krause *Das Urbild der Menschheit* eds. P. Hohlfeld and A. Wünsche, p. 43
27. Schelling *Philosophie der Kunst* in *Werke* 3. Ergänzungsband, p. 282
28. Novalis 'Logologische Fragmente (II)', 'Poesie' *Schriften* II, p. 534
29. Goethe, letter to Zelter 30 Oct. 1808 *Briefwechsel zwischen Goethe und Zelter* I, p. 221; this letter refers specifically to the absence of 'specification' in the works of some younger Romantic poets: Werner, Ohlenschläger, Arnim and Brentano.
30. See M. H. Abrams *The Mirror and the Lamp* pp. 273-84
31. *Memoirs of the Life of John Constable* ed. Jonathan Mayne, p. 281
32. Tieck 'Kritische Schriften' *Nachgelassene Schriften* ed. R. Köpke, IV, p. 12

33. Tieck *Franz Sternbald* in *Werke* I, p. 889
34. Goethe 'Kampagne in Frankreich' *Sämtliche Werke* XXVIII, p. 122
35. Coleridge 'On Poesy or Art' *Biog. Lit.* II, pp. 257-8. 'If the artist copies the mere nature, the *natura naturata,* what rivalry! If he proceeds only from a given form ... what an emptiness ... Believe me, you must master the essence, the *natura naturans,* which presupposes a bond between nature in the higher sense and the soul of man.' Coleridge's view culminates in the celebrated passage of man's mind being 'the very focus of all the rays of intellect which are scattered throughout the images of nature. Now so to place these images, totalized and fitted to the limits of the human mind, as to elicit from, and to superinduce upon, the forms themselves the moral reflections to which they approximate, to make the external internal, the internal external, to make nature thought, and thought nature – this is the mystery of genius in the Fine Arts.'
36. Krause *Das Urbild der Menschheit* p. 44
37. Goethe 'Einleitung in die Propyläen' *Sämtliche Werke* XXXIII, p. 110
38. Krause *Das Urbild der Menscheit* p. 43
39. F. Schlegel 'Fragmente II' *Literary Notebooks* fragment number 1760, p. 176; see also fragment no. 2079 *Kritische Schriften* pp. 307 and 93. Schlegel was a veritable merchant of chaotica.
40. A. W. Schlegel *Vorlesungen über dramatische Kunst und Literatur* in *Kritische Schriften und Briefe* VI, p. 112.
41. Novalis 'H. v. Ofterdingen *Schriften* I, p.286

Chapter VIII

1. Nolde *Jahre der Kämpfe* p. 94
2. Macke, letter to Bernhard Koehler, 30 March 1913 in P. Westheim *Künstlerbekenntnisse* p. 167; and *August Macke. Tunisian Watercolours and Drawings* (New York: H. N. Abrams, Inc., n.d.), p.1. This study contains excerpts of Macke's writing.
3. Macke 'Die Masken' *Der Blaue Reiter* p. 54 and 'Notizen über Kunst' *August Macke* by Gustav Vriesen, p. 177. Vriesen's monograph contains some of Macke's essays and aphorisms, pp. 175-7; 255-64
4. Kandinsky *Point and Line to Plane* p. 21
5. Kandinsky 'Meine Holzschnitte' (1938) *EEK* p. 227

6. Kandinsky 'Text Artista' *Wassily Kandinsky Memorial* p. 68
7. *Ibid.* p. 69
8. Kandinsky 'Malerei als reine Kunst' (1918) *EEK* p. 64
9. Klee *The Thinking Eye* p. 457
10. *Ibid.* p. 383
11. *Ibid.* pp. 69, 169, 449
12. *Ibid* p. 82
13. Runge *Hinterlassene Schriften* I, pp.15-16
14. Klee *The Thinking Eye* pp. 453, 460
15. Arp *On My Way* p.70
16. *Ibid.* p. 50
17. Quoted by Hans Richter in *Dada. Art and Anti-Art* p. 45
18. Arp *On My Way* p. 51
19. Quoted in *Dada. Art and Anti-Art* p. 33
20. Kandinsky 'Zugang zur Kunst' (1937) *EEK* p. 209
21. Bryen in *Theorien zeitgenössischer Malerei* ed. Jürgen Claus (Rowholt Taschenbuch Verlag, 1963), p. 39. See also Willi Baumeister, *Das Unbekannte in der Kunst.* Speaking of contemporay art Baumeister writes (p. 185): 'Ihre grossen Werke sind einfach, selbstverständlich, ohne Pose. Sie sehen nicht aus, wie wenn sie von jemand gemacht, sondern als wenn sie von selbst entstanden wären. Natur hat sich geäussert.'
22. The assertion made is that non-representational art holds up a mirror to nature's way of working as examplified for instance in the structures of crystals, rocks, metals, minerals or other formations looked at under the microscope or through a telescope. The question why nature should want to 'duplicate' itself in abstract art is seldom raised let alone conclusively answered. Are we to assume, moreover, that those non-representational paintings which do not correspond to any known microcosmic or macrocosmic formations are works of non-art? Ultimately, the whole approach reduces art to *mimesis*, thus denying creativity
23. Däubler *Nordlicht* II, p. 223
24. Hartung *Theorien zeitgenössischer Malerei* p. 86
25. Kandinsky, Preface to the catalogue for the second *Blaue Reiter* exhibition (Hans Goltz gallery, Munich, 12 Feb. 1912); quoted in Grohmann *Wassily Kandinsky. Life and Work* p. 67. Also quoted by Mme Nina Kandinsky in the introduction to *CSA* p. 11
26. Kandinsky 'Analyse der primären Elemente der Malerei' (1928) *EEK* p.117

27. Kandinsky 'und' (1927) p. 108
28. Klee *The Thinking Eye* p. 79
29. *Ibid.* p. 93
30. *Diaries* entry no. 1104
31. Klee *The Thinking Eye* p. 70
32. Macke, letter to Bernhard Koehler, 30 March 1913 *Künslerbekenntnisse* p. 167. See also Karl Otten's reminiscences according to which Macke maintained that 'Natur ist alles was wir hervorbringen. Genauso wie wir von Natur natürlich sind, so sind auch Geist, Idee, Seele, Kunst, Schöpfung natürlich.' (Karl Otten, 'Erinnerung an August Macke und die Rheinischen Expressionisten' *Expressionismus. Aufzeichnungen und Erinnerungen der Zeitgenossen* p. 150.)
33. Kandinsky 'Malerei als reine Kunst' (1918) *EEK* pp. 64 and 68
34. Kandinsky *CSA* p. 73
35. Klee *The Thinking Eye* p. 451
36. Marc 'Die neue Malerei' in the periodical *Pan* II 1912, p. 469
37. Klee *The Thinking Eye* p. 461
38. Kandinsky 'Interview Nierendorf-Kandinsky' (1937) *EEK* p.213
39. Kandinsky 'Zwei Richtungen' (1935) *EEK* p. 194
40. Kandinsky 'Leere Leinwand undsoweiter' (1935) *EEK*, p. 179 and 'Der Wert des theoretischen Unterrichts in der Malerei' (1926) *ibid.* p. 94
41. Coleridge *Shakespearean Criticism* I, pp. 197-8
42. Kandinsky *Point and Line to Plane* p. 106 (footnote). An unfortunate argument considering that nature discontinued the development of several species.
43. Kandinsky 'Analyse der primären Elemente der Malerei' (1928) *EKK* p.116. See also 'und' *ibid.* p. 108
44. Kandinsky 'Betrachtungen über die abstrakte Kunst' (1930) *EEK* pp. 151-2
45. Klee, quoted in W. Haftmann *The Mind and Work of Paul Klee* p. 151. See also Klee's *Diaries* entry no. 536
46. Klee 'Wege des Naturstudium' *dokumente zum verständnis der modernen malerei* p. 84; *Diaries* entry no. 536
47. Klee, *The Thinking Eye* p. 59
48. Kant *Critique of Judgement* paragraph 46, p.168
49. Klee *The Thinking Eye* p. 70. Willi Baumeister in *Das Unbekannte in der Kunst* is more explicit. Quoting Kant at length (p. 179) he writes of the creative artist: 'Er produziert ohne Lehrgut, ohne Erfahrung ... Das Genie "kann" nichts und nur damit alles.'

(p. 171.) There is also a touch of pure Schelling: 'In der absoluten Freiheit finden sich die höheren Gesetze wieder . . . Er (the artist) ist der Statthalter höherer Gesetze . . . Er ist das Organ eines Weltganzen dem er verantwortlich bleibt. In der künstlerischen Zone vereinigen sich das allgemein gesetzmässige, natüliche Entstehen und der Freiheitsbegriff.' (pp. 99, 172.)

50. Delacroix, quoted in Etienne Gilson *Painting and Reality* p. 257

51. 'Marginal Notes' of Nolde excerpts of which are collected in Werner Haftmann *Emil Nolde, the Forbidden Pictures* (London: Thames and Hudson, 1965), p. 19

52. Kirchner's reply to the question 'Ein neuer Naturalismus??' *Das Kunstblatt* 1922, p. 376. See also Kirchner's 'Die Kunst der Malerei . . .' *Davoser Tagebuch* p. 225

53. Kandinsky 'Text Artista' *Wassily Kandinsky Memorial* p. 63

54. Kandinsky *CSA* p. 77 (footnote)

55. Kandinsky 'Text Artista' *Wassily Kandinsky Memorial,* p. 63

56. Klee, *The Thinking Eye* p. 79

57. Klee, quoted in W. Haftmann, *The Mind and Work of Paul Klee* p. 118

58. F. Schlegel 'Gespräch über die Poesie' *Athenüeum* III, 1800, p. 107

59. *Erinnerungen an Paul Klee* ed. L. Grote (München: Prestel Verlag, 1959), p. 90

60. Arp *On My Way* p. 70. See also p. 60: 'Man calls the concrete abstract. This is not surprising, for he commonly confuses front and back . . . In my opinion a picture or a sculpture without any object is just as concrete and sensual as a leaf or a stone.'

61. Arp *Unsern Täglichen Traum . . . Erinnerungen, Dichtungen und Betrachtungen aus den Jahren 1914-1954* p. 83

62. Kandinsky 'abstrakt oder konkret?' (1938) *EEK* p.225

63. Braque *Le Jour et la nuit: Cahiers, 1917-1952* (Paris: Gallimard, 1952), p. 13

64. Gleizes and Metzinger 'Cubism' *Modern Artists on Art* pp. 7 and 5

65. Quoted in *On the Enjoyment of Modern Art* by J. Morris (The Gallery of Canadian Art 5, 1964), p. 20

66. Kandinsky, Catalogue to the first *Blaue Reiter* exhibition at the Sturm gallery (Berlin, March 1912), quoted in W. Grohmann *Wassily Kandinsky. Life and Work,* p. 67

67. Marc 'Die neue Malerei- *Pan* II, 1912, p.469

68. Klee *On Modern Art* transl. Paul Findlay with an introduction by Herbert Read, p. 45; *The Thinking Eye* p.92. Findlay's translation

of this important passage seems to me to be the more accurate one.

69. In Klaus Lankheit *Franz Marc, Watercolours, Drawings, Writings,* p. 33
70. Klee *The Thinking Eye* p.63
71. Kandinsky 'Fragen und Antworten' (1935) *EEK* pp. 154-5
72. Kandinsky 'Der Wert des theoretischen Unterrichts in der Malerei' (1926) *EEK* p.95
73. Klee *The Thinking Eye* p.35
74. Ibid. pp.59 and 79
75. *Erinnerungen an Paul Klee* pp. 90-1. A condensed version in *dokumente zum verständnis morderner malerei* pp. 84-5
76. Nolde *Jahre der Kämpfe* p. 184. See also p. 42. To Fehr Nolde mentioned his collaboration with nature; while painting in sub-zero temperatures which froze his colours into 'crystals, stars and rays'. At such moments he felt artist, painting and reality fused into one entity. (Fehr, p. 49)
77. Macke 'Die Masken' *Der Blaue Reiter* pp. 54-5
78. Kandinsky 'Der Wert des theoretischen Unterrichts in der Malerei' (1926) *EEK* p. 92
79. Klee *On Modern Art* p. 49 and *The Thinking Eye* p. 93
80. Kandinsky *Point and Line to Plane* p. 103
81. Kandinsky 'Interview Nierendorf-Kandinsky' (1937) *EEK* p. 213
82. Klee *The Thinking Eye* p. 67 (I have slightly altered the English translation in order to come closer to Klee's meaning in the German text). See also Klee's observation on p. 541: 'Having gained new strength from my naturalistic studies, I can venture to return to my original field of psychic improvisation.'
83. *Ibid,* p. 66
84. *Ibid.*
85. *Ibid.*
86. Kandinsky 'Zwei Richtungen' (1935) *EEK* p. 192
87. Klee *On Modern Art* pp. 49 and 51; *The Thinking Eye* p. 93

Chapter IX

1. Heynicke, poem 'Lieder an Gott' *Das Lyrische Werk* 3 vols. (Worms: Erich Norberg, 1974), I, p. 190
2. Goll *Gedichte* p. 70
3. Becher *Um Gott* p. 35
4. Däubler *Nordlicht* II, pp. 540 and 226: 'Wir sind den Ursprung zu

erglühn verpflichet ... Urbrunstgluth muss uns zum Ursprung führen.'

5. *Ibid* p.75
6. Nolde *Jahre der Kämpfe* p. 177
7. One of Hazlitt's 'Round Table' essays in the *Examiner* (1816)
8. Nolde *Das Eigene Leben* (2nd edition), p. 200
9. Nolde *Jahre der Kämpfe* p. 173
10. Heine 'Zur Geschichte der Religion und Philosophie in Deutschland' *Sämtliche Werke* V, p. 266
11. Klee, on the occasion of Emil Nolde's sixtieth birthday *Festschrift für Emil Nolde* (Dresden, 1927) p. 26. Also published in *Wie Sie Einander Sahen, Moderne Maler im Urteil Ihrer Gefährten*, ed. H. M. Wingler, p. 62
12. Klee *The Thinking Eye* p. 94
13. *Ibid.* p. 70
14. *Ibid.* pp. 92 and 463
15. Wordsworth 'The Fountain' *Poetical Works* IV p. 72
16. Rilke *Duino Elegies* translated and introduced by J. B. Leishman and Stephen Spender (London: Hogarth Press, 1957), p. 77
17. Marc *Briefe, Aufzeichnungen und Aphorismen* I, p. 50
18. *Ibid.*
19. Aphorism no. 97 quoted in Peter Thoene *Modern German Art* p. 68
20. Gotthilf Heinrich Schubert 'Ansichten von der Nachtseite der Naturwissenschaft' *Lebenslehre und Weltanschauung der Jüngeren Romantik* ed. Wilhelm Bietak (Leipzig: Verlag von Philipp Reclam, jun., 1936), pp. 195-6
21. Marc, quoted in *Franz Marc. Skizzenbuch aus dem Felde* ed. K. Lankheit, p. 16
22. Kandinsky 'Text Artista' *Wassily Kandinsky Memorial* p. 63
23. Kandinsky *Rückblick* p. 40
24. Grohmann *Kandinsky (1866-1944)* p. 4
25. Fritz Burger *Einführung in die Moderen Kunst* pp. 5-6
26. Marcel Brion *Kandinsky* p. 45
27. Kandinsky, letter to the author in Grohmann *Wassily Kandinsky, Life and Work* p. 188
28. *Ibid.* p. 180
29. Runge *Hinterlassene Schriften* I, p.11
30. A. W. Schlegel *Vorlesungen über dramatische Kunst und Literatur* in *Kritische Schriften und Briefe* VI, p. 112
31. Charles Maurras quoted in Marcel Raymond *From Baudelaire to*

Surrealism p. 54. How strangely this contrasts with Däubler's 'Das Urfeuer will sich des Endes schämen' *Dichtungen*, p. 672 or with Klee's 'Where is the Spirit at its purest? In the beginning.' *(Diaries,* entry no. 944.) Cf. also Max Picard: 'Expressionismus, Ein Vortrag' *Die Erhebung* I, pp. 329-38

32. Schelling *Philosophie der Kunst* in *Werke* 3. Hauptband, p. 485
33. Hesse, 'Gedanken zu Dostojewskijs 'Idiot' (1919) *Betrachtungen und Briefe, Gesammelte Schriften* VII, pp. 185-6 and 171
34. Goldwater *Primitivism in Modern Art* p. 251.
35. Kandinsky *Point and Line to Plane* p. 106
36. Edschmid *UELD* p. 61
37. Marc, quoted in Klaus Lankheit *Franz Marc* p. 15
38. Marc *Briefe, Aufzeichnungen und Aphorismen* I, p. 121
39. Nolde expressed it well in his account of why he frequented cafés, nightclubs and pubs peopled with prostitutes and drunks. 'Ich zeichnete und zeichnete, das Licht der Säle, den Oberflächenflitter, die Menschen alle, ob schlecht ob recht, ob halbwelt oder ganz verdorben, ich zeichnete diese Kehrseite des Lebens mit seiner Schminke, mit seinem glitschigen Schmutz und dem Verderb ... Der Bauer liebt seinen Dung, und der Maler schaut sich die giftigen Blüten an. *(Jahre der Kämpfe* p. 137).
40. Benn 'Gesänge' *Gesammelte Werke* III (Gedichte), p. 25
41. A. Doeblin 'Von der Freiheit eines Dichtermenschen' (1918) *EKLB* p.118
42. *Ibid.*
43. Paul Hatvani 'Der Expressionismus ist tot ... es lebe der Expressionismus!' (1921) *EKLB* p. 185: 'Wir bewundern die Entfesseltheit des Gefühls, wir denken mit dem Blute, sind Abenteuern auf der Spur, die zwischen Grosstadt und Urwald sehnsüchtig pendeln.' The name 'primitive-voyager' derives from James Baird's challenging study *Ishmael* (Baltimore: Johns Hopkins Press, 1956) which deals with the primitivistic elements in Melville and other writers and painters of the nineteenth century. Although somewhat restricted in scope and interpretation it is an indispensible study which brilliantly illuminates the artist's efforts to restore compelling archetypal symbols.
44. Nolde *Das Eigene Leben* p. 158. See also *Jahre der Kämpfe* (pp. 172-5) where Nolde glowingly describes the artistic expression of primitive peoples and its relationship to modern art. Nolde was full of praise for primitive races whose seeming virtue he

compared with the 'decadence' of our civilisation. As he wrote in a letter from the South Sea Islands: 'The natives are a magnificent people in so far as they have not already been spoiled by contact with the civilisation of the white man.' *(Jahre der Kämpfe* p. 203.) In another letter, published in M. Sauerlandt *Emil Nolde, Briefe aus den Jahren 1894-1926,* Nolde was even more explicit. Primitive man, he maintained, was a far more healthy creature than civilised man. Living according to nature, the primitive was part of creation.

45. Sequel to 'Die Grundkräfte des Expressionismus' by Johannes von Allesch in *Zeitschrift für Aesthetik und Allgemeine Kunstwissenschaft* ed. Max Dessoir, XIX, pp.112-20

46. Marc, 'Die "Wilden" Deutschlands' *Der Blaue Reiter* p. 30

47. Marc, letter to August Macke, 14 Jan. *August Macke/Franz Marc Briefwechsel* pp. 39-40

48. Macke 'Die Masken' *Der Blaue Reiter* p.58

49. Quoted in W. Haftmann *The Mind and Work of Paul Klee* p. 53

50. A conversation recalled by Lothar Schreyer *Erinnerungen an Sturm und Bauhaus* p. 168

51. Klee *The Thinking Eye* p. 451

52. Kandinsky writing on the origin of the *Blaue Reiter* group *EEK*, p. 135

53. Kandinsky 'Über die Formfrage' *EEK* pp. 42-3

54. Kandinsky *CSA* pp. 23-4

55. Novalis 'Fragmente und Studien 1799-1800' *Schriften* III, p. 684

56. Wilhelm Waetzoldt in a sequel to 'Die Grundkräfte des Expressionismus' by Johannes von Allesch in *Zeitschrift für Aesthetik und Allgemeine Kunstwissenschaft* XIX, 1925, p. 119

57. *The Intimate Journals of Paul Gauguin* transl. Van Wyck Brooks (London: Heinemann, 1931), p. 22; and letter to August Strindberg (1895) republished in George Boudaille's *Gauguin* (London: Thames and Hudson, 1964) pp. 210-11

58. Joan Miro in *XXe Siecle* no. 9, June 1957; reprinted in *The Visual Arts Today* ed. Gyorgy Kepes p. 93

59. Malevich 'Suprematism' *Modern Artists on Art* p. 96

60. Benn 'Bekenntnis zum Expressionismus' *Gesammelte Werke* I, p. 248

61. *Ibid.* 'Drei Alte Männer' II, pp.403-4

62. Wordsworth *The Prelude* Book III p. 79

63. John Stuart Mill *Early Essays* ed. J. W. M. Gibbs (London, 1897)

64. Coleridge *Biogr. Lit.* II, p. 121

65. Shelley *Prose* p. 197
66. Kokoschka, quoted in J. P. Hodin *The Dilemma of Being Modern* p. 76
67. Marc *Briefe, Aufzeichnungen und Aphorismen* I, p. 124
68. Nolde *Das Eigene Leben* p.98
69. Baumeister *Das Unbekannte in der Kunst* pp. 45-6
70. Kandinsky 'Text Artista' *Wassily Kandinsky Memorial* p. 52
71. *Ibid.* p. 51. Kandinsky insists (p. 72) that his experience of Moscow formed the inspiration and starting point of all his endeavours. To translate such scenes into paint became one of his greatest desires. In this context one is immediately reminded of Tieck's *Franz Sternbald* (p. 907): 'O, my friend, if only you could entice this wonderful music, this poetry which is created today by heaven, into your paintings.'
72. Kandinsky 'Konkrete Kunst' (1938) *EKK* p. 218
73. Kandinsky 'Text Artista' *Wassily Kandinsky Memorial* p. 62
74. Kandinsky 'Zugang zur Kunst' (1937) *EEK* p. 210
75. Kandinsky 'Über die Formfrage' *EEK* p. 40
76. Kandinsky *CSA* p. 71
77. Bergson 'The Individual and the Type' from *Laughter* in *A Modern Book of Esthetics, An Anthology* ed. Melvin Rader, pp. 80-3
78. Novalis 'Poeticism' *Schriften* II, p. 545
79. Edschmid *UELD* p. 66
80. Kandinsky at one stage seems to have been well aware of this danger. Thus, quoting from the German text of *Über das Geistige in der Kunst* (1912), he writes: 'The artist today cannot exclusively rely on purely abstract forms. Such forms are not sufficiently precise. Limiting oneself to the imprecise means to deprive oneself of possibilities; it means to exclude the purely human and, therefore, to impoverish the means of expression.' The Wittenborn translation of *Concerning the Spiritual in Art* contains Kandinsky's addition of 1914 – a significant one which claims: 'Nevertheless, there are artists who even today experience abstract form as something quite precise and use it to the exclusion of any other means. This seeming stripping bare becomes an inner enrichment.' It is difficult to reconcile this conviction with other views expressed by Kandinsky. Thus in 'Die Kunst von heute ist lebendiger denn je' (1935) *EEK* p. 166, Kandinsky praises the indeterminacy or 'openess' of abstract shapes. As he put it: "Geometric" or "free" outlines not tied to an object elicit ... impressions which ... are *less precisely bound*

than those called forth by the object. They are freer, more elastic, more "abstract" [my italic].'

81. Ernst Gombrich 'Expression and Communication' *Meditations on a Hobby Horse and Other Essays on the Theory of Art* p. 62. See also 'On Physiognomic Perception' *ibid*. pp. 45-55

82. John Dewey *Art as Experience* chapter VI goes so far as to say that free forms and colours satisfy an organic hunger of our sensory motor system. If this is a justification of non-objective art the obvious reply is that man does not live by bread alone.

83. Salvador Dali *Diary of a Genius* (London: Hutchinson, 1966), p. 95

84. 'Und es soll am deutschen Wesen/Einmal noch die Welt genesen.' A much-quoted couplet by Emanuel Geibel.

85. Josef Goebbels *Michael. Ein deutsches Schicksal in Tagebuchblättern*, written during 1921-2 and published in 1929 by the Party's publishing house, Eher-Verlag, München.

Goebbels' relationship to the Expressionist movement was an ambiguous one, to say the least. Right up to 1934 he secretly admired, indeed collected some Expressionist works. Yet his personal likes were wholly subordinated to political aims at the time, one of which was to assume total control of the *Reich's* cultural programme, an aim which in turn clashed with the avowed intentions of Alfred Rosenberg and the *Kampfbund* who were pressing for a more nationalist and racially purified art ever since the party's inception. Goebbels' temporary triumph over this group which culminated in the birth of the *Reichskulturkammer* as a branch of the Ministry of Propaganda left room for a kind of 'Nordic' or 'Aryan' Expressionism taken up by Benn and other Expressionist writers. It was a short-lived respite. The *Kulturkampf* of the *Kampfbund* continued, its policies being finally approved by Hitler. By 1937 – a year famous for its infamous exhibition of 'degenerate art' in Munich – Expressionism became identified with primitivism, internationalism, the *Novembergeist* and the despised Weimar period. Obeying the voice of his master, Goebbels issued a directive which demanded confiscation of all 'degenerate' art since 1910 – a date which remained as unexplained as the precise meaning of 'degenerate' itself.

86. Heynicke, poem 'Rhythmen gegen die Falschheit' *Die Erhebung* II,1. English translation from W. H. Sokel's *Writer in Extremis* p. 210

87. Benn, letter to Klaus Mann (1933) published in *Doppelleben*,

Gesammelte Werke IV, p. 79. The famous Klaus Mann-Gottfried Benn debate originated with Mann's accusation that Benn's vitalist irrationalism led directly to Hitler and National Socialism. The theme was fully exploited and pounded out of all proportions by the Marxist critic Bernhard Ziegler (alias Alfred Kurella) in 'Nun ist dies Erbe zu Ende'. First published in *Das Wort*, Moscow, Jg 2 (1937) Heft 9; republished in *EKLB* pp. 273-282. A far better reasoned, though equally partisan, view was expressed by Georg Lukács 'Grösse und Verfall des Expressionismus' (1934), an abridged version in *EKLB* pp. 254-73

88. Marc, in W. Hess *dokumente zum verständnis der moderen malerei* p. 78

89. Hence Nolde's bitter resentment at being classified as a 'decadent' artist, a resentment which he made plain in a letter to Goebbels (2 July 1938): 'When National Socialism also labelled me and my art "degenerate" and "decadent", I felt this to be a profound misunderstanding because it is just not so. My art is German, strong, austere, and sincere,' (From *In Letzter Stunde, 1933-1945* ed. Diether Schmidt (Dresden 1964) p. 152; republished and translated in *Voices of German Expressionism* pp. 209-10

90. The supreme irony in this context were the Expressionist and non-representational posters which the party used to announce the exhibition of 'degenerate' art in Munich.

91. William Barrett *Irrational Man. A Study in Existential Philosophy* (London: Mercury Books, 1964), p. 160

Bibliography

The following bibliography lists books and documents cited in the text together with a selection of works which served as background reading to the periods and artists covered. The selection does not aim to be complete, merely representative. General comparative and monographical studies were chosen for both critical and historical interest. Items marked with an asterisk list extensive bibliographical sources.

ROMANTICISM

I. Texts

Baader, Franz von *Schriften* ed. M. Pulver. Leipzig: Insel Verlag, 1921

Baudelaire, Charles
 Art in Paris 1845-1862 Translated and ed. Jonathan Mayne. London: Phaidon Press, 1965
 The Painter of Modern Life Translated and ed. Jonathan Mayne. London: Phaidon Press, 1964

Blake, William *Poetry and Prose of William Blake* G. Keynes. London: The Nonesuch Library, 1956

Carlyle, Thomas *Critical and Miscellaneous Essays* in his *Works* (Centenary edition) ed. H. D. Trail. London: Chapman and Hall, 1905
 Heroes and Hero Worship in *Works*

Carus, Karl Gustav *Neun Briefe über Landschaftsmalerei* K. Gerstenberg. Dresden: Wolfgang Jess, n.d.

Coleridge, Samuel Taylor
Biographia Literaria 2 vols. ed. J. Shawcross. Oxford University
Press, 1939
Complete Poetical Works ed. E. H. Coleridge Oxford, 1966
Miscellaneous Criticism ed. T. M. Raysor. Cambridge, Massachusetts,
1936
Philosophical Lectures ed. K. Coburn. London: The Pilot Press, 1949
Shakespearean Criticism ed. T. M. Raysor. Everyman's Library, 1960
Constable, John *Memoirs of the Life of John Constable* ed. Jonathan
Mayne. London: Phaidon Press, 1951
Delacroix, Eugène *Journals* Translated by W. Pach. London: J. Cape,
1938
Fichte, Johann Gottlieb *Sämtliche Werke* Vols. I and II ed.
J. H. Fichte. Leipzig, 1844
Friedrich, Caspar David *Bekenntnisse* ed. Kurt Karl Eberlein. Leipzig:
Klinkhardt and Biermann Verlag, 1924. A small selection of
Friedrich's writings translated from the German appears in *From
the Classicists to the Impressionists. A Documentary History of Art* vol.
III, selected and ed. E. G. Holt. New York: Anchor Books,
Doubleday & Co., Inc., 1966
Goethe, Johann Wolfgang von *Sämtliche Werke* Stuttgart und Berlin:
Jubiläumsausgabe, 1902-07
Hazlitt, William *Selected Essays* ed. G. Keynes. London: Nonesuch
Press, 1930
Hazlitt William and Leigh Hunt *The Round Table* A collection of
essays. Edinburgh, 1817
Hegel, Georg Wilhelm Friedrich
Hegel Selections ed. J. Lowenberg. New York: Charles Scribner's
Sons, 1957
Vorlesungen über die Aesthetik 3 vols. Introduction by H. G. Hotho in
Sämtliche Werke. Jubiläumsausgabe. ed. H. Glockner. Stuttgart:
Frommanns Verlag, 1927-39
Heine, Heinrich *Zur Geschichte der Religion und Philosophie in
Deutschland* and *Die Romantische Schule* in *Sämtliche Werke*
Hamburg: Hoffmann und Campe, 1876
Herder, Johann Gottfried von *Sämtliche Werke* ed. B. Suphan. Berlin:
Weidmannsche Buchhandlung, 1877-99
Hoelderlin, Friedrich *Sämtliche Werke* ed. N. von Hellingrath, F.
Seebass and L. von Pigenot. Berlin: Propyläen Verlag, 1923
Hoffmann, E.T.A. *Hoffmanns Dichtungen und Schriften* ed. W.
Harich. Weimar: Lichtenstein, 1924

Kant, Immanuel *The Critique of Judgement* Translated and ed. James
Creed Meredith. Oxford University Press, 1957
Keats, John
Poetical Works ed. H. W. Garrod. Oxford, 1939
The Letters of John Keats ed. M. B. Forman. (3rd ed.) Oxford
University Press, 1947
Keller Gottfried *The Green Henry* Translated by A. M. Holt. London:
J. Calder. 1960
Kleist, Heinrich von *Kleists Werke* ed. E. Schmidt. Leipzig und Wien:
Klassiker Ausgaben, 1905
Krause, Karl Christian Friedrich
Abriss der Aesthetik ed. J. Leutbecher. Göttingen, 1837
Das Urbild der Menschheit ed. P. Hohlfeld and A. Wünsche. (3rd
ed.) Leipzig: Dietrische Verlagsbuchhandlung, 1903
Novalis (Friedrich von Hardenberg)
Schriften ed. P. Kluckhohn and R. Samuel. Stuttgart: Kohlhammer
Verlag, 1960
Werke ed. A. Friedemann. Berlin, Leipzig, Wien, Stuttgart, n.d.
Werke und Briefe ed. A Wasmuth. Heidelberg, 1943-55
Pater, Walter *The Renaissance* (4th ed.) London: MacMillan and Co.
1893
Poe, Edgar Allan
Letters of E. A. Poe ed. J. Ostrom. Harvard University Press, 1948
Poems and Essays Everyman's Library, 1955
Richter, Jean Paul F. *Vorschule der Ästhetik* ed. J. Müller. Leipzig:
Verlag F. Meiner, 1923
Runge, Philipp Otto *Hinterlassene Schriften* ed. D. Runge. Hamburg,
1840-1. A small selection of Runge's writings translated from
German appears in *From the Classicists to the Impressionists. A
Documentary History of Art* vol. III, ed. E. G. Holt New York: Anchor
Books, Doubleday & Co., Inc., 1966
Ruskin, John *The Art Criticism of John Ruskin* Selected, edited and
introduced by Robert L. Herbert. New York: Anchor Books,
Doubleday & Co., Inc., 1964
Schelling, Friedrich Wilhelm Joseph von *Werke* (Münchner
Jubiläumsdruck) ed. M. Schröter. München, 1958
Schiller, J. C. Friedrich von *Werke* ed. L. Bellermann. Leipzig and
Wien: Meyers Klassiker Ausgaben, n.d.
Schlegel, August Wilhelm.
Athenaeum 1798-1800 ed. A.W. and F. Schlegel. Republished in the
J. G. Cotta'sche Buchhandlung. Nachf. Stuttgart, 1960

Sämtliche Werke ed. E. Böcking. Leipzig, 1846-7
Vorlesungen über dramatische Kunst und Literatur in *Kritsche Schriften und Briefe* E. Lohner. Berlin, Köln, Mainz: Kohlhammer Verlag, 1966-7
Vorlesungen über philosophische Kunstlehre with annotations by K .C .F. Krause, ed. A. Wünsche. Leipzig, 1911
Schlegel Friedrich
Kritische Ausgabe ed. E. Behler, J. J. Anstett and H. Eichner. München: Verlag F. Schöningh, 1959-69
Kritische Schriften ed. W. Rasch. München: Carl Hanser Verlag, 1956
Literary Notebooks of 1797-1801 ed. H. Eichner. University of London: Athlone Press, 1957
Schleiermacher. Friedrich E. D.
Monologen ed. F. M. Schiele. Leipzig, 1902.
Über die Religion ed. H. J. Rothert. Hamburg: Verlag von Felix Meiner, 1958
Shelley, Percy Bysshe
The Complete Poetical Works ed. T. Hutchinson. Oxford University Press, 1960
Shelley's Prose ed. D. L. Clark. University of New Mexico Press, 1966
Staël, Germaine de *De l'Allemagne* ed. Charpentier. Paris 1866
Tieck, Ludwig
Nachgelassene Schriften ed. R. Köpfe. Leipzig, 1855
Werke ed. M. Thalmann. München: Winkler Verlag, 1963
Turner, J. M. William. *Lectures* British Museum Add. MS 46151
Wackenroder, Wilhelm Heinrich *Weke und Briefe* Heidelberg: Verlag Lambert Schneider, 1967
Wordsworth, William
Literary Criticism ed. N. C. Smith. London: Humphrey Milford, 1925
Poetical Works ed. E. de Selincourt and H. Darbishire. Oxford, 1949
The Prelude ed. E. de Selincourt. Oxford, 1936
Young, Edward *Conjectures on Original Compositions* ed. E. Morley. Manchester, 1918

II. Comparative and General

Abercrombie, Lascelles *Romanticism* London: Martin Secker, 1927
Abrams, Meyer Howard *The Mirror and the Lamp* New York; Norton Library, 1958

Abrams, Mayer Howard. (ed.) *English Romantic Poets* Oxford University Press, 1960

Antal Frederick *Classicism and Romanticism* London: Routledge, 1966

Appleyard, J. A. *Coleridge's Philosophy of Literature* Cambridge, Massachusetts: Harvard University Press, 1965

Artz, Frederick Binkerd *From the Renaissance to Romanticism* University of Chicago Press, 1962

Aubert, A. *Runge und die Romantik* Berlin: P. Cassirer, 1909

Babbitt, Irving
The New Laokoon London: Constable and Co., Ltd, 1910
Rousseau and Romanticism New York: Meridian Books, 1959

Baker, J. V. *The Sacred River* Louisiana State University Press, 1957

*Barzun, Jaques *Classic, Romantic and Modern* London: Secker & Warburg, 1961

Bate, Walter Jackson (ed.) *Keats. A Collection of Critical Essays* New Jersey: Spectrum Book, Prentice Hall, 1964

Benz, Richard *Deutsche Romantik* (5th ed.) Stuttgart: Reclam Verlag, 1956

Benziger, James 'Organic Unity: Leibniz to Coleridge' *Publications of the Modern Language Association of America* LXVI, 1951, pp.24-48

*Bernbaum, Ernest *Guide through the Romantic Revolt* New York: 1949

Beyer, Otto *Die Unendliche Landschaft. Über Religiöse Naturmalerei und Ihre Meister* Berlin: Furche Verlag, 1922

Bietak, Wilhelm (ed.) *Lebenslehre und Weltanschauung der Jüngeren Romantik* Leipzig: P. Reclam jun., 1936

Bloom Harold
Shelley's Mythmaking New Haven, 1959
The Visionary Company New York, 1961

Boas, George *French Philosophies of the Romantic Period.* Baltimore, 1925

Bonarius, G. *Zum Magischen Realismus bei Keats und Novalis* Giessen: W. Schmitz, 1950

Bowra, Cecil Maurice *The Romantic Imagination* Oxford University Press, 1961

Bradley, Andrew Cecil *Oxford Lectures on Poetry* London, 1926

Brieger, Lothar *Die Romantische Malerei* Berlin, 1926

Brion, Marcel *Art of the Romantic Era* London: Thames and Hudson, 1956

Christoffel, U. *Die Romantische Zeichnung von Runge bis Schwind* München: F. Hanfstaengel Verlag, 1920

Coburn, Kathleen (ed). *Coleridge. A Collection of Critical Essays* New

Jersey: Spectrum Book, Prentice Hall, Inc., 1967

Curtius, Ernst Robert. *Europäische Literatur und Lateinisches Mittelalter* Bern, 1948

Deutschbein Max *Das Wesen des Romantischen* Coethen, 1921

Dilthey, Wilhelm

 Das Erlebnis und die Dictung (6th ed.) Leipzig and Berlin, 1919

 'Die Typen der Weltanschauung' *Gesammelte Schriften* 8. Leipzig, 1931

Eichner, Hans 'F. Schlegel's Theory of Romantic Poetry' *Publications of the Modern Language Association of America* LXXI, 1956, pp. 1018-41

Emmerich, I. *Caspar David Friedrich* Weimar: H. Bohlaus Nachfolger, 1964

Frye, Northrop *In Fearful Symmetry: A Study of William Blake* Princeton, 1947

Frye, Northrop (ed.) *Romanticism Reconsidered: Selected Papers from the English Institute* New York, London, 1963

*Furst, Lilian R. *Romanticism in Perspective* London, Melbourne, Toronto, New York: Macmillan, 1969

Gage, John *Colour in Turner. Poetry and Truth* London: Studio Vista, 1969

Gilbert, Katharine and H. Kuhn *History of Aesthetics* New York, London: MacMillan, 1956

Gowing, L. *Turner: Imagination and Reality* New York: Museum of Modern Art, 1966

Grimme, A. *Vom Wesen der Romantik* Braunschweig, 1947

Grundy, J. B. C. *Tieck and Runge. A Study in the Relationship of Literature and Art in the Romantic Period* Strassburg, 1930

Grützmacher, Curt *Novalis und Philipp Otto Runge* München, 1964

Guardini, Romano 'Erscheinung und Wesen der Romantik' *Romantik. Ein Zyklus Tübinger Vorlesungen* ed. T. Steinbüchel. Tübingen, 1948

Halsted, John Burt (ed.) *Romanticism: Problems of Definition, Explanation and Evaluation* Boston, Massachusetts, 1965

Hamburger, Michael *Reason and Energy* London: Routledge & Kegan Paul, 1957

Hartmann, Geoffrey H. *The Unmediated Vision. An Interpretation of Wordsworth, Hopkins, Rilke and Valery.* New York: Harcourt, 1966

Hartmann, Nicolai *Die Philosophie des deutschen Idealismus* vol. I. Berlin und Leipzig, 1923

Hauser, Arnold *The Social History of Art. 3. Rococo, Classicism and Romanticism* London: Routledge & Kegan Paul, 1962

Haym, Rudolf *Die Romantische Schule* Berlin 1870
Haywood, Bruce *Novalis: the Veil of Imagery* The Hague: Mouton & Co., 1959
Heinisch, Klaus Joachim *Deutsche Romantik. Interpretationen* Paderborn: F. Schöningh, 1966
Heller, Erich
 The Artist's Journey into the Interior London: Secker & Warburg, 1966
 The Disinherited Mind chapter 1. Harmondsworth: Penguin Books, 1961
Hirsch, Eric Donald *Wordsworth and Schelling* New Haven, 1960
Holt, Elizabeth (ed.) *From the Classicists to the Impressionists. A Documentary History of Art* vol. III. New York: Anchor Books, 1966
Huch, Ricarda *Romantik. Ausbreitung, Blütezeit und Verfall* Tübingen und Stuttgart: R. Wunderlich Verlag. H. Leins, 1951
Jenisch, Erich *Die Entfaltung des Subjektivismus* Königsberg Press, 1929
Joel, Karl *Wandlungen der Weltanschauung* vol. 2. Tübingen, 1934
Jolles, Matthijs *Goethes Kunstanschauung* Bern, 1957
Jones, W.T. *The Romantic Syndrome* The Hague, 1961
Kircher, Ernst *Philosophie der Romantik* Jena, 1906
Kleinmayer, H. von *Die Deutsche Romantik und Die Landschaftsmalerei* Strassburg, 1912
Kluckhohn, Paul
 Die deutsche Romantik Leipzig, 1924
 Das Ideengut der deutschen Romantik (3rd ed.) Tübingen: Niemeyer Verlag, 1953
Knox, I. *The Aesthetic Theories of Kant, Hegel and Schopenhauer* New York: Columbia University Press, 1936
Kohlschmidt, Werner *Form und Innerlichkeit* Bern: Francke Verlag, 1955
Korff, Herman August *Geist der Goethezeit* 4 vols. (6th ed.) Leipzig: Koehler & Amelang, 1964, 1966
Krebs, S. *Philipp Otto Runges Entwicklung* Heidelberg, 1909
Leander, Folke *Humanism and Naturalism* Goteborg, 1937
Lion, F. *Romantik als deutsches Schicksal* Stuttgart: Kohlhammer Verlag, 1963
Lovejoy, Arthur O.
 The Great Chain of Being Cambridge, Massachusetts: Harvard University Press, 1936
 The Reason, the Understanding and Time Baltimore, 1961
 'On the Discrimination of Romanticism' *Essays in the History of*

Ideas Baltimore, 1948

Lucas, Frank Laurence *The Decline and Fall of the Romantic Ideal* Cambridge University Press, 1948

McFarland, Thomas *Coleridge and the Pantheist Tradition* Oxford, 1969

Mason, Eudo Colecestra *Deutsche und englische Romantik* Göttingen: Vandenhoeck & Ruprecht, 1959

Mayer, Hans *Zur Deutschen Klassik und Romantik* Pfullingen: G. Neske Verlag, 1963

Müller, Andreas (ed.) *Kunstanschauung der Jüngeren Romantik* Leipzig, 1934

Nemitz, Fritz *Caspar David Friedrich. Die Unendliche Landschaft* (4th ed.) Münchner Verlag, 1949

Newton, Eric *The Romantic Rebellion* London: Longmans, 1962

Nohl, Hermann *Stil und Weltanschauung* Jena, 1923

Orsini, Gian N. G. *Coleridge and German Idealism* London & Amsterdam: Southern Illinois University Press, 1969

Peckham, Morris
Beyond the Tragic Vision New York, 1962
'Toward a Theory of Romanticism' *Publications of the Modern Language Association of America* LXVI' 1951
'Toward a Theory of Romanticism: Reconsiderations' *Studies in Romanticism* I, 1961

Pelles, G. *Art, Artists & Society. Painting in England and France 1750-1850* New Jersey: Spectrum Book, Prentice Hall Inc., 1963

Peterson J. *Der Wesensbestand der deutschen Romantik* Leipzig, 1926

Piper, Herbert Walter *The Active Universe* University of London: The Athlone Press, 1962

Prawer, Siegbert Salomon (ed.) *The Romantic Period in Germany* London: Weidenfeld and Nicolson, 1970

Praz, Mario *The Romantic Agony* Oxford University Press, 1933

Read, Herbert *The True Voice of Feeling* London: Faber and Faber, 1953

Rehder, H. *Die Philosophie der Unendlichen Landschaft* Halle/Saale, 1932

Reiff, P. F. *Die Asthetik der deutschen Frühromantik* Urbana: University of Illinois Press, 1946

Reynolds, Graham *Turner* London: Thames and Hudson, 1969

Richards, Ivor Armstrong *Coleridge on Imagination* (3rd ed.) London: Routledge and Kegan Paul, 1962

Ridenour, George M. (ed.) *Shelley. A Collection of Critical Essays.* New Jersey: Spectrum Book, Prentice Hall, 1965

'Romanticism: a symposium' *Publications of the Modern Language Association of America,* LV, 1940

Rössle W. (ed.) *Romantische Naturphilosophie* Jena, 1926

Schenk, H.G. *The Mind of the European Romantics* With a Preface by Isaiah Berlin. London: Constable, 1966

Schirmer, W. F. *Kleine Schriften* Tübingen, 1950

Schmidt, Paul Ferdinand
Philipp Otto Runge Leipzig, 1923
Deutsche Landschaftsmalerei München, 1922

Schrade, H. *Deutsche Maler der Romantik* Köln: Verlag M. DuMont Schauberg, 1967

Silz, Walter *Early German Romanticism. Its Founders and Heinrich von Kleist* Cambridge, Massachusetts, 1929

Sloane, J. C. *French Painting Between the Past and the Present* Princeton University Press, 1951

Spranger, Eduard *Lebensformen* Halle, 1914

Stefansky, K. *Das Wesen der deutschen Romantik* Stuttgart, 1923

Steffen, Hans, (ed.) *Die deutsche Romantik* Göttingen: Kleine Vandenhoeck-Reihe, 1967

Strich, Fritz *Deutsche Klassik und Rommantik* (4th ed.) Bern: A. Franke Verlag, 1949

Thalmann, Marianne
Das Märchen und die Moderne Stuttgart: Kohlhammer Verlag, 1961
Romantik und Manierismus Stuttgart: Kohlhammer Verlag, 1963

Thorlby, Anthony (ed.) *The Romantic Movement* London: Longmans, 1966

Tuveson, Ernest *The Imagination as a Means of Grace: Locke and the Aesthetics of Romanticism* Berkeley, 1960

Tymms, Ralph *German Romantic Literature* London: Methuen & Co., Ltd., 1955

Walzel, Oskar *German Romanticism* New York: F. Ungar Publishing Co., 1965

Wellek, René 'The Concept of Romanticism in Literary History' and 'Romanticism Re-examined' *Concepts of Criticism* New Haven and London: Yale University Press, 1973
'German and English Romanticism' *Confrontations* Princeton University Press, 1965

Wilkinson, Elizabeth Mary and Leonard Ashley Willoughby *Goethe Poet and Thinker* London: E. Arnold, 1962

Willoughby, Leonard Ashley
The Romantic movement in Germany Oxford, 1930

'English Romantic Criticism' *Weltliteratur: Festgabe für F. Strich*
Bern, 1952

EXPRESSIONISM

I. Texts A. Periodicals and Pamphlets

Die Aktion ed. Franz Pfemfert. Berlin, 1911-33
Der Anbruch ed. I. B. Neumann and O. Schneider. Berlin, 1918-22
Der Ararat Glossen, Skizzen und Notizen zur neuen Kunst ed. L.
 Zahn. München, 1919-21
Der Bildermann ed. P. Cassirer. Berlin, 1916
Der Cicerone ed. Georg Biermann. Leipzig, 1909-30
Feuer ed. G. Bagier. Weimar, 1919-21
Das Forum ed. W. Herzog. Berlin, München: Forum Verlag, 1914-29
Genius ed. C. G. Heise and H. Mardersteig. München, 1919-21
Im Kampf um die Kunst. Die Antwort auf den 'Protest Deutscher Künstler'
 Contributions by Kandinsky, Macke, Marc, Pechstein and others.
 München: P. Piper Verlag, 1911
Das junge Deutschland. hrsg. vom Deutschen Theater A. Kahane and H.
 Herald. Berlin, 1918-19
Die Kunst ed. A. Bruckmann. München, 1899-1937
Das Kunstblatt ed. Paul Westheim. Weimar, Berlin, Potsdam, 1917-32
Kunst und Künstler ed. Karl Scheffler. Berlin: B. Cassirer, 1903-33
Menschen ed. F. Steimer, H. Schilling, W. Hasenclever and I. Goll.
 Dresden: 1918-21
Neue Blätter für Kunst und Dichtung ed. Hans Zehder. Dresden, 1918-
 20
Das neue Pathos ed. H. Ehrenbaum-Degele, R. R. Schmidt, P. Zech
 and L. Meidner. Berlin, 1913-20
Pan ed. W. Herzog. Berlin: P. Cassirer, 1911-13
Romantik (Berliner) ed. Kurt Bock. Berlin, 1918-25
Sirius ed. W. Serner. Zürich: Sirius Verlag, 1915-16
Der Sturm Published and edited by Herwarth Walden. 1910-32
Die Weissen Blätter ed. R. Schickele and P. Cassirer. Leipzig, Berlin
 and Zürich, 1913-25
Das Wort Moscow, 1936-9
Zeitschrift für Aesthetik und Allgemeine Kunstwissenschaft vol. XIX, 1925.
 ed. Max Dessoir. Stuttgart: F. Enke Verlag.
Zeitschrift für bildende Kunst Leipzig: E. A. Semann, 1866-1932

B. Year-Books, Anthologies and Documents

Das Aktionsbuch ed. Franz Pfemfert. Berlin: Verlag der Wochenschrift *Die Aktion*, 1917

Eine Anthologie 1914-16. ed. Franz Pfemfert. Berlin: Verlag *Aktion*, 1916

dokumente zum verständnis der modernen malerei ed. Walter Hess. Hamburg: Rowohlt Taschenbuch Verlag, 1956. A basic text

Die Erhebung. Jahrburch für neue Dichtung und Wertung ed. A. Wolfenstein. 2 Vols. Berlin: S. Fischer, 1910-20

Expressionismus. Aufzeichnungen und Erinnerungen der Zeitgenossen ed. Paul Raabe and K. L. Schneider. Olten and Freiburg im Breisgau: Walter Verlag, 1965

Expressionismus. Die Kunstwende ed. H. Walden. Berlin: Verlag der Sturm, 1918

Expressionismus. Literatur und Kunst 1910-1923 A catalogue covering 'Eine Ausstellung des Deutschen Literaturarchivs im Schiller-Nationalmuseum, Marbach am N.', ed. P. Raabe and H. L. Greve. München: A. Langen, G. Müller, 1960. Contains useful selections from numerous documents

Expressionismus. Der Kampf um eine literarische Bewegung ed. Paul Raabe. München: Deutscher Taschenbuch Verlag, 1965. A vital collection of major essays

Expressionistiche Dichtungen vom Weltkrieg bis zur Gegenwart ed. H. Walden and P. A. Silbermann. Berlin: C. Heymann, 1932

Gedichte des Expressionismus ed. D. Bode. Stuttgart: P. Reclam, 1966

Die Gemeinschaft. Dokumente der geistigen Weltwende Ludwig Rubiner. Potsdam: Kiepenheuer, 1919

Jahrbuch der jungen Kunst ed. Georg Biermann. Leipzig, 1920-24

Das Jahrbuch der Zeitschrift 'Das neue Pathos' ed. Paul Zech. Berlin, 1914-19

Kameraden der Menschheit. Dichtungen zur Weltrevolution ed. Ludwig Rubiner. Potsdam: Kiepenheuer, 1919

Der Kondor. Manifest jüngster Lyrik ed. Kurt Hiller. Heidelberg: R. Weissbach, 1912

Künstlerbekenntnisse ed. Paul Westheim. Berlin: Propyläen Verlag, n.d. c.1925

Literatur-Revolution 1910-1925. Dokumente. Manifeste. Programme vol.I: *Zur Aesthetik und Poetik* Vol.II: *Zur Begriffsbestimmung der Ismen* ed. Paul Portner. Darmstadt, Berlin, Neuwied: H. Luchterhand, 1960 and 1961. A good collection but unreliable in listing sources

Lyrik des expressionistischen Jahrzehnts ed. Gottfried Benn. München: Taschenbuch Verlag, dtv, 1966

Die Lyrik des Expressionismus. Voraussetzungen, Ergebnisse und Grenzen ... ed. Clemens Heselhaus. Tübingen, 1956

Manifeste, Manifeste 1905-1933. Schriften deutscher Künstler des zwanzigsten Jahrhunderts I ed. Dieter Schmidt. Dresden, n.d. (c.1964-5)

*Meschheitsdämmerung. Ein Dokument des Expressionismus New edition by Kurt Pinthus. Hamburg: Rowohlt Taschenbuch Verlag, 1964. Still the most representative anthology of Expressionist verse.

Der Mistral. Eine lyrische Anthologie vols. IV and V ed. A. R. Meyer. Berlin-Wilmersdorf: Bücherei Maiandros 1913

Modern Artists on Art. Ten Unabridged essays ed. R. L. Herbert. New Jersey: Spectrum Book, Prentice Hall Inc. 1964. Includes writings by Kandinsky, Klee and Beckmann in English

Schöpferische Konfession vol.XIII of *Tribüne der Kunst und Zeit* ed. Kasmir Edschmid. Berlin: E. Reiss, 1920

Theories of Modern Art. A Source Book by Artists and Critics ed. Herschel B. Chipp. Berkeley and Los Angeles: University of California Press, 1968. An excellent book including excerpts from the writings of Klee, Kandinsky, Kokoschka, Kirchner, Nolde, Marc, and Beckmann in English

Unser Weg. Ein Jahrbuch des Verlages Berlin: P. Cassirer, 1919 and 1920

Verkündigung. Anthologie junger Lyrik ed. Rudolf Kayser. München: Roland Verlag, 1921

Verse der Lebenden. Deutsche Lyrik seit 1910 ed. H. E. Jacob. Berlin: Propyläen Verlag, 1924, 1927

Voices of German Expressionism ed. Victor H. Miesel. New Jersey: Spectrum Book, Prentice Hall Inc, 1970. A long overdue collection, with uneven translations

Vom jüngsten Tag. Ein Almanach neuer Dictung Leipzig: Kurt Wolff, 1916

Wie Sie Einander Sahen. Moderne Maler Im Urteil Ihrer Gefährten ed. H. M. Wingler. München: A. Langen, 1957

Die Zeitschriften und Sammlungen des literarischen Expressionismus, 1910-21 ed. Paul Raabe. Stuttgart: Metzlersche Verlagsbuchhandlung, 1964. Repertorien zur deutschen Literaturgeschichte I

C. Individual Sources

Arp, Hans (Jean) *On My Way, poetry and essays 1912-1947* New York

Wittenborn, Schultz Inc., 1948

Unsern Täglichen Traum ... *Erinnerungen, Dichtungen und Betrachtungen aus den Jahren 1914-1954* Zurich: Im Verlag der Arche, 1955

Ball Hugo

Die Flucht aus der Zeit München und Leipzig, 1927

Hugo Ball. Sein Leben in Briefen und Gedichten ed. Emmy Ball-Hennings. Berlin: S. Fischer Verlag, 1930

'Die Kunst unserer Tage' from a lecture on Kandinsky (1916), *Literatur-Revolution 1910-1915*. vol. 1 *Zur Aesthetik und Poetik*.

Barlach, Ernst

Ernst Barlach: Leben und Werk in seinen Briefen ed. F. Dross. München: R. Piper, 1952

Ein selbsterzähltes Leben München: R. Piper, 1948

Baumeister, Willi *Das Unbekannte in der Kunst* Köln: Verlag M. DuMont Schauberg, 1960

Becher, Johannes R.

Sonnet-Werk 1914-54. Düsseldorf: Progress Verlag, 1956

Um Gott Leipzig: Insel Verlag, 1921

Vom Verfall zum Triumph. Aus dem Lyrischen Werk 1912-1958 ed. Deutsche Akademie der Künste zu Berlin. Berlin and Weimar: Aufbau-Verlag, 1965

Beckmann Max

'On My Painting' *Theories of Modern Art* ed. H. B. Chipp (see previous section)

Reply to 'Das Neue Programm' *Kunst und Künstler* XII, 1914

'Schöpferische Konfession' *Tribüne der Kunst und Zeit* Vol.XIII, ed. K. Edschmid. Berlin 1920

Benn Gottfried

Gesammelte Werke ed. D. Wellershoff. 4 vols. Wiesbaden: Limes Verlag, 1959

Primal Vision. Selected writings of Gottfried Benn ed. E. B. Ashton. London: The Bodley Head, 1961

Bill, Max (ed.) *Wassily Kandinsky* A collection of essays with contributions by W. Grohmann, H. Art, L. Grote and others. Paris: Maeght Editeur, 1951

Blümner, R. 'Die absolute Dichtung' *Der Sturm* XIII, No.7

Däubler, Theodor

Dichtungen und Schriften ed. F. Kemp. München: Kösel-Verlag, 1956

Im Kampf um die moderne Kunst Vol.III of *Tribüne der Kunst und Zeit* ed. K. Edschmid. Berlin: E. Reiss Verlag, 1919

Der Neue Standpunkt Leipzig: Insel Verlag, 1919
Döblin, Alfred 'Von der Freiheit eines Dichtermenschen'
Expressionismus. Der Kampf . . . *Bewegung* (see previous section)
Edschmid, Kasimir
Die doppelköpfige Nymphe Berlin: P. Cassirer, 1920
Lebendiger Expressionismus München: Ullstein Buch, Verlag, K.
Desch, 1964
Das Rasende Leben Leipzig: K. Wolff Verlag, 1915
'Uber den Expressionismus in der Literatur und die neue Dichtung'
vol. I of *Tribüne der Kunst und Zeit* Berlin: E. Reiss Verlag, 1919
'Expressionismus in der Dichtung' (1918) *Expressionismus. Der Kampf*
. . . *Bewegung* (see previous section)
'Über die dichterische deutsche Jugend' *Das Kunstblatt* 1918,
pp.306-13
Edschmid Kasimir (ed.) *Briefe der Expressionisten* Frankfurt/M., Berlin:
Ullstein Buch, Ullstein Verlag, 1964
Ehrenstein Albert *Gedichte und Prosa* ed. K. Otten. Darmstadt: H.
Luchterhand Verlag, 1961
Erdmann-Macke, Elisabeth *Erinnerung an August Macke* Stuttgart:
Kohlhammer Verlag, 1962
Feininger, Lyonel 'Ein Brief' *Das Kunstblatt* 1931
Flake, Otto 'Von der Jüngsten Literatur' *Expressionismus. Der Kampf*
. . . *Bewegung* (see previous section)
Goll, Iwan
Dichtungen. Lyrik. Prosa. Drama. ed. C. Goll. Darmstadt:
H. Luchterland Verlag 1960
'Der Expressionismus stirbt' *Expressionismus der Kampf* . . .
Bewegung (see previous section)
Hasenclever, Walter *Gedichte. Dramen, Prosa* ed. K. Pinthus.
Hamburg: Rowohlt Verlag, 1963
Hatvani, Paul 'Der Expressionismus ist tot . . .' *Expressionismus. Der
Kampf um* . . . *Bewegung* (see previous section)
Hausenstein, Wilhelm 'Vom Expressionismus in der Malerei' vol.II
of *Tribüne der Kunst und Zeit* ed. K. Edschmid. Berlin: E. Reiss
Verlag, 1919
Herzog, Otto 'Der abstrakte Expressionismus' *Der Sturm* X, No. 2
Hesse, Hermann *Betrachtungen und Briefe Gesammelte Schriften* vol.
VII. Berlin und Frankfurt: Suhrkamp Verlag, 1957
'Zum Expressionismus in der Dichtung' *Expressionismus. Der Kampf
um* . . . *Bewegung* (see previous section)
Heym, Georg *Dichtungen und Schriften* ed. K. L. Schneider. H.

Ellermann, 1964
Heynicke, Kurt
Gottes Geigen München: Roland Verlag, 1918
Die Hohe Ebene Berlin: E. Reiss Verlag, 1921
'Seele zur Kunst' *Das Kunstblatt* vol. 1, 1917
'Der Willen zur Seele' *Masken* [periodical]. vol. XIII, No. 16, ed. H. Franck. Düsseldorf, 1917-18
Hiller, Kurt 'Zur Neuen Lyrik' *Expressionismus. Der Kampf ... Bewegung* (see previous section)
Hoddis, Jacob van *Weltende. Gessammelte Dichtungen* Zürich: Verlag die Arche, 1958
Huebner, F. M. 'Der Expressionismus in Deutschland' *Expressionismus. Der Kampf ... Bewegung* (see previous section)
Kandinsky, Wassily *Essays über Kunst und Künstler* ed. M. Bill (2nd enlarged edition). Bern-Bümpliz: Benteli-Verlag, 1963. This collection of articles contains Kandinsky's major essays written between 1912 and 1943.
Punkt und Linie zu Fläche. Beitrag zur Analyse der malerischen Elemente Introduction by M. Bill (3rd edition). Bern Bümpliz: Benteli-Verlag, 1955; translated as *Point and Line to Plane* New York : S. R. Guggenheim Foundation, 1947
Rückblick [A short autobiography] Introduction by L. Grote. Baden-Baden: W. Klein Verlag, 1955 (reprint). An English translation which derives from a Russian edition is listed as 'Text Artista' in *Wassily Kandinsky Memorial* New York: S. R. Guggenheim Foundation, 1945.
Über das Geistige in der Kunst Introduction by M. Bill (6th edition). Bern-Bümpliz: Benteli-Verlag, 1959; translated as *Concerning the Spiritual in Art* New York: Wittenborn Inc., 1964
'Abstrake Kunst' *Der Cicerone* XVII, 1925
'Über Kunstverstehen' *Der Sturm* III, No. 129, 1912
Kandinsky, Wassily and Franz Marc (ed.) *Der Blaue Reiter Almanach.* Dokumentarische Neuausgabe von K. Lankheit München: R. Piper Verlag, 1965
Kayser Rudolf
'Das Ende des Expressionismus' *Der Neue Merkur* [periodical] IV, No. 4
'Literatur in Berlin' *Das Junge Deutschland* I, 1918
Kirchner, Ernst Ludwig
Briefe an Nele und Henry van de Velde München: R. Piper, 1961
Davoser Tagebuch ed. L. Grisebach Köln: Verlag M. DuMont

Schauberg, 1968.
Reply to 'Ein neuer Naturalismus' *Das Kunstblatt* 1922
'Über die plastischen Arbeiten Kirchners' *Der Cicerone* XVII 1925
'Über Kirchners Graphik' *Genius*, III, 1921
'Zeichnungen von E. L. Kirchner' *Genius* II, 1920
Klee Felix *Paul Klee. Leben und Werk in Dokumenten* [ausgewählt aus den nachgelassenen Aufzeichnungen und den unveröffentlichen Briefen]. Zürich: Diogenes Verlag, 1960
Klee, Paul
The Diaries of Paul Klee 1898-1918 London, P. Owen, 1965
Gedichte Edited by F. Klee. Zürich: Verlag die Arche, 1960
On Modern Art Introduction by H. Read. London: Faber and Faber, 1966
The Thinking Eye. The Notebooks of Paul Klee ed. J. Spiller. Translated by R. Mannheim. London: Lund Humphries. New York: G. Wittenborn, 1961
Kokoschka, Oskar *Schriften. 1907-1955* ed. H. M. Wingler. München: A. Longman, G. Müller Verlag, 1956
Kubin, Alfred *Die Andere Seite* München, 1908
Lasker-Schüler, Else *Gesammelte Werke* ed. F. Kemp. München: Kösel Verlag, 1961
Macke August
August Macke/Franz Marc Briefwechsel Köln: M. DuMont Schauberg, 1964
'Die Antwort auf den Protest Deutscher Künstler' *Im Kampf um die Kunst*
'Brief über den Kubismus' *Maler des Expressionismus im Briefwechsel mit Eberhard Grisebach* Hamburg: C. Wegner Verlag, 1962
'Die Masken' *Der Blaue Reiter Almanach*.
Reply to 'Das Neue Programm' *Kunst und Künstler* XII 1914
Marc, Franz
August Macke/Franz Marc Briefwechsel (see Macke)
Botschaften an den Prinzen Jussuff Introduction by M. Marc. München: R. Piper, 1954
Briefe, Aufzeichnungen und Aphorismen 2 vols. Berlin: P. Cassirer, 1920
Skizzenbuch aus dem Felde ed. K. Lankheit. Berlin: Gebrüder Mann, 1956
'Anti-Beckmann' *Pan* II, 1912
'Die Futuristen' *Der Sturm*, III No.132, 1912
'Ideen über Ausstellungswesen' *Der Sturm* III, 1912, No. 113-14,

1912

'Die konstruktiven Ideen der neuen Malerei *Pan* II

'Die 'Wilden' Deutschlands' *Der Blaue Reiter Almanach.*

'Zur Sache' *Der Sturm* III, No. 115-16, 1912

Meidner, Ludwig

 Septemberschrei Berlin: P. Cassirer, 1920

'Anleitung zum Malen von Grossstadtbildern' *Kunst und Künstler* XII, 1914

'Gruss des Malers an die Dichter' *Literatur-Revolution, 1910-25* I

Reply to 'Ein neuer Naturalismus??' *Das Kunstblatt* 1922

Nolde, Emil

 Briefe aus den Jahren 1894-1926 ed. M. Sauerlandt. Berlin: Furche Kunstverlag, 1927

 Das Eigene Leben Berlin: J. Bard, 1931; (2nd Revised edition) Flensburg: C. Wolff, 1949

 Jahre der Kämpfe Berlin: J. Bard, 1934

Pander, Oswald. 'Revolution der Sprache' *Das junge Deutschland,* I, No. 5, 1918

Pechstein, Max 'Schöpferische Konfession' *Tribüne der Kunst und Zeit* vol. XIII

Pinthus, Kurt 'Introduction' *Menschheitsdämmerung* (see previous section)

'Zur jüngsten Dichtung' *Expressionismus der Kampf* . . . *Bewegung* (see previous section)

'Rede für die Zukunft', *Die Erhebung* I

Rohlfs, Christian 'Postkarten und Briefe' *Das Kunstblatt* 1930

Schickele, René

 Werke in Drei Bänden ed. H. Kesten. Köln, Berlin: Keipenheuer & Witsch, 1959

'Antwort an Otto Flake' *Expressionismus Der Kampf* . . . *Bewegung* (see previous section)

Schmidt-Rottluff, Karl Reply to 'Das Neue Programm' *Kunst und Künstler* XII, 1914

Schreyer, Lothar

 Erinnerungen an Sturm und Bauhaus München: A. Langen, Georg Müller Verlag, 1956

'Expressionistische Dichtung' *Literatur-Revolution* I

'Die neue Kunst' *Der Sturm* X, No. 5, 6, 7, 8

'Der neue Mensch', *Der Sturm* X, No. 2

Sorge, Reinhard *Werke* 3 vols, ed. H. G. Rotzer. Nuremberg: Glock und Lutz, 1962

Stadler, Ernst *Dichtungen* ed. K. L. Schneider. Hamburg: Verlag,
H. Ellermann, n.d. c., 1955
Stramm, August *Das Werk* ed. R. Radrizzani. Wiesbaden: Limes
Verlag, 1963
Trakl, Georg *Dichtungen und Briefe* 2 vols, ed. W. Killy and H.
Szklenar. Salzburg: O. Müller Verlag, 1969
Walden, Herwarth
"Das Begriffliche in der Dichtung' *Der Sturm* IX, No.5
'Einblick in Kunst' *Der Sturm,* VI, No.21-2
'Erster deutscher Herbstsalon' (Introduction), *Der Sturm* IV,
No. 180-1
'Kritik der vorexpressionistischen Dichtung' *Der Sturm* XI, Nos. 7,
8, 9 and 10; XII, Nos. 1, 2, and 3: XIII, No. 2
'Kunst und Leben' *Der Sturm* X, No. 1
Walden, Nell and Schreyer, Lothar *Der Sturm. Ein Gedenkbuch an
Herwarth Walden und die Künstler des Sturmkreises.* Baden-Baden: W.
Klein Verlag, 1954
Werfel, Franz
Das Lyrische Werk ed. A. D. Klarmann. S. Fischer Verlag, 1967
'Substantiv und Verbum: Notiz zu einer Poetik' *Die Aktion* VII,
1917

II. General References

Adorno, Theodor W. 'Expressionismus und Künstlerische
Wahrhaftigkeit. Zur Kritik neuer Dichtung' *Die neue Schaubühne* 2,
1920
Ahlers-Hestermann, F. *Stilwende: Aufbruch der Jugend um 1900* Berlin:
Gebr. Mann, 1941
Arnheim, Rudolf *Art and Visual Perception* London: Faber and Faber,
1967
Arnold, A. *Die Literatur des Expressionismus. Sprachliche und
thematische Quellen.* Stuttgart, Berlin, Köln, Mainz: W.
Kohlhammer Verlag, 1966
Bahr, Hermann *Expressionismus* München: Delphin Verlag, 1920
Baird, James *Ishmael* Baltimore: John Hopkins Press, 1966
Barr, A. H. Jr.
Cubism and Abstract Art. New York: The Museum of Modern Art,
1936.
German Painting and Sculpture New York: The Museum of Modern
Art, 1931.

Blanchard, Francis B. *Retreat from Likeness in the Theory of Painting* New York: Columbia University Press, 1949

Bloch, Ernst. *Erbschaft dieser Zeit* (2nd. ed.) Frankfurt: Suhrkamp, 1962.
Contains perceptive observations on Expressionism. pp. 255-278

Bockmann, P. 'Gottfried Benn und die Sprache des Expressionismus' *Der deutsche Expressionismus. Formen und Gestalten* Göttingen, 1965

Braun, H. 'Das Religiöse und die jüngste Dichtung', *Der Neue Merkur* 3, 1919-20, pp. 600-10

Brenner, H. *Die Kunstpolitik des Nationalsozialismus* Hamburg, 1963

Brinkmann, R. 'Expressionismus. Forschungsprobleme 1952-1960.' Sonderdruck aus *Deutsche Vierteljahrschrift für Literaturwissenschaft und Geistesgeschichte* 33, 1959, and 34, 1960. Stuttgart: 1961

Brion, Marcel *Kandinsky* London: Oldbourne Press, 1961.

Brisch, Klaus *Wassily Kandinsky. Untersuchungen zur Enstehung der gegenstandslosen Malerei an seinem Werk von 1900 bis 1921* Bonn: Dissertation, 1955

Bruggen, M. F. E. van *Im Schatten des Nihilismus: Die expressionistische Lyrik im Rahmen und als Ausdruck der geistigen Situation Deutschlands* Amsterdam: Dissertation, 1946

Buchheim, Lothar-Günther
Der Blaue Reiter und die 'Neue Künstlervereinigung München' Feldafing: Buchheim Verlag, 1959
Graphik des deutschen Expressionismus Feldafing: Buchheim Verlag, 1959
Die Künstlergemeinschaft Brücke Feldafing: Buchheim Verlag, 1956

Burger, Fritz *Einführung In Die Moderne Kunst* Berlin-Neubabelsberg: Akademische Verlagsgessellschaft, 1917

Centaire de Kandinsky, XXe siecle No. 27, decembre 1966. A centenary edition with essays by W. Grohmann, H. H. Stuckenschmidt, M. Deutsch, K. Lankheit, K. C. Lindsay, J. Arp *and others*

Claus, Jürgen *Theorien zeitgenössischer Malerei* Rowohlt Verlag, 1963

Coellen, Ludwig *Die neue Malerei* München: E. W. Bonsels, 1912

Denecke, C. *Die Farbe im Expressionismus* Düsseldorf, Triltsch Verlag n.d

Deri, Max 'Idealismus und Expressionismus' *Das junge Deutschland* I, 1918, 95-98
Einführung in die Kunst der Gegenwart Leipzig: E. A. Seeman, 1918

Dewey, John *Art as Experience* London: Allen & Unwin, 1934

Dresler, A. *Deutsche Kunst und entartete Kunst* München, Volksverlag, 1938

Eddy, Arthur J. *Cubists and Post-Impressionists* London: Grant Richards, Ltd. 1915

Ehrenzweig, Anton *The Hidden Order of Art* London: Weidenfeld & Nicolson, 1967

Eichner, Johannes *Kandinsky und Gabriele Münter* München: Verlag F. Bruckmann, 1957

Einstein, Carl *Die Kunst des 20. Jahrhunderts* Propyläen-Kunstgeschichte, vol. XVI. Berlin: Propyläen Verlag, 1926

Ettlinger, L.D. *Kandinsky's 'At rest'* London, 1961

Fechter, Paul. *Der Expressionismus* München: R. Piper, 1919

Fehr, Hans *Emil Nolde. Ein Buch der Freundschaft* Köln: Verlag M. DuMont, Schauberg, 1957

'Feininger Lyonel-Marsden Hartley' New York: Museum of Modern Art, 1944

Finke, Ulrich *German Painting from Romanticism to Expressionism* London: Thames and Hudson, 1974

Fischer, Ernst
 Art against Ideology London: Allen Lane, The Penguin Press, 1969
 The Necessity of Art A Marxist Approach. Harmondsworth: Penguin Books, 1963

Fischer, O *Das neue Bild* München: Delphin Verlag, 1912. A reply to the *Blaue Reiter* almanac

Friedmann, Hermann and Mann, Otto, (ed.)
 Deutsche Literatur im XX. Jahrhundert (3rd. ed.), Heidelberg: W. Rothe Verlag, 1959
 Expressionismus. Gestalten einer literarischen Bewegung Heidelberg: W. Rothe Verlag, 1956

Friedrich, Hugo *Die Struktur der modernen Lyrik* Hamburg: Rowohlt Taschenbuch, 1956

Ortgega y Gasset, Jose *The Dehumanization of Art* New York: Doubleday Anchor Books, n.d.

Gehlen, Arnold *Zeit-Bilder. Zur Soziologie und Ästhetik der modernen Malerei* Frankfurt a.M. Bonn: Athenäum Verlag, 1960

Giedion-Welcker, Carola *Paul Klee* New York: The Viking Press, 1952

Gilson, Etienne *Painting and Reality* New York: Meridian Books, 1959

Glaser, Kurt 'Die Geschichte der Berliner Sezession', *Kunst und Künstler,* XXVI, 1927-8, pp. 14-20, 66-70

Goldschmidt, K. W. 'Expressionismus und Romantik,' *Romantik 2,* 1919-20. No. 2, 10-14

Goldwater, Robert J. *Primitivism in Modern Art* (Rev. Edition) New York: A Vintage Book, Random House, 1967

Gombrich, Ernst H. *Meditations on a Hobby Horse* London: Phaidon Press, 1963

*Gordon, D. E. *Ernst Ludwig Kirchner* Cambridge, Massachusetts: Harvard University Press, 1968

Grohmann, Will
Kandinsky (1866-1944) London: Beaverbrook Newspapers, Ltd., 1960
Karl Schmidt-Rottluff Stuttgart: Kohlhammer Verlag, 1956
Paul Klee New York: Harry N. Abrams, 1954
Wassily Kandinsky, Life and Work New York: Harry N. Abrams, 1958
Das Werk Ernst Ludwig Kirchners München: K. Wolff Verlag, 1926

Grote, Ludwig *Der Blaue Reiter: München und die Kunst des 20. Jahrhunderts* München: Filser Verlag, 1949
Deutsche Kunst im 20. Jahrhundert (2nd. ed.) München: Prestel Verlag, 1954

Haftmann, Werner
The Mind and Work of Paul Klee. London: Faber and Faber, 1954
Painting in the Twentieth Century 2 vols. London: Lund Humphries, 1960

Hamann, Richard. *Die deutsche Malerei vom Rokoko bis zum Expressionismus* Leipzig: G. B. Teubner, 1925

Händler, Gerhard *Deutsche Maler der Gegenwart* Berlin: Rembrandt Verlag, 1956

Hartlaub, G. F.
Die Graphik des Expressionismus in Deutschland Stuttgart: G. Hatje, 1947
Kunst und Religion Leipzig: K. Wolff, 1919
'Die Kunst und die neue Gnosis' *Das Kunstblatt* I, 1917, 166-179

Hatvani, Paul 'Versuch über den Expressionismus' *Die Aktion*, VII, 1917, 146-50

Hausenstein, Wilhelm
Die bildende Kunst der Gegenwart Stuttgart and Berlin: Deutsche Verlagsanstalt, 1914
'Was ist Expressionismus?' *Der neue Merkur*, III, 1919, 119-125

Hodin, J. P.
The Dilemma of Being Modern London: Routledge and Kegan Paul, 1956
Oskar Kokoschka. The Artist and His Time. (a biographical study)

London: Cory, Adams & Mackay, 1966
"Expressionism", *Horizon*, XIX, 1949, pp. 45-6
*Hoffmann, Edith *Kokoschka: Life and Work* Boston: Boston Book and Artshop, 1946
Holzhausen, Walter *August Macke* München: F. Bruckmann, 1956
Hospers, John *Meaning and Truth in the Arts* Chapel Hill : University of North Carolina Press, 1946
Hulme, T. A. *Speculations* ed. H. Read. London: Routledge & Kegan Paul, 1960
Justi, L. *Von Corinth bis Klee* Berlin: J. Bard, 1931
Kepes, Gyorgy (ed).
 Sign Image and Symbol. London: Studio Vista, 1966.
 (ed.) *The Visual Arts Today* Middletown, Connecticut: Wesleyan University Press, 1960
Klages, Ludwig
 Der Geist als Widersacher der Seele Leipzig: Barth, 1929
 Grundlagen der Charakterkunde Leipzig, 1928
 Mensch und Erde München: G. Müller Verlag, 1920
Klarmann, A. D. 'Expressionism in German Literature ...' *Modern Language Quarterly*, XXVI, 1965
Koestler, Arthur *The Act of Creation* London: Hutchinson, 1964
Korn, Richard *Kandinsky und die Theorie der abstrakten Malerei* Berlin-Ost: Henschel Verlag, 1960
Landauer, Gustav *Der werdende Mensch* ed. M. Buber. Potsdam: Kiepenheuer, 1921
Landsberger, Franz *Impressionismus und Expressionismus* Leipzig: Klinkhardt und Biermann, 1919
Lankheit, Klaus
 Franz Marc Berlin: Verlag K. Lemmer, 1950
 'Die Frühromantik und die Grundlagen der "gegenstandslosen Malerei"' *Neue Heidelberger Jahrbücher*, 1951, pp. 55-90
 'Die Geschichte des Almanachs' *Der Blaue Reiter*. Dokumentarische Neuausgabe von K. Lankheit. München: R. Piper, 1965, pp. 253-301
Lehmann, Arthur George *The Symbolist Aesthetics in France 1885-1895* Oxford: Basil Blackwell, 1950
Lehmann-Haupt, Helmut *Art under a Dictatorship*. Oxford University Press, 1954
Leonhard, Kurt *Augenschein und Inbegriff*. Die Wandlungen der neuen Malerei Stuttgart: Deutsche Verlagsanstalt, 1953
*Lindsay, Kenneth C. *An Examination of the Fundamental Theories of*

Wassily Kandinsky University of Wisconsin: Dissertation, 1951
Lohner, Ernst 'Die Lyrik des Expressionismus' *Expressionismus* ed. H.
Friedmann and O. Mann, pp. 57-83.
Lorck, Carl von *Expressionismus* Einführung in die europäishce Kunst
des 20. Jahrhunderts I. M. Wildner Verlag, 1947
Lukács, Georg. 'Grösse und Verfall des Expressionismus'
Schicksalswende Berlin: Aufbau Verlag, 1948, pp. 180-235. *Expr.
Kampf um eine lit. Bew.*
Lützeler, Heinrich *Abstrakte Malerei* SM Bücher, Sigbert Mohn
Verlag, 1961
Lynton, Norbert *Klee* London: Spring Art Books, 1964
Maerker, F. *Lebensgefühl und Weltgefühl* München: Delphin Verlag,
1920
Mann, Otto, 'Einleitung' in H. Friedmann and O. Mann (eds.)
Expressionismus, pp. 9-26
Martini, Fritz *Was war Expressionismus?* Urach: Port Verlag, 1948
Marzynski, Georg *Die Methode des Expressionismus* Leipzig: Klinkhardt
and Biermann, 1921
Mautz, K. 'Die Farbensprache der expressionistischen Lyrik'
Deutsche Vierteljahrsschrift für Literatur und Geistesgeschichte 31, 1957,
pp. 198-240
Mayer, Hans *Zur deutschen Literatur der Zeit* Hamburg, 1957. See
chapter: 'Retrospektive des Expressionismus', pp. 37-53
Meier-Graefe, Julius *Entwicklungsgeschichte der modernen Kunst* Vol.
III. München: R. Piper, 1920
Michel, Wilhelm *Der Mensch versagt. Tribüne der Kunst und Zeit*, XX.
Berlin, 1920
Mohlzahn, Johann 'Das Manifest des absoluten Expressionismus' *Der
Sturm*, X, 1919, No. 6, 90-93
Musil, Robert 'Expressionismus' (Notizen zu einem Vortrag, 1919)
Tagebücher, Aphorismen, Essays ... (ed) A. Frise. Hamburg:
Rowohlt, 1955, p. 206-7. Republished in *Expr. Kampf um eine lit.
Bew.*
*Myers, Bernhard S. *Expressionism. A Generation in Revolt* London:
Thames and Hudson, 1963
Naumann, H. *Die deutsche Dichtung der Gegenwart*. Stuttgart, 1931
Nemitz, Fritz *Deutsche Maler der Gegenwart*. München: R. Piper, 1948
Neumeyer, Alfred *The Search for Meaning in Modern Art* New Jersey: A
Spectrum Book, Prentice Hall, Inc., 1964
Overy, Paul *Kandinsky: the language of the eye* London: Elek, 1969
Pankok O. (ed.), *Deutsche Holzschneider* Düsseldorf: Progress-Verlag,

1958
Paulsen, Wolfgang. (ed.) *Das Nachleben der Romantik* Heidelberg: Lothar Stiehm Verlag, 1969
Expressionismus und Aktivismus Bern und Leipzig: Gotthelf Verlag, 1935
Perkins, G. C. *Expressionismus. Eine Bibliographie zeitgenössischer Dokumente 1910-1925* Zurich: Verlag für Bibliographie, 1971
Pesch, Ludwig *Die Romantische Rebellion in der Modernen Literatur und Kunst* München: Verlag C. H. Beck, 1962
Petitpierre, P., (ed.) *Aus der Malklasse von Paul Klee* Bern: Benteli-Verlag, 1957
Picard, Max
Expressionistische Bauernmalerei München: Delphin Verlag, 1915.
'Expressionismus. Ein Vortrag', *Die Erhebung* I, pp. 329-38
Portner, Paul 'Vorwort' and 'Einführung, *Literatur-Revolution 1910-1925*
'Was heisst Expressionismus?' *Neue Züricher Zeitung* Literaturbeilage, 29 Jan. 1961
Raabe, Paul *Zeitschriften des Expressionismus* vol. 1. Stuttgart: Metzlersche Verlagsbuchhandlung, 1964
Rader, Melvin (ed.) *A Modern Book of Esthetics. An Anthology* (3rd ed.) New York, Chicago, San Francisco, Toronto, London: Holt, Rinehart and Winston, 1966 See H. Bergson 'The Individual and the Type' pp. 80-87
Raphael, Max *Von Monet bis Picasso* München: R. Piper, 1919
Rasch, W. 'Was ist Expressionismus', *Akzente,* III, 1956, pp. 368-73
Rave, Paul Ortwin *Kunstdiktatur im dritten Reich* Hamburg: Verlag Gebr. Mann, 1948
Raymond Marcel *From Baudelaire to Surrealism* New York: Wittenborn, Schultz Inc. 1950
Read, Herbert *Art Now* London: Faber and Faber, 1948
Ringbohm, Sixten *The Sounding Cosmos*: a study in the spiritualism of Kandinsky and the genesis of abstract painting. Abo: Abo Akademi, 1970
Rodman, Selden
Conversations with Artist New York: Capricorn Books, 1961
The Insiders Rejection and Rediscovery of Man in the Arts of our Time. Louisiana State University Press, 1960
Roh, Franz *Streit um die moderne Kunst* München: P. List Verlag, 1962
Rosenberg, Harold
The Anxious Object London: Thames and Hudson, 1965

The Tradition of the New London: Thames and Hudson, 1962
Rosenblum, Robert *Modern Painting and the Northern Romantic Tradition* London: Thames and Hudson, 1975
Rothe, W., (ed.) *Expressionismus als Literatur. Gesammelte Studien* Bern München: Franke Verlag, 1969
Röthel, H. K.
 Gabriele Münter München: Verlag F. Bruckamnn, 1957
 The Blue Rider New York: Praeger, 1971
Samuel, Richard and Hinton R. Thomas. *Expressionism in German Life, Literature and the Theatre* Cambridge: W. Heffer & Sons, 1939
Sauerlandt, Max.
 Emil Nolde. Briefe aus den Jahren 1894-1926 München: Kurt Wolff, 1921
 Die Kunst der letzten 30 Jahre Berlin: Rembrandt Verlag, 1935
*Schardt, Alois *Franz Marc* Berlin: Rembrandt Verlag, 1936
Schmidt, Paul Ferdinand *Geschichte der modernen Malerei* Stuttgart: Kohlhammer Verlag, 1952
Schneider, Karl Ludwig
 Der bildhafte Ausdruck in den Dichtungen Georg Trakls und Ernst Stadlers Heidelberg, 1954
 Zerbrochene Formen Wort und Bild im Expressionismus. Hamburg: Hoffman und Campe Verlag, 1967
Schonauer, F. *Deutsche Literatur im Dritten Reich* Olten und Freiburg im Breisgau: Walter Verlag, n.d
Sedlmayr, Hans
 kunst und wahrheit Hamburg: Rowohlt Taschenbuch Verlag, 1959
 die revolution der modernen kunst Hamburg: Rowohlt Taschenbuch Verlag, 1961
 Verlust der Mitte Salzburg; O. Müller Verlag, 1948
Selz, Peter
 **German Expressionist Painting* Berkeley and Los Angeles: University of California Press, 1957
 **Emil Nolde* New York: Museum of Modern Art, 1963
Soergel, A. *Dichtung und Dichter der Zeit.* (New series). Leipzig: R. Voigtlander, 1925
Sokel, W. H. *The Writer in Extremis. Expressionism in Twentieth Century German Literature* Stanford, California: Stanford University Press, 1959
Steffen, H. (ed). *Der deutsche Expressionismus. Formen und Gestalten* Göttingen, 1965

Strothmann, Dietrich *Nationalsozialistische Literaturpolitik* (2nd ed.)
Bonn, 1963

Sydow, Eduard von *Die deutsche expressionistische Kultur und Malerei*
Berlin: Furche Kunstverlag, 1920

Sypher Wylie *Rococo to Cubism* New York: Vintage Books, 1960

Thoene, Peter *Modern German Art* Harmondsworth: Penguin Books, 1938

Vinnen, Carl, (ed.) *Protest deutscher Künstler* Jena: E. Diederichs, 1911

*Vriesen, Gustav. *August Macke* Stuttgart: Kohlhammer Verlag, 1953

Walden, Herwarth *Die neue Malerei* Berlin: Verlag der Sturm, 1919

*Weiler, Clemens *Alexey von Jawlensky* Wiesbaden, Limes Verlag, 1955

Whitford, Frank *Expressionism* (Movements of Art) London: Hamlyn, 1970

Willett, John, *Expressionism* London: Weidenfeld and Nicolson, 1970

Winkler, Walter *Psychologie der modernen Kunst* Tübingen: Alma Mater Verlag, 1949

Woringer, Wilhelm
Abstraction and Empathy. London: Routledge & Kegan Paul, 1953
Problematik der Gegenwartskunst München: R. Piper, 1948

Zehder, Hans *Wassily Kandinsky* Dresden: R. Kaemmerer Verlag, 1920

Index

323